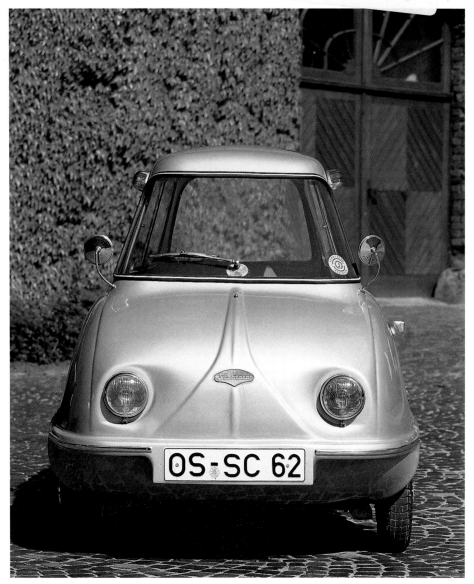

OS-SC 62

212790

205565

Hans-Ulrich von Mende · Matthias Dietz

KLEINWAGEN
SMALL CARS · PETITES VOITURES

BENEDIKT TASCHEN

FRONT COVER / UMSCHLAGVORDERSEITE / COUVERTURE:

Isetta
Germany, 1956

Austin Mini
Great Britain, 1959

Fiat 500
Italy, 1957

Messerschmitt KR 200
Germany, 1956

Glas Goggomobil
Germany, 1955

BMW Dixi
Germany, 1928

ILLUSTRATION PAGE 1 / ABBILDUNG SEITE 1 / REPRODUCION PAGE 1:

Scootacar
Great Britain, 1957

ILLUSTRATION PAGE 176 / ABBILDUNG SEITE 176 / REPRODUCTION PAGE 176:

Scootacar
Great Britain, 1957

BACK COVER / RÜCKTITEL / AU DOS:

Renault Matra Zoom
France, 1992

BMW E 1
Germany, 1993

ACCE Mazda
Switzerland, 1991

Daihatsu Marienkäfer
Japan, 1990

Fiat 126 Bambino
Italy, 1972

Honda S 800
Japan, 1966

**This book was printed on 100 % chlorine-free bleached
paper in accordance with the TCF-standard**

© 1994 Benedikt Taschen Verlag GmbH
Hohenzollernring 53, D-50672 Köln

Edited by Matthias Dietz, Dietz Design Management, Frankfurt am Main
Text: Hans-Ulrich von Mende, Frankfurt am Main
Coordinated and copy-edited by Simone Philippi, Cologne, Torge Eßer, Cologne, Ute Fischer, Ascheberg
Design: Peter Courtin, Dietz Design Management GmbH, Frankfurt am Main
English translation: Hugh Beyer, Leverkusen
French translation: Michèle Schreyer, Cologne
Typesetting: Utesch Satztechnik GmbH, Hamburg
Printed by Printer, Trento

Printed in Italy
ISBN 3-8228-8910-5

Contents

Inhalt

Sommaire

Small Cars

Kleinwagen

Petites voitures

Since the early beginnings of the automobile era, DIY enthusiasts and engineers have been seeking more than success on four wheels. Alongside developments in the car industry itself, there have been so many general technological innovations that the automobile has profited greatly. During the first few decades of its existence, the car gradually acquired its current shape through developments of its various components. The chassis was borrowed from the horse-drawn carriage, occasionally even with spring suspension. Electrical engineering provided improvements in the ignition system and reliable lighting. Air-filled tyres made for greater comfort, and innovations in metal processing ensured that the body no longer suffered damage in bad weather. With every increase in technological expertise it became easier to design cars that were small and therefore inexpensive. And yet everything had started in a very small way.

In 1885, in Mannheim, Karl Benz succeeded in putting together a vehicle with an internal combustion engine. However, even in those days, good ideas required legal protection in the form of a patent. On January 29th 1886 Karl Benz was given the patent number 37435 by the German Imperial Patent Office. The vehicle which Benz had raised to such illustrious heights was probably the first small car in the world. Everything about it was small, dainty and modest. Feeling that it would be difficult to manoeuvre four wheels any more elegantly than the swivelling bolster of a horse-drawn carriage, Benz decided to have only three wheels. It was the principle of the three-legged stool: everyone knows that three legs give an object enough stability to stand without wobbling, and three wheels are sufficient for a vehicle

Seit dem Beginn der automobilen Zeitrechnung haben Bastler und Ingenieure immer wieder nicht nur schlicht den Fortschritt auf vier Rädern gesucht: Die Technik hatte parallel zur Entwicklung des Automobils viel Neues zu bieten, von dem das Auto profitieren konnte. In den ersten Jahrzehnten suchte es sich über alle Bereiche seiner Bauteile den Weg zu seiner heutigen Form. Vom Pferdewagen lieh es sich das Fahrgestell, bisweilen schon gefedert, aus der Elektrotechnik kamen Entwicklungen für bessere Zündsysteme und verläßliche Beleuchtung. Luftgefüllte Reifen sorgten genauso für besseren Komfort wie verfeinerte Technik der Blechverarbeitung für eine wetterunabhängige Hülle. Je weiter sich das technische Verständnis entwickelte, desto eher war ein Auto auch so zu bauen, daß es preiswert, weil klein war. Dabei fing alles sehr bescheiden an.

Bereits 1885 bastelte Karl Benz in Mannheim an einem Fahrzeug mit Explosionsmotor. Schon damals benötigten gute Ideen rechtlichen Schutz, den ein Patent bot. Und dieses wurde Karl Benz unter der Nummer 37435 vom Deutschen Reichspatentamt am 29. Januar 1886 erteilt. Das Gefährt, das Benz mit einem Patent adeln ließ, dürfte der erste Kleinwagen der Welt gewesen sein. Denn alles an ihm war klein, zierlich und sparsam,. Benz, aus Sorge, zwar Räder bewegen zu können, aber nicht deren vier so elegant, daß sie leichter lenkbar sind als Drehschemel einer Kutschenkonstruktion, begnügte sich deshalb mit dreien. Drei Aufstandspunkte sind, jeder weiß es vom Hokker, stabil genug, der Hocker wackelt nicht, drei Räder sind ausreichend für ein Fahrzeug dieser Leistung. Was Benz da bewegte, war gerade 2378 Millimeter lang, hatte

Depuis son apparition, l'automobile n'a cessé d'être le champ d'activité des bricoleurs et des ingénieurs qui l'ont fait profiter des nouveautés d'une technique en pleine évolution. Des dizaines d'années se sont écoulées avant qu'elle ne trouve sa forme actuelle, et toutes les pièces d'origine ont été repensées. Le coche lui a prêté son châssis, déjà suspendu sur ressorts, les développements de l'électrotechnique l'ont dotée de meilleurs systèmes d'allumage et d'un éclairage sûr. Les pneus remplis d'air ont amélioré le confort, et une technique élaborée du travail de la tôle a rendu la carrosserie hermétique. Les méthodes de fabrication se sont perfectionnées et construire une voiture bon marché parce que de petites dimensions s'est avéré possible. Il n'empêche que tout a commencé bien modestement.

En 1885 à Mannheim, Karl Benz travaille déjà sur un véhicule équipé d'un moteur à explosion. A l'époque, il était déjà sage de protéger ses bonnes idées par un brevet. Le Deutscher Reichspatentamt remis ce brevet n° 37435 à Karl Benz le 29 janvier 1886. Le véhicule de Benz fut certainement la première petite voiture. Tout en elle était petit, mince, économique – comme quoi les choses ont bien changé. Benz, qui craignait de ne pouvoir manœuvrer quatre roues aussi élégamment et facilement que le chariot de rotation d'un coche, construisit un tricycle. Il suffit d'observer un tabouret pour comprendre que trois points d'appui assurent parfaitement la stabilité d'une construction, trois roues suffisaient donc au véhicule de Benz qui mesurait 2378 mm de longueur, pesait 265 kilos et abritait un moteur monocylindrique de 3/4 de CV plafonnant à 18 kilomètres à l'heu-

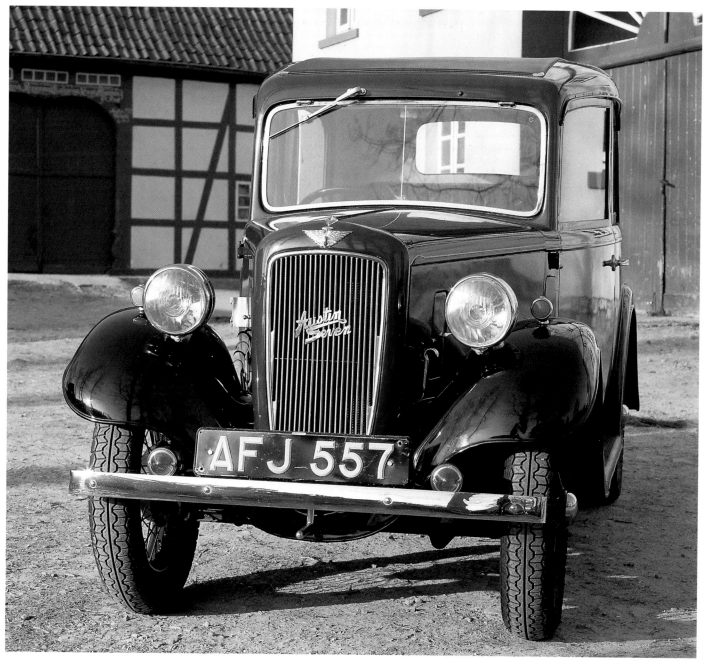

Austin Seven
Great Britain
England
Angleterre, 1932
747 ccm, 10 PS

of this size. Benz's car was a mere 93½ inches (2,378 mm) long, had a single cylinder and no more than a three-quarter horsepower engine! The entire car, including the engine, only weighed 584 lbs (265 kg), and its maximum speed was 12 miles (18 km) per hour. If it had not been for the front wheel, the little two-seater would have resembled a two-wheel Sulky, i.e. an extremely light little horse-drawn carriage. Bicycle-thin wheel rims with wire spokes, the front wheel on a fork and thin full-rubber tyres meant that the car had very little roll-

einen Einzylindermotor mit einem dreiviertel PS! Es wog samt Motor nur 265 Kilogramm und schaffte höchstens 18 Kilometer pro Stunde. Hätte das kleinere Vorderrad gefehlt, das zweisitzige Gefährt wäre einem einachsigen Sulky, einem ultraleichten Pferdewägelchen, nicht unähnlich. Fahrraddünne Felgen mit Drahtspeichen, das Vorderrad in einer Gabel geführt, sorgten mit dünnen Vollgummireifen für geringen Rollwiderstand. Wegen des großen Durchmessers der kettenangetriebenen Hinterräder hatte das Motörchen jedoch viel Arbeit.

re. S'il n'avait pas été doté d'une petite roue à l'avant, le véhicule à deux places aurait ressemblé à un sulky, cette voiture légère à deux roues que l'on utilise pour les courses au trot. La voiture de Benz roulait facilement sur de minces bandages en caoutchouc plein chaussés sur des jantes aussi étroites que celles d'une bicyclette et munies de rayons en fil de fer, la roue avant était placée dans une fourche. Le petit moteur peinait malgré tout à cause du grand diamètre des roues arrière entraînées par chaîne.

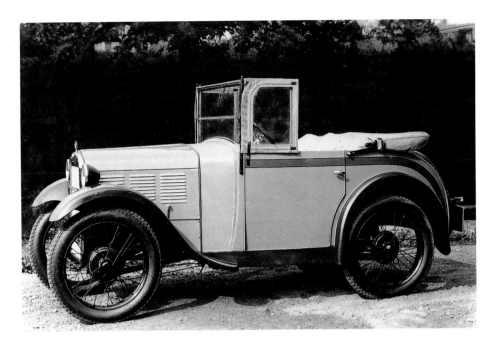

BMW Dixi
Germany
Deutschland
Allemagne, 1929
749 ccm, 15 PS

ing resistance. The large diameter of the chain-driven back wheels meant that the little engine had to work extremely hard. Significantly, the first big outing was undertaken by Benz's wife, Berta, and their two sons, Eugen and Richard. This was in August 1888. Berta went from Mannheim to Pforzheim, a route that was considered excellent proof of the reliability of this new horseless carriage. The fuel had to be bought at a chemist's. The first petrol stations were not opened until much later. This fascinating new form of travelling – without horses – spread very fast. People's desire for mobility seemed to be boundless and was only surpassed by some people's aspiration to match Benz's achievement. The development of the automobile was too fast for historians to record every vehicle that was welded together in those days. Not surprisingly, many automobile manufacturers had originally started off with the production of bicycles or in related industries. Opel is a good example, a company that originally made bicycles and sewing machines. Another German firm, Victoria in Nuremberg, produced their first Voiturette in 1903 – the first car after countless bicycles. Then there was Ruppe & Son in Apolda with their 1904 Piccolo, a name that summed up the idea behind it very aptly – mobility and small size. Even the music industry had no qualms about exploiting this fashion for small cars. Polyphon in Wahren, near Leipzig, held the German licence for an American vintage car called Curved Dash, which it sold under the name of Gazelle until 1908. The original US car had an elegant upwardly curved floorboard at the front (hence »Curved Dash«). Nearly all industrial countries had their heroes of the

Die erste große Ausfahrt, ausgerechnet, hatte seine Frau Berta mit den Söhnen Eugen und Richard unternommen. Das war im August 1888. Die Strecke führte von Mannheim nach Pforzheim und galt als bester Beweis für die Zuverlässigkeit der neuen, pferdelosen Konstruktion, die ihren Treibstoff nur in Apotheken bekam. Tankstellen – so etwas war erst für spätere Jahrzehnte vorgesehen.
Schnell hatte sich die Faszination dieser neuen Art des Reisens – ohne Pferde – durchgesetzt. Der Wunsch nach Mobilität war grenzenlos, übertroffen nur vom Drang vieler, es Benz gleichzutun. Die automobile Entwicklung ging so rasant vonstatten, daß die Geschichtsschreibung kaum alles erfassen konnte, was damals schraubte und schweißte. Es versteht sich, daß viele Hersteller von Automobilen eine Vergangenheit im Fahrradbau und artverwandten Industrien hatten.
Opel ist ein Beispiel dafür: Fahrräder und Nähmaschinen standen auf dem Programm. Eine andere deutsche Marke, Victoria in Nürnberg, kam 1903 mit ihrer Voiturette, dem ersten Auto nach unzähligen Fahrrädern. Auch der Piccolo – der Name war Programm – der Firma Ruppe & Sohn aus Apolda, war 1904 ein Beispiel für Mobilität im Kleinen. Selbst die Musikbranche scheute sich nicht, den Trend zum Auto, zum kleinen Auto, zu nutzen. Die Polyphon Musikwerke in Wahren bei Leipzig bauten in Lizenz den amerikanischen Oldsmobile »Curved Dash« bis 1908 als Polymobil »Gazelle«, im US-Original bildschön mit dem elegant nach oben geschwungenen Bodenbrett an der Front (daher »Curved Dash«). Fast jede Industriemacht hatte Helden der ersten Stunde, die mit vorhandenen Produk-

C'est sa femme Bertha qui utilisa la voiture pour la première fois avec ses deux fils Eugen et Richard en août 1888. Elle se rendit de Mannheim à Pforzheim et prouva ainsi on ne peut mieux les qualités du nouveau véhicule qui se déplaçait sans l'aide d'un cheval et ne pouvait faire le plein que dans les pharmacies. Les stations-service ne firent leur apparition que des dizaines d'années plus tard.
L'idée s'imposa rapidement car les gens étaient fascinés par cette nouvelle possibilité de voyager sans chevaux. Ils voulaient se déplacer et étaient nombreux à vouloir faire la même chose que Benz. La construction automobile évolua si rapidement que les historiens ont eu du mal à suivre. De nombreux constructeurs, cela va de soi, avaient un passé dans la bicyclette ou un produit industriel apparenté.
Opel, par exemple, était spécialiste des bicyclettes et des machines à coudre. Victoria, une autre société allemande sise à Nuremberg, mit au point en 1903 sa Voiturette qui succédait à d'innombrables bicyclettes. Le Piccolo de la Maison Ruppe & Sohn d'Apolda, autre exemple de petit véhicule comme son nom l'indique, sortit en 1904. Ceux qui travaillaient dans la musique n'eurent, eux non plus, aucun scrupule à tirer parti du succès de la voiture, de la petite voiture. Jusqu'en 1908 les Polyphon Musikwerke à Wahren près de Leipzig construisirent sous licence le Oldsmobile Curved Dash américain sous le nom de Polymobil Gazelle. La voiture originale était très belle avec son plancher élégamment arqué vers le haut à l'avant (d'où le nom de «curved dash»). Presque chaque puissance industrielle a eu ses pionniers qui contribuèrent à développer la

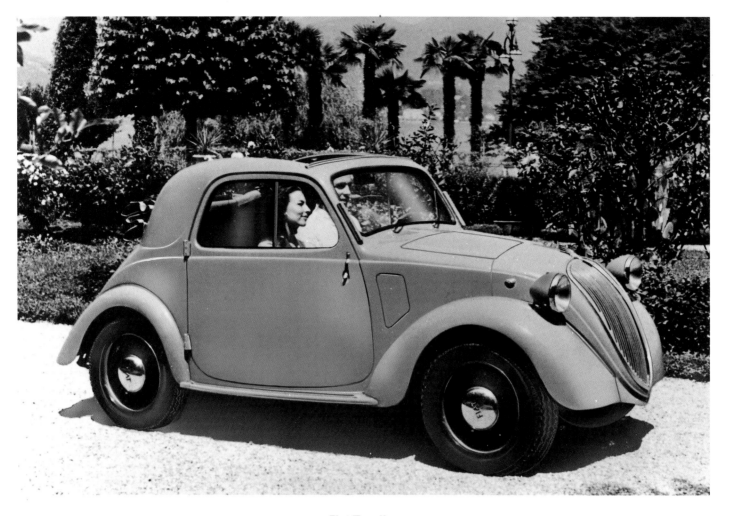

Fiat Topolino
Italy
Italien
Italie, 1936
569 ccm, 14 PS

first hour who helped to design this new product – the automobile – with their existing manufacturing facilities.

Unlike nowadays, cars were still easy to make. The frame, the engine, the wheels, the suspension and some kind of body were put together in a modular system, using whatever was technically feasible and available. The design was still very much that of a stage coach. At the same time, new models were produced in an attempt to be technically more progressive than the competition. Within a matter of years the classical coach design had disappeared altogether. The wheels had become smaller, though they still had the same diameter, and thanks to Dunlop's invention, they were now of the pneumatic kind. Stronger engines and the increased use of steel resulted in the sheet-metal construction still common today.

Small cars met the general desire – or perhaps greed – for mobility, so that even the less well-off could afford it. The very first

tionsmöglichkeiten das neue Produkt Auto mitgestalteten.

Noch war das Auto einfach zu bauen – aus heutiger Sicht. Rahmen, Motor, Räder, Radaufhängung, ein Hauch Karosserie, alles wurde wie im Baukastensystem aus technisch mach- und verfügbaren Elementen zusammengesetzt. Noch hatte der Kutschenbau seinen Anteil am Fahrzeugkonzept. Neue Modelle versuchten gleichzeitig, technisch fortschrittlicher zu sein als die Konkurrenz. Nach wenigen Jahren war von der klassischen Kutschenkonstruktion nichts mehr übriggeblieben. Kleinere Räder mit gleichem Durchmesser, dank der Erfindung von Dunlop luftbereift, stärkere Motoren und erhöhter Einsatz von Stahl gaben dem Auto die Konzeption, wie wir sie, blechverkleidet, heute noch kennen.

Kleinwagen entsprachen dem allgemeinen Wunsch, ja der Sucht nach Mobilität auch der Menschen mit kleinem Portemonnaie. Denn was sich normalerweise automobil in der ersten Zeit entwickelte, war preislich

voiture avec les moyens de production existants.

Avec le recul, nous nous disons que construire une voiture était alors un jeu d'enfant. Le châssis, le moteur, les roues, la suspension, un rien de carrosserie, tout était fait d'éléments mobiles techniquement réalisables ou disponibles. Au départ, la conception du véhicule s'inspirait encore de la construction des coches, mais comme les nouveaux modèles essayaient d'être techniquement plus avancés que leurs concurrents, on ne trouva, au bout de quelques années, plus trace du coche classique dans l'automobile. Des roues plus petites de même diamètre chaussées de pneus à chambre à air, invention de Dunlop, des moteurs plus puissants, et une utilisation plus poussée de l'acier donnèrent à l'automobile le visage que nous lui connaissons.

Les petites voitures répondaient au souhait général, on pourrait même dire au désir effréné de mobilité, et les personnes aux

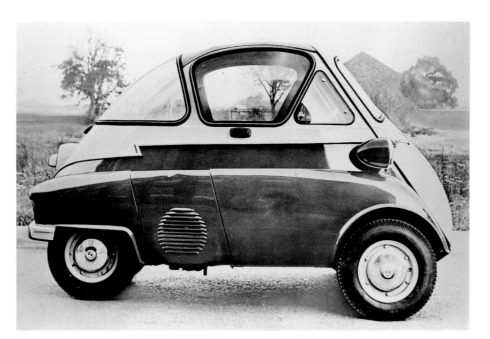

BMW Isetta
Germany
Deutschland
Allemagne, 1955
250 ccm, 12 PS

automobiles were so expensive and power-ful that only nobility could afford such a ve-hicle as well as the service of a chauffeur, who had replaced the coachman. The chauf-feur derived his name from the technology of the first engines, which had to be pre-fired before they would run. Both the pur-chase price and the maintenance expenses of these cars were too high for any wide-spread use. Designers therefore tried to meet the demand for greater but inexpens-ive mobility with so-called cycle cars. We would be attempting the impossible if we tried to list all the examples. But it is worth noting that the sum total of cars manufac-tured in Germany was only slightly higher than the number of companies. In 1901, for example, annual production was 845, in 1902 it had gone up to 1,310 and in 1906 it was 4,866. The figure of 10,000 was only reached in 1911!

Small is of course relative. The word itself becomes meaningless if everything else is huge, and developments in the automobile industry tended more towards large dimen-sions, rather than spending creative energy on designing small vehicles or keeping their size to a minimum. The main challenge was seen in improving the design rather than in reducing its size. However, any designer who wanted to manufacture cars at low cost tried to produce light cars and to concentrate on the things that really mattered, such as light steel rims with wire spokes, similar to bicycle wheels, and three wheels instead of four. Small narrow wheels meant that, if there was any mudguard at all, it had to be small. Even when enclosed bodies became common, they had to be reduced to the bare minimum to accommodate the engine and the seats and to protect passengers against

und leistungsmäßig ein Produkt für die Herr-schaften, die bis dato mit dem Kutscher vor-gefahren waren und sich nun den Chauf-feur leisteten. Seinen Namen prägte die Technik der ersten Motorkonstruktionen, die nur durch Vorwärmen zum Laufen zu be-wegen waren. Diese Autos konnten weder vom Kaufpreis noch von den Unterhalts-kosten her eine weite Verbreitung finden. Also versuchten Konstrukteure von soge-nannten Cyclecars, den Wunsch nach Mobi-lität bei kleinem Etat zu erfüllen. Alle Bei-spiele aufzuzeigen ist unmöglich. Dabei lag die Gesamtzahl aller in Deutschland gebau-ten PKWs kaum höher als die Firmenzahl. Beispiele: Jahresproduktion 1901: 845 PKW, 1902: 1310, 1906: 4866. Erst 1911 wurde die Zehntausendergrenze erreicht! Alles Kleine hat seine Relationen. Was ist schon klein, wenn alles andere übergroß ist. Die automobile Entwicklung tendierte eher zur Größe, als daß Erfindergeist sich auf die Miniaturisierung oder Minimierung richtete. Es galt, die Konzeption des Autos zu verbes-sern, nicht dessen Verkleinerung anzustre-ben. Wer an der Konzeption arbeiten, aber auch preisgünstigere Autos produzieren woll-te, versuchte, leicht zu bauen und sich auf Wesentliches zu konzentrieren. Also: leichte Stahlfelgen mit Drahtspeichen wie beim Fahrrad, drei Räder statt vier. Schmale, kleine Räder erfordern, wenn überhaupt, nur schmale Kotflügel. Die Karosserie reduziert sich auf die notwendigste Verkleidung von Motor und Sitzen – auch dann noch, als ge-schlossene Karossen selbstverständlich wur-den, um Passagiere vor dem Straßenstaub zu schützen. Beim Antrieb der Räder, wo sonst ein Differential wegen der breiten Fahr-zeugspur notwendig war, genügte bisweilen die Kette oder der Riemen, mit dem Antrieb

moyens limités ne faisaient pas exception. Il ne faut pas oublier que les premières auto-mobiles étaient de par leurs prix et leurs performances destinées à ceux qui possé-daient jusqu'ici un équipage et s'offraient maintenant un chauffeur, appelé ainsi parce que les premiers moteurs ne démarraient qu'après un préchauffage. Le prix d'achat de ces voitures et le montant des frais d'en-tretien faisaient obstacle à une large diffu-sion. Les constructeurs de ce qu'on appe-lait les cycles à moteur essayèrent donc de satisfaire les désirs de mobilité des person-nes au petit budget. Enumérer tous les exemples serait un exercice de longue halei-ne, pourtant le nombre total des voitures particulières construites en Allemagne était à peine plus élevé que le nombre de con-structeurs. En 1901, par exemple, la produc-tion s'élevait à 845 voitures, en 1902: 1310, en 1906: 4866. La barre des 10000 ne fut passée qu'en 1911!

Mais tout est relatif. Qu'est-ce qui est petit si tout est trop grand? On tendait plus à dé-velopper des véhicules de grande taille, qu'à inventer des modèles de petite taille ou à ré-duire les proportions des modèles existants. On voulait améliorer la voiture et non dimi-nuer ses dimensions. Les concepteurs, déci-dés à produire des voitures moins coûteu-ses, s'efforçaient de construire léger et de se concentrer sur l'essentiel, c'est-à-dire: jantes en acier léger avec des rayons en fil de fer comme les bicyclettes, trois roues au lieu de quatre. Des roues petites et étroites n'exigent que des ailes étroites, ou pas d'ai-les du tout. La carrosserie se réduisait au re-vêtement nécessaire du moteur et des siè-ges, même à l'époque où les voitures fer-mées protégeant les passagers de la pous-sière étaient devenues l'évidence même.

FMR TG 500 Tiger
Germany
Deutschland
Allemagne, 1957
194 ccm, 19,9 PS

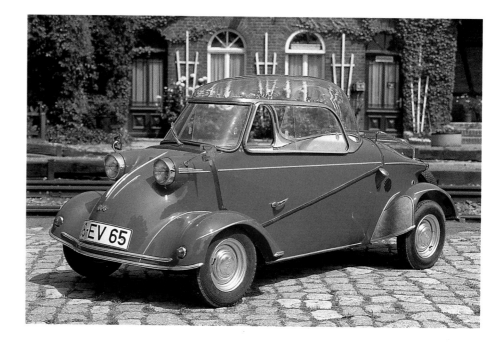

road dust. The actuation of the wheels would normally have required a differential to cater for the large distance between them: here, many cars simply had a chain or a drive belt which sometimes only drove one of the back wheels. If the distance was any wider, the differential was automatically superfluous anyway. Another method that was even simpler, and perhaps more primitive, was the use of a friction drive.

One successful example of such endeavours was the Omnimobile of the Aachener Stahlwerke AG, from 1904 to 1910. Its modular principle allowed DIY enthusiasts to build their own cars or to create their own designs using parts of it. Another car with a heart for the DIY fiend had a ventilated 1.3-litre engine (0.29 UK gallons, 0.34 US gallons) which eliminated the need for a water cooler and thus also for many other components. It was sold by Peter & Moritz in Eisenberg, Thuringia, in 1919. Only two sizes of spanner were needed to disassemble this car and – hopefully – reassemble it again so that it would run.

The Bedelia cycle car, a French design, was truly eccentric. Sold by Bourbeau & Devaux from 1910 to 1920, it was extremely narrow, open and belt-driven, with a design so contorted that the driver had to sit behind the passenger – like a bungled version of a tandem. A similarly quaint vehicle had been designed in France in 1900 – also a tandem, but with the driver sitting at the front. It was called La Nef and looked like the elongated post-war vehicles used for transporting injured persons. The front wheel had to be forced round corners with a long handlebar. However, we only smile because of the distance in time. It is worth noting that the engine was by the ingenious De Dion who

gar nur auf ein Hinterrad. Bei breiterer Spur konnte automatisch auf das Differential verzichtet werden. Noch einfacher, um nicht zu sagen primitiver, war der Reibradantrieb. Erfolge dieses Bemühens waren beispielsweise Angebote wie das Omnimobil der Aachener Stahlwerke AG zwischen 1904 und 1910. Weil im Baukasten konzipiert, konnten sich Bastelfreudige das Auto selber bauen oder mit Teilen davon eine eigene kleine Marke kreieren. Ein anderes Auto bewies ebenso ein Herz für Bastler. Es hatte einen luftgekühlten 1,3-Liter-Motor (spart den Wasserkühler und damit viele Bauteile) und war 1919 von der Firma Peter & Moritz in Eisenberg, Thüringen, angeboten worden. Mit gerade zwei Schraubenschlüsselgrößen konnte es zerlegt und hoffentlich auch wieder fahrbereit zusammengeschraubt werden. Vom Konzept her französisch skurril zeigte sich das Cyclecar »Bedelia«. Von 1910 bis 1920 konnte die Firma Bourbeau & Devaux das Vehikel verkaufen. Schmalbrüstig, offen, mit Riemenantrieb und so verquer konstruiert, daß der Fahrer hinter dem Beifahrer saß: Tandem total verkehrt. Ähnlich verrückt war aus Frankreich bereits 1900 ein dreirädriges Gefährt dahergekommen, ebenfalls Tandem, doch saß der Fahrer vorne. Dieses »La Nef«, wie ein langgezogenes Versehrtengefährt aus der Nachkriegszeit anmutend, zwang mit entsprechend langer Lenkstange das Vorderrad in die Kurven. Unser Lächeln darüber ist nur aus dem zeitlichen Abstand zu erklären. Immerhin stammte der Motor von dem ingeniös arbeitenden De Dion, der durch eine Hinterachskonstruktion unsterblich wurde. Diese wurde 1969 im Opel Kapitän und Opel Admiral verwendet und wird es bei Aston Martin bis heute. Ernster zu nehmen war die Entwicklung der

Les roues étaient parfois entraînées par une chaîne ou une courroie, alors qu'un différentiel était nécessaire à cause du large écartement des roues, la transmission se faisait ici uniquement sur une roue arrière. Lorsque l'écartement était plus large, le différentiel devenait inutile. Quant à l'entraînement par friction, il était encore plus simple, pour ne pas dire plus primitif.

Ces efforts aboutirent à la construction de voitures comme la Omnimobil des Aachener Stahlwerke entre 1904 et 1910. Elle était composée d'éléments démontables et les bricoleurs pouvaient la construire eux-mêmes ou créer leur propre petite marque en utilisant certaines pièces. Une autre voiture faisait la joie des bricoleurs. Elle avait un moteur de 1,3 litres refroidi par air (pas de radiateur d'eau, donc moins de pièces) et avait été présentée en 1919 par la société Peter & Moritz à Eisenberg en Thuringe. Il suffisait de deux clés à vis de tailles différentes pour la démonter et la remonter correctement, du moins l'espérons-nous.

Le cycle à moteur «Bedelia», vendu de 1910 à 1920 par la Société Bourbeau & Devaux, dénotait une conception très française. Il était étroit, découvert, doté d'une commande à courroie et construit de manière si grotesque que le conducteur était assis derrière le passager. Une trois-roues tout aussi extravagante était déjà venue de France en 1900, le conducteur et le passager y étaient placés l'un derrière l'autre, mais cette fois le conducteur était devant. Cette «La Nef» toute en longueur, et qui faisait songer à un véhicule construit pour les invalides d'après-guerre, forçait sa roue avant dans les virages avec une bielle de direction de longueur adéquate. Le temps a passé et ce véhicule nous fait sourire aujourd'hui, pourtant

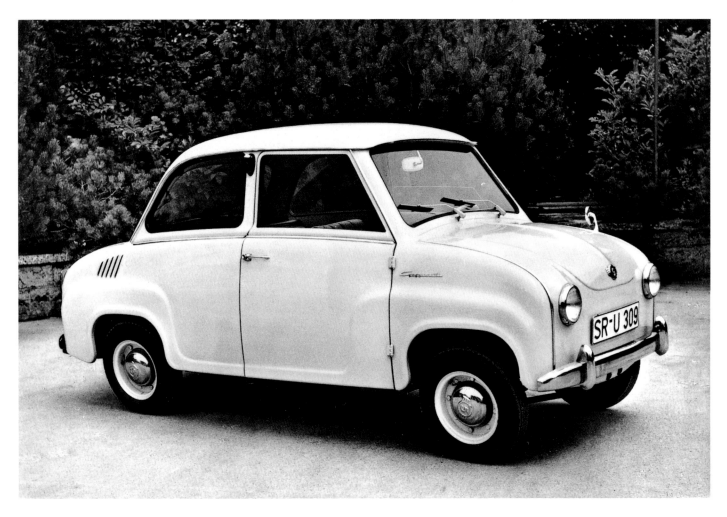

Glas Goggomobil
Germany
Deutschland
Allemagne, 1955
247 ccm, 14 PS

achieved lasting fame with his design of the rear axle that was used in the Opel Kapitän and Opel Admiral until 1969 and is still used in the Aston Martin today.

A number of small vehicles, however, lasted much longer and/or turned out to be fully fledged cars on a small scale. These are worthy of more serious attention. After the First World War the obvious shortage of material led to a certain oversupply of designers, especially in Germany. As the Treaty of Versailles had forbidden Germans to build aeroplanes, designers could now put their energy into automobiles. After all, a vehicle that flies in the air can also move on land. What is more, in order to take off at all, it has to be light. This was a good opportunity for the automobile industry to receive fresh impulses for growth. Nearly everything about the car benefited, even the outside. Manufacturers were learning that aerodynamics also works on the ground. A well streamlined car is faster than a box

kleinen Autos, die lange gebaut wurden und/oder die sich als vollwertiges Auto auch in kleinerem Maßstab erwiesen. Nach dem Ersten Weltkrieg war Materialknappheit ebenso evident wie ein gewisses Überangebot – gerade in Deutschland – an Konstrukteuren. Hatte der Versailler Vertrag den Deutschen verboten, Flugzeuge zu bauen, so fanden deren Konstrukteure nun die Möglichkeit, im Automobilbau mitzuwirken. Denn was fliegt, das fährt auch. Und was fliegt, ist leicht. Und was leicht ist, muß das Fliegen verkraften: Eine Chance, den Automobilbau durch frische Ideen voranzubringen. Davon profitierte alles am Auto, nicht zuletzt die Außenhaut.

Aerodynamik wirkt, wie man erkannte, auch am Boden. Aerodynamik macht schwach motorisierte, aber windschlüpfig (jawohl, ohne »r«) karossierte Autos schneller als Kästen auf Rädern.

Einer dieser ehemaligen Flugzeugbauer war Hans Grade, der 1921 in Friedenszeiten ein Dreirad auf die Achsen stellte. Konsequen-

son moteur était l'œuvre de l'ingénieux marquis de Dion immortalisé pour l'essieu arrière qu'il a mis au point. D'ailleurs celui-ci était encore en service en 1969 dans l'Opel Kapitän et l'Opel Admiral, et il est toujours en faveur chez Aston Martin.

L'évolution des petites voitures qui furent construites longtemps et/ou celles dont les qualités étaient manifestes, même si elles ne furent pas fabriquées en grand nombre, était à prendre plus aux sérieux. Après la Première Guerre mondiale, le manque de matériel était aussi évident que l'excès de constructeurs – notamment en Allemagne. Le Traité de Versailles interdisant aux Allemands de construire des avions, ils se replièrent sur les automobiles, partant du principe que ce qui peut voler peut aussi rouler. Ce qui vole est léger, et ce qui est léger doit être résistant. Idées neuves dont la construction automobile ne pouvait que tirer profit, surtout au niveau de la carrosserie. On reconnut que les lois de l'aérodynamique n'étaient pas seulement valables

Glas Goggomobil Coupé
Germany
Deutschland
Allemagne, 1957
296 ccm, 14 PS

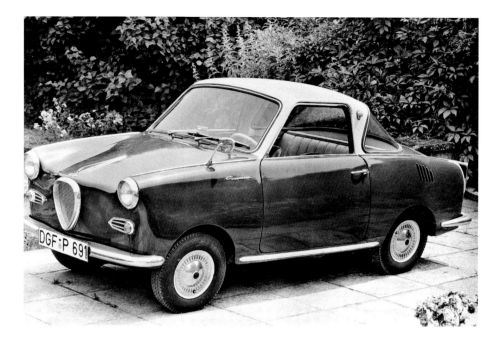

on wheels, even if its engine is relatively weak.

Among these former aircraft designers was Hans Grade who built a three-wheeler in 1921. The French pilot Marcel Leyat was more faithful to his previous occupation: he obviously could not live without a propeller, so he decided to put one at the front of the car, saving complicated constructions for the gear drive. He entered the market straight after the war, in 1918, with his Helica. To avoid mowing down pedestrians, he surrounded the four-blade propeller with a case made of wire netting. Although this box on wheels could not fly, it could nevertheless move on the ground. One of his fellow countrymen was more perceptive to shape: having built a carriage called Traction Aérienne in Neuilly from 1921 to 1926, he placed it under a smart, completely enclosed aircraft chassis. The result still looks modern today.

In the UK, after the war, a lot of furore was caused by a three-wheeler. It was light and performed well, so that it continued to sell for several decades. When production finally stopped in 1952, others tried to latch on to its success with a similar design – the Triking as the successor of the Morgan Three-wheeler. The Morgan, mass-produced from 1910 onwards and smartened up as the Aero, captivated people's minds with its eccentric front. In front of the hood – which was designed like that of a »real« car – it had two cylinders that sat right between its wheels. The V-shape of this arrangement was further emphasized by the obliqueness of the bumper in relation to the valve control, which made it truly inimitable. If there is character in ugliness, then this is certainly a prime example. A similar construction by

ter war ein französischer Pilot, Marcel Leyat: Er konnte sich offenbar nicht vom Propeller trennen, setzte ihn auf die Nase eines Autos, sparte aufwendige Konstruktionen für den Radantrieb und war sofort nach Kriegsende 1918 mit seinem »Helica« am Markt. Gemetzelte Passanten durfte es natürlich nicht geben; daher bot ein mit Maschendraht umhüllter Reif Schutz vor dem vierblättrigen Propeller. Es war keine fliegende, aber eine rollende Kiste. Mehr formales Feingefühl bewies ein Landsmann: Er setzte sein von 1921 bis 1926 in Neuilly gebautes Fahrgestell »Traction Aerienne« unter eine schicke, komplett geschlossene Flugzeug-Karosse, die heute noch modern aussieht.

In England machte nach dem Krieg ein Dreirad Furore, das, weil leicht und leistungsstark, jahrzehntelang Abnehmer fand. Als die Produktion 1952 eingestellt wurde, versuchte ein ähnliches Konzept an dessen Erfolg anzuknüpfen: Das Original war der Morgan Threewheeler, der Nachkomme Triking. Der Morgan, bereits seit 1910 in Serie, als »Aero« etwas schicker verfeinert, bestach durch eine abartige Front. Vor dem Kühler, der wie bei einem »richtigen« Auto gestaltet war, rutschte ihm der Zweizylinder zwischen die Räder. Die V-Form der Zylinderanordnung, betont durch die schräg stehende Stoßstangenführung zur Ventilsteuerung, machte dieses Gefährt unnachahmlich in der Erscheinung. Wenn Häßlichkeit Charakter hätte, dann hier. Wenig anders mutet eine ähnliche Konstruktion der Marke BSA an.

So richtig ein Auto, das wurde der Austin Seven. 1922 auf die mobile Welt gekommen, sollte er nach der Erholung vom Kriege die Horde der Bastelmobile ablösen. Er

pour les avions et qu'une voiture faiblement motorisée mais dont la carrosserie est fuselée, est plus rapide qu'une caisse montée sur roues.

Hans Grade, qui construisit un tricycle en 1921, était un ancien avionneur. Marcel Leyat, un pilote français, alla jusqu'au bout de ses idées: il semble bien qu'il ne pouvait se passer de l'hélice puisqu'il en plaça une à l'avant de sa voiture, évitant ainsi des constructions compliquées pour entraîner les roues. En 1918, tout de suite après la guerre, il présenta son «Hélica» au public. Il n'était évidemment pas question de massacrer les passants et les quatre pales de l'hélice étaient protégées par un cerceau entouré de grillage métallique. Une ressemblance avec l'avion s'arrête là, l'Hélica n'était qu'une caisse roulante. Un autre Français attacha plus d'importance aux formes: il pourvut sa «Traction aérienne», construite à Neuilly de 1921 à 1926, d'un élégant corps d'avion dont les lignes sont restées modernes.

Après la guerre, un tricycle à moteur connut un succès fou en Angleterre. La Morgan Threewheeler était si légère et si performante qu'on l'acheta pendant des dizaines d'années. Lorsqu'on cessa de la fabriquer en 1952, un modèle de conception semblable, la Triking, essaya de reprendre le flambeau. La Morgan, fabriquée en série à partir de 1910, avec une version élégante l'Aero, avait un visage bien séduisant: devant le radiateur, conçu comme celui d'une «vraie» voiture, le moteur de deuxcylindres se glissait entre les roues. Le «V» formé par la disposition des cylindres et souligné par la ligne des pare-chocs vers la commande à soupapes lui prêtait un aspect inimitable. Elle était peut-être laide, mais quelle allure!

BSA arouses the same sentiments.
A real, proper car was the Austin Seven. Having seen the light of day in 1922, it was to replace the host of DIY vehicles as soon as the country had recovered from the war. And it succeeded. By 1939, 290,000 Austin Sevens had been built, showing that even a small car can make it. It is interesting to compare these figures with Germany, where 68,997 cars were built from 1901 to 1913, and it was only in 1938 that the entire German car industry produced the same number of cars per year as there were Austin Sevens on the roads. The body of the Swallow was especially well designed. The manufacturers had originally built side-cars for motor-bikes and then delicately rounded bodies for Jaguars. Austin's success – The Triumph – was a challenge to their competitors whose imitation was better equipped and called Super Seven (probably for this reason). However, it remained unsuccessful. An Austin licence product, called Bantam, on the other hand, sold much better in the States. Germany benefited, too. Surprisingly, the Dixi – which, later (in 1929), was manufactured by BMW – turned out to be as successful as the Austin Seven. It was to make history as BMW's first car. BMW (Bayerische Motorenwerke) had originally started as manufacturers of aircraft engines. Hence their stylized rotating propeller as a company logo.
Although many small cars were built in the US, the idea never caught on. Here, the way towards the mobile society was totally »American«. Henry Ford came to the conclusion that it was the price, rather than the car itself, which had to be small. With his world-famous Tin Lizzy he also introduced the principle of conveyor belt production – a rationalized method which enabled him to sell the car extremely cheaply. From 1908 to May 1927 a total of over 15 million Tin Lizzies were built. One of the tricks with which Ford tried to shave prices was by asking suppliers to deliver the components in wooden boxes of the same standard size. He then simply recycled them as base plates for the chassis. Only one person, Crosley, made a name for himself with a small car, selling several ten thousands of models over a number of years. Another car, the 1946 Playboy, was built less than a hundred times and is probably only of historical interest because of its name which was later adopted by a famous centrefold magazine. (You may have guessed which.)
The German Dixi meant the same to the Austin Seven as the »Laubfrosch« (Tree Frog) (Type 4/12 HP) to Opel. Built in 1924, it was a real car with a folding top, steel body and steel disc wheels. A new plant was built specially for the production of this car. By now

schaffte es. Mit 290 000 gebauten Exemplaren bis 1939 hatte er gezeigt: Es geht auch klein komplett. Zum Vergleich: In Deutschland wurden von 1901 bis 1913 68 997 Autos gebaut, und erst 1938 fertigte man hier so viele Autos pro Jahr, wie insgesamt Austin Sevens auf die Straßen kamen. Besonders formschön war die Swallow-Karosserie; der Hersteller, der erst Seitenwagen für Motorräder baute, entwarf dann feingliedrig gerundete Bodies für Jaguar. Dieser Austin-Erfolg lockte die Konkurrenz. Ein besser ausgestatteter Triumph, daher wohl Super Seven genannt, sonst beinahe identisch, versuchte sich dagegen erfolglos. Besser lief eine Austin-Lizenzproduktion in den USA unter dem Namen Bantam. Auch den Deutschen war es recht. Ausgerechnet der Dixi, später (1929) unter die Fittiche von BMW genommen, war ähnlich erfolgreich als Lizenzbau des Austin Seven und ging als erstes Auto von BMW in die Geschichte ein. Denn BMW, die Bayerischen Motorenwerke, bauten Flugzeugtriebwerke – daher der stilisierte, sich drehende Propeller als Firmenlogo.
Es wurden viele Kleinwagen in den USA gebaut, durchgesetzt hat sich das Konzept nicht. Hier wurde der Weg zur mobilen Gesellschaft ganz »amerikanisch« beschritten. Henry Ford kam zu dem Schluß, daß nicht das Auto, sondern sein Preis klein sein muß. Bei der weltberühmten »Tin Lizzy« sorgte die rationale Fließbandproduktion dafür, daß das Auto billigst angeboten werden konnte; es wurde zwischen 1908 und Mai 1927 in insgesamt über 15 Millionen Exemplaren gebaut. Ein Beispiel für die Tricks, mit Hilfe derer Ford den Preis zu drücken versuchte: Zulieferer mußten Bauteile in Holzkisten bringen, die eine genormte Größe hatten. Er recyclete sie kurzerhand und nutzte sie als Bodenplatten auf dem Wagenchassis. Nur einer, Crosley, hatte von 1939 bis 1952 Achtungserfolge mit einem Kleinwagen, der es in verschiedenen Modelljahren insgesamt auf einige 10 000 Exemplare brachte. Ein anderer, der 46er Playboy, ist historisch mit weniger als 100 gebauten Autos wohl nur wegen des Namens interessant, denn diesen trug später ein Magazin mit Mittelfaltblatt – erraten? Was für den Seven der deutsche Dixi, das bedeutete den Opels ihr ab 1924 gebauter »Laubfrosch« (Typ 4/12 PS), ein richtiges Auto mit Klappverdeck, Stahlkarosse und Stahlscheibenrädern. Eigens für seine Produktion wurde ein neues Werk errichtet. Inzwischen war die Technik des Karosseriebaus so weit fortgeschritten, daß sie Ganzstahlkonstruktionen liefern konnte. Das war in der Herstellung einfacher und schneller,

Une construction similaire de la marque BSA laisse le même genre d'impression. L'Austin Seven, ça c'était une voiture. Elle fut créée en 1922, alors que le souvenir de la guerre s'effaçait progressivement. Elle devait remplacer tous les véhicules bricolés chez soi, et elle y réussit. Elle apporta la preuve qu'une petite voiture complète était parfaitement vendable puisqu'on en fabriqua 290 000 exemplaires jusqu'en 1939. En comparaison: de 1901 à 1913 on construisit en Allemagne 68 997 voitures, et ce n'est qu'en 1938 qu'on commença à produire ici autant de voitures que d'Austin Seven en Angleterre. La carrosserie de la Swallow était particulièrement réussie; le fabricant, ancien constructeur de side-cars, créa ensuite des carrosseries finement arrondies pour Jaguar. Le succès d'Austin attira l'attention de la concurrence. Une Triumph mieux équipée, d'où son nom de Super Seven, mais par ailleurs presque identique à la Seven, ne connut pas le succès escompté. En revanche la Bantam, une production sous licence de Austin, se vendit bien aux Etats-Unis. En Allemagne, la Dixi, production sous licence de la Austin Seven, remporta un succès similaire; plus tard, en 1929, BMW la prit sous son aile et elle devint la première BMW. Il ne faut pas oublier qu'à l'origine BMW, les Bayerische Motorenwerke, construisaient des moteurs d'avion, ce qu'illustre leur emblème, une hélice en mouvement stylisée.
De nombreuses petites voitures furent construites aux Etats-Unis, mais cette conception ne réussit pas à s'imposer. Les Américains se faisaient une autre idée de l'automobile. Henry Ford en arriva à la conclusion que ce n'était pas la voiture qui devait être petite, mais son prix, et la «Tin Lizzy», le célèbre modèle T fabriqué en série, était très bon marché; elle sera fabriquée à plus de 15 millions d'exemplaires entre 1908 et mai 1927. Ford essayait par tous les moyens d'écraser les prix, un exemple: les fournisseurs devaient livrer les pièces détachées dans des caisses en bois standardisées. Ford n'hésitait pas à recycler les caisses et les transformait en planches de fond posées sur le châssis du véhicule. Crosley fut le seul constructeur à connaître le succès avec une petite voiture dont on fabriqua quelques dizaines de milliers d'exemplaires en plusieurs modèles de 1939 à 1952. Quant au Playboy de 46, on n'en fabriqua pas une centaine, mais son nom est resté célèbre, car c'est celui que choisit plus tard un magazine pour messieurs.
La «Laubfrosch» (la rainette) à 4 cylindres, 12 CV, construite dès 1924, devint pour Opel ce que la Dixi allemande représentait

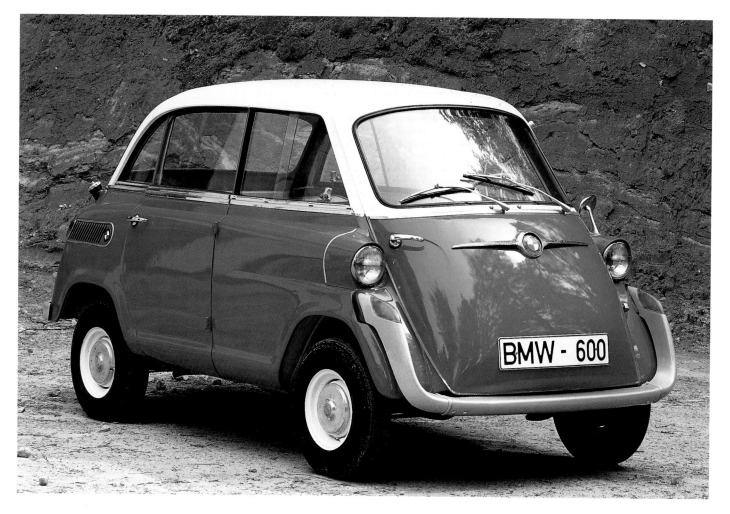

BMW 600
Germany
Deutschland
Allemagne, 1957
582 ccm, 20 PS

technology had advanced far enough to produce all-steel bodies. These were simpler and faster to make. Permanent stove-enamel paint was also available now – a totally new principle! The idea of the German Tree Frog – though usually painted yellow instead of green – was also applied by a French car, which was soon extremely successful on French roads: the Citroën 5CV Type C. Its unusual tail soon gave rise to the nickname »cul de poule« – parson's nose. The company had every reason to be proud of its 80,232 cars of this type built since 1922, because the Tree Frog was no more than a copy of the Parson's Nose. It was confirmed by a court, in the third instance, that no licence fee had ever been paid. Nevertheless, the German company was finally acquitted.

Another German car, which was even smaller than the Tree Frog or the Parson's Nose, was the »Kommissbrot« (loaf of army bread) by Hanomag (Type 2/10 HP). The nickname also served as a guiding principle: plain and

auch konnte man endlich die dauerhafte Einbrennlackierung anwenden. Man stelle sich das bei Holzaufbauten vor! Auf dem gleichen Konzept wie der grün lackierte Deutsche (daher »Laubfrosch«) basierte ein ähnliches Exemplar, das sich, meist gelb lackiert, auf Frankreichs Straßen erfolgreich durchsetzte: der Citroën 5CV Typ C. Sein Heck trug ihm den Spitznamen »cul de poule« – Hühnersterz – ein. Man konnte stolz auf die 80 232 seit 1922 gebauten Exemplare sein, denn der Laubfrosch war eine reine Kopie. Daß nie für die Lizenz bezahlt worden war, beschäftigte die Gerichte bis zur dritten Instanz – das Ganze endete jedoch mit einem Freispruch.

Bei einem anderen kleinen Deutschen, kleiner noch als Laubfrosch und Hühnersterz, das »Kommißbrot« von Hanomag (Typ 2/10 PS), war der Spitzname zugleich Programm: Einfach wie das genannte Brot, war er der erste für jeden erschwingliche Wagen, gebaut von 1924 bis 1928 in 15 775 Exemplaren, sogar in geschlossener Variante. Was

pour la Seven: une vraie voiture avec un toit décapotable, une carrosserie en acier et des roues en plaques d'acier. On installa une usine rien que pour elle. Entre-temps la technique de fabrication des carrosseries était si avancée que les usines pouvaient livrer des constructions d'acier. Celles-ci étaient plus faciles et plus rapides à construire, et on pouvait enfin utiliser le vernis à cuire plus résistant. C'est l'époque de la «rainette» allemande peinte en vert ou de la «petite Citron» de Citroën, 5 CV type C, de conception semblable, mais peinte la plupart du temps en jaune, et qui s'imposa sur les routes de France. Son arrière-train rebondi lui valut le nom de «cul de poule». La «rainette» n'étant qu'une copie, on pouvait être fier des 80 232 exemplaires construits depuis 1922. La licence n'avait jamais été payée, ce qui occupa les tribunaux jusqu'à la troisième instance et s'acheva par un acquittement.

Une autre petite voiture allemande, plus petite encore que la «rainette» et le «cul de

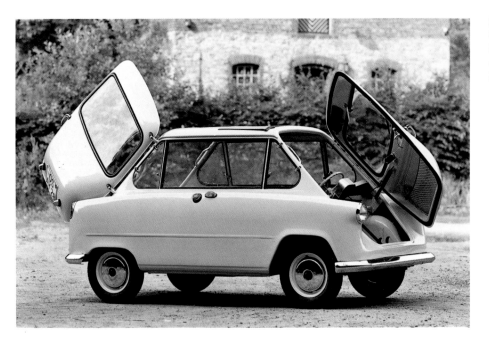

Zündapp Janus
Germany
Deutschland
Allemagne, 1957
248 ccm, 14 PS

simple like a loaf of bread, it was the first car which everyone could afford: 15,775 cars of this type were built between 1924 and 1928, including closed ones. What made this car so unique was the integration of the wheels: all four of them, suspended separately, were situated within the body which was smooth, rounded on one side and therefore easy to construct. This produced a unified appearance. In later models, the design of the front mudguard even added a touch of elegance. 109 inches (2,780 millimetres) long and 46 inches (1,180 millimetres) wide, it was far below the dimensions of the relatively big Tree Frog, which was 126 inches (3,200 millimetres) long and 53 inches (1,350 millimetres) wide. Both cars were two-seaters. The space-saving design of the Hanomag body, which was due to its lack of a foot board, was shared by other cars, including a Bugatti racing car. It was appropriately nicknamed »tank« due to its consistent shape, which was reminiscent of First World War tanks. Compared with the Loaf, the Goliath Pioneer (1931–1934), another smooth-surface three-wheeler, was far from beautiful. Its wooden body was made weather-proof with a layer of imitation leather, a material popular with a number of manufacturers at the time. The same principle was used again, after the Second World War, in another car which – like the Goliath – also came from Bremen. This was the Lloyd 300, nicknamed »Leukoplastbomber« (sticking plaster bomber) – a name that reminded people of the war and became legendary.

The Second World War also saw the creation of the Volkswagen. However, it does not fit into the category of small cars as it was in fact larger than the first 1974 Golf. Nicknamed »beetle«, it went the way of the Tin

ihn unverwechselbar machte: Alle vier Räder, einzeln aufgehängt, saßen in der Karosserie, die glattflächig, einseitig gerundet und damit einfach zu bauen war, ein sehr geschlossenes Bild abgab und bei späteren Modellen durch die vorderen Kotflügelansätze sogar einen Hauch Eleganz zeigte. Seine Außenmaße – Länge 2780 Millimeter, Breite 1180 Millimeter – lagen weit unter denen des hochbeinigen Laubfroschs, der es auf 3200 Millimeter Länge und 1350 Millimeter Breite brachte; beides waren Zweisitzer. Die raumschaffende, weil trittbrettfreie Hanomagkarosse hatte unter anderem auch ein Bugatti-Rennwagen, der, weil die Form konsequent durchgehalten war, zu Recht den Spitznamen »Tank« bekam: Sie erinnerte an die Panzer des Ersten Weltkriegs. Verglichen mit dem »Kommißbrot« war der ebenfalls glattflächige, dreirädrige Goliath »Pionier« (1931-1934) keine Schönheit. Seine Karosserie aus Holz wurde wetterfest durch einen Kunstlederbezug, der zu dieser Zeit bei manchen Herstellern Verwendung fand. Er war nach dem Zweiten Weltkrieg bei einem Auto wieder aufgetaucht, das wie der Goliath aus Bremen kam: dem Lloyd 300. Als »Leukoplastbomber« – der Name erinnert an Kriegszeiten – wurde er so etwas wie eine Legende.

Das Stichwort Kriegszeiten läßt auch an die Entstehung des Volkswagens denken. Auf ihn muß in diesem Zusammenhang verzichtet werden, er war nie ein Kleinwagen, wies mehr an Maßen auf als der erste Golf von 1974. Der »Käfer« ging den Weg einer »Tin Lizzy«, die Masse macht's, nicht die Größe. Diese Konzeption gereichte aber einem italienischen Auto zum Vorteil. Konstruktive Details von Motor, Radaufhängung und Blechverarbeitung waren so verbes-

poule« fut construite par Hanomag : la «Kommißbrot» (pain boule), type 2 à 10 CV, était vraiment bonne comme le pain et fut le premier véhicule d'un prix abordable. On en fabriqua 15 775 exemplaires de 1924 à 1928, il en existait même une version fermée. Elle était unique en son genre avec ses quatre roues indépendantes intégrées dans la carrosserie lisse, arrondie d'un côté et donc facile à construire, qui lui donnait une allure très fermée et dont les modèles ultérieurs, dotés de minuscules ailes avant, montrèrent même un soupçon d'élégance. Ses dimensions extérieures – longueur 2780 millimètres, largeur 1 180 millimètres – étaient bien inférieures à celles de la «rainette» haute sur pattes et longue de 3 200 millimètres pour 1 350 millimètres de large. Les deux voitures offraient deux places. Une carrosserie de Hanomag, spacieuse parce que sans marche-pieds, habillait également une voiture de course de Bugatti. Elle offrait une ressemblance certaine avec les chars d'assaut de la Première Guerre mondiale et reçut fort justement le nom de «tank». Comparée au «pain boule», la Goliath Pionier (1931–1934), un tricycle aux lignes nettes, manquait de grâce, c'est le moins que l'on puisse dire. Un revêtement synthétique, utilisé à cette époque par quelques fabricants, protégeait sa carrosserie en bois des intempéries. On le retrouva après la guerre sur la Lloyd 300, originaire de Brême comme la Goliath, et qui entra dans la légende sous le nom de «bombardier en sparadrap», terme où s'expriment certaines réminiscences de guerre.

Quand on parle de guerre, on pense automatiquement à la Volkswagen, pourtant il ne sera pas question d'elle ici car elle ne fut jamais une petite voiture: elle était plus

Lloyd Alexander
Germany
Deutschland
Allemagne, 1957
596 ccm, 25 PS

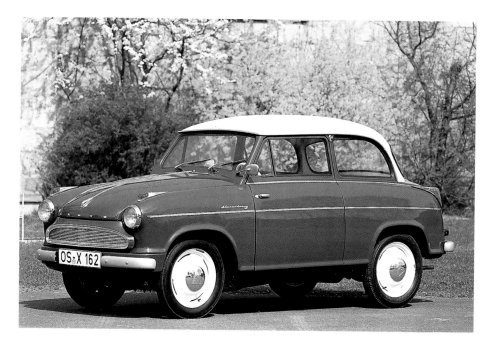

Lizzy, owing its popularity to the large number that was produced rather than to its small size. However, the underlying principle was picked up successfully by an Italian company. The constructional details of the engine, the suspension and the metalwork had improved so much that building on a smaller scale was no longer such a refined skill as it had been for the Loaf. The little Italian car made its appearance on the roads as a 500 and was soon nicknamed »topolino« (little mouse). Its design turned out to be so crisis-proof that it helped the Turin car manufacturers to pick up business again after the war. It had a front four-cylinder engine, 569 cc with single-wheel suspension at the front and an X-frame. This was sufficient reason to license the principle to Simca in France in 1938. The Little Mouse was available as a saloon, roller-roof coupé and estate. In one form or another, it has survived to the present day. Ranging from the 500, through the 126 – of which there is also a Polish licence – to the Cinquecento of 1993, it is an extremely compact car, and any further additions would have spoiled the overall impression.

The same principle also guided the creators of the legendary French Citroën 2CV. Pierre Boulanger, Managing Director in 1936, put it in a nutshell: »This car is intended to be an umbrella on wheels, the sort that can carry a basket full of eggs across a field without breaking them.«

The result was rounded corrugated iron, a headlight, a folding roof made of cloth, a large wheel base, soft suspension and a minute engine. The »duck« is still alive today and, until 1990, was still built in Portugal. A different design principle was used in a much smaller French car, the Renault 4CV. Developed before the war, it was laun-

sert, daß kleiner zu bauen nicht mehr eine solch hohe Kunst war wie einst beim »Kommißbrot«. Der kleine Italiener kam 1936 als »500« auf die Straßen, hatte schnell den Kosenamen »Topolino« (Mäuschen) und war so krisensicher konstruiert, daß er, der Frontvierzylinder bei 569 Kubikzentimetern mit Einzelradaufhängung vorn und X-Rahmen, der Turiner Marke nach dem Krieg den Anlauf erleichterte. Grund genug, das erfolgreiche Konzept seit 1938 in Frankreich bei Simca in Lizenz zugrunde zu legen. Dieses »Mäuschen« gab es als Limousine, als Coupé mit Rolldach und als Kombi. Es überlebte, verwandelt, bis heute, vom 500er über den 126er – der auch in polnischer Lizenz gebaut wird – bis zum »Cinquecento« von 1993, einem extrem kompakten Auto, bei dem zu fragen ist, ob jedes »Mehr« nicht ein »Zuviel« wäre.

Das jedenfalls war das Motto der Väter des legendären französischen Citroën 2CV. Der Generaldirektor Pierre Boulanger formulierte es 1936 so: »Das Auto soll ein Schirm auf Rädern werden, fähig, einen Korb Eier über's Feld zu transportieren, ohne sie zu knicken.«

Das Ergebnis: gerundetes Wellblech, ein Scheinwerfer, Wickeldach aus Stoff, großer Radstand, weiche Federung, kleinster Motor. Die »Ente« lebt noch heute, wurde bis 1990 gebaut, zuletzt in Portugal. Eine andere Planungsmaxime lag einem weiteren kleinen Franzosen zugrunde, dem Renault 4 CV. Vor dem Krieg noch entwickelt, 1946 vorgestellt und bei uns als »Cremeschnittchen« beliebt geworden, stellte er ein geschrumpftes Mittelklasseauto dar. Trotz Heckmotor wies er ein richtiges Gesicht auf mit einer Kühlerattrappe aus Chromstreifen, hatte vier Türen und Stufen-

grande que la première Golf de 1974. La Coccinelle reprit le principe qui avait procédé à la création du modèle T: c'est le nombre de voitures fabriquées qui est important, pas leur taille. En revanche, les Italiens surent mettre à profit l'idée de petit véhicule. Le progrès était tel en ce qui concerne les détails de construction du moteur, de la suspension et de la finition de la carrosserie que construire «petit» n'était plus un art ingrat comme au temps du «pain boule». Le modèle «500», quatre cylindres à l'avant, 569 cm^3, suspension indépendante à l'avant et cadre en X, sortit de l'usine en 1936 et reçut vite le surnom de «Topolino» (souriceau). Sa conception était si solide qu'elle permit à Fiat de reprendre un bon départ après la guerre. Il n'en fallait pas plus pour que le constructeur français Simca commence à la construire sous licence dès 1938. La Fiat Topolino existait en version berline, coupé à toit pliant et break. Passant par la Fiat 126, construite sous licence polonaise, on la retrouve aujourd'hui dans la Fiat Cinquecento de 1993, une voiture extrêmement compacte qui donne l'impression que tout équipement supplémentaire serait superflu.

C'était aussi la philosophie des pères de la légendaire 2 CV. Le directeur général, Pierre Boulanger, la formula ainsi en 1936: «La voiture doit être un parapluie sur roues, capable de transporter un panier d'oeufs à travers un champs, sans les casser.»

Résultat: une carrosserie en tôle ondulée arrondie, un phare, un toit pliant en tissu, un large empattement, une suspension douce et un tout petit moteur. La «Deuch» existe toujours, elle a été construite jusqu'en 1990, à la fin au Portugal. La 4 CV de Renault, une autre petite Française est le résul-

ched in 1946 and became popular in Germany as a »Cremeschnittchen« (slice of cream cake). It was a shrunk version of a medium-sized car. Despite its rear engine, it had a real face, with a dummy bonnet made of chromium strips, four doors and a notchback. At its première it was only available in sand colour, because leftover stock from the African Corps was still being used up. We hardly need to mention Voisin, the manufacturers of luxury cars who developed a small »Biscooter« after the war, intended for Spanish production.

In Germany, no »little mice« survived the war or continued to be built after it. Although 162 Loaves and 798 Dixis were still on the road in 1955, they were really only museum pieces rather than contributions to the country's universal motorization. The process of putting every German citizen on three or four wheels had not even started. What is more, the dismantling programme of the Allies and the extreme shortage of material made it difficult for the country to get back on its feet. »Necessity is the mother of invention« was the motto of the time. Similar to the post-war years after 1918, the motoring industry after the Second World War soon became extremely diverse. Having reached a higher level of technology than five decades earlier, those with enough stamina were now in a much better position to improvise. Although the car was an established means of transport, it was still unattainable for many people. It is difficult to provide a comprehensive list without forgetting some. However, none of the small car manufacturers has survived, either as a brand name or as a model. The only exceptions may be BMW and Opel. All the others that sprouted in the early Fifties

heck und war bei der Premiere nur in Sand-beige lieferbar: Es wurden Restbestände des Afrika-Korps aufgebraucht. Ist da noch der Luxuswagenbauer Voisin erwähnenswert, der nach dem Krieg für die spanische Produktion »Biscooter«-Kleinwagen entwickelte?

In Deutschland gab es kein »Mäuschen«, das den Krieg überdauert hätte und weitergebaut worden wäre. Gut, selbst 1955 waren immer noch 162 »Kommißbrote« und 798 Dixis zugelassen. Sie waren wohl eher Museumsstücke denn Beiträge zur allgemeinen Motorisierung. Die Nation auf drei oder vier Rädern mußte erst einen Anlauf nehmen. Das war um so schwieriger, da die Demontage der Wirtschaft durch die Alliierten und eine extreme Materialknappheit den Start erschwerten. »Not macht erfinderisch« war das Motto der Zeit. Wie die Nachkriegsjahre nach 1918 war auch die Zeit nach dem Zweiten Weltkrieg in Hinblick auf den Automobilbau unübersichtlich. Technisch versierter als fünf Jahrzehnte vorher, konnten Unentwegte besser improvisieren. Das Auto war ein etabliertes Transportmittel, nur für viele noch unerreichbar. Wen nennen, wen unterschlagen, wen vergessen? Überlebt hat keiner der Kleinwagenhersteller, weder als Marke noch als Modell. Ausnahmen bilden vielleicht BMW und Opel; die anderen, die zu Beginn der 50er Jahre wuchsen, gingen unter oder wurden von großen Marken geschluckt.

Der einfachste Weg, die Kleinen zu unterscheiden: Wir zählen ihre Räder. Das ist erfolgversprechender, als die Radspuren im Schnee zu zählen – wies doch manch Kleinster vier Räder und vier Spuren auf wie eine Heinkel-Kabine oder eine Isetta von

tat de réflexions d'un autre ordre. Développée avant la guerre et présentée en 1946, elle évoque une voiture de gamme moyenne qui aurait rétréci. Bien que le moteur ait été placé à l'arrière, elle possédait un vrai capot avec une calandre à baguettes chromées, quatre portes et un coffre classique. Au départ elle n'était livrable qu'en beige sable, car il fallait utiliser les stocks de l'armée d'Afrique. N'oublions pas de mentionner Voisin, fabricant d'automobiles de luxe, qui conçut après la guerre les «Biscooter» pour la production espagnole.

En Allemagne, aucun «souriceau» n'a survécu à la guerre. Malgré tout, on trouvait encore en 1955 162 «pains boule» immatriculés et 798 Dixis, mais ils tenaient plus de la pièce de musée que de l'automobile. Tout était à refaire. Ceci était d'autant plus difficile que les Alliés avaient démantelé l'économie et que le matériel était extrêmement rare. Mais le dénuement rend inventif. Comme c'est le cas pour les années qui ont suivi la Première Guerre mondiale, il est difficile de savoir exactement comment les choses se sont passées après 1945. Les esprits inébranlables, techniquement plus informés qu'un demi-siècle auparavant, pouvaient mieux improviser. La voiture était reconnue en tant que moyen de transport, mais elle n'était pas encore accessible à tous. Qui doit-on nommer, ne pas citer, oublier? Aucun des constructeurs de petites voitures n'a survécu. BMW et Opel sont peut-être des exceptions; les autres, ceux qui prirent de l'ampleur au début des années 50, disparurent ou furent engloutis par de grandes marques.

Le moyen le plus simple pour distinguer les petites voitures les unes des autres est de compter leurs roues. C'est plus gratifiant

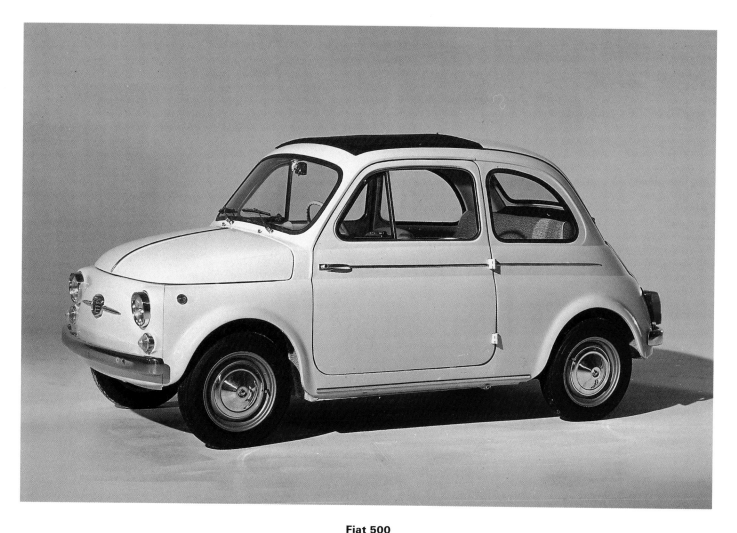

Fiat 500
Italy
Italien
Italie, 1957
479 ccm, 22 PS

either went under or were swallowed by big companies.

The best way of distinguishing between the various small cars is to count their wheels. This is a far more reliable method than counting their wheel tracks in the snow. After all, many of the smallest cars had four wheels and four tracks, e.g. the Heinkel-Kabine or BMW's Isetta. Or indeed only one, as in the case of single-track cars. Stabilizers and other techniques were a useful way of supporting a car while it was stationary. Wolseley, a British company, had built their Gyrocar – stabilized by a spinning top – as early as 1913, at the request of a Russian nobleman. However, this prototype with two rows of seats for six persons can quickly be discarded as a freak. In 1922, the German armourer Mauser in Oberndorf on the river Neckar commissioned a single-track car with stabilizers. With its dummy bonnet, two protruding headlights, a front windscreen and a folding roof, it looked like a motor-bike. Nevertheless, to give the impression of a ge-

BMW. Oder nur eine wie bei Einspurautos. Stützräder oder andere Techniken halfen, wenn der Wagen stand. Schon 1913 hatte das englische Werk Wolseley im Auftrag eines russischen Aristokraten ihren »Gyrocar« gebaut, stabilisiert durch einen Kreisel. Diesen Prototyp mit zwei Sitzreihen für sechs Personen vergessen wir jedoch schnell als Ungetüm und finden 1922 bei der deutschen Waffenschmiede Mauser in Oberndorf am Neckar ein Einspurauto mit Stützrädern. Es sah aus wie ein Motorrad mit über dem Vorderrad liegender Kühlerattrappe, zwei außen liegenden Scheinwerfern, Frontscheibe und Faltverdeck. Das Gefühl, im Auto zu sitzen, vermittelte ein echtes Lenkrad. Die Autogeschichte kennt sonst kaum Beispiele für einspurige Autos, warum auch. Entweder Motorrad oder Motorroller, wenn mehr Blechverkleidung gewünscht wird, oder gleich auf Dauer mindestens drei Räder. Aber in jüngster Zeit, Mitte der 80er Jahre, suchte die Firma Quasar Motor Cycles Limited aus Bristol auf zwei

que de compter les traces de pneus dans la neige, si l'on sait que certaines quatre-roues laissaient quatre traces: la Kabine de Heinkel, par exemple, ou l'Isetta de BMW. Il arrivait aussi qu'elles laissent une seule trace… Des roues d'appui ou d'autres techniques maintenaient la voiture debout. En 1913, déjà, Wolseley, une usine anglaise, avait construit sur la demande d'un aristocrate russe un «Gyrocar», stabilisé par un gyroscope. Mais oublions vite ce prototype monstrueux, conçu pour deux rangées de sièges et six passagers, et penchons-nous sur un véhicule à voie unique avec roues de soutien construit en 1922 par l'armurerie Mauser à Oberndorf, Neckar. Il ressemblait à une moto avec un radiateur factice posé sur la roue avant, deux phares placés à l'extérieur, un pare-brise et un toit pliant. Un volant donnait l'impression au conducteur de se trouver dans une véritable voiture. On ne connaît pour ainsi dire pas d'autres exemples de ce type de voiture, il n'y avait d'ailleurs aucune raison à ce qu'elles se dé-

19

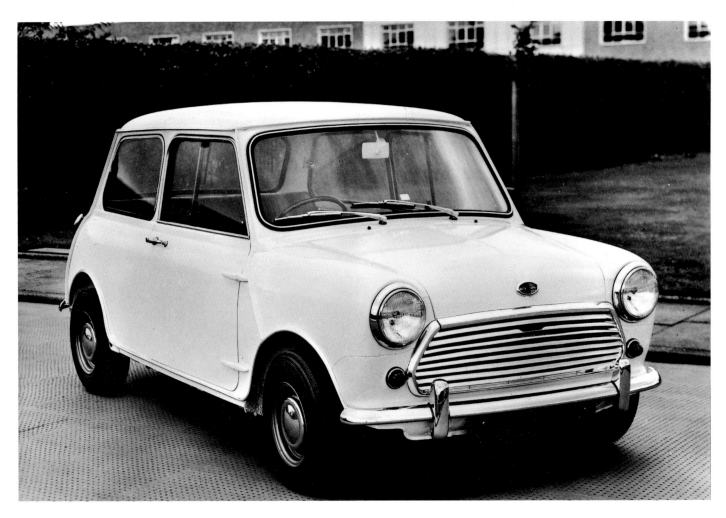

Austin Mini
Great Britain
England
Angleterre, 1959
850 ccm, 35 PS

nuine car, it did have a real steering wheel. The history of motoring has virtually no examples of single-track cars – and indeed, why should it? You might as well buy a motor-bike or scooter or, if you wanted more metal round your vehicle, a three-wheeler. Recently, however, in the mid-Eighties, Quasar Motor Cycles Ltd. in Bristol tried their economic luck with a two-wheel vehicle: it was fully encased, streamlined and without side doors. The BMW C1 study in 1992 attempted a similar project, using an even smaller body – just enough to provide some protection against a head-on crash.

Obviously, for safety reasons, three wheels make more sense than two. But where did three-wheelers fit in? The history of the car industry shows that there have been more three-wheelers with two front wheels than with one. Anyone who has driven both types knows why, especially where corners are concerned: transverse acceleration requires stability. In 1914 the Swiss company Tribelhorn built an electric three-wheeler

Rädern ihr wirtschaftliches Glück: Das Gefährt war vollverkleidet und windschnittig, ohne seitliche Türen. Ähnliches versuchte 1992 die BMW-Studie C1 mit noch geringerem Karosserieanteil – gerade so viel, um den Forderungen des Aufprallschutzes zu genügen.

Drei Räder machen also mehr Sinn, wenn man sicher vorankommen will. Aber wie waren sie anzuordnen? Die Geschichte des Automobilbaus beweist: Es gibt mehr Dreiradautos mit zwei vorderen Rädern als solche mit einem. Wer je beides fuhr, weiß, warum, besonders wenn's in die Kurven geht: Querbeschleunigung verlangt eben Stabilität. 1914 hatte die Schweizer Firma Tribelhorn ein Elektrodreirad gebaut, das das Konzept der italienischen Vespa-Lieferwägelchen vorwegnahm. In Deutschland entstand 1920 ein Wagen mit Solofrontrad. Edmund Sielaff und Fritz Gary bauten den »Gasi« mit Bootsformkarosse und Tandemsitzanordnung. Schon mehr Autogesicht zeigte 1934 der englische Raleigh Safety

veloppent: les uns choisissaient une motocyclette, ceux qui voulaient plus de carrosserie un scooter, et les autres se décidaient durablement pour trois roues au moins. Récemment pourtant, vers 1985, la maison Quasar Motor Cycles Limited de Bristol a tenté de lancer des véhicules à deux roues, carrossés et aérodynamiques, sans portes latérales. L'étude C1 1992 de BMW montre une création du même genre, mais avec juste ce qu'il faut de carrosserie pour satisfaire aux normes de sécurité.

Trois roues sont donc indispensables si l'on veut se déplacer en toute sécurité. Mais comment les placer? Nous constatons qu'il existe plus de tricycles à moteur dotés de deux roues à l'avant que d'une roue à l'avant. Celui qui a pu conduire les deux types de véhicule et pris des virages sait qu'une certaine stabilité est nécessaire pour accélérer dans un mouvement transversal. En 1914, la firme suisse Tribelhorn avait construit un tricycle électrique qui anticipait la conception de la Vespa italienne. En 1920,

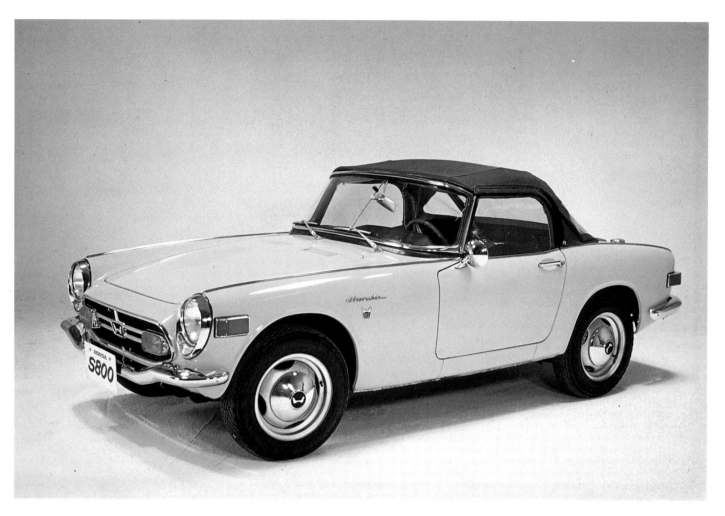

Honda S 800
Japan
Japon, 1966
791 ccm, 67 PS

which anticipated the principle of the little Italian Vespa van. In Germany, a car with a solo front wheel was built in 1920 by Edmund Sielaff and Fritz Gary. It was called Gasi, had a boat-shaped body and a tandem seating arrangement. The British car Raleigh Safety Seven (1934) looked a bit more like a real car. Externally, it resembled a reliable German van made by Vidal & Son, a vehicle which became known as the Tempo after the war. In 1955 the British car designer Allard Clipper showed that even a three-wheeler can be compatible with the fashionable, soft contours of a real car. After all, when times are tough, such objects of desire have to be built with only three wheels for a while. In 1952, the British company Reliant started building a number of less attractive models. These threewheelers were meant to be car-shaped. However, they remained rather crude boxes. The cheapest model in the UK was the Gordon, not unlike to the Reliant. Built from 1954 to 1958, its engine was attached

Seven, der formal an den in Deutschland nach dem Krieg als treuen Lieferwagen bekannt gewordenen »Tempo« der Hamburger Firma Vidal & Sohn erinnert. 1955 zeigte der englische Allard Clipper, daß auch ein Dreirad die modisch weich gezeichneten Formen eines echten Autos verträgt. In knappen Zeiten müßte dieses Objekt der Sehnsüchte eben erst einmal dreibeinig gebaut werden. Ab 1952 entstanden weniger schöne Modelle bei Reliant in England. Diese Threewheeler sollten die Form von Autos annehmen, sie blieben aber plumpe Schachteln. Billigstes Modell in England war der Gordon, den Reliants nicht unähnlich; sein Motor hing rechts wie eine Warze an der Außenhaut. Er wurde von 1954 bis 1958 gebaut. Da waren die Bond-Modelle aus England formbewußter, bis hin zu dem Bond-Bug, den der Designer Ogle schuf: Rallyestreifen, Überrollbügel und Abrißheck. Ein rasender Keil auf drei Rädern. In den USA entstand von 1947 bis 1949 mit dem Davis ein Vertreter des Dreiradkon-

le «Gasi», un véhicule à roue unique à l'avant apparut en Allemagne. Construit par Edmund Sielaff et Fritz Gary, sa carrosserie avait la forme d'un bateau et les passagers étaient assis les uns derrière les autres. La Raleigh Safety Seven, apparue en 1934 et dont les lignes évoquent celles de la camionnette «Tempo» de la firme Vidal & Sohn de Hambourg, avait déjà plus l'air d'une vraie voiture. En 1955, l'Anglais Allard Clipper montra qu'un tricycle à moteur peut avoir aussi les formes modernes et lisses d'une véritable automobile. N'oublions pas que l'époque était aux vaches maigres et qu'il revient moins cher de construire une trois-roues qu'une quatre-roues. Les modèles créés par l'Anglais Reliant à partir de 1952 étaient moins agréables à regarder, ils voulaient adopter la forme des voitures, mais restèrent des boîtes grossières. La Gordon, construite de 1954 à 1958 et qui était la voiture la moins chère d'Angleterre, ressemblait à la Reliant; son moteur pendait sur le côté droit de la carrosserie comme une verrue

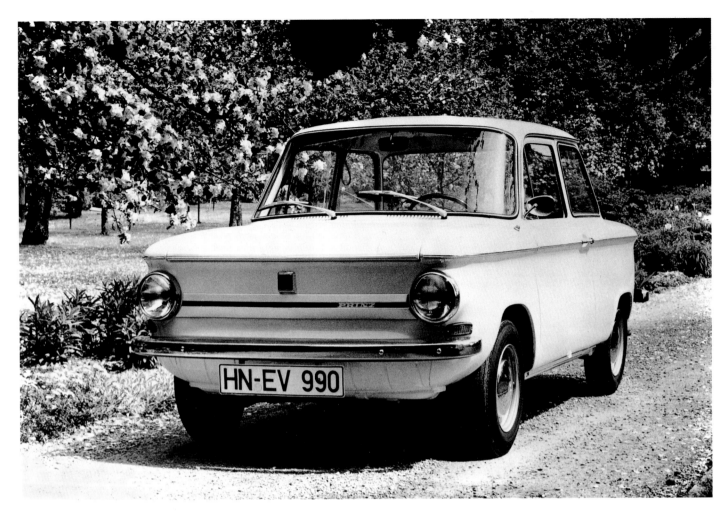

NSU Prinz 4L
Germany
Deutschland
Allemagne, 1961
598 ccm, 30 PS

to the outside skin, like a wart. The Bond models (also UK) were far more elegant, including the Bond Beetle, designed by Ogle, which had rally stripes, a roll bar and a separation edge – like a high-speed wedge on three wheels.

In the US, the principle of the three-wheeler was launched with the Davis (1947 to 1949) – a car with a round, bonnetless front, folding headlights and a large, curved front windscreen. Its smooth, futuristic outer appearance is reminiscent of the scooters on a roundabout at an amusement arcade. The same impression is given by the Trivette, a 1974 model with concealed front wheel. This US creation remained at the prototype stage, as did a little Chevrolet commuter car with an electric engine, designed by Shinda for General Motors in 1968, together with several other minicars. Its well-proportioned shape nevertheless included the rear window of a Corvette super sports car, a design originally developed by Pininfarina. If desired, a three-wheeler with a single front

zepts – ein Auto mit runder, kühlerloser Front, Klappscheinwerfer und großer, gebogener Frontscheibe. Es erinnerte durch seine futuristische glatte Außenhaut an die Scooter auf dem Jahrmarkt. Futuristisch mit dem in der Front versteckten Rad mutete auch das 1974 gezeigte Modell »Trivette« an. Diese US-Schöpfung blieb ein Prototyp wie ein Chevrolet-Commuterwägelchen mit Elektroantrieb, das der Designer Shinoda 1968 bei General Motors zusammen mit anderen Minis konzipierte. Die gut proportionierte Form bezog immerhin das Heckfenster eines Corvette-Supersportwagens ein, ursprünglich ein von Pininfarina entwickeltes Designmotiv. Dreiradversionen mit einem Frontrad bieten, wenn gewollt, schlanke Fronten – Anlaß genug, den Karosseriekörper wie einen Flugzeugrumpf auszulegen. Prototypen wie eine 1982 gezeigte »Leanmachine« von General Motors, mit der Eigenart, sich im Wortsinne in die Kurve neigen zu können, oder ein 175 Kilometer pro Stunde schneller »Pulsar« aus den USA

sur le nez. Chez Bond, on avait déjà plus le sens de l'esthétique et la Bond-Bug, créée par le designer Ogle, l'illustre bien: bandes rallye, arceau de sécurité et arrière détachable, elle était un bolide sur trois roues. De 1947 à 1949, on vit rouler aux Etats-Unis la Davis, une voiture à trois roues et à capot rond, sans radiateur, avec des phares pliables et un vaste pare-brise incurvé. Sa carrosserie lisse et futuriste rappelle les scooters des foires. La «Trivette», présentée en 1974, a elle aussi des airs futuristes à cause de la roue cachée dans sa partie avant. Cette création américaine resta un prototype, tout comme la mini-navette à moteur électrique de Chevrolet, conçue en 1968 avec d'autres véhicules en miniature par le designer Shinoda chez General Motors. La carrosserie bien proportionnée intégrait en tout cas la lunette arrière d'une Corvette de haut niveau, motif conçu initialement par Pininfarina. Les versions dotées d'une seule roue à l'avant sont plus étroites devant que derrière – une bonne raison pour traiter les carrosseries com-

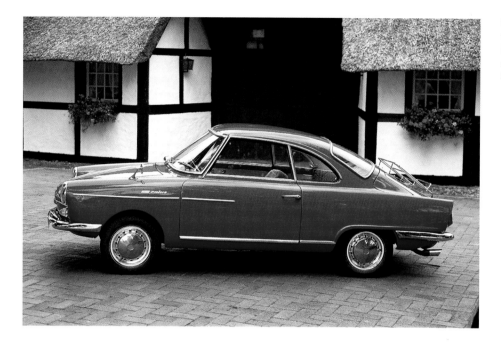

NSU Sport-Prinz
Germany
Deutschland
Allemagne, 1959
598 ccm, 30 PS

wheel can have a very lean front, so that the body can be designed like that of an aircraft. A number of prototypes made very little sense as small vehicles – such as General Motors' 1982 Lean Machine which would literally lean over when going round corners, or the 1986 Pulsar, an American car that could do 110 mph (175 km/h) but was in fact a plagiarized version of the Lean Machine, though on four wheels. The same was true of BMW's playful design of 1991: a smooth egg for a single person, suspended between the front wheel and extremely narrow rear wheels. This may delight the hearts of freaks, but in the age of congested roads such vehicles are better placed in museums. Compared with so much seductive beauty, the three-wheelers IFG Gnome (Germany, 1950), Grewe & Schulte and Meyra were no more than DIY jobs in the mid-Fifties. However, this was excusable, as they were meant as vehicles for the disabled and therefore had to run reasonably cheaply.

In Italy, it was designers such as Michelotti and Sessano who produced three-wheeler studies. The LEM by Michelotti, a car with small wheels and large windows, was especially conspicuous with its front doors. They were a mixture of normal and folding doors. The hinge pin led diagonally from the centre of the front to the edge of the roof. In Japan, this type of construction was not produced until the early Nineties when Toyota's coupé Sera was manufactured in large series. Sessano used a design that was similar to the LEM. His one-box minicar had no emphatic bonnet or boot step and its shape was based on the trapezium. A similar principle was apparent in the go-cart-like model called Gemini of 1982,

(1986 ein formaler Diebstahl der Lean Machine auf vier Rädern) sind verspielte, wenig sinnvolle Varianten der kleinen Verkehrsmittel. Gleiches gilt für eine Designspielerei, die BMW 1991 anstellte: Ein glattes Ei für eine Person, zwischen Frontrad und extrem eng stehenden Heckrädern aufgehängt, mag Freaks gefallen, im Zeitalter verstopfter Straßen sind dergleichen Fahrmaschinen besser im Museum aufgehoben. Gegen so viel verführerische Schönheit stellten die Dreiräder IFG »Gnom« (Deutschland 1950), Grewe & Schulte oder Meyra Mitte der 50er Jahre Basteleien dar. Verzeihlich jedoch, da sie als Behindertenfahrzeuge ihre Aufgabe billig meistern mußten.

In Italien waren Dreiradstudien mit Fronteinzelrad bei Designern wie Michelotti und Sessano zu sehen. Der LEM von Michelotti mit kleinen Rädern und großen Fensterflächen fiel durch die Fronttüren auf: Eine Mischung aus Flügel- und Normaltür, die Drehachse führte diagonal von der Frontmitte an die Außenecken des Daches. In Japan war eine solche Konstruktion erst Anfang der 90er Jahre am Toyota Coupé »Sera« in Großserie zu sehen. Sessano hatte sich eines dem LEM ähnlichen Designs bedient; sein Kleinstwagen im »one box«-System, also ohne betonte Kühlerhaube und Kofferraumstufe im Heck, basierte auf der Trapezform als Grundvolumen. Im Konzept verwandt war das golfcartähnliche Mobil »Gemini« von 1982 mit einer anderen Türöffnungsraffinesse. Ähnlichkeiten wies auch 1984 eine Studie mit variantenreichen Aufbauten auf, der »Spazio 3« des englischen Designers Martin.

Designlösungen dieser Art, besonders bei Vierradautos im Miniformat, gab und gibt es unzählige, besonders als Designstudien

me des fuselages. Des prototypes tels la «Lean Machine» de General Motors présentée en 1982, et qui s'inclinait dans les virages comme son nom l'indique, ou le «Pulsar» américain (réplique quadricycle de la Leanmachine) plafonnant à 175 kilomètres à l'heure, sont des variantes ludiques offrant peu d'intérêt dans le cadre de nos recherches. Il en va de même de la petite voiture que les designers de BMW semblent avoir dessinée durant leurs loisirs en 1991. Cet oeuf à une place, suspendu entre une roue avant et des roues arrière très serrées, peut plaire aux adeptes, mais vu l'état de la circulation urbaine, sa place serait plutôt dans un musée. Face à de telles splendeurs, les tricycles IFG «Gnome» (Allemagne 1950), Grewe & Schulte ou Meyra, apparus vers 1955, ne font pas le poids. Mais c'est excusable du fait qu'ils étaient conçus pour les personnes handicapées et devaient remplir leur tâche le plus économiquement possible.

En Italie, des designers comme Michelotti et Sessano présentaient des études de tricycles à roue avant unique. La LEM de Michelotti, dotée de petites roues et de grandes vitres, surprenait à cause de ses portières avant, synthèse de porte normale et de porte à deux battants, l'axe de rotation allant diagonalement du milieu de la partie avant aux bords extérieurs du toit. Au Japon, un modèle de ce genre ne fut construit en grande série qu'en 1990, c'est le coupé «Sera» de Toyota. Sessano s'était servi d'un design proche de celui de la LEM; sa voiture miniature, système «one box», ne possédait pas de couvre-radiateur ou coffre à bagages proéminent à l'avant ou à l'arrière; la forme de base de la voiture était le trapèze. La Gemini de 1982, aux airs de golfcart et équipée d'un autre système raffiné d'ouverture de

which had a similarly sophisticated method of opening the door. Another model along these lines was a 1984 study called Spazio by the British designer Martin, with a superstructure in many different variations.

There have been and still are countless designs of this type, especially for small four-wheelers and in the form of design studies (e.g. the Ford Ghia Berlina, 1968; the Zagato Minivan Elettrica, 1981; the SGS minicar, 1986; the Teoplan Leo, 1988; and the Styling International Concept 92, 1989). However, nothing beats the unforgettable Italian Vespa, a three-wheeler that would bravely chug along for a good number of years, and which the driver literally had to manoeuvre around. Bends had to be negotiated with the pull-rod rather than the steering wheel, as the brake and the speed had to be controlled manually. This wealth of variety also included a small articulated vehicle particulary well adapted to the transport problems encountered in the narrow streets of Naples.

A mini-artic with a solo wheel at the rear is extremely hard to imagine. Yet models of this type were extremely widespread. With the engine at the rear, it had a clear advantage, due to its lack of a differential, i.e. the simplest transmission of power from the connecting rod to the hub of the wheel. The Morgans and BSAs in the UK had found it much harder with their front engines and rear drives. Ernst Neumann-Neander, a German, still remembers how his three and four-wheel cars of the Thirties combined the chassis and covering with a minimum of material. Arzens' plexiglass body of 1942 was rather an exotic car; his concept of a Centomobile was copied with great boldness at the centenary celebrations of the automobile.

The Mathis 333 of 1946 was an amazing feat of post-war engineering: a confidently styled French car whose three wheels are integrated in such a way that its design might have survived for many years to come. However, the construction of the body was too extravagant for many manufacturers. They had to limit themselves to a minimum, as in the 1947 Flitzer (a colloquial German word for a fast little car) by Fend. This car was driven by bicycle-type pedals, though propulsion was later handled by the tumbler-sized 38 cc of a two-cycle engine. The Flitzer, however, enabled Fend to rise sharply in the industry. He soon built other three-wheelers with aircraft-like cockpits that lived on in the Messerschmitt cabin scooter. The KR 175 alone sold 19,668 times. But there were other German cabin scooters, modelled on aeroplanes, such as

(z. B. Ford Ghia »Berlina« 1968, Zagato »Minivan Elettrica« 1981, das SGS-Kleinstauto 1983, der Ghia »Trio« 1983, ein Mercedes-Kleinstwagen 1986, der Tecoplan »Leo« 1988 oder Styling International »Concept 92« 1989). Aber unvergessen bleibt das einst wacker rollende italienische Vespa-Dreirad. Jahrzehnte vor einem »Spazio 3« wurde hier auf der Basis des pobackigen Motorrollers ein ganzer Baukasten von Kleinwagen konzipiert, bei denen der Fahrer der Lenker im Wortsinne war. Mit dem Lenker, nicht mit dem Lenkrad, wurde die Kurve genommen, Bremse und Gas wurden mit den Handgriffen dosiert. Der Variantenreichtum umfaßte auch einen kleinen Sattelschlepper, und seine Daseinsberechtigung wird ersichtlich, wenn man an enge Gassen in Neapel denkt und sich fragt, wie Omas Sofa dahin transportiert werden kann.

Ein Minisattelschlepper mit Solorad im Heck ist ungleich schwerer vorstellbar. Dafür gab es um so mehr Angebote dieser Bauart. Vorteilhaft für die Konstruktion ist bei Wagen mit Heckmotoren der Verzicht auf das Differential, also die einfachste Art der Kraftübertragung vom Pleuel auf die Radnabe. Da hatten es die Morgans und BSAs in England einst schwerer mit Frontmotor und Heckantrieb. Der Deutsche Ernst Neumann-Neander erinnerte sich bei seinen Drei- und Vierradautos in den 30er Jahren noch daran, wie Fahrgestell und Verkleidung mit minimalen Mitteln zu verbinden waren. Als exotisch einzustufen war 1942 eine Plexiglaskarosse von Arzens in Frankreich, deren Konzept das »Centomobil« beim hundertjährigen Jubiläum des Automobils eiskalt kopierte.

Eine erstaunliche Leistung für die Nachkriegsjahre stellte der 1946 gezeigte Mathis 333 dar: Ein Franzose mit stilsicherer Form, die drei Räder so integriert, daß sein Design noch lange Bestand hätte haben können. So viel Aufwand im Karosseriebau konnten nicht viele Hersteller treiben. Sie mußten sich auf ein Minimum beschränken – wie bei dem 1947 gebauten Fend »Flitzer«. Pedale wie beim Fahrrad sorgten für den Vortrieb, den später die schnapsglasgroßen 38 Kubikzentimeter eines Zweitakters übernahmen. Dieser »Flitzer« bildete aber den Grundstein für einen steilen Aufschwung. Fend baute weitere Modelle mit drei Rädern auf der Basis dreier Räder und flugzeugähnlicher Kanzel, die später bei Messerschmitt als Kabinenroller weiterlebten. Allein das Modell KR 175 brachte es auf 19 668 Exemplare. Es gab auch andere deutsche Kabinenroller mit Hang zum Flugzeug: Gommel 1947 und den Keinath 1948. Der Franzose Reyonnah (1950) konnte so-

portières, et «Spazio 3», une étude du designer anglais Martin aux carrosseries très variées, étaient de conception voisine.

Les designers étaient déjà prodigues en solutions de ce genre, surtout en ce qui concerne les petites quatre-roues: les études de design ne manquent pas, par exemple la Ford Ghia «Berlina» de 1968, la Zagato «Minivan Elletrica» de 1981, la voiture miniature SGS de 1983, la Ghia «Trio» de 1983, la Mercedes miniature de 1986, la Tecoplan «Leo» de 1988 ou le «Concept 92» de Styling International de 1989. Mais tout le monde se souvient de la Vespa italienne trois-roues, cette vaillante petite voiture. Des dizaines d'années avant la «Spazio 3», on a conçu ici sur la base du scooter fessu tout un système de construction de petites voitures. On prenait les virages avec le guidon, pas avec le volant, freiner et accélérer se faisait à la main. Le programme comprenait aussi une petite semi-remorque remarquablement adaptée aux ruelles étroites de Naples.

On imagine difficilement une petite semi-remorque dotée d'une seule roue arrière, pourtant ce genre de construction fut le plus courant. Les voitures équipées d'un moteur à l'arrière n'ont pas besoin de différentiel et c'est très avantageux. Les Morgan et les BSA de l'époque dont le moteur était à l'avant et la propulsion à l'arrière devaient faire face à de nombreux problèmes. Constructeur d'automobiles à trois et quatre roues dans les années 30, l'Allemand Ernst Neumann-Neander se rappela comment réunir le plus simplement possible le châssis et la carrosserie. On qualifiera d'exotique la carrosserie de plexiglas d'Arzens présentée en France en 1942, celle-là même que la «Centomobil» imita sans états d'âme lors de la célébration du Centenaire de l'automobile.

La Mathis 333, française, sortie en 1946 est une prouesse des années d'après-guerre: ses formes étaient si recherchées, ses trois roues si bien intégrées, que son design aurait pu devenir un classique. De nombreux constructeurs ne pouvaient se permettre autant de recherches dans la construction de carrosseries. Ils devaient se contenter d'un minimum – c'est le cas de la «Fend Flitzer» (rapide comme une flèche) de 1947. La marche avant était assurée par des pédales, plus tard par un moteur à deux temps de 38 cm^3 grand comme un verre à liqueur. Cette Flitzer est pourtant la première d'une série qui prit très vite de l'ampleur. Fend construisit d'autres véhicules à trois roues et possédant une sorte d'habitacle d'avion que l'on retrouve plus tard chez les scooters carénés de Messerschmidt. Le type KR 175 fut fabriqué en 19668 exemplaires. D'autres scooters carénés allemands se donnaient des al-

the Gommel of 1947 and the Keinath of 1948. The French car Reyonnah (1950) even had a collapsible front (useful for parking), and AEMS and Inter (also French) looked even more like aeroplanes.

The German Fuldamobiles closely resembled the shape of full-sized cars. The body was at first made of slightly curved aluminium sheets with a granular surface or plywood covered with imitation leather. What is more, the 1951 »Forelle« (»trout«) model in this series had a negative roll radius, a feature which, several decades later, was considered to be an ingenious device in front-wheel geometry and directional stability. With its rear twin wheels and an aluminium body that was later enhanced by softly rounded contours, this model lasted until 1969, after a total of 3,000 cars had been built. The open »Spatz« (»sparrow«) by Brütsch was even more rounded – a three-wheeler within a series of four-wheel cars that were comparatively plain. The open Austrian »Libelle« (»dragonfly«) of 1954, on the other hand, was more on the bizarre side, with a front-to-back tube that doubled up as an imaginary roof contour and a roll bar. The Kroboth, also from Austria, seemed to follow more serious purposes, whereas the German Meyra 200–2 of 1955 remained unsuccessful: outwardly, it was a stark mixture of a cabin scooter and a car and still formed part of the rising trend towards motorization. Nevertheless, it only sold 480 times. The American Tri-Car of the same year was coarser in appearance and never made it beyond the prototype stage. Modelled on the Isetta, its wheels were far too large and its body too short.

gar seine breite Frontspur beim Parken einklappen, seine Landsmänner AEMS und Inter hatten 1953 noch größere Ähnlichkeit mit einem Flieger.

Stärkere Anklänge an die Form des Autos wiesen deutsche Fuldamobile auf. Zunächst hatte flach gekrümmtes Alublech mit körniger Oberfläche oder kunstlederbespanntes Sperrholz für die Hülle gesorgt. Was Jahrzehnte später als ingeniöser Kniff für die Frontradgeometrie und stabilen Geradeauslauf – negativer Lenkrollradius – galt, das zeichnete das Fuldamobil »Forelle« schon 1951 aus. Für das Heck mit Zwillingsrad und die später weich gerundete Alukarosse endete die Karriere erst 1969, insgesamt 3000 Exemplaren waren gebaut worden. Runder noch als dieses Dreirad war der offene Brütsch »Spatz«; er bildete mit seinen vierrädrigen Brüdern eine Marke, die vergleichsweise schnörkellose Formen fand. Skurriler mutete dagegen die offene österreichische »Libelle« von 1954 an – mit einem Längsrohr, das eine imaginäre Dachkontur zeichnete und Überrollbügel sein wollte. Ernstere Absichten verfolgte der ebenfalls aus Österreich stammende Kroboth, während der deutsche Meyra 200-2 erfolglos blieb: Formal eine herbe Mixtur von Kabinenroller und Auto, wirkte dieses Gefährt 1955 mit 480 gebauten Exemplaren noch an der steigenden Motorisierung mit. Brutaler und nur ein Prototyp im gleichen Jahr in den USA: der »Tri-Car« im Isetta-Konzept mit viel zu großen Rädern und viel zu kurzer Karosse.

Zum Glück gelten Naturgesetze auch in der Technik: Nur starke Konzepte setzten sich durch. So fiel der Dreirad-Urtyp des deutschen vierrädrigen NSU-Prinz ebenso

lures d'avion: le Gommel en 1947 et le Keinath en 1948. En France, Reyonnah (1950) pouvait même replier la partie avant de son véhicule s'il voulait se garer, quant à AEMS et Inter, sortis en 1953, ils ressemblaient encore plus à des avions.

Les Fuldamobils allemandes évoquaient déjà davantage une automobile classique. Les premières avaient un revêtement de tôle d'aluminium cintrée à la surface granuleuse ou de contreplaqué recouvert de cuir synthétique. Quant à la Fuldamobil «Forelle» (la truite), elle connaissait déjà en 1951 le déport au sol négatif, technique que l'on juge de nos jours particulièrement ingénieuse pour régler les problèmes de géométrie de la roue avant et assurer la stabilité de la conduite en ligne droite. Petit engin aux roues arrière jumelées et à la carrosserie d'aluminium plus tard doucement arrondie, elle termina sa carrière en 1969 après avoir été fabriquée en 3000 exemplaires. La Brütsch «Spatz» (le moineau), voiture découverte, était plus ronde encore; elle et ses soeurs à quatre roues étaient le produit d'une marque qui conçut des formes d'une simplicité sans pareille. Comparée à elle, la «Libelle» (la libellule) autrichienne découverte, apparue en 1954, nous déconcerte avec son tuyau longitudinal dessinant un contour de toit imaginaire et prétendant être un arceau de sécurité. Les intentions de Kroboth, Autrichien également, sont plus sérieuses, alors que l'Allemand Meyra 200–2 n'eut aucun succès avec sa carrosserie, mélange grossier de scooter caréné et de voiture dont on ne fabriqua que 480 exemplaires en 1955. Sortie aux Etats-Unis la même année, la «Tri-Car», inspirée de l'Isetta, avait des roues beaucoup trop grandes et une carrosserie beaucoup trop courte. Elle est restée un prototype.

Fiat 126 Bambino
Italy
Italien
Italie, 1972
652 ccm, 23 PS

Fortunately, the laws of nature also apply to technology, and ideas do not survive unless they are strong enough. The three-wheel prototype of the German four-wheeler NSU Prinz also failed. As for the ugly Max Kabine, its manufacturers had to recognize their own limitations when their Board of Managers tried to go on a trial ride but were stopped by the authorities. Business acumen was not always coupled with ingenuity, let alone an eye for suitable body shapes – even when we make allowances for the times. All too often, designers wanted to construct three-wheelers that were »real« cars at least as far as shape was concerned. There was something pathetic about the Czech »Velorex«, a motorized sidecar with a folding roof, sold from 1958 to 1973. Man learns to be humble in times of want – whether with four or three wheels.

Growing affluence meant that small cars – especially three-wheelers like the British Peel (1962) with its minute wheels – became increasingly rare. It was only when the roads turned into car parks that small cars were considered a sensible option again. Two examples of three-wheelers with a solo rear wheel were the Ford Ghia Cockpit of 1981 and the VW Scooter. Neither of them had a chance, as the prevailing desire for speed – and thus also for the necessary safety – would have priced them out of the market. The three-legged approach remained an intellectual game, rather than a way of solving transportation problems. This was much easier on four legs, although the beginnings were equally humble.

Indeed, they were so humble that the idea of cycle cars was revived again. In France, just after the war, Mochet tried to maintain his market position with a series of diminutive vehicles. From 1946 to 1950, his fellow-countryman Rovin built extremely beautiful round bodies with wheels that were far too small. In 1947, the German magazine *Der Spiegel* reported on the first German Champion: a car that is easy to mend and can be lifted by hand if a tyre needs changing – and it can easily be carried off by thieves. The Kleinschnittger was hardly any heavier: with a radiator made of chicken wire, it hardly sold at all. But even an attractively designed fastback car with a self-bearing body failed to secure survival for Kleinschnittger. The change from a small series with craftsman-like production methods (e.g. the frame was welded, the glass-fibre fabric of the outer case attached manually, and the mechanical parts purchased) made it far too expensive for many. Inventors like Prof. Kersting with

durch. Die häßliche »Max-Kabine« mußte den Fahrversuchen eines Vorstandes Grenzen aufzeigen, als diesem ein Geländeausritt verweigert wurde. Nicht immer war unternehmerisches Können gepaart mit ingeniösem Denken, geschweige denn mit einem Blick für angemessene Karosserieformen, selbst aus der Sicht dieser Zeit betrachtet. Zu oft wollte man wenigstens formal »richtige« Autos schaffen. Rührend wirkte ein Dreiradgefährt aus der damaligen Tschechoslowakei: Eher wie ein motorisierter Beiwagen mit Faltdach, so sah der »Velorex« aus, der von 1958 bis 1973 verkauft wurde. In Zeiten des Mangels lernte man Bescheidenheit – mit vier oder wie hier mit drei Rädern.

Mit wachsendem Wohlstand wurden kleine Autos, besonders dreirädrige wie z. B. ein englischer Peel mit winzigen Rädern von 1962, immer seltener. Erst als die Straßen zu Parkplätzen degradiert wurden, dachte man über kleine Autos nach. Dreiräder mit Solorad im Heck als Beispiel: 1981 der Ford Ghia Cockpit und der VW Scooter. Beide blieben chancenlos, der Wunsch nach Geschwindigkeit und die damit erforderliche Sicherheit hätte sie zu sehr verteuert. »Dreibeinig« wird zum Spiel mit dem Konzept und nicht zur Lösung von Transportaufgaben, wenn das »vierbeinig« besser geht. Auch das begann bescheiden. So bescheiden, daß die Cyclecars wieder auflebten. In Frankreich versuchte Mochet, seine Winzlinge in den Nachkriegsjahren am Markt zu halten. Sein Landsmann Rovin baute von 1946 bis 1950 sehr schöne runde Karossen mit viel zu kleinen Rädern. 1947 berichtete der »Spiegel« vom ersten Champion in Deutschland: Reparaturfreundlich läßt er sich zum Radwechsel leicht per Hand hochheben – und von Dieben ohne Schwierigkeiten wegtragen. Kaum schwerer, wollte der Kleinschnittger mit Hasendrahtkühler auf Touren kommen. Aber auch ein wirklich ansprechendes Fließheckauto mit selbsttragender Karosse konnte Kleinschnittger nicht zum Überleben verhelfen. Denn der Wechsel von der Kleinserie mit handwerklichen Fertigungsmethoden (tragender Rahmen geschweißt, die Glasfasergewebe der Kunststoffhaut von Hand aufgelegt, die Mechanik zugekauft u. s. w.) war für viele zu teuer. Ideenproduzenten wie Professor Kersting kamen mit einem Sperrholzwägelchen nicht über einen Prototyp hinaus (1950). Champion schaffte den Wechsel, nicht das Überleben mit schönen, runden Formen. Hurst trat 1948 mit winzigen Blechautos an, schon 1950 blieben seine Cyclecars stehen. Brütsch tat sich schwer, fand aber im Industriellen Friedrich

Par chance, la technique n'échappe pas aux lois de la nature, et seules les idées fortes réussirent à s'imposer. Le tricycle, ancêtre de la NSU Prinz allemande à quatre roues, fut un flop. Quant à la vilaine «Max-Kabine», ses possibilités étaient très limitées. L'esprit d'entreprise n'était pas toujours accompagné d'ingéniosité, et encore moins d'un souci d'esthétique, même avec les yeux de l'époque. On voulait trop souvent créer de «véritables» voiture du moins au niveau de la forme. Un tricycle à moteur originaire de Tchécoslovaquie, le «Vélorex», vendu de 1958 à 1973, ressemblait davantage à un side-car à moteur et toit pliant qu'à une voiture. Qu'on ait quatre ou, comme c'est le cas ici, trois roues, la modestie est de mise en temps de pénurie.

Le temps passait, la prospérité s'annonçait et les petites voitures, surtout les trois roues, telles par exemple la Peel anglaise de 1962 aux roues minuscules, se firent de plus en plus rares. On ne se souvint d'elles que lorsque les rues commencèrent à se transformer en parkings, envisageant par exemple la création de tricycles à roue arrière unique comme la Ford Ghia Cockpit et la Volkswagen Scooter en 1981. Elles n'avaient aucune chance, car les voitures rapides – et les gens veulent des voitures rapides – doivent répondre à certaines normes de sécurité, et cela les auraient rendues trop chères. Penser «trois-pattes», c'est faire joujou avec la conception et non régler les problèmes de transport, quand penser «quatre-pattes» est plus simple. Le renouveau des petites voitures commença modestement.

Si modestement même que les cyclecars refirent leur apparition. En France après la guerre, Mochet essaya de maintenir ses voiturettes sur le marché. Son compatriote Rovin construisit de 1946 à 1950 de très belles carrosseries rondes mais aux roues beaucoup trop petites. En 1947, le magazine «Spiegel» fit un rapport sur la première Champion en Allemagne: facile à réparer, elle se laisse soulever manuellement quand on veut changer une roue – et les voleurs peuvent facilement l'emporter. La Kleinschnittger au radiateur en grillage à lapin était à peine plus lourde. Mais même une voiture à la ligne fluide et vraiment intéressante, dotée d'une caisse monocoque, ne pouvait plus sauver Kleinschnittger: en effet, de nombreux constructeurs ne pouvaient plus financer la fabrication en petite série qui, réalisée avec des méthodes artisanales (châssis portant soudé, tissu de fibre de verre du revêtement de cuir synthétique posé à la main, mécanique achetée etc.) était devenue trop chère. Le professeur Ker-

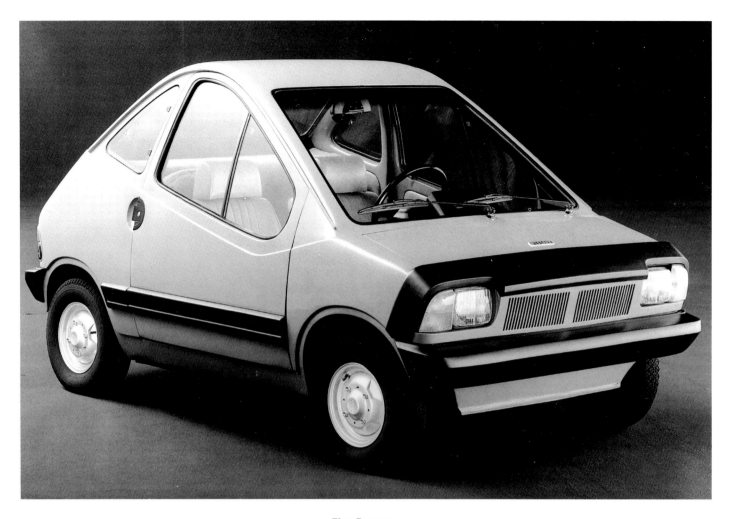

Fiat Prototyp
Italy
Italien
Italie, 1973
Elektrofahrzeug

his plywood vehicle (1950) never made it beyond a prototype. The Champion did succeed in adapting, though without its beautifully curved shape. Hurst entered the scene with tiny tin vehicles in 1948, but had to abandon his cycle cars again in 1950. Brütsch was slow at first, but succeeded in inspiring Friedrich, an industrialist who was still proudly demonstrating the sturdiness of the »Spatz« (»sparrow«) in 1955, when he officially maltreated it with a hammer at the IFMA trade fair in Frankfurt. This was after the failure of Brütsch's idea to attach the suspension straight to the fibre-glass case. Unfortunately, the case then became torn. The famous Tatra engineer Ledwinka helped the Sparrow to keep its wheels. The real fame of this car, however, is due to its carburettor fires which frequently destroyed the whole case.

The smoothly curved shape of Trippel's car is similar to the Tatra. Trippel had already made a name for himself with his amphibian vehicles. However, his beautiful fastback

einen Interessenten, der noch 1955 während der Frankfurter IFMA mit dem Hammer stolz die Plastikkarosse des »Spatz« traktierte, um Festigkeit zu demonstrieren – nachdem Brütschs Idee, die Radaufhängung direkt an der Kunststoffschale zu befestigen, sich als unzulänglich erwiesen hatte, weil sich Risse bildeten. Der berühmte Tatra-Ingenieur Ledwinka half dem »Spatz«, die Räder festzuhalten. Bekannter wurde das Auto jedoch durch den Umstand, daß Vergaserbrände häufig dazu führten, daß das Gehäuse abfackelte.

Tataähnlich wirkten die glatten, runden Formen des Trippel-Autos. Trippel war früher durch seine Schwimmwagen bekannt. Jetzt aber blieben die bildschönen Fließheckautos Einzelanfertigungen in Stahlblech, eines hatte sogar Flügeltüren. Der Witz der Konstruktion überzeugte Mercedes; sie erwarben das Patent für den legendären Mercedes 300 SL. Der erfolgreichste deutsche Kleinwagen, der es von einem Gehäuse aus kunstlederbespanntem Sperr-

sting, père de la voiturette en contreplaqué, ne sut fournir qu'un prototype (1950). Champion réussit à passer le cap, mais ses formes rondes et belles ne survécurent pas. Hurst entra dans l'arène en 1948 avec de minuscules voitures de tôle, déjà délaissées en 1950. Brütsch eut du mal, mais trouva dans l'industriel Friedrich un client potentiel, qui en 1955 encore, pendant la IFMA de Francfort, martelait fièrement la carrosserie de plastique du Spatz pour bien montrer sa solidité, après que l'idée de Brütsch – fixer directement la suspension des roues à la coque de plastique – se soit avérée inutilisable, parce que la coque se fissurait. Le célèbre ingénieur de Tatra, Ledwinka, travailla, lui, à la suspension des roues. Mais le «moineau» est surtout resté dans les mémoires pour ses incendies de carburateur qui transformaient souvent la carrosserie en torche. L'automobile de Trippel ressemblait aux Tatras par ses formes rondes et lisses. Trippel s'était fait connaître pour ses véhicules amphibies. Maintenant les belles voitures à

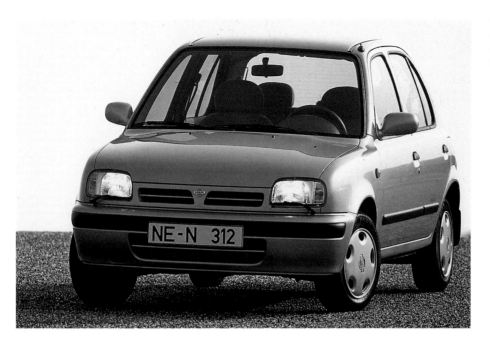

Nissan Micra
Japan
Japon, 1992
998 ccm, 55 PS

cars in steel sheet never got as far as mass production. One of them even had folding doors. Nevertheless, the ingenuity of the design did convince Mercedes, who bought the patent for the legendary Mercedes 300 SL. The most successful Geman car that managed to evolve from a plywood car with imitation leather to a solid metal vehicle was the Lloyd. First as a two-stroke, then as a four-stroke engine, it achieved annual production figures that were far above the Mercedes models. As early as 1956, the German magazine *Der Spiegel* carried far more Lloyds adverts than Opel, Ford and DKW, as all of these were more than twice as expensive. Staunau, an ice-machine manufacturer from Harburg, near Hamburg, intended to pull off the biggest coup of all. But dreaming of a Buick and building it as a small car was not quite the same and far too expensive. By autumn 1950, after only 100 cars, Staunau went bankrupt. Germany had a Passat a long time before it was built by VW, but the short-sighted policy of the manufacturers and a lack of funds meant that it never went beyond the prototype stage. Named after its creator, the Espenlaub (»aspen leaves«) of 1952 had a similar shape as the French Mathis 333, though it remained a prototype.

In the two Germanies, the Lloyd also had its counterpart in the East, where it was manufactured in Zwickau. Throughout its lifetime, until 1991, the lack of steel meant that the P 70 and its successor, the Trabant, had to have a fibre-glass body, reinforced by ground wood pulp and cotton. In 1992, when there was a wave of fire attacks in Rostock, it became obvious that this car was highly dangerous: the car burnt like cinder, leaving behind no more than a metal

holz zu einer Vollblechkarosserie brachte, war der Lloyd. Zunächst als Zwei-, dann als Viertakter schaffte er Jahresproduktionen, die weit über denen der Mercedesmodelle lagen. Allein 1956 hatte er mit Abstand die meisten Anzeigen im »Spiegel«, vor Opel, Ford und DKW, die alle weit mehr als das Doppelte kosteten. Den ganz großen Coup wollte der Eismaschinenhersteller Staunau aus Hamburg-Harburg landen. Aber vom Buick träumen und ihn als blechgewordenen Kleinwagen wirklich bauen war nicht dasselbe und viel zu teuer. Bis zum Herbst 1950 entstanden weniger als 100 Exemplare, Staunau meldete Konkurs an. Lange vor VW gab es in Deutschland (1952) einen Passat, doch eine kurzsichtige Firmenpolitik und Geldmangel ließen ihn schon am Start als Prototyp scheitern. Und auch das Auto, das 1952 »Espenlaub« wie sein Schöpfer hieß und formal einem französischen Mathis 333 ähnelte, mußte Einzelstück bleiben. Im geteilten Deutschland hatte auch der Lloyd sein Pendant im Osten. Als P 70, dann als Trabant war dieses Auto aus Zwikkau bis an sein »Lebensende« 1991 mit einer Karosse versehen, die – mangels Stahlblechzuteilung – aus Kunststoff bestand, der mit Holzschliff und Baumwolle Festigkeit gewann. Nicht zuletzt die schädlichen Feuerangriffe in Rostocks Vororten machten 1992 deutlich, wie schnell die Haut dieses Autos wegbrannte und nur eine rostbraune Metallkorsage übrigblieb. Als rollendes Symbol des Überlebenwollens in einer tristen Umgebung wurde der »Trabi« unsterblich: als unverwüstlicher Filmstar(»Go Trabi Go« 1990, »Trabi goes west« 1992) und als goldlackiertes, vierfüßiges Denkmal in der Deutschen Botschaft in Prag. Läßt sich vergleichbares vom Lloyd sagen, von

deux volumes en tôle n'étaient plus fabriquées que sur commande. L'une d'entre elles avait des portes battantes et l'idée sut convaincre Mercedes qui acheta le brevet pour sa légendaire Mercedes 300 SL. La Lloyd fut la première petite voiture allemande à succès qui sut passer d'un revêtement de cuir synthétique tendu sur contreplaqué à une carrosserie en tôle. D'abord dotée d'un moteur à deux temps puis à quatre temps, elle réussit à atteindre des chiffres de production bien plus importants que ceux des modèles de Mercedes. En 1956, par exemple, elle rassemblait plus d'annonces dans le «Spiegel» que les Opel, Ford et DKW, qui coûtaient toutes au moins le double. Le fabricant de machines à glace Staunau de Hambourg-Harbourg voulait frapper fort, mais rêver d'une Buick est une chose, construire une petite voiture de tôle qui ressemble à une Buick en est une autre et, en outre, c'est beaucoup trop cher. Staunau fabriqua moins de cent voitures avant de déposer son bilan en automne 1950. En 1952, il existait une Passat en Allemagne, bien avant celle de VW, mais une politique commerciale imprévoyante et le manque d'argent firent qu'elle resta un prototype. Quant à l'«Espenlaub» (feuille de tremble), nommée d'après son créateur et dont les lignes évoquaient la Matthis 333 française, elle resta, elle aussi, une pièce unique. Dans l'Allemagne divisée, la Lloyd avait son pendant à l'Est: la P 70, appelée plus tard Trabant. Construite à Zwickau, et commercialisée jusqu'en 1991, celle-ci était dotée d'une carrosserie de plastique (la tôle faisait défaut) renforcée à l'aide de pâte mécanique et de coton. On n'attendit ni 1992, ni les incendies de la banlieue de Rostock, pour constater combien la carrosserie de la

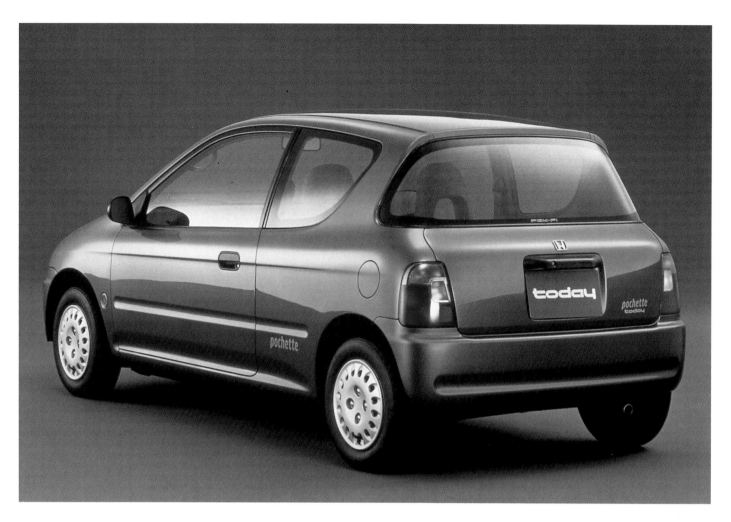

Honda Today
Japan
Japon, 1993
656 ccm, 48 PS

carcass. The »Trabi« acquired fame as a symbol on wheels, epitomizing people's desire to survive in a drab monotonous world, first as an indestructible film star in »Go Trabi Go« (1990) and »Trabi Goes West« (1992) and eventually as a gold-painted four-legged memorial at the German embassy in Prague. The same may or may not be true of the Lloyd which was jocularly referred to as a car for the death-defying. Interestingly, there were even a large number of variations, including a coupé, a convertible saloon, an estate and a small truck with a straight front.

The Gutbrod, with its elongated pontoon shape was more successful than the curved Champions and Maicos, and was one of the models Nissan emulated for the Japanese car market with its surfeit of forms with its post-modern Figaro of 1989. It was rather ordinary and as nauseatingly sentimental as the nostalgia behind it, but good for marketing. The achievements of Italian designers in the mid-Fifties had been works of art by com-

dem es scherzhaft hieß: »Wer den Tod nicht scheut, fährt Lloyd«? Obwohl dieses Auto noch durch Variantenreichtum glänzte: Es gab ein Coupé, Limousinencabrio, Kombi und Kleinlaster mit Plattschnauze. Erfolgreicher als die rundlichen Champions und Maicos war der Gutbrod mit gestreckter Pontonlinie. Er wurde unter anderem Vorbild für eine satt gewordene japanische Autogesellschaft, für die Nissan 1989 den postmodernen »Figaro« anbot – technisch alltäglich, formal so schmalzig wie der getrübte Blick zurück, aber günstig für das Marketing. Da waren die Leistungen italienischer Designer Mitte der 50er Jahre geradezu Kunstwerke: Karossiers schufen für die kleinen Fiats 500 und 600 Hüllen, die problemlos auf knappe Radstände paßten und bildschön gerieten. Wir kannten die Grundmodelle und das seltsame plattschnäuzige Familiengefährt Fiat »Multipla« als arg verzerrte Grundform der 600er-Limousine. Erst mit dem NSU-Prinz »Sport« von Bertone und dem offenen Wankel-Spi-

Trabant brûlait vite, ne laissant qu'un squelette de métal brunâtre. La «Trabi» est devenue le symbole du désir de survivre dans un environnement morose, on la retrouve star du grand écran («Go Trabi Go» 1990, «Trabi goes west» 1992) et monument quadrupède et doré dans l'ambassade allemande de Prague. Difficile de tenir des propos aussi positifs sur la Lloyd, vu qu'on louait le courage de ses conducteurs. Elle existait pourtant dans de nombreuses versions: un coupé, une berline-cabriolet, un break et une camionnette au capot aplati.

La «Gutbrod» allongée eut plus de succès que les Champions et Maicos aux lignes rondes. Les Japonais, qui possédaient déjà toutes les voitures imaginables, la prirent pour modèle, et Nissan présenta en 1989 la «Figaro» aux lignes post-modernes, banale sur le plan technique, aussi sentimentale que nostalgique au niveau des formes, mais intéressante au point de vue du marketing. Comparées à elle, les créations des designers italiens du milieu des années 50 font figure

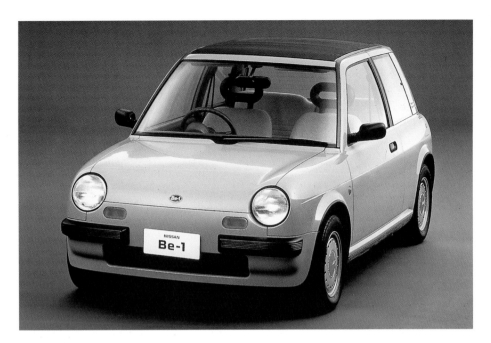

Nissan BE–1
Japan
Japon, 1987
987 ccm, 52 PS

parison, when body designers had created bodies for the small Fiat 500 and 600, bodies which easily fitted onto the narrow wheel bases and were in fact beautiful. The basic models of the Fiat Multipla had an unusual straight front, a gross distortion of the Fiat 600 estate. Italian expertise finally found its way to Germany with Bertone's NSU Prinz Sport and the open Wankel Spider (1965). This was because the Lloyd 600 coupé by Pietro Frua was only produced 49 times. The Prinz had an amazing career: after a round, compact shape, the second version cleverly picked up the 1959 design trend of General Motors (Chevrolet Corvair) with its protruding roof edge at the back, wrap-around windscreen and the bath-tub profile of the chassis as a self-bearing body. Over the years, as engines became bigger, it was stretched twice and thus made to look uglier.

1955 was the year of the Delta – all tinny, small und ugly. With this vehicle, the aircraft designer Dornier wanted to create a car where people could sit back to back. Hinged at the top, the front and rear doors had divided windscreens. The sides were symmetrical in relation to the centre of the car, so that it appears double-faced. Appropriately named Janus, the car was manufactured under licence by Zündapp. However, because of its weak engine, it was never successful. There were plenty of small and efficient »real« cars. And a long time before the Janus, this market had already been saturated by the Isetta, after a licence dispute with the manufacturers of the Hoffmann cabin (the Isetta had side doors instead of a front door, while everything else was identical, almost down to the smallest screw). Even the Messerschmitt scooter – a tiger on four wheels and a lone rocket on

der (1965) gab es auch in Deutschland Beispiele italienischen Könnens. Denn vom Lloyd 600-Coupé von Pietro Frua existierten nur 49 Exemplare. Eine erstaunliche Karriere machte der »Prinz«: Zunächst von kompakter, rundlicher Form, übernahm er in zweiter Version gekonnt den Designtrend der 59er-Modelle von General Motors (Chevrolet Corvair) mit der überhängenden hinteren Dachkante, Panoramaheckscheibe und Badewannenprofil des Unterbaus als selbsttragender Karosserie. Sie wurde im Laufe der Jahre wegen der größeren Motoren zweimal gestreckt und damit immer häßlicher.

Ganz in Blech, klein und häßlich, kam 1955 der »Delta« daher. Mit diesem Fahrzeug wollte der Flugzeugkonstrukteur Dornier die Menschen Rücken an Rücken sitzend auf die Straße bringen. Oben angeschlagene Front- und Hecktüren mit geteilten Scheiben und eine symmetrische Seitenansicht um die Fahrzeugmitte machten das Wägelchen doppelgesichtig. Als an Zündapp verkaufte Lizenz folgerichtig »Janus« genannt, war es schwach motorisiert und blieb erfolglos. Es gab bereits »richtige« Autos, klein und leistungswillig. Und lange vor dem Janus hatte die vierspurige Isetta den Markt abgegrast, nachdem ein Lizenzstreit mit dem Hersteller der Hoffmann-Kabine überstanden war (Seitentüren anstelle der Fronttür bei der Isetta, ansonsten fast bis zur letzten Schraube ähnlich). Auch Messerschmitt-Roller, vierrädrig als »Tiger« eher einsame Raketen auf den Autobahnen (130 Kilometer pro Stunde), waren für die Masse der Autokäufer keine zukunftweisende Lösung.

Da ging Hans Glas in Dingolfing geschickter vor. Sein nach dem ältesten Enkel benann-

d'œuvres d'art: les carrossiers élaborèrent pour les petites Fiat 500 et 600 des coques s'adaptant sans problèmes à des empattements courts et jolies, ce qui ne gâte rien. Nous connaissions les modèles de base et la voiture familiale Fiat Multipla au capot plat, version de base vilainement déformée de la berline 600. Il fallut attendre la NSU-«Prinz Sport» de Bertone et la Wankel-Spider découverte (1965) pour que les talents des designers italiens soient reconnus en Allemagne, car le coupé Lloyd 600 de Pietro Frua n'existait qu'en 49 exemplaires. La Prinz connut une carrière étonnante: la première version était compacte et ronde avant d'adopter, dans la seconde version, le design des modèles 59 de General Motors (Chevrolet Corvair): arête arrière du toit en surplomb, lunette arrière panoramique et carrosserie monocoque sur un châssis en forme de baignoire. Le moteur se faisant plus performant, elle fut allongée deux fois au cours des années et n'y gagna pas en beauté.

En 1955, la «Delta», petite, vilaine et tout en tôle fit son apparition. Dornier, le constructeur d'avion, avait prévu que les passagers seraient assis dos à dos. Des portières avant et arrière fixées en haut avec des vitres en deux parties, l'avant et l'arrière symétriques vus de profil, lui donnaient deux visages. Le brevet fut vendu à Zündapp et la voiture, nommée «Janus», ce qui témoigne d'un grand sens de l'observation, n'eut aucun succès, son moteur était trop faible. Il y avait déjà de «vraies» voitures, petites et performantes. Et l'Isetta avait tondu le marché bien avant qu'apparaisse la Janus, après qu'un différend au sujet du brevet avec le constructeur de la cabine Hoffmann ait été réglé (portières latérales au lieu de portière avant chez l'Isetta, sinon

the motorway (80 mph / 130 km/h) – was not seen as an option for the future by the mass of motorists.

Hans Glas from Dingolfing, Germany, was more astute. The prototype of his Goggo-mobile, named after his eldest grandson, still had a complete front bonnet as well as a windscreen that was part of a front door, hinged on the side. In 1955, when this car was mass-produced, its ludicrous design was quickly corrected. Alongside a version with a tiny notchback, there were also a minivan and a coupé with a giant wrap-around windscreen and gears that could be electrically pre-selected – a car that (almost) seemed like a precursor of the Porsche Tip-tronic of 25 years later. This time of grow-ing affluence also gave rise to the Glas 600, a car which, like the Prinz, was influenced by American designs. Its curves were shaped identically to those of an Opel Re-kord, as was its expensive wrap-around front windscreen. However, like Borgward, Glas had too many types and thus fell prey to a similar fate: having ventured into the medium-size range and even attempted to sell an eight-cylinder car with a Frua body, the company had to give up and was bought up by BMW. The survival of Glas had been secured by the Isetta at one time, now called BMW 600. Under this new name, it played rather a minor role, vaguely located between a cabin and a car. It was more an intermediate vehicle, leading up to the classically beautiful models of the 700 series designed by Michelotti from Italy. In the mid-Sixties, Goggo mechanics were used for a body with a rectangular-tube jump link in an unsuccessful project named AWS Piccolo. One consolation for Glas was that the most beautiful Goggomobile of all times was developed on the other side of the world in 1959 – by Buckle in Australia: with its fibre-glass body, the Dart was so elegant that the Alfa Spider (by Pininfarina) with its rounded rear looked like a cheap imitation.

But there were also cheap imitations of a completely different kind: while the Italians had their own counterparts, with the Vespa, Autobianchi and – later – with the Lancia, the NSU bath-tub Prinz was gratefully imitated by the Zaporozhez works in Russia, in the form of the ZAZ 968 M, in 1962. Egypt had a similar »re-building« project, which it gave the lyrical name Ramses. When the lean post-war years were over in the UK, there was an upward orientation. Following the Seven, the Austin Seven (1951) – soon called the A 30 – was to resemble the big ve-hicles parked outside the stately homes of nobility: Daimler, Jaguar, Wolseley and Rolls-

tes »Goggomobil« hatte als Prototyp noch eine komplette Fronthaube inklusive Front-scheibe als seitlich angeschlagene Tür. Die-se unsinnige Konstruktion wurde in der Se-rie ab 1955 schnell korrigiert. Neben der winzigen Stufenheckform gab es noch ei-nen Kleinlieferwagen, ein Coupé mit rie-siger Panoramaheckscheibe und elektrisch vorwählbarer Gangschaltung – man könnte meinen, hier einen Vorläufer der 25 Jahre jüngeren Tiptronic von Porsche (fast) vor sich zu haben. In dieser Zeit des wachsen-den Wohlstands entstand der – wie der Prinz – amerikanisch angehauchte Glas 600. Die ins Blech geprägten Schwünge hatten die gleiche Form wie die Chromleisten ei-nes Opel Rekord. Ähnlich war auch die teu-re Panoramafrontscheibe. Glas, der wie Borgward auch zu viele Typen anbot, erlitt ein ähnliches Schicksal: Nachdem er sich in die Mittelklasse und gar an einen Achtzylin-der mit Frua-Karosse gewagt hatte, mußte er aufgeben und wurde von BMW aufgefan-gen. Deren Überleben hatte einst die Isetta gesichert – als Langversion BMW 600 eher nebensächlich, weil undefinierbar zwischen Kabine und Auto angesiedelt. Der Wagen stellte nur den Übergang zur klassisch schö-nen Baureihe der 700er dar, eingekleidet von Michelotti aus Italien. Goggomechanik wurde Mitte der 60er Jahre für eine Karos-se mit Vierkantrohr-Steckverbindung ver-wendet, ein erfolglos gebliebener Versuch namens AWS-Piccolo. Ein Trost für Glas: Das schönste Goggomobil aller Zeiten wur-de auf der anderen Seite des Erdballs 1959 in Australien von der Firma Buckle gebaut – als »Dart« mit Kunststoffkarosserie und so elegant, daß ein Rundheck-Alfa Spider von Pininfarina dagegen nur wie ein schnöder Abklatsch wirkte.

Ein Abklatsch anderer Art: Hatten die Italie-ner mit Vespa und Autobianchi, später auch mit Lancia eigene Pendants zu bieten, so fand der NSU-Badewannenprinz in Rußland bei den ZAZ 968 M der Zaporozhets-Werke seit 1962 dankbare Nachahmer. In Ägypten erdachte man für den »Klaubau« 1966 den bedeutungsvollen Namen »Ramses«. Die Engländer versuchten sich, nachdem die Not der Nachkriegszeit überstanden war, nach »oben« zu orientieren. Wie einst der Seven, so sollte der neue Austin Seven, bald A 30 genannt, schon 1951 aussehen wie die Großen, die beim Adel vorfuhren: Daimler, Jaguar, Wolseley, Rolls-Royce. Hauptsache, etwas Kühlerattrappe und die ins Blech gekniffenen Linien eines ge-schwungenen Kotflügels waren vorhanden. Da hatte der geniale Kopf Issigonis 1949 bei seinem Entwurf des Morris Minor mehr Sachlichkeit bewiesen. Der Name war nicht

presque semblable jusqu'à la dernière vis). Les scooters de Messerschmidt, «tigres» à quatre roues plutôt considérés comme des fusées solitaires parcourant les autoroutes (ils plafonnaient à 130 km/h), n'offraient pas de perspectives acceptables à la masse des acheteurs potentiels.

Hans Glas à Dingolfing fit montre de plus d'habileté. Le prototype de sa «Goggomo-bil», d'après le nom de l'aîné de ses petits-fils, offrait encore un capot avant à pare-bri-se intégré qui tenait lieu de portière s'ou-vrant sur le côté. Cette construction insen-sée fut vite corrigée dans la fabrication de série à partir de 1955. A côté de la voiture miniature dotée d'un coffre, on trouvait aus-si une camionnette, un coupé équipé d'une gigantesque lunette arrière et d'une boîte de vitesses préselectibles électriquement – on a presque l'impression de voir ici un pré-curseur du «Tiptronic» de Porsche qui a 25 ans de moins. A cette époque de prospéri-té croissante apparut la Glas 600 d'inspira-tion américaine comme la Prinz. Les arcs de tôle emboutie avaient la même forme que les baguettes chromées d'une Opel Re-kord, le pare-brise panoramique coûteux était également semblable à celui de l'Opel. Glas, qui, comme Borgward, offrait trop de modèles, connut un destin similaire. Il se lança dans la classe moyenne et construisit même un huit-cylindres habillé par Frua, avant de renoncer et d'être englouti par BMW. L'Isetta avait autrefois permis à BMW de survivre – la version longue BMW 600, mi-cabine mi-voiture, resta plutôt ac-cessoire. Elle ne faisait qu'annoncer la belle série des 700 habillées par l'Italien Michelot-ti. Au milieu des années 60, on utilisa la mé-canique de la Goggo dans une carrosserie composée de tuyaux carrés, une tentative nommée AWS-Piccolo et demeurée incon-nue. Glas eut la consolation de voir construi-re en Australie en 1959 par la firme Buckle la plus belle Goggomobil de tous les temps: une «Dart» à la carrosserie de plastique et si élégante que comparée à elle une Alfa Spider de Pininfarina ressemblait à une mé-prisable imitation.

A propos d'imitation: si les Italiens avaient leurs propres pendants avec Vespa et Auto-bianchi, et plus tard aussi avec Lancia, les Russes imitèrent à partir de 1962 la NSU-Prinz en construisant les ZAZ 968 M dans les usines Zaporojets. Les Egyptiens dotè-rent leur imitation du nom prestigieux de «Ramsès». Les Anglais, qui avaient surmon-té les peines de l'après-guerre, tentèrent de s'orienter vers le haut de gamme. La nou-velle Austin Seven, qui deviendra la A 30, devait, comme déjà la Seven en 1951 res-sembler aux voitures de la société la plus

Royce. The main thing was to have a mock bonnet and the elegant lines of curved mudguards etched into the metal. However, when the ingenious Issigoni designed the Morris Minor in 1949, he showed a lot more sense. The name was not quite correct, because the car – though a good one – was in fact quite large. When Alec Issigoni was knighted in 1969, he had certainly earned it. For ten years he had been promoting a modern car in the automobile industry, a car that had all the right technical details and which could be developed into a major series – the only way to success. The conditions were that it must not exceed the maximum length of 10 feet (3,050 millimetres), that it had to become the terror of the Monte Carlo Rallye and win several races, and that it had to be built – without changes – for at least 30 years (if not 50). This was the legendary Mini. This car was designed completely from scratch. The starting point was not how many people could be accommodated in as little space as possible, but how much space would be required four people to transport comfortably. The result: a front engine with front-wheel drive, built in sideways and directly connected to the gears, the wheels just about big enough to cope with mediocre road surfaces and to fit into small wheel cases and – as a result – very small suspension elements. The self-bearing steel body does not have a single superfluous kink and is divided into individual elements, which is useful for production purposes. The dashboard has been reduced to a round speedometer. Although there is no boot, the minute tailgate has been designed so as to take in stacked objects when open. The entire car was more than the sum total of its parts, and the design

ganz korrekt, weil das Auto gut, aber recht groß war. Doch Alec Issigonis hatte sich 1969 sein Adelsprädikat verdient. Zehn Jahre zuvor hatte er der automobilen Welt einen modernen Wagen mit allen technischen Details vorgestellt, der für die Großserie entwickelt werden konnte – der einzig erfolgversprechende Weg. Bedingungen waren dabei, eine Länge von 3050 Millimetern nicht zu übe hreiten, der Schrecken der Rallye Monte Carlo zu werden (mehrere Siege) und mindestens 30 Jahre unverändert gebaut zu werden (wenn nicht gar 50): Es handelt sich um den legendären Mini. Dieses Auto wurde von Grund auf neu durchdacht: Man fragte sich nicht, wie Menschen in möglichst wenig Volumen unterzubringen seien, sondern wieviel Volumen vier Personen zusätzlich benötigen, um sich mit technischer Hilfe bequem fortbewegen zu können. Das Ergebnis: Ein quer eingebauter Frontmotor mit direkt angekoppeltem Getriebe und Frontantrieb, die Räder gerade so groß, daß sie mäßigen Straßen gewachsen waren und nur kleine Radhäuser benötigten, Federung mit Gummifederelementen entsprechend klein. Die selbsttragende Stahlkarosserie hat keine Falte zuviel und ist – günstig für die Produktion – in einzelne Elemente unterteilt. Das Armaturenbrett ist auf einen Rundtacho reduziert. Trotz fehlender Heckklappe wird der winzige Deckel so ausgelegt, daß er – geöffnet – gestapelte Ladung aufnimmt. Das Ganze war hier mehr als die Summe seiner Teile. Millionen Autos anderer Marken übernahmen das Baumuster, weil der Kleine hielt, was Große versprachen. Varianten mit Kühlerattrappe und Heckflossen (Riley Elf), als Kombi und als Geländewagen (Mini Moke) ließen ihn dennoch neben Tin

huppée: Daimler, Jaguar, Wolseley, Rolls-Royce. Il lui fallait avant toute chose une imitation de radiateur et des lignes d'aile arquée pincées dans la tôle. Issigoni fit montre de plus de réalisme en 1949 en concevant la Morris Minor. Le nom n'était pas correct car la voiture était plutôt grande. Alec Issigoni fut ennobli en 1969. Pendant dix ans il avait présenté au monde automobile une voiture moderne pourvue de tous les détails techniques et susceptible d'être fabriquée en série – la seule voie prometteuse de succès. Conditions: ne pas dépasser 3 050 millimètres de long, devenir la terreur de Monte-Carlo (plusieurs victoires) et ne pas subir de transformations pendant 30 ans au moins (sinon 50). Vous l'avez deviné, il est question de la légendaire Mini. La conception de cette automobile était complètement différente de celle des autres petites voitures; on ne se demanda pas comment placer des gens dans le plus petit espace possible, mais de combien d'espace quatre personnes ont besoin pour se déplacer en voiture confortablement. Le résultat: un moteur transversal à l'avant , boîte de vitesses et traction avant directement accouplées, les roues assez grandes pour affronter des routes normales et n'ayant besoin que de petits dégagements de roues, suspension avec éléments en caoutchouc, petits eux aussi. La carrosserie monocoque en acier n'avait pas un pli de trop et se démontait en éléments isolés – ce qui est avantageux pour la production. Le tableau de bord n'abritait qu'un tachymètre rond. Il n'y avait pas de hayon, mais le petit couvercle était conçu de telle sorte qu'il pouvait, ouvert, abriter les bagages empilés. Le tout était ici plus que la somme des parties, des millions de constructeurs de voitures adop-

was emulated by millions of other manufacturers. Small though it was, the Mini kept the promises of the big company that made it. Despite variations with mock bonnets and rear wings (Riley Elf), as an estate car and as a cross-country vehicle (Mini Moke), it became a legend alongside the Tin Lizzy and the Beetle, a legend that is still alive today.

Meanwhile Germany's small cars had metamorphosed into fully-fledged cars – e.g. the Lloyd Arabella, the DKW Junior (later Opel Kadett), the Ford Fiesta, the Audi 50 and the VW Polo. The French Renault R4 the excellently designed R5 and, later, Clio, followed by the smaller Twingo. Peugeot launched their 104, and Italy its Innocenti – a variation on the theme of the Mini, as well as a conservatively styled A 112 and, later, the Panda, praised as a »great thing« by its advertisers. In Holland there was the dear old DAF 33 Daffodil with »shoestring mechanism« (1959). The Japanese owed their boom in the car industry partly to small cars. Within a matter of decades they caught up with a standard that had taken half a century to evolve in Europe. They can now claim to be number one in automobile engineering. As early as 1954 Suzuki produced the Flying Feather, a Japanese cycle car. It was built under licence by Hino in 1957, as the Renault 4 CV, called »Cremeschnittchen« (slice of cream cake) in Germany. The first post-war car by Mitsubishi, the 500, was built in 1960, as a mixture of a Goggo and a Trabi. The first Subaru 360 in 1958 was a cross between a Beetle and a Fiat 500, decorated with frog's eyes. And when Honda produced their N 360 saloon in 1962, they learnt their first little lesson very quickly. Tough tax laws and the abolition of certain requirements meant that the car could develop and spread extremely fast. Buyers of small cars, for example, no longer had to give evidence of sufficient parking space. The endeavour to build small »battleships« sometimes tempted companies to imitate one another. It was only in the Eighties that cars finally became functional and compact, following the ideal of the Mini. Today's range of small cars is largely covered by Daihatsu (Leeza, Mira and Opti), Honda (Today), Mazda (Carol), Mitsubishi (Minica), Subaru (Vivio) and Suzuki (Alto and Cervo). Nissan and Toyota have no cars below ten feet (three metres). Like the large, strong and comfortable Opel Corsa, Ford Fiesta and Renault Clio, the Japanese Micra and Starlet have followed the example of their bigger brothers and are available with power steering, air conditioning, window winder, turbocharging or large-capacity en-

Lizzy und Käfer zur Legende werden, die weiterlebt.

Die deutschen Kleinwagen hatten sich zu kleinen Wagen gemausert – so Lloyd Arabella, DKW Junior, später Opel Kadett, Ford Fiesta, Audi 50, VW Polo; aus dem französischen Renault R4 entwickelte sich der im Design vorbildliche R5 und später ein Clio, dem der kleinere Twingo folgte. Peugeot schickte den 104 ins Rennen und Italien seine Minivariante Innocenti neben einem konservativ gestylten A 112 und später den in der Werbung als »tolle Kiste« gepriesenen Panda; in Holland gab es seit 1959 den braven DAF 33 Daffodil mit »Schnürsenkelautomatik«. Die Japaner dagegen haben gerade mit Kleinwagen den Aufbau ihrer Autoindustrie geschafft. In nur wenigen Jahrzehnten haben sie nachgeholt, wofür Europa ein halbes Jahrhundert brauchte. Sie können sich heute als die Nummer 1 im Autobau fühlen.

Schon 1954 hatte Suzuki mit der »Flying Feather« ein japanisches Cyclecar anzubieten. 1957 übernahm Hino den Lizenzbau des »Cremeschnittchens« (Renault 4 CV). Der erste Nachkriegswagen von Mitsubishi, der »500«, erschien 1960 wie eine Mixtur aus Goggo und Trabi. Der erste Subaru 360 war 1958 eine Kreuzung aus Käfer und Fiat 500, mit Froschaugen garniert. Und Honda lernte 1962 bei seiner ersten Limousine N 360 die Minilektion sehr schnell. Harte Steuergesetze und der Wegfall von Auflagen wie dem Nachweis eines Parkplatzes beim Kauf eines Kleinwagens trieben dessen Entwicklung und Verbreitung voran. Beim Versuch, kleine Straßenkreuzer zu bauen, bestand zeitweise die Versuchung der Imitation. Erst in den 80er Jahren geriet die Form sachlich, kompakt und folgte dem Ideal eines Minis. So konnten selbst Kleinbusse mit nur drei Metern Länge entstehen. Das heutige Kleinwagenangebot bestreiten hauptsächlich Daihatsu (Leeza, Mira, Opti), Honda (Today), Mazda (Carol), Mitsubishi (Minica), Subaru (Vivio) und Suzuki (Alto, Cervo). Nissan und Toyota haben in der Länge bis zu knapp über drei Meter nichts zu bieten. Wie die groß, stark und komfortabel gewordenen Opel Corsa, Ford Fiesta und Renault Clio sind die japanischen Micra und Starlet teilweise – wie die Großen – mit Servolenkung, Klimaanlage, Fensterheber, Turboaufladung oder hubraumstarken Motoren erhältlich: Mini, ade.

Heute, bei ausgereifter Technik, müssen Kleinwagen wie die Großen ökologischen Erfordernissen genügen. Als Werkstoffe werden recyclebare Kunststoffe und Metalle kommen. Das Problem der Verbren-

tèrent cette conception, parce que la petite tenait ce que les grandes promettaient. Laissant derrière elle des variantes dotées d'une imitation de radiateur et d'ailes arrière (Riley Elf), des breaks et des voitures tout-terrain (Minimoke), la Mini est entrée dans la légende aux côtés du modèle T de Ford et de la Coccinelle.

Les Allemands construisaient maintenant de véritables petites voitures, par exemple la Lloyd Arabelle, la DKW Junior, plus tard l'Opel Kadett, la Ford Fiesta, l'Audi 50 et la VW Polo; en France, la R4 fut suivie de la Renault R5 au design exemplaire puis de la Clio et de la Twingo plus petite. Peugeot créa sa 104 et l'Italien Autobianchi l'Innocenti, variante de la Mini, à côté de l'A 112 d'allure plus conservatrice, Fiat créa sa petite Panda. Les Hollandais avaient depuis 1959 la DAF 33 Daffodil et son «automatique à lacets». Les Japonais, qui avaient fondé leur industrie automobile sur les petites voitures, ont comblé en quelques décennies un retard que l'Europe a mis un demi-siècle à rattraper. Aujourd'hui ils peuvent se considérer comme les leaders de la construction automobile.

En 1954 déjà, Suzuki présentait un tricycle à moteur japonais, la «Plume volante». En 1957, Hino entreprit de construire sous licence la Renault 4 CV. La première voiture construite après la guerre par Mitsubishi, la 500, apparut en 1960, synthèse de Goggo et de Trabi. En 1958, la première Subaru 360 était un mélange de Coccinelle et de Fiat 500, le tout agrémenté d'yeux de grenouille. Honda apprit très vite à manier les petites voitures en construisant en 1962 sa première berline N 360. Des règlements fiscaux très durs et le fait que les acheteurs de petites voitures n'aient plus eu à remplir certaines conditions imposées, par exemple prouver qu'ils possédaient une place de parking, entraînèrent le développement et la diffusion des petits véhicules. En fait, on essayait de miniaturiser les grosses voitures et il fallut attendre les années 80 pour que les formes se fassent pratiques et compactes selon l'idéal d'une Mini. C'est ainsi qu'on vit même apparaître de petits autobus de trois mètres de long. Aujourd'hui, le marché japonais des petites voitures est aux mains de Daihatsu (Leeza, Mira, Opti), de Honda (Today), de Mazda (Carol), de Mitsubishi (Minica), de Subaru (Vivio) et de Suzuki (Alto, Cervo). Nissan et Toyota n'ont pas de voitures de moins de trois mètres de long. Comme l'Opel Corsa, la Ford Fiesta et la Renault Clio devenues spacieuses, puissantes et confortables, les Micra et Starlet japonaises sont équipées en partie – comme les grandes – d'une direction assistée, de climatisation, de lève-glaces électri-

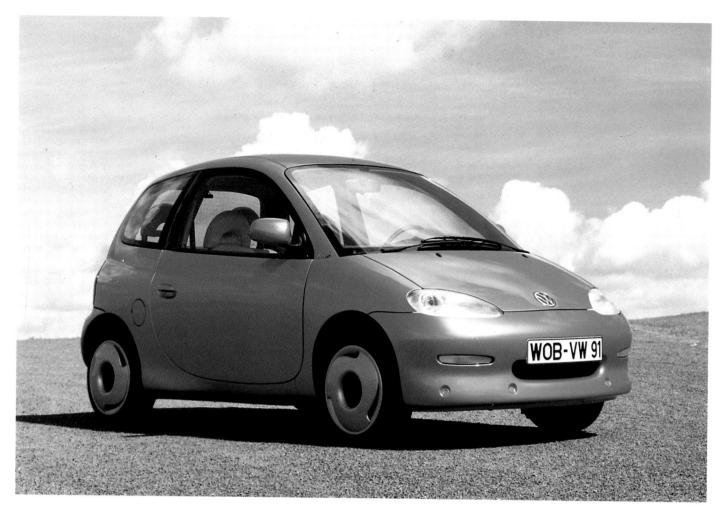

VW Chico
Germany
Deutschland
Allemagne, 1991
Hybridmotor

gines. There is no room for Minis any longer.

In our present age of sophisticated technology small and big cars meet a number of environmental standards. The material, whether fibre glass or metal, must be recyclable. The problem of the combustion engine will continue to be with us until the storage capacity of batteries can be increased drastically while at the same time reducing their weight. Some small cars, like the Ecos by Pininfarina (1978), are perfectly beautiful minis with a lasting design, but their power engineering makes it impossible for them to gain widespread acceptance. The Hotzenblitz, a stylized cabin car, and the Swiss Horlacher are first steps, but most motorists cannot yet afford a second car just for a trip into town. Even Opel's proposal of the Twin, a one-box design of 1991, requires a small garage to store at least the exchangeable rear axle together with the connected electric engine while the other axle with the combustion engine is being used on the motor-

nungsmaschine wird so lange ungelöst bleiben, wie die Batteriespeicherkapazität nicht drastisch erhöht, das Batteriegewicht nicht gesenkt werden kann. Kleinwagenentwürfe wie der »Ecos« von Pininfarina (1978) sind perfekt schöne Minis mit immer gültigem Design, aber die Antriebstechnik versagt ihnen die Chance auf eine Verbreitung. Ein »Hotzenblitz« als gestylte Kapsel, ein Horlacher aus der Schweiz sind Ansätze, aber noch können sich die meisten Autobesitzer nicht allein für die Stadtfahrt ein Zweitauto leisten. Auch der Vorschlag von Opel, »Twin«, ein »One box«-Design von 1991, braucht eine winzige Garage, wo zumindest die austauschbare Hinterachse mit angekoppeltem Elektromotor so lange verbleibt, wie die andere mit Verbrennungsmotor gerade auf der Autobahn benutzt wird. Auf einem ähnlichen Konzept mit Hybridantrieb (feste Koppelung von E- und Verbrennungsmotor) basiert 1991 der VW »Chico«, doch das kurvenreiche Design bester Japanschule fällt stärker auf als

ques, de suralimentation par turbo-soufflante ou de grosses cylindrées: adieu la Mini. La technique est aujourd'hui au point, les petites voitures doivent, comme les grandes, satisfaire aux exigences écologiques. Les matériaux utilisés seront des métaux et des plastiques recyclables. Le problème du moteur à combustion ne sera pas réglé tant que la capacité de stockage de la batterie ne sera pas radicalement augmentée et que le poids de la batterie ne pourra être réduit. Les petites voitures comme l'«Ecos» de Pininfarina (1978) sont très belles et leur design toujours valable, mais leur technique ne leur laisse aucune chance de diffusion. Une «Hotzenblitz», capsule stylisée, ou une Horlacher suisse sont susceptibles d'être développées, mais la plupart des propriétaires de voiture ne peuvent pas encore s'offrir un second véhicule à fonction urbaine. Et la Twin de Opel, un design «one-box» de 1991, a besoin d'un garage minuscule où l'on puisse ranger l'essieu arrière équipé d'un moteur électrique pendant que l'autre,

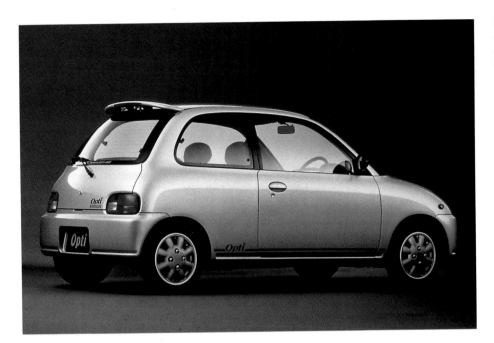

Daihatsu Opti
Japan
Japon, 1992
659 ccm, 40 PS

way. The hybrid-drive principle (i.e. a firm connection of electric and combustion engines) also formed the basis of the VW Chico of 1991, though the curved design – apparently inspired by Japanese designs – is far more conspicuous than the drive principle. And BMW's E1 of the same year proves that the characteristic BMW kidney shape, designed in Munich, also suits a small car. Regrettably, however, a year later, the Z13 study got stuck in a concept which tried to unite sports car aspirations for the chassis with the body of a small car, while at the same time implementing a seating arrangement for three persons that was far from new.

It seems that, at the beginning of the Nineties, the focus is now on playing with the design, though this is often so sophisticated that any mass production would send the prices up sky-high. Nicholas Hayek, Switzerland's »Mr. Swatch«, wants to apply the idea of colourful watches to minicars. But VW have already rejected the idea on the grounds that it would be too expensive and price such a car out of the market. They prefer their own Chico. In 1993, however, Mercedes expressed their interest in the »Swatch car« – a revolutionary change for this company which is now involuntarily beginning to consider minicars. Design colleges are currently offering more variants of small cars in their workshops and at international competitions than are produced by Japanese manufacturers every year. Fiat's Cinquecento proved that a single model can easily occur in many different types and shapes. The cream of Italian designers included everything, ranging from a little beach car to a minibus – fashionable, colourful and full of curves and pep. The outer

das Antriebskonzept. Und der »E1« von BMW aus demselben Jahr beweist, daß die BMW-Niere als Münchener Designleistung auch dem Kleinwagen steht. Man blieb aber leider ein Jahr später mit der Studie »Z 13« in einem Konzept stecken, das Sportwagenattitüden des Unterbaus mit einem Kleinwagenaufbau vereinen wollte bei einer Sitzanordnung für drei, die alles andere als neu war.

Offenbar wird zu Anfang der 90er Jahre beim Kleinwagen mit dem Design gespielt – zum Teil so aufwendig, daß beim Serienbau die Preise in unerschwingliche Höhen klettern würden. Der Schweizer »Mister Swatch« Nicholas Hayek will das Marketingkonzept für Buntuhren auf ein Miniauto übertragen. Unter anderem hat VW aus Kosten- und damit aus Preisgründen abgewunken, der eigene Chico wird bevorzugt. 1993 ist zu hören, daß – welche Wende – Mercedes, wo man eher unfreiwillig zum Nachdenken über Kleinstautos kam, Interesse am »Swatch-Auto« zeigt. Die Designschulen bieten in Workshops und bei internationalen Wettbewerben noch mehr Varianten an, als jährlich neue Kleinwagen aus Japan auf den Markt kommen. Wie typen- und formenreich allein ein Modell umgestrickt werden kann, bewies Fiat mit dem »Cinquecento«. Die besten italienischen Designer boten alles – vom Strandwägelchen bis zum Kleinbus, modisch kurvig, peppig, bunt. Die Hülle war wichtiger als die Minimierung eines Konzepts beim Respekt vor den ergonomischen Massen.

Wenn bei aller Spielerei der ernste Hintergrund nicht vergessen wird, daß der Mensch Maßstab ist, daß Antrieb und verarbeitete Materialien wiederverwendungsfähig werden müssen, daß die Emissionen

doté d'un moteur à combustion, roule sur l'autoroute. Le principe de la VW Chico de 1991 à traction hybride est semblable, mais sa carrosserie riche en courbes du meilleur design japonais est plus digne d'intérêt que sa technique. La E1 de BMW conçue la même année tendait à prouver que la marque munichoise sait aussi dessiner de petites voitures. Mais un an plus tard, l'étude Z 13 nous laisse patauger dans une conception manquant d'originalité, puisqu'elle combine un châssis faussement sportif à une carrosserie de petite trois-places.

En ce début des années 90, il est manifeste que dans le domaine de la petite voiture on joue avec le design, poussant ceci parfois si loin que les prix grimperaient à des hauteurs inaccessibles si la voiture était construite en série. Le Suisse Nicholas Hayek, le roi de la «montre Swatch», veut mettre sa conception du marketing au service d'une voiture miniature. VW a refusé son offre pour des raisons financières, elle préfère élaborer sa Chico. En 1993, on rapporte que Mercedes, qui a dû, involontairement il faut bien le dire, se pencher sur les voitures miniatures, s'intéresse à la voiture «Swatch». Les écoles de design présentent dans leurs ateliers et lors de compétitions internationales plus de créations que n'apparaissent chaque année de petites Japonaises sur le marché. Avec son Cinquecento, Fiat a montré la richesse potentielle d'un modèle. Les meilleurs designers italiens offrent tout ce qui est possible, de la voiturette de plage au minibus, tous leurs modèles ont des lignes rondes à la mode, du chien, de la couleur. La carrosserie est passée avant la minimalisation de la conception tout en respectant les volumes ergonomiques.

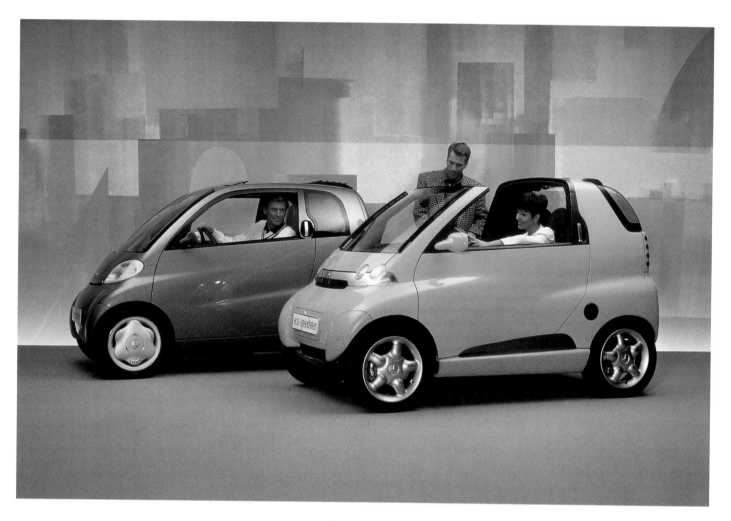

Swatch Car
Switzerland,
Schweiz, Suisse, 1994
Hybridmotor

clothing was more important than the minimization of the overall design in favour of ergonomic principles.

With all this playfulness, it is important to remember the serious background of small cars and the demand that man should always be the measure of all things: as the number of cars on the roads is unlikely to get any less, the engine and the material must be made reusable, and there must be a further reduction in emission, both in electric and combustion engines. If these aims are achieved, we will have made great strides. All that is missing will then be a little rethinking process in people's – usually men's – minds, so that any proven principles of small cars are propagated widely. The Mini is still a good example. More than 100 years after Karl Benz's invention a development along such lines might even herald a new era for the automobile.

von E- wie von Verbrennungsmotoren weiter reduziert werden müssen, daß Tempo 100 einzuführen auch in Deutschland keine Sünde mehr ist, weil die Zahl der Autos nicht sinken wird, dann sind wir schon einen großen Schritt weiter. Dann muß nur noch im (meist männlichen) Kopf ein Gedankengang so verlegt werden, daß inzwischen perfektionierte Kleinwagenkonzepte – der Mini ist immer noch Vorbild – wirklich zum Tragen kommen. So wird vielleicht ein Jahrhundert nach Herrn Benz wieder eine neue Ära des Automobils beginnen können.

Si ces petits jeux ne nous font pas oublier le sérieux du contexte, c'est-à-dire que l'on construit avant tout pour l'homme, que le moteur et les matériaux utilisés doivent être recyclables et les émissions des moteurs encore réduites – c'est un fait, le nombre de voitures ne diminuera pas – nous avons déjà fait un grand pas en avant. Il faut alors voir plus loin afin que des conceptions aujourd'hui perfectionnées de petites voitures – la Mini fait toujours fonction de modèle – portent vraiment leurs fruits. Peut-être assistera-t-on alors, plus d'un siècle après la découverte de Monsieur Benz, à l'apparition d'une nouvelle ère de l'automobile.

Adventurous Beginnings

Am Anfang war das Abenteuer

Des débuts mouvementés

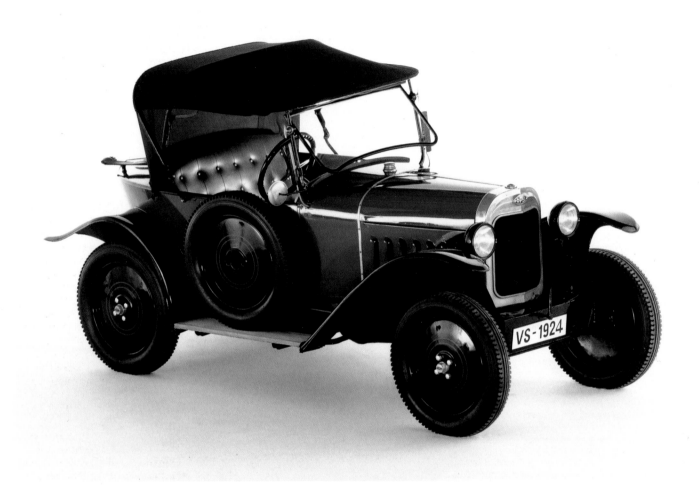

Opel 4/12, »Laubfrosch«, Germany, Deutschland, Allemagne, 1924

With 12 HP, 951 cc and a total weight of 1,322 pounds (600 kilograms), this car reached a maximum speed of 41 mph (66 km/h), using 6 litres of petrol per 100 kilometres (just over 2 UK gallons / 2½ US gallons per 100 miles). Because of its green colour and also its slightly jerky movement, it was nicknamed »tree frog«. Anyone in 1924, with 4,500 German marks to spare, could find out for themselves.

12 PS aus 951 Kubikzentimeter brachten 600 Kilogramm bis auf maximal 66 Kilometer pro Stunde bei einem Verbrauch von 6 Litern auf 100 Kilometern. Wegen der grünen Farbe, aber auch wegen der leicht hüpfenden Fahrweise bestand der Spitzname »Laubfrosch« völlig zu Recht. Jeder, der 1924 genau 4500 DM übrig hatte, konnte das nachprüfen.

La «rainette» était dotée d'un moteur de 12 CV et d'une cylindrée de 951 centimètres cube. Elle pesait 600 kilos et plafonnait à 66 kilomètres/heures. Consommation: 6 litres aux cent kilomètres. Son prix s'élevait à 4500 Marks en 1924. Sa couleur verte et son allure sautillante lui ont donné son nom.

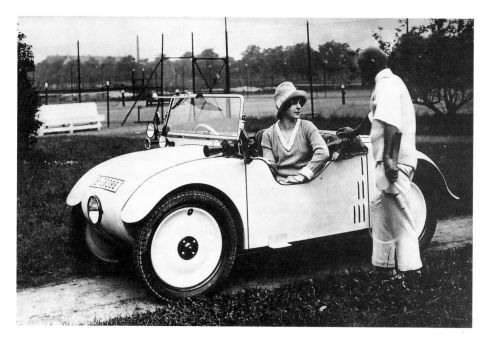

Hanomag 2/10 »Kommißbrot«, Germany, Deutschland, Allemagne, 1927

Less is more, said Mies van der Rohe. This is also true of the Hanomag Loaf. One central headlight (quite common in 1925 with unusual shapes of cars such as Rumpler's Drop Car), no door but a folded sheet of metal to help you get in, a one-sided curvature of the metal at the front, and four wheels – those were all the necessary ingredients. The illustration shows a two-seater sports car built in 1927/28. Its predecessor had been even more frugal, with a body that covered all four wheels so that no mudguards were necessary. Angular and with rounded edges – just like a loaf of German army bread.
Although the side view does not show it, the Hanomag was a mere 46½ inches (112 cm) wide, with a wheel gauge of 41 inches (104 cm) at the front and 35 inches (91 cm) at the back. Its crooked legs seem to declare, »I've got individually suspended wheels!« – a complete luxury at the time. Perhaps the 160,000 loaves were too good for the times. With a few changes, its classic form would still be attractive today.

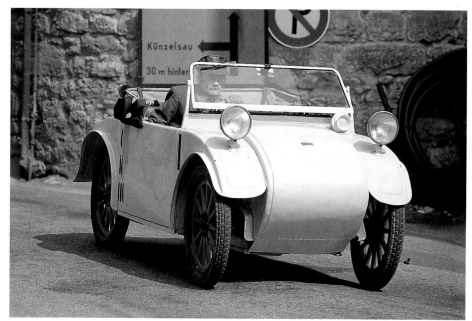

Weniger ist mehr, sagte Mies van der Rohe. Für den Hanomag Kommißbrot gilt dasselbe. Ein Zentralscheinwerfer, damals, 1925, nicht ungewöhnlich bei ungewöhnlichen Formen wie z. B. Rumplers Tropfenwagen, die fehlende Tür mit dafür angebotenem Winkelblech als Einstiegshilfe, die einseitig gekrümmte Blechfläche der Front, vier Räder, das genügt. Im Bild der Sport-Zweisitzer des Baujahrs 1927/28. Der Vorgänger war noch frugaler, weil die Karosserieform alle Räder überdeckte und so auf Kotflügel verzichten konnte. Eckig und rundlich zugleich – wie ein Kommißbrot. Die Seitenansicht verrät es nicht, der Hanomag war tatsächlich nur 118 Zentimeter breit, die Spurweite betrug vorn 104 Zentimeter, hinten 91 Zentimeter. Und die schiefen Beine erklären: Ich habe einzeln aufgehängte Räder. Für diese Zeit absoluter Luxus in dieser Klasse. Vielleicht waren die 160 000 gebackenen Kommißbrote zu gut für ihre Zeit. Diese klassische Form könnte sich mit Anpassungen problemlos bis heute sehen lassen.

«Moins, c'est davantage», disait Mies Van der Rohe. C'est aussi la philosophie des pères du «pain boule». Un phare central, rien d'inhabituel à l'époque, si l'on songe par exemple à la voiture en forme de goutte de Rumpler, pas de portière mais une tôle coudée en guise de marche-pieds, le capot arrondi à l'avant, quatre roues, ça suffit. Dans l'idée des sportives biplaces construites en 1927/1928. Le modèle antérieur était encore plus sobre, car la carrosserie recouvrait les roues et on pouvait ainsi renoncer aux ailes. Elle était à la fois anguleuse et ronde... comme un pain boule.
La Hanomag n'avait que 118 centimètres de largeur, sa voie avant était large de 104 centimètres, sa voie arrière de 91 centimètres. Ses jambes torses nous rappellent sa suspension à quatre roues indépendantes: le comble du luxe à l'époque dans cette catégorie. Cette forme classique, dûment adaptée, ne nous choquerait pas aujourd'hui.

Austin Seven Swallow, Great Britain, England, Angleterre, 1927

There is a touch of elegance about the Austin Seven Swallow of 1927. The first Sevens, in 1922, were sold with braked wheels – a feature that was by no means standard at the time.

Elegant, elegant, der Austin Seven Swallow von 1927. Die ersten Seven kamen schon 1922 mit vier gebremsten Rädern auf den Markt. Damals war das durchaus keine Selbstverständlichkeit.

L'Austin Seven Swallow de 1927: l'élégance sur quatre roues. Les premières Seven possédaient en 1922 des freins sur les quatres roues, une exception à l'époque.

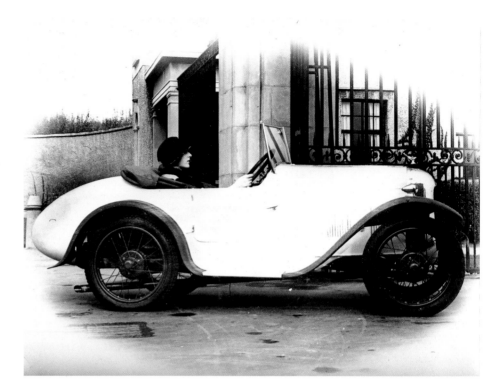

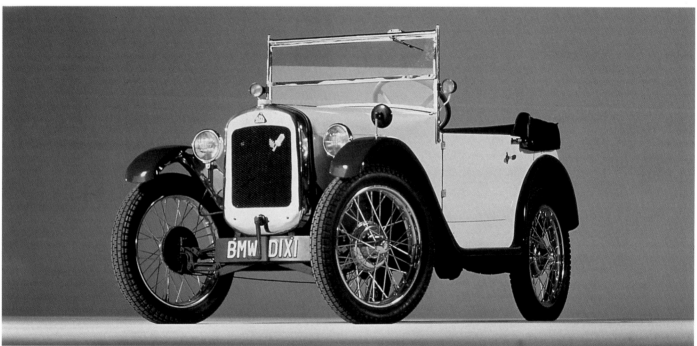

BMW Dixi, Germany, Deutschland, Allemagne, 1928

This car has nothing to do with Jazz, but with the licence to copy the Austin Seven in Eisenach from 1927 to 1929. Cars called Dixi had been around in Eisenach as early as 1904. The Dixi plant was bought up by BMW in 1928, which is why BMW-like cars were manufactured under the East German regime in postwar Eisenach. The successor of the Dixi, the BMW 3/15 HP, carried the advertisement: »Smaller inside than outside«. This slogan became a general motto for everyone building small cars and wanting to sell cars with a good sales argument. The Dixi was available in a number of variations: as an open two-seater, a four-seater touring car, a saloon and a coupé. The illustration shows a two-seater, still without the BMW logo.

Dieses Auto hat nichts mit Jazz zu tun, sondern mit der Lizenz zum Nachbau des Austin Seven von 1927 bis 1929 in Eisenach. Den Namen Dixi trugen schon 1904 Autos aus dieser Stadt. 1928 gingen die Werke an BMW, deshalb kamen auch noch nach dem Zweiten Weltkrieg zu DDR-Zeiten Autos aus Eisenach, die einem BMW ähnelten. Der Dixi-Nachfolger als BMW 3/15 PS warb so: »Innen kleiner als außen«. Das wurde zum allgemeingültigen Motto für alle, die kleine Autos bauen und argumentativ vermarkten wollten. Den Dixi gab es vielseitig: als offenen Zweisitzer, als viersitzigen Tourer, als Limousine und als Coupé. Das Bild zeigt den Zweisitzer, noch ohne BMW-Logo.

Cette voiture n'a rien à voir avec le jazz. Reproduction de l'Austin Seven, elle fut construite sous licence de 1927 à 1929 à Eisenach. En 1904, des voitures portaient le même nom dans cette ville. BMW acheta les usines en 1928 et c'est la raison pour laquelle des voitures construites à Eisenach en Allemagne de l'Est après la Seconde Guerre mondiale ressemblaient encore à une BMW. Publicité de la BMW 3/15 CV, successeur de la Dixi: «Plus petite à l'intérieur qu'à l'extérieur.» Cela devint l'argument de vente de tous les constructeurs de petites voitures. La Dixi était livrable en tant que deux-places découverte, sportive à quatres places, berline et coupé. L'illustration montre la biplace qui ne porte pas encore l'emblème BMW.

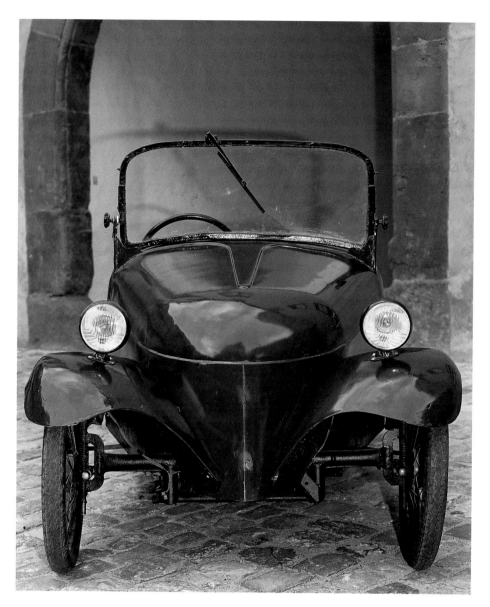

Mochet 100, France, Frankreich, 1948

Do you remember Monsieur Hulot on his famous holiday, terrorizing the French coast, banging and clattering along the promenade in his jalopy? It was probably very similar to this little French Mochet 100 of 1948 – a car that is truly timeless, with a simple design that might easily have started its career as a cycle car in 1925.

War es nicht Monsieur Hulot, der in seinen Ferien an der Küste mit einem knallend knatternden Winzling die Promenadenstraße unsicher machte? So ähnlich jedenfalls muß er diesem kleinen französischen Mochet 100 von 1948 gesehen haben. Das Zeitlose an dem Wägelchen: Es hätte auch schon 1925 als Cyclecar Karriere machen können, so primitiv war sein Konzept.

On se souvient de Monsieur Hulot en vacances sur la côte et sévissant sur les routes au volant d'une toute petite voiture toussotante et pétaradante. C'est l'image qu'évoque en tous cas la petite Française Mochet 100 de 1948. Elle est si primitive qu'elle pourrait aussi bien dater de 1925. Une intemporelle en quelque sorte.

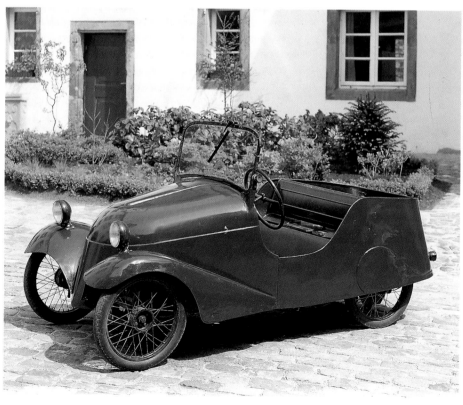

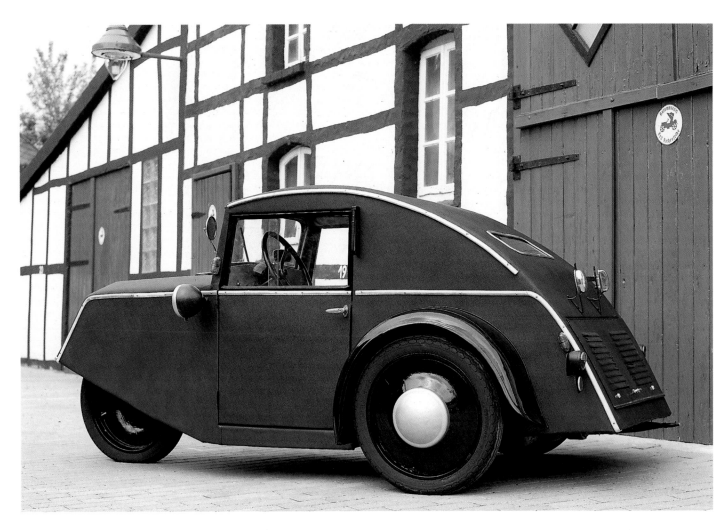

Goliath Pionier, Germany, Deutschland, Allemagne, 1934

It seems amusing that a small car should be called Goliath – though for a »Pioneer« this is a different matter. The 1934 body is pleasantly smooth, with a curved back that is almost elegant. A pity that the front windscreen is not a little more at an angle. The position of the driver's seat and a fairly high steering wheel betray the lack of space inside the car. Built for the first time in 1931, the Pioneer was 122 inches (310 cm) long and had a rear engine, proving that the three-wheel design was perhaps less compact than it seemed.

Ein Kleinwagen mit dem Namen Goliath – aber für einen »Pionier« relativiert sich die Sache. Die Karosserie von 1934 war erfreulich glattflächig, fast schon elegant der Rückenschwung, schade, daß die Frontscheibe nicht etwas schräger stand. Die Fahrerhaltung verrät eine gewisse Enge im Innenraum und ein hochstehendes Lenkrad. Der seit 1931 gebaute Wagen bewies mit 310 Zentimetern Länge und Heckmotor, daß dieses Dreiradkonzept vielleicht doch nicht so kompakt war.

Un nom bien ronflant pour une petite voiture, mais le terme «pionnier» l'atténue. La carrosserie de 1934 était agréablement lisse, son galbe presque élégant, dommage que le pare-brise n'ait pas été plus incliné. L'habitacle était étroit et le volant haut placé. Ce tricycle à moteur arrière, construit à partir de 1931, mesurait 310 centimètres, ce qui prouve que ce genre de voiture n'était pas si compact que cela.

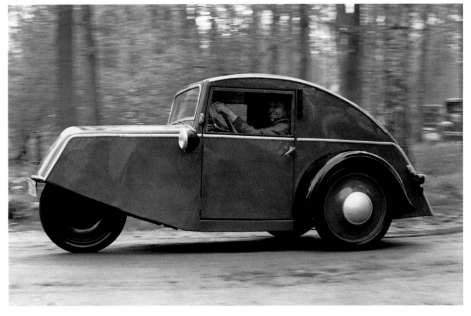

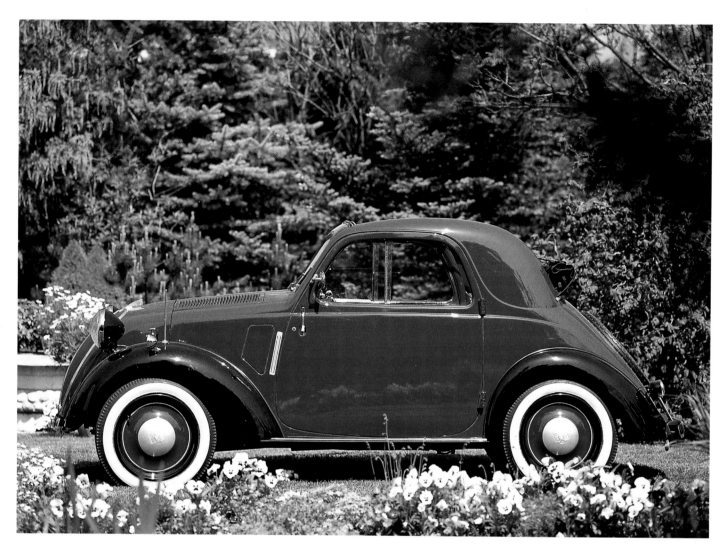

Fiat Topolino, Italy, Italien, Italie, 1936

Ten years had elapsed between the Dixi and this »little mouse« from Italy, the Fiat Topolino of 1936. It had an allsteel body and enough space for two adults and two children. Small cars of this generation did not yet have that typical compactness of the engine and the drive. They were still miniature cars. To save weight, manufacturers would put holes in the frame, though without reducing its solidness.

Zehn Jahre liegen zwischen einem Dixi und diesem »Mäuschen«, dem Topolino von Fiat aus Italien (1936). Eine Ganzstahlkarosse bot Platz für zwei Erwachsene und zwei Kinder. Kleinwagen dieser Generation wiesen noch nicht die typischen Kompaktbauweisen von Motor und Getriebe auf, sie waren eben nur kleine Autos. Um Pfunde zu sparen, wurde der Rahmen gelöchert, ohne ihm die Festigkeit zu rauben.

Dix années séparent la Dixi de la Topolino créée par Fiat en 1936. La carrosserie d'acier pouvait abriter deux adultes et deux enfants. Les petites voitures de cette génération ne connaissaient pas encore le mode de construction compacte moteur/boîte de vitesses, elles n'étaient que des voitures en miniature. Le châssis était percé de trous, pour être léger tout en restant stable.

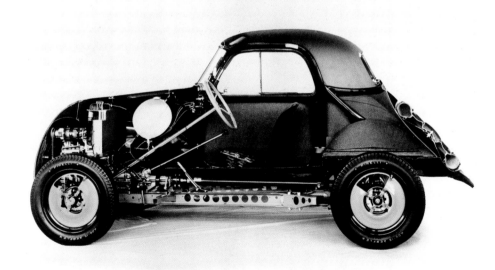

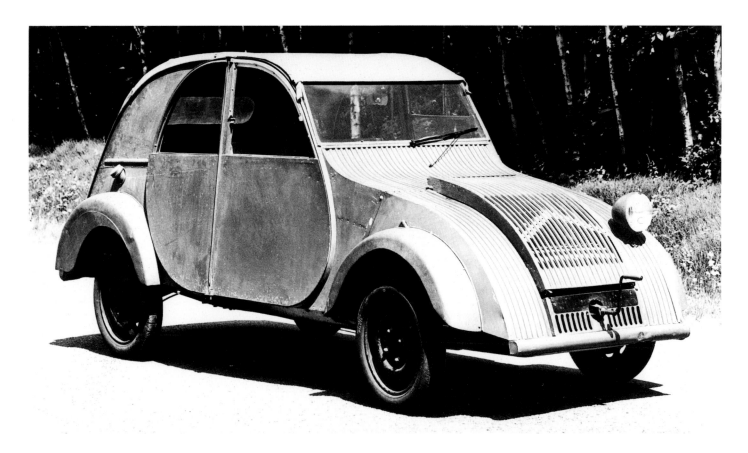

Citroën 2 CV, France, Frankreich, 1936

Like the Topolino, this mother of all ducks was born in 1936. Citroën had proved to be extremely consistent. French small cars had always been dwarfs with regard to their cubic capacity, though not their internal space, and the Renault 4 CV was an exception. The crank at the front was not part of the original plan. The lack of power was compensated for by a piece of cord wound round a disc on the engine shaft, requiring a sharp tug. The single headlight, screwed asymmetrically onto the corrugated steel, made it seem as though the duck had only one eye. Nevertheless, the overall idea survived until 1990, because the Duck had the same »animal strength« as the Beetle.

Die Urente stammt wie der Topolino aus dem Jahr 1936. Citroën bewies extreme Konsequenz. Schon immer waren französische Kleinautos eher Hubraum- als Innenraumzwerge gewesen, mit Ausnahme des Renault 4 CV. Die Kurbel am Bug war ursprünglich nicht gewollt; eine Schnur, um eine Scheibe auf der Motorwelle gewickelt, sollte bei kräftigem Zug die wenigen PS munter machen. Und der einzelne Scheinwerfer, asymmetrisch aufs Wellblech geschraubt, läßt die Ente schon einäugig wirken. Das Gesamtkonzept konnte sich bis 1990 halten, denn die Ente hatte »tierische« Qualitäten wie der Käfer.

Comme la Fiat Topolino, la 2 CV date de 1936. Citroën fit preuve d'esprit de décision. Les petites voitures françaises s'étaient jusque-là plus distinguées par la petitesse de leur cylindrée que par celle de leur habitacle, avec exception de la Renault 4 CV. Au départ, la manivelle n'était pas prévue, mais une ficelle entourant une plaque sur l'arbre du moteur et qu'il suffisait de tirer d'un coup sec. Le phare unique, vissé à gauche sur la tôle ondulée, fait de la «Deuch» une voiture borgne. La 2 CV a survécu jusqu'en 1990, car, comme la Coccinelle de Volkswagen, elle avait d'énormes qualités.

Datsun Typ 14, Japan, Japon, 1935

This Japanese company, with the rising sun in their logo, mainly built utility vehicles. Their first attempt to establish themselves in the private automobile market was the Type 14 Roadster of 1935. Variations that were inspired by European cars – e.g. the Topolino – continued to be built after the war.

Die japanische Marke mit der aufgehenden Sonne im Firmenzeichen, Datsun, baute vornehmlich Nutzfahrzeuge. Erster Versuch im PKW-Bereich war der 1935 vorgestellte Typ 14 Roadster. Noch nach dem Krieg wurde er, europäisch inspiriert – siehe Topolino –, in Varianten gebaut.

Datsun, la marque à l'emblème du Soleil levant, fabriquait surtout des véhicules utilitaires. Le type 14 Roadster est sa première tentative dans le domaine des voitures de tourisme. S'inspirant des voitures européennes (par exemple la Topolino), il fut fabriqué jusqu'après la guerre en plusieurs versions.

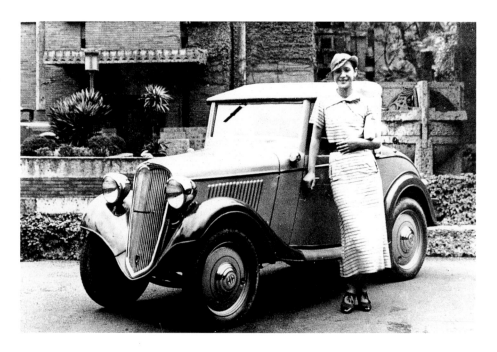

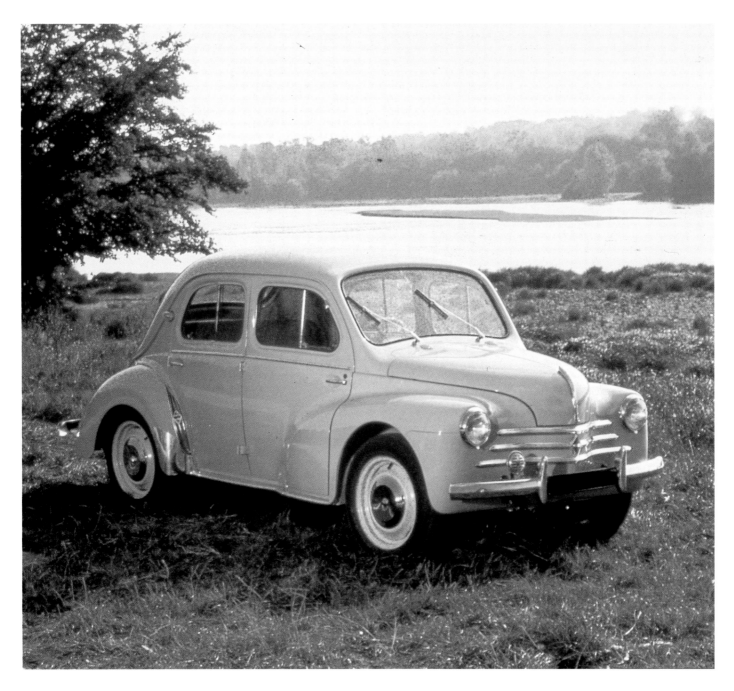

Renault, France, Frankreich, 1942

The precursors of this French classic among small cars between 1942 and 1943 were far more rounded at the front and rear and therefore quite similar to the first prototypes of the German Beetle. This was partly due to details such as the strikingly rounded windows in the allsteel doors. The self-bearing body was a totally new concept. With its chromium strips at the front, it seemed to negate the fact that the engine was situated at the back and that it could only get its air through the rear mudguards to achieve 59 mph (95 km/h). When production finally ceased in 1961, it had been built over a million times. Hino in Japan were sufficiently impressed with its quality and small size to manufacture it under licence.

Die Vorläufer dieses französischen Klassikers unter den Kleinen hatten, weil an Bug und Heck wesentlich rundlicher, zwischen 1942 und 1943 viel Ähnlichkeit mit den ersten Prototypen des deutschen Käfers, schon wegen solcher Details wie den kräftig gerundeten Fensterausschnitten in den Vollblechtüren. Modern im Konzept war die selbsttragende Karosserie. Sie negierte mit ihren Chromstreifen am Bug die Tatsache, daß der Motor hinten saß und seine Atemluft an den Kiemen der hinteren Kotflügel ansog, wenn er 95 Kilometer pro Stunde schaffen wollte. Nach Produktionsende 1961 war er mehr als eine Million Mal gebaut worden. Hino in Japan fand ihn gut und klein genug für eine Lizenzproduktion.

Les prédécesseurs de cette classique petite voiture française avaient entre 1942 et 1943 une grande ressemblance avec les premières Coccinelles, à cause par exemple des fenêtres arrondies découpées dans les portières de tôle pleine. La caisse monocoque était de conception moderne. Les bandes chromées sur le capot font oublier que le moteur, plafonnant à 95 kilomètres à l'heure, était derrière et aspirait de l'air par les ouvertures pratiquées à la base des ailes arrière. Jusqu'en 1961, on en construisit plus d'un million d'exemplaires. Le Japonais Hino la trouva assez bonne et assez petite pour la construire sous licence.

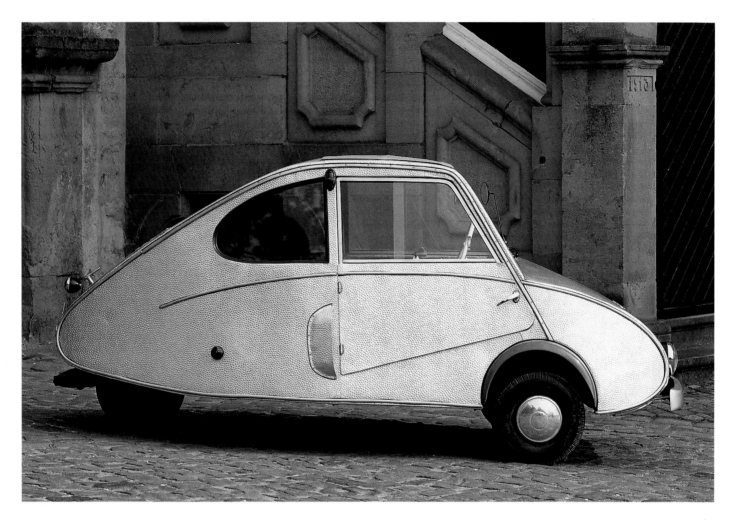

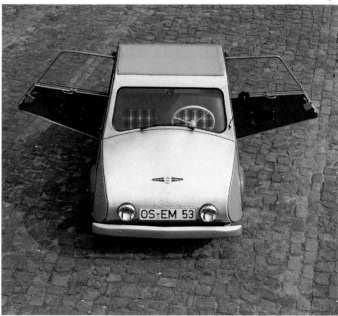

Fuldamobil N-2, Germany, Deutschland, Allemagne, 1952

The Fuldamobile – here version N-2 (1952–1955) – had undergone continuous refinement in its body and technology from the very beginning. Like the Lloyd 300, the »Leukoplastbomber« (sticking plaster bomber), it started off with a plywood body covered with imitation leather which had been easier to make because of its smooth surface. This was then clothed in aluminium and finally a layer of fibre glass. There were a large number of models, including a roadster version.

Beim Fuldamobil – hier die Version N-2 (1952–1955) – wurden seit Produktionsbeginn Karosserie und Technik immer weiter verfeinert. Das Auto hatte zunächst wie der Leukoplastbomber Lloyd 300 eine Hülle aus kunstlederbespanntem Sperrholz, die wegen der glatten Flächen einfacher herzustellen war, und wurde dann mit Hammerschlagalublech und schließlich mit Kunststoffhaut eingekleidet. Es gab eine große Modellvielfalt, selbst eine Roadsterversion war machbar.

La carrosserie et la technique de la Fuldamobil – ici la version N-2 (1952–1955) – ont fait dès le départ l'objet d'améliorations constantes. A l'origine, la carrosserie était, comme celle du «bombardier en sparadrap» Lloyd 300, une structure de contre-plaqué recouverte de cuir synthétique, lisse donc facile à fabriquer. Plus tard elle fut recouverte de tôle d'aluminium martelée et enfin de matériel synthétique. Elle était livrable en de nombreuses versions, dont un roadster.

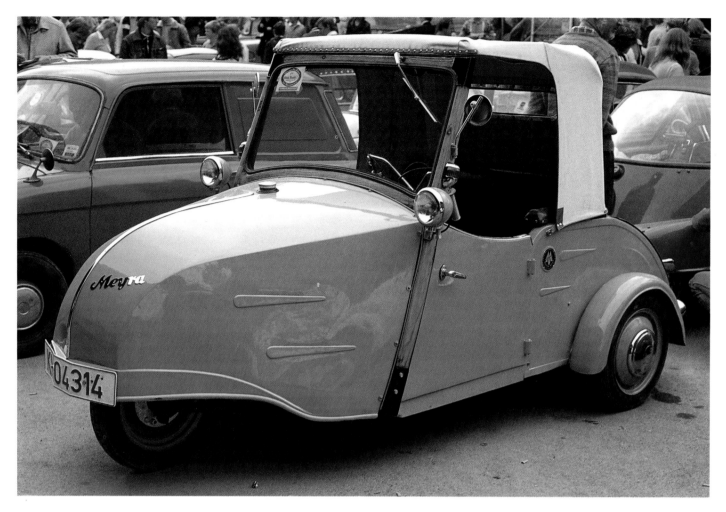

Meyra 55, Germany, Deutschland, Allemagne, 1950

Like Gutbrod, the manufacturers of this tin-clad three-wheeler with a folding roof are still alive today. Meyra, a company that was well-versed in the production of vehicles for the disabled, tried to exploit the post-war motoring boom for themselves. Adding a little more tin and technology, they came up with the Meyra 55 in 1950. The first version still had a canvas door.

Wie Gutbrod, so lebt auch der Hersteller dieses Dreirades mit Blechhaut und Klappdach noch heute. Die Firma Meyra, versiert im Bau von Behindertenfahrzeugen, versuchte, den Motorisierungsboom nach dem Zweiten Weltkrieg auch für sich zu nutzen. Mit etwas mehr Technik und Blech versehen, entstand 1950 dieser Meyra 55, in der ersten Version noch mit segeltuchbespannter Tür.

Le constructeur de ce tricycle à la carrosserie de tôle et au toit pliant est encore en vie. La firme Meyra, spécialiste de véhicules pour handicapés, essaya après la guerre de profiter de l'essor des voitures à moteur. Cette Meyra 55 vit le jour en 1950, la première version était dotée d'une portière tendue de toile.

Meyra 200-2, Germany, Deutschland, Allemagne, 1955

To avoid the poor quality of the three wheels, Meyra should have produced fewer models and put more emphasis on form with the Meyra 200–2 of 1955. Using fibre glass for the body made it easier to produce a chubby front than with metal.

Die Firma Meyra hätte weniger auf Modellvielfalt setzen und statt dessen mehr auf die Form achten müssen, dann wäre die Gestaltung der drei Räder weniger schlecht ausgefallen als bei dem 200–2 von 1955. Bei dieser Kunststoffkarosserie ließ sich die plumpe Front leichter als in Blech verwirklichen.

Si la firme Meyra avait accordé plus d'attention aux formes qu'au nombre de versions, le tricycle à moteur 200–2 de 1955 aurait été moins vilain. La carrosserie est en plastique, car la partie avant grossière était plus facile à fabriquer en plastique qu'en tôle.

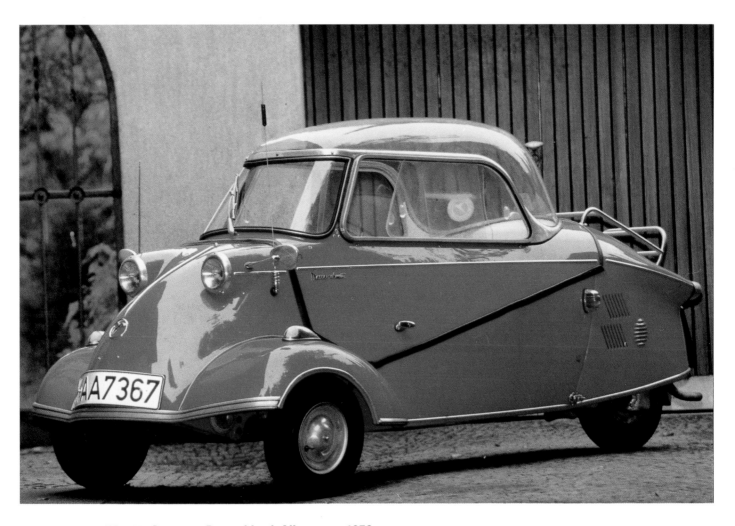

Messerschmitt KR 200, Germany, Deutschland, Allemagne, 1956

Originally designed by Fend, this three-wheeler did extremely well on the market. Dubbed »Snow White's Coffin«, the first version had a motor-bike handlebar and no recesses in the front mudguards. Sold as a »motor scooter with a roof«, the first model, KR 175, sold 19,668 times. The KR 200 (see illustration) sold 20,840 times from February to December 1956. Due to financial difficulties, the car engineering operations of Messerschmitt changed hands, and the model was called FMR. Interestingly, the reverse gear involved electric change-over ignition, so that, theoretically, all its gears were available up to the maximum speed of 60 mph (100 km/h).

Ursprünglich ein Konzept des Herstellers Fend, machte dieses Dreirad eine echte Karriere. Der »Schneewittchensarg« hatte in der ersten Version keine Ausschnitte in den vorderen Kotflügeln und einen Motorradlenker. Dieser »überdachte Motorroller«, so der werbliche Auftritt, kam als erstes Modell KR 175 auf 19 668 verkaufte Exemplare. Der KR 200 (Bild) wurde von Februar bis Dezember 1956 genau 20 840 Mal verkauft. Nachdem der Messerschmitt-Fahrzeugbau aufgrund finanzieller Schwierigkeiten den Besitzer gewechselt hatte, hieß das Modell fortan FMR. Eine Kuriosität: Das Rückwärtsfahren wurde durch elektrische Zündumschaltung gesichert. So konnten theoretisch alle Gänge bis zur Höchstgeschwindigkeit von 100 Kilometern pro Stunde ausgedreht werden.

A l'origine une idée du constructeur Fend, ce tricycle fit une belle carrière. La première version du «cercueil de Blanche-Neige» n'avait pas d'échancrures dans les ailes avant et un guidon de motocyclette. On vendit 19 668 exemplaires de la première version KR 175 du «scooter à toit», ainsi que le désignait la publicité. La KR 200 (illustration) fut vendue exactement 20 840 fois de février à décembre 1956. Les usines Messerschmitt changèrent ensuite de propriétaire et le modèle devint la FMR. Une curiosité: la marche arrière était assurée par commutation de l'allumage. On pouvait théoriquement couper toutes les vitesses jusqu'à la vitesse maxi de 100 kilomètres à l'heure.

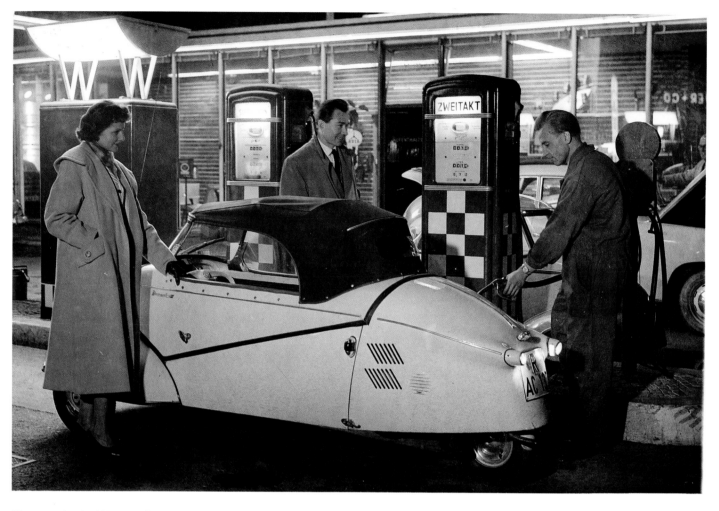

Messerschmitt KR 201, Germany, Deutschland, Allemagne, 1956

This picture is more realistic than a reader today might think. The Messerschmitt as a convertible was indeed slightly exotic, and there was nothing shabby about it – despite the dowdiness of the people shown here. And lubricated petrol was available straight from the petrol pump, pre-mixed and ready for use.

Das Bild ist realistischer, als der Betrachter heute vermutet. Der Messerschmitt als Cabrio wie hier war schon leicht exotisch und wirkte gar nicht ärmlich – wie die Dame und der Herr. Und Zweitaktgemisch konnte man noch an der Säule tanken, schon fix und fertig vorgemischt.

La photographie est plus réaliste qu'il n'y paraît aux yeux du spectateur aujourd'hui. Le Messerschmitt Cabrio que nous voyons ici avait une allure exotique et pas du tout médiocre – comme le couple. Les stations-service offraient déjà un mélange tout prêt pour les moteurs à deux temps.

Getting into the cabin scooter was like boarding a fighter aeroplane, with the co-pilot sitting in the back. The view of the road was not dissimilar to the view from a Formula 1 racing car, and the car was about as spacious as a bath-tub.

Der Einstieg in den Kabinenroller erfolgte wie beim Jagdflugzeug, der Co-Pilot saß hinten. Die Sicht auf die Straße war der aus einem Formel 1-Rennwagen nicht unähnlich, es herrschten Platzverhältnisse wie in der heimischen Badewanne.

On entrait dans cette voiture comme dans un avion de chasse, le copilote étant assis à l'arrière. La visiblité ressemblait à celle d'une voiture de course Formule 1 et pour ce qui ait de la place, on se serait cru dans une baignoire.

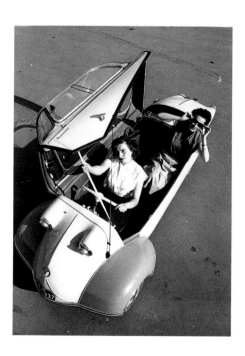

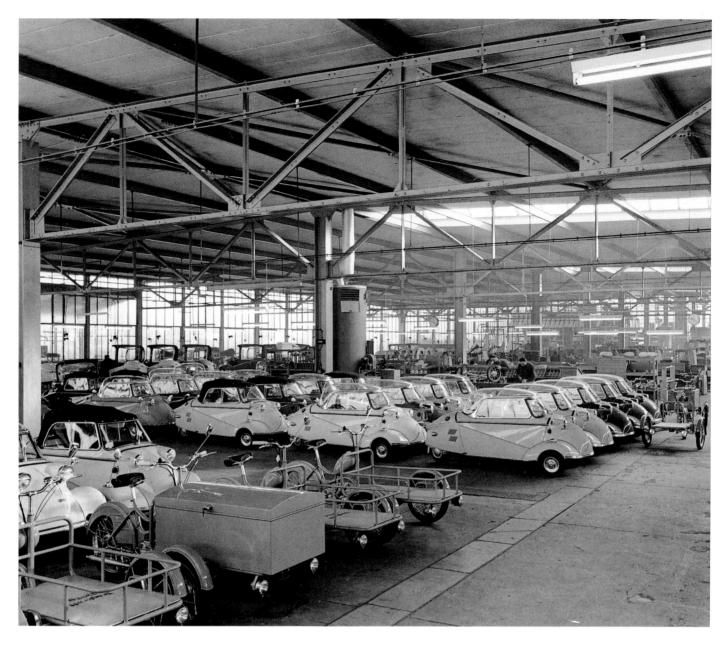

Messerschmitt Regensburg, Germany, Deutschland, Allemagne, ca. 1956

A rare view – a row of convertible Snow White's Coffins, ready for delivery and complete with plexiglass cabins. The other, moped-based, three-wheelers were largely used by the German Post Office and occasionally also, with closed boots, by magazine subscription companies.

Ein seltenes Motiv, die fertig zur Auslieferung aufgereihten Schneewittchensärge, mit Plexiglaskanzel und als Cabrio. Die anderen Dreiräder auf der Basis von Mopeds waren vorzugsweise bei der Post im Einsatz – und manchmal sah man auch solche mit dem geschlossenen Koffer als Lieferwägelchen der Lesezirkel.

Les «cercueils de Blanche-Neige», avec cockpit en plexiglas ou en version cabriolet, prêts à la livraison: un motif rare. Les autres tricycles, basés sur des vélomoteurs étaient surtout utilisés par la Poste. Les cercles de lecture les utilisaient quelquefois en version à coffre pour livrer leurs magazines.

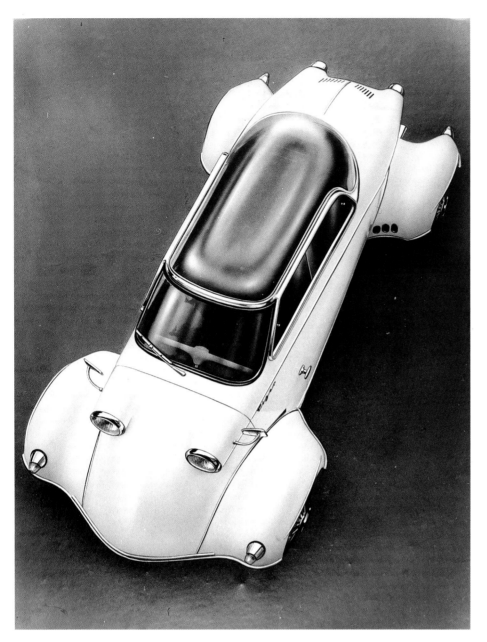

Messerschmitt TG 500, Germany, Deutschland, Allemagne, 1957

This rocket – now on four wheels – celebrated its launch at the 1957 International Automobile Exhibition in Frankfurt. Not only did the two-cylinder two-stroke engine splutter in a more mellow tone of voice; with its 20 HP, it now sought its peers among semi-luxury vehicles. The last three cars of this type were built in 1964. Note the three little air holes in the rear mudguard – a little extravagance you would normally find on the side of a Buick.

Auf der IAA 1957 in Frankfurt/Main feierte diese Rakete auf nun vier Rädern Premiere. Der Zweizylinder-Zweitakter brabbelte nicht nur sonorer, sondern gab mit seinen 20 PS nun auch nur noch der gehobenen Mittelklasse eine Chance mitzuhalten. 1964 wurden die letzten Exemplare gebaut. Man achte auf das Detail der drei kleinen Luftlöcher am hinteren Kotflügel. So etwas trug ein Buick »just for fun« an den Flanken.

Cette fusée sur quatre roues fêta sa sortie au Salon de l'Automobile (IAA) de Francfort en 1957. Le moteur à deux temps et deux cylindres n'était pas seulement plus bruyant, mais ses 20 CV lui permettaient maintenant aussi de se mesurer aux voitures de catégorie moyenne. Les dernières sont sorties des chaînes de fabrication en 1964. On observera les trois petits trous d'aération sur les ailes arrière. Une Buick portait les mêmes sur ses flancs, pour des raisons purement esthétiques.

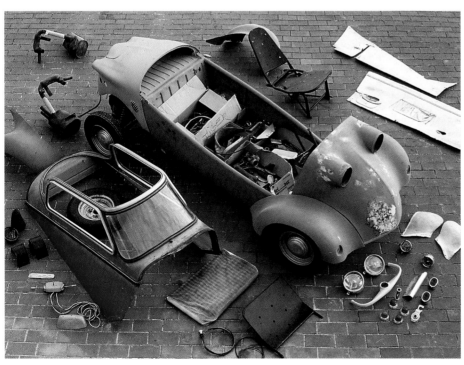

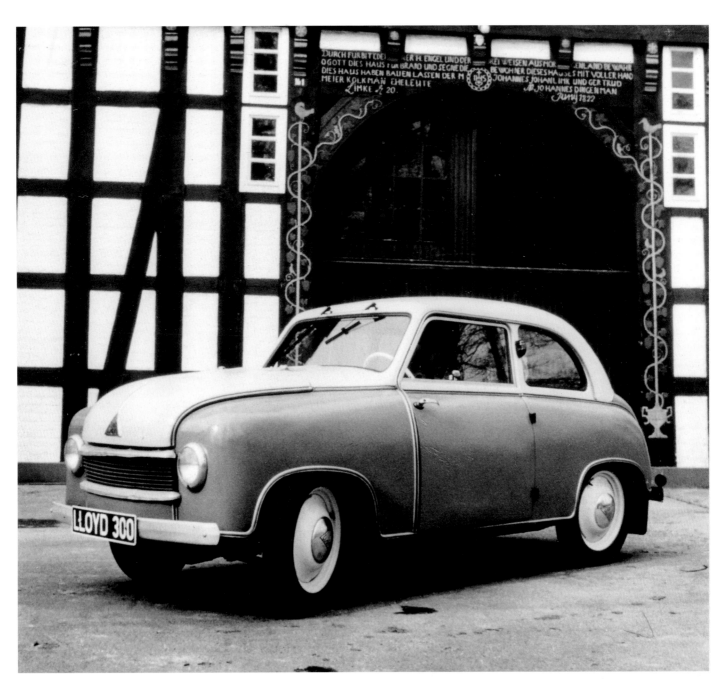

Lloyd LP 300, Germany, Deutschland, Allemagne, 1950

And why not indeed? Mr. Borgward succeeded in reducing the pontoon shape of these large cars from Bremen to a mere 126 inches (320 cm). The central tube framework was borne by a wooden frame, covered with plywood and imitation leather. The total weight was 1,058 lbs (480 kg). Blue flags announced a 293 cc two-stroke engine. The German authorities were happy to accept no more than a single indicator on either side of the car, in the middle. The price of the car in 1950 was DM 3,334.

Doch, es geht. Herr Borgward war in der Lage, die Pontonform der großen Autos aus Bremen auch auf 320 Zentimeter Gesamtlänge zu reduzieren. Der Zentralrohrrahmen trug ein Holzgerippe, das mit kunstlederbezogenem Sperrholz verkleidet war. Gesamtgewicht: 480 Kilogramm. Blaue Fahnen kündeten von 293 zweitaktenden Kubikzentimetern. Der Gesetzgeber begnügte sich, wie bei vielen Kleinautos, mit einem Blinker in der Mitte auf jeder Wagenseite. Für den Preis von 3334 DM war er 1950 zu erwerben.

Le constructeur Borgward réussit à réduire la longueur des grandes voitures de Brême à 320 centimètres. Le châssis en tube central portait une structure en bois revêtue de contre plaqué tendu de cuir synthétique. Poids total: 480 kilogrammes. Moteur à deux temps, cylindrée: 293 centimètres cube. A l'époque, la législation se contentait pour les petites voitures de clignotants latéraux. En 1950, la Lloyd 300 coûtait 3334 Marks.

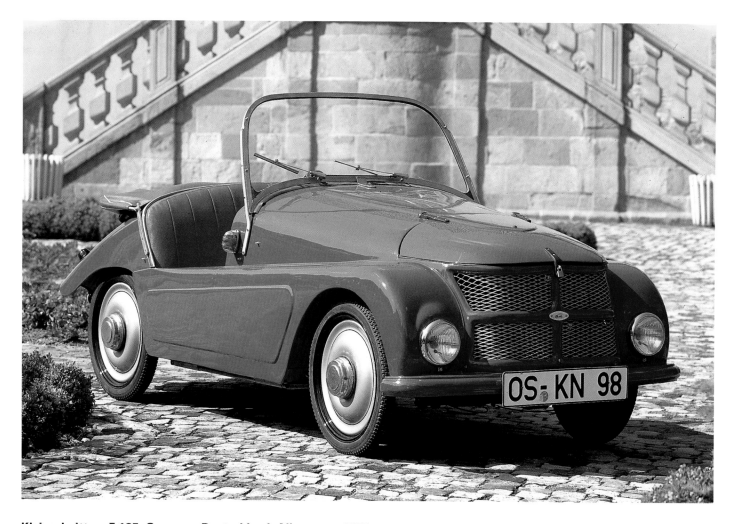

Kleinschnittger F 125, Germany, Deutschland, Allemagne, 1950

No, this is not a pedal car. It is the Kleinschnittger F 125, a vehicle that was bought by 2,980 motorists between 1950 and 1957 and whose aspirations never went beyond the role of a macintosh on wheels, 114 inches (2,895 mm) long, 46 inches (1,180 mm) wide and 5 HP strong. Its designer also tried his hand at making »real« cars – beautifully styled compact coupés, which were never mass-manufactured. The F 125, on the other hand, seemed more like an English Morgan made for the man in the street.

Das ist kein Tretautochen, sondern als Kleinschnittger F 125 ein Fahrzeug, das von 1950 bis 1957 für 2980 Käufer nichts weiter sein wollte als ein vierrädriges Regencape von 2895 Millimetern Länge, 1180 Millimetern Breite und 5 PS. Sein Erbauer wagte sich auch an »richtige« Autos, an formschöne Kompaktcoupés; sie blieben Einzelanfertigungen. Der F 125 wirkte derweil wie ein englischer Morgan für den kleinen Mann.

Ce n'est pas une voiture à pédales mais une Kleinschnittger F 125, un véhicule qui, de 1950 à 1957 et pour 2980 acheteurs, ne voulait être rien d'autre qu'un imperméable à quatre roues de 2895 millimètres de long, 1180 millimètres de large et 5 CV. Son constructeur se risqua aussi à fabriquer de «vraies» voitures, des coupés compacts et élégants, qui restèrent des pièces uniques. La F 125: des airs de Morgan anglaise pour l'homme aux petits moyens.

The Kleinschnittger was seen as an ideal minicar: it was light and simple. The metal was aluminium, the design of the chassis simplicity itself, and the tyres so narrow that the problem of aquaplaning never arose at all. But if your entire car weighed no more than 37 lbs (17 kg), it could easily happen that someone just carried it off.

Wie ein Kleinschnittger, so sollten Kleinstwagen sein: leicht und einfach. Das Blechkleid in Alu, das Fahrgestell so einfach wie möglich konstruiert. Schmalste Reifen kennen kein Aquaplaningproblem. Aber dem, dessen Auto fahrbereit 17 Kilogramm wog, konnte schnell ein Streich gespielt werden: Man trug das Wägelchen einfach weg.

Les voitures miniatures devraient être comme une Kleinschnittger: légère et simple. La carrosserie en aluminium, le châssis le plus sobre possible. Les pneus étroits ne craignent pas l'aquaplaning. Mais avec une voiture qui ne pèse que 17 kilos, on est facilement victime de plaisantins qui l'emportent avec eux.

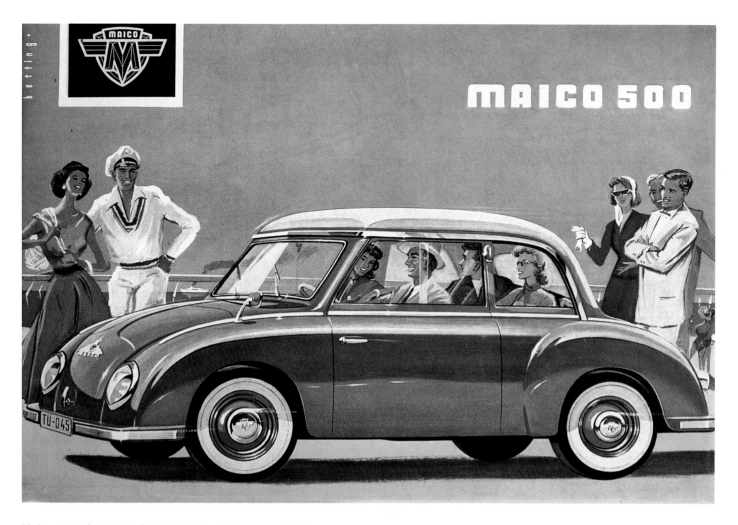

MAICO 500

Maico 500, Germany, Deutschland, Allemagne, 1956

The Maico 500 was originally a convertible and even more rounded than a Gutbrod which it otherwise resembled. Before it was bought up by a different company, it was called Champion. With a mere 15 HP, the engine of the saloon was at first rather too weak, and later – when it had become stronger – too noisy. White-wall tyres and an overall length of 135 inches (342 cm) provided some consolation. The car sold 6,300 times between 1956 and 1958.

Der Maico 500 war einst eine Cabriolimousine, noch runder als ein Gutbrod, dem er ansonsten recht ähnlich sah, und hieß vor dem Aufkauf Champion. Die Limousine litt zunächst mit 15 PS an Untermotorisierung, und später – mit stärkerer Maschine – störte ein lautes Innenleben. Weißwandreifen und 342 Zentimeter Länge trösteten ein wenig. Von 1956 bis 1958 fanden sich 6300 Käufer.

La Maico 500 était au départ une berline-cabriolet, plus ronde encore qu'une Gutbrod, à laquelle elle ressemblait par ailleurs beaucoup, et s'appelait Champion avant d'être rachetée. Faiblement motorisée au départ (15 CV), la berline dotée plus tard d'un moteur plus puissant était très bruyante à l'intérieur. Sa longueur de 342 centimètres et ses pneus aux flancs blanchis consolaient un peu les acheteurs qui furent au nombre de 6 300 de 1956 à 1958.

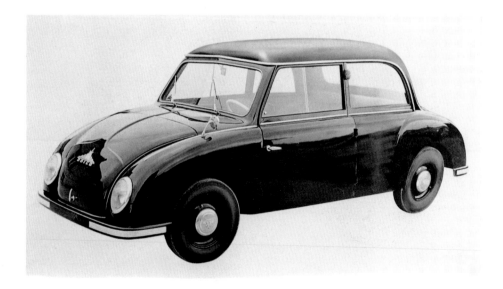

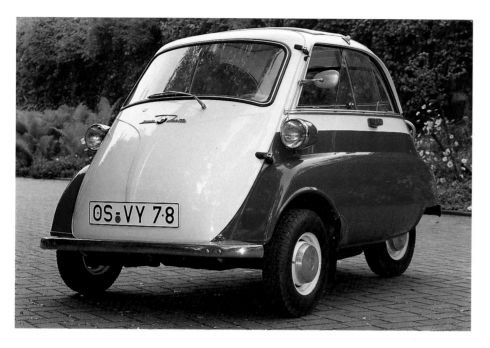

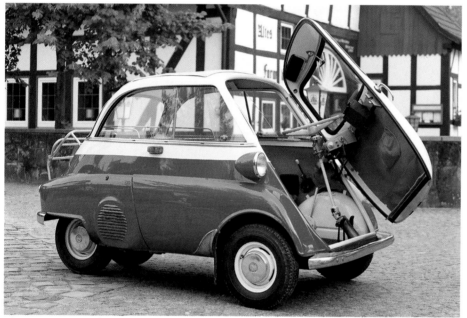

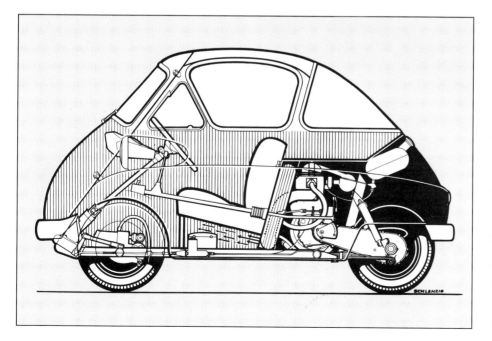

BMW Isetta, Germany, Deutschland, Allemagne, 1956

The BMW Isetta, an Italian design, was the most popular cabin scooter in Germany. Built under German licence, the body of this car would shake when running idle. This was due to its one-cylinder four-stroke engine. The faint hint of a cockpit was given up in later versions. If we count subsequent licences to the UK, Brazil and France (Velam), then this car sold 161,360 times. This short vehicle trundled along the roads in that typical Isetta style. The picture shows that the steering column, which was at an angle, provided good safety and allowed people to get in and out very easily. Its universal joint made it seem less like a skewer. A close look reveals that, even in a left-hand drive car, the ignition for this 12 HP vehicle was on the left.

Die BMW Isetta war eine italienische Entwicklung und die beliebteste Kabinenrollerversion im Lande. Die Karosse des deutschen Lizenzbaus schüttelte sich im Leerlauf wegen des Einzylinder-Viertakters. Der Hauch Flugzeugkanzel wurde in der späteren Version aufgegeben. Inklusive später weiter vergebener Lizenzen nach England und Brasilien und der französischen Produktion bei Velam kamen 161 360 Exemplare auf die Straße.
Das kurze Vehikel schaukelte über Land in typischer Isetta-Art. Wie das Bild zeigt, bot die geknickte Lenksäule für einen bequemeren Einstieg auch etwas mehr Sicherheit; wegen des Kreuzgelenks wirkte sie nicht wie ein Spieß. Ein genauer Blick verrät: Die 12 PS wurden mit der linken Hand geschaltet.

La BMW Isetta de 12 CV, conçue par des designers italiens, était le scooter caréné le plus apprécié d'Allemagne. Un moteur à quatre temps et un cylindre fabriqué sous licence allemande secouaient la carrosserie au ralenti. Ce qui ressemblait à une cabine de pilotage disparut dans les versions ultérieures. Si l'on compte les licences vendues plus tard en Angleterre et au Brésil et la production française près de Velam, on peut évaluer à 161 360 le nombre d'Isetta construites. Le véhicule avait une allure tressautante caractéristique. La colonne de direction était pliable, ce qui facilitait l'entrée et jouait également comme critère de sécurité puisqu'elle ne risquait pas d'embrocher le conducteur. Un examen attentif nous indique que les vitesses étaient passées avec la main gauche.

With a long wheel base of 59 inches (150 cm), a wheel gauge of 47 inches (120 cm) at the front and 20 inches (52 cm) at the back, the Isetta had enough space for two persons and some hand luggage. Anything else had to be put on the luggage carrier which had to be purchased separately.

Radstand 150 Zentimeter, Spurweite vorn 120, hinten 52 Zentimeter, das genügt für zwei Personen mit etwas Handgepäck. Jedes Mehr mußte auf die nachrüstbaren Gepäckträger wandern.

Empattement 150 centimètres, voie avant 120, voie arrière 52 centimètres. C'est suffisant pour deux personnes et un sac de voyage. Sinon il fallait acheter un porte-bagages.

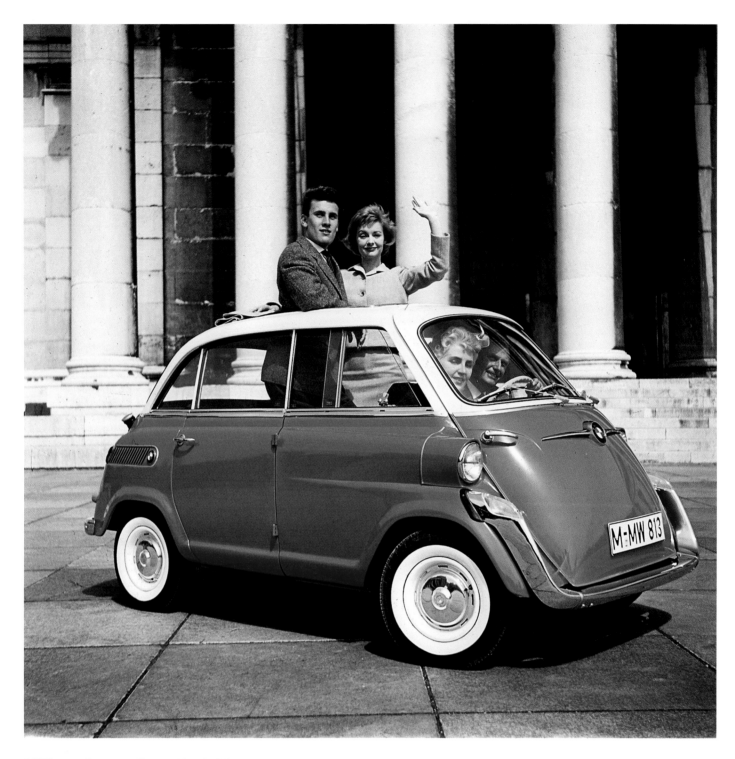

BMW 600, Germany, Deutschland, Allemagne, 1957

As BMW were just as short of funds as every-one else, there was a big gap between their big 501 models and the Isetta. The only way out was to produce a number of variations of the Isetta, which therefore served as a model for the front door and the shape of the side windows of the BMW 600. The integrated headlights and the elegantly curved mudguard were on the expensive side, while the back door, on the left, was relatively cheap. As a result, the general impression gained from a side view was rather bizarre and asymmetrical. The BMW 600 sold 34,318 times from 1957 to 1959. The car took 58 seconds to accelerate from 0 to 60 mph (100 km/h).

Da es auch BMW an Geld mangelte, klaffte ei-ne Lücke zwischen großen 501-Modellen und der Isetta. Nur Variationen der Isetta können helfen. Von der Isetta hatte der BMW 600 das Fronttürkonzept und die Form der Seitenfen-ster. Teurer wurden die integrierten Scheinwer-fer und die elegant geschwungene Stoßstan-ge; dafür hatte man an der linken hinteren Tür gespart. So wirkte der BMW, von dem 34318 Exemplare zwischen 1957 und 1959 entstan-den, vom Konzept her skurril und asymme-trisch in den Seitenansichten. Für die Be-schleunigung von 0 auf 100 Kilometer pro Stunde brauchte er 58 Sekunden.

BMW avait comme les autres des problèmes financiers et son programme ne prévoyait pas de modèles entre ceux de la série 501 et l'Iset-ta. Seules des versions de l'Isetta pouvaient remplir ce trou. La BMW 600 avait la portière avant de l'Isetta et les formes des vitres latéra-les. Les phares intégrés et le pare-chocs à la ligne élégante étaient plus chers, mais on cher-chait vainement la portière arrière gauche. La BMW 600 avait une allure bizarre et asymétri-que. Elle accélérait de 0 à 100 kilomètres à l'heure en 58 secondes. Elle fut fabriquée de 1957 à 1959 en 34318 exemplaires.

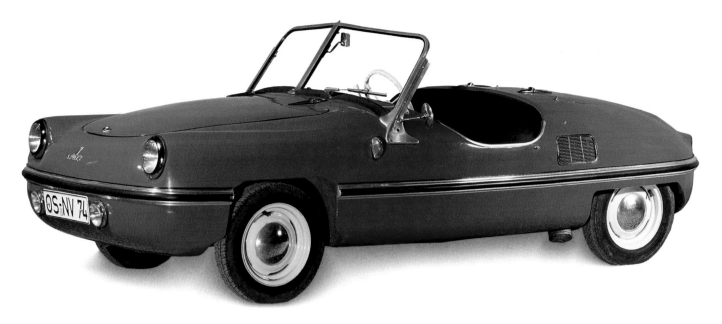

Victoria Spatz, Germany, Deutschland, Allemagne, 1956

Once the design was sold, the Sparrow developed into a fully fledged Victoria 250, showing that Germany's economic miracle had many fathers among small cars, both old and new. The engine had grown from 200 to 250 cc and was now quite fast, though also too expensive. Of the 1,588 Sparrows manufactured between 1956 and 1958, many ended up in flames at the end of the small cars era.

Aus einem Spatz wurde durch Firmenverkauf ein Wirtschaftswunder. Recht flott, aber zu teuer. Von den zwischen 1956 und 1958 gebauten 1588 Exemplaren gingen, gegen Ende der Kleinwagenära, viele oft unrühmlich in Flammen auf.

La maison fut vendue, c'était l'époque du miracle économique, et le «moineau» devint une Victoria 250, car son moteur passa de 200 à 250 centimètres cube. Rapide, peut-être, mais trop chère. On en construisit 1588 exemplaires de 1956 à 1958, mais elles furent nombreuses à partir peu glorieusement en fumée à la fin de l'ère des petites voitures.

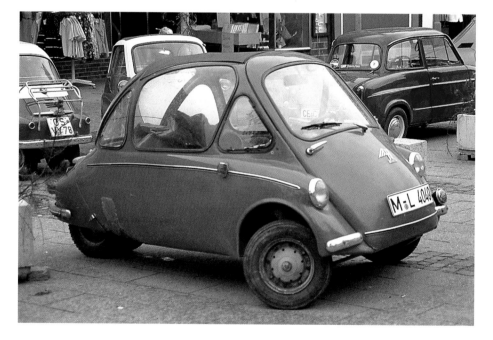

Heinkel Kabine, Germany, Deutschland, Allemagne, 1956

The Heinkel Cabin (built between 1956 and 1958) was narrower than the Isetta, though its height (52 inches / 132 cm) was almost identical, and it also had two children's seats at the back. Nicknamed »smooch bowl« in Germany, it achieved just under a tenth of the Isetta's production. From 1966, after it had been manufactured in Ireland for a while, it was built under licence in the UK.

Die Heinkel-Kabine (1956–1958 gebaut) war schlanker als die Isetta bei fast identischer Höhe (132 Zentimeter), dabei hatte die »Knutschkugel« hinten noch zwei Kindersitze zu bieten. Gerade ein Zehntel der Isetta-Produktion wurde erreicht. Ab 1966, nach einem Umweg über Irland, baute man das Auto in Lizenz in England.

La «cabine» de Heinkel (fabriquée de 1956 à 1958) était presque aussi haute que l'Isetta (132 centimètres), mais moins large, ce qui ne l'empêchait pas d'offrir à l'arrière de la place pour deux enfants. Elle fut construite à environ 16 000 exemplaires. A partir de 1966, après un détour par l'Irlande, la voiture fut construite sous licence en Angleterre.

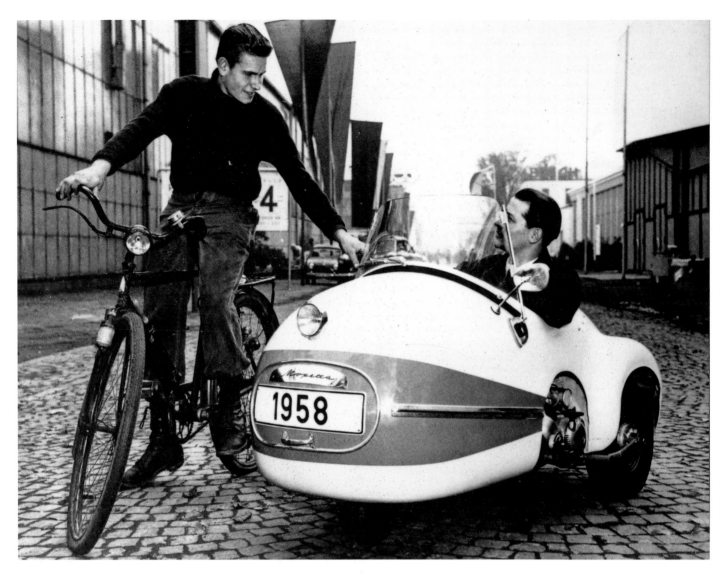

Brütsch Mopetta, Germany, Deutschland, Allemagne, 1957

Egon Brütsch, the inventor of the Sparrow, created a large number of small cars, all of which were rounded and smooth. As late as 1957, he still believed that he had done mankind a great favour with this one-seater, which was only 67 inches (170 cm) long, and that people's desire for greater mobility could be fulfilled with high-quality small cars. However, the increase in affluence meant that there was no longer any great demand for his Mopetta.

Der Erfinder des Spatzkonzepts, Egon Brütsch, schuf viele Kleinwagen in rundlich-glatter Form. Noch 1957 glaubte er, mit diesem Einsitzer von nur 170 Zentimetern Länge der Menschheit einen Gefallen zu tun, die sich den Wunsch nach Mobilität mit inzwischen besseren Kleinwagen erfüllen sollte. Bei wachsendem Wohlstand wollte man jedoch nicht mehr »Mopetta« fahren.

Egon Brütsch, l'inventeur du «moineau», créa de nombreuses petites voitures aux formes rondes et lisses. En 1957 il croyait encore que cette monoplace de 170 centimètres de longueur ferait le bonheur de ceux qui voulaient se déplacer facilement dans des petites voitures bien conçues. Mais, les gens devenant de plus en plus aisés n'achetèrent pas la Mopetta.

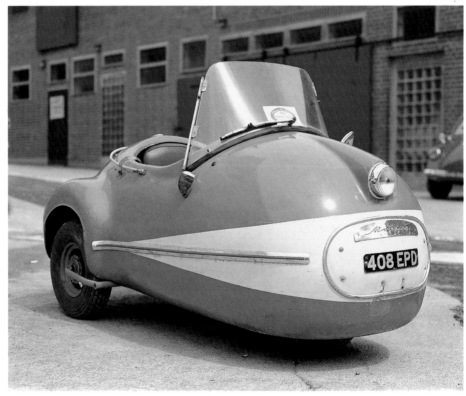

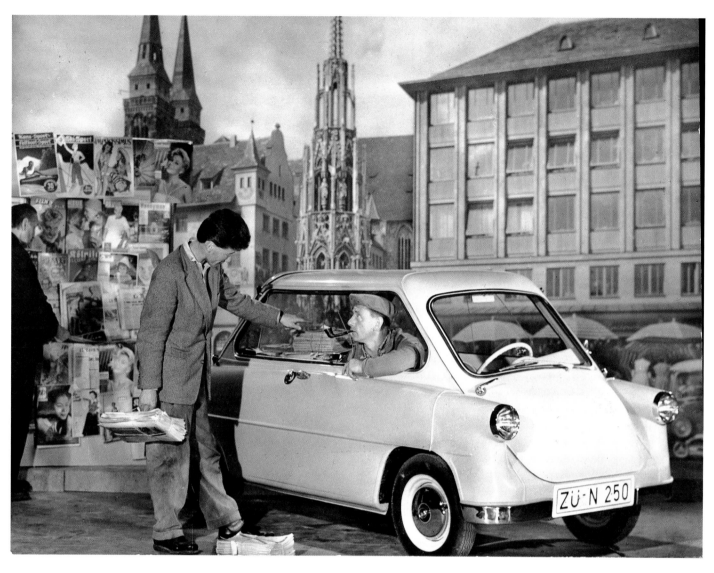

Zündapp Janus, Germany, Deutschland, Allemagne, 1957

In the history of motoring the seating arrangement of this Zündapp Janus (1957–58) had originally borne the exquisite name »dos à dos« (back to back). It was a kind of double Isetta, and the idea had originally come from the Dornier Delta. Because of its centrally situated engine and symmetrical distribution of weight on the front and back axles, it was said to have ideal road qualities – despite its rather sluggish and noisy engine. The model sold 6,902 times, and although it was only 114 inches (289 cm) long, it provided ample space for passengers.

Am Anfang der automobilen Geschichte nannte sich die Sitzanordnung des Zündapp Janus (1957–1958) vornehm »dos a dos« – Rücken an Rücken. Dieser vom Dornier Delta abgeleitete Kleinwagen – quasi eine doppelte Isetta – soll wegen seinem Zentralmotor und idealer, weil symmetrischer Lastenverteilung auf Vorder- und Hinterachse gute Fahreigenschaften gehabt haben – trotz des müden und lauten Motors. Bei nur 289 Zentimetern Länge bot das 6902 Mal verkaufte Modell den Insassen ausreichend Raum.

Dans la Zündapp Janus les passagers prenaient place dos à dos. Cette petite voiture inspirée de la Dornier Delta semble avoir montré, malgré un moteur sonore et peinant beaucoup, de grandes qualités de conduite, dues à son moteur central et la répartition idéale, parce que symétrique, des charges sur l'essieu avant et l'essieu arrière. Elle était suffisamment spacieuse avec seulement 289 centimètres de longueur. Construite de 1957 à 1958, elle fut fabriquée à 6902 exemplaires.

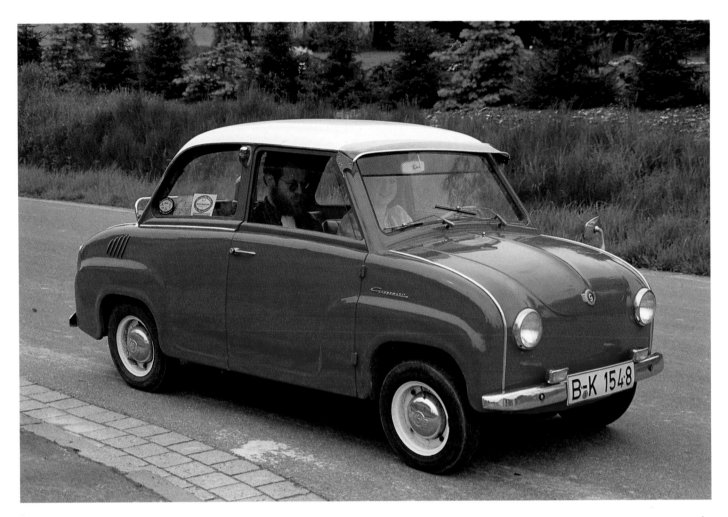

Glas Goggomobil, Germany, Deutschland, Allemagne, 1955

An amazing achievement: 210,531 cars were built, with a tin silhouette that was 6 inches (15 cm) shorter than a Mini but had the exact contours of a real saloon car. What is more, it survived from 1955 to 1969 – i.e. 14 years. This certainly proves that its design was sufficiently practical. The two-colour version and the windscreen visor were not available in mass production.

Erstaunlich: 210 531 Mal wurde diese Blechsilhouette gebaut, die mit 15 Zentimetern weniger Gesamtlänge als ein Mini die Kontur einer richtigen Limousine nachzeichnete – und das von 1955 bis 1969, 14 Jahre lang. Ein Beweis für ein offensichtlich sinnvolles Kleinwagenkonzept. Zweifarbenlackierung und Sonnenblende gab es nicht in Serie.

Un phénomène étonnant la Goggo: elle fut fabriquée 210 531 fois de 1955 à 1969. Ce qui prouve sa conception manifestement ingénieuse. Elle mesurait 15 centimètres de moins que la Mini et ressemblait à une vraie berline miniaturisée. La peinture deux-tons n'était pas en série et le pare-soleil non plus.

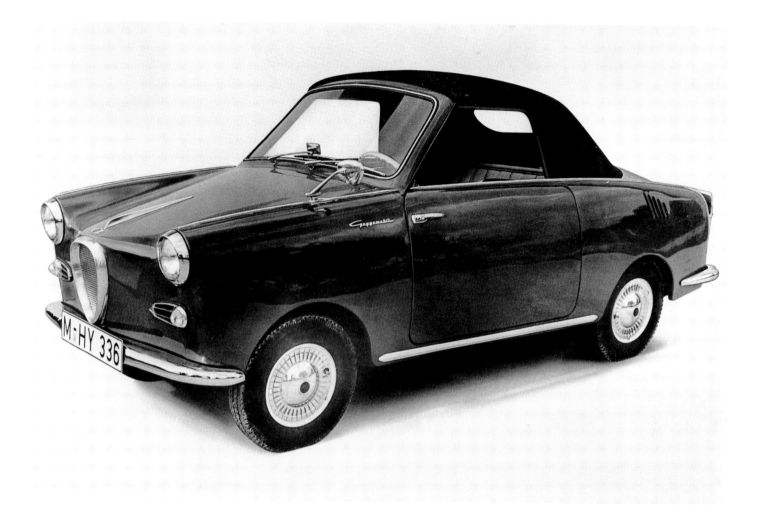

Glas Goggomobil Coupé, Germany, Deutschland, Allemagne, 1957

Anyone with a German class 4 driving licence (for mopeds up to 50 cc / 30 mph or 50 km/h) was also allowed to drive this saloon car – in fact the more refined coupé. The car was built 66,511 times. Logically, a convertible was also developed, though only nine cars of this type were actually built. It was accelerated to a maximum speed of 60 mph (100 km/h) through magnetic preselection at the flick of a button.

The petrol tank was sufficiently far away from the direct impact zone, and there was plenty of space in the engine section, despite the air-cooling system. The car started off with a mere 250 cc in 1957, and when the last car left the production line in 1967, it had 395 cc and 20 HP.

Der Tank hielt sich von direkter Aufprallzone fern, und dennoch gab es viel Platz im Motorraum, auch weil mit Luft gekühlt wurde. Hier werkelten erst 250 Kubikzentimeter (1957), zu Produktionsende 1967 waren es 395 Kubikzentimeter mit 20 PS.

Le réservoir à essence n'était pas placé dans une zone de collision et il y avait encore beaucoup de place sous le capot vu que le moteur était refroidi à l'air. En 1957 la cylindrée était de 250 centimètres cube, vers la fin de la production, en 1967, le moteur avait 20 CV et une cylindrée de 395 centimètres cube.

Wer den Führerschein IV besaß, durfte die Limousine fahren – und dann auch das feinere Coupé. 66 511 Exemplare wurden gebaut. Logischerweise entwickelte man 1957 ein Cabrio, von dem angeblich nur neun Stück gefertigt wurden. Wie das Coupé wurde es mit dem kleinen Finger über eine elektromagnetische Vorwählschaltung auf maximal 100 Kilometer pro Stunde gebracht.

Ceux qui possédaient un permis de conduire n°IV pouvaient piloter la limousine et ce coupé plus élégant fabriqué en 66 511 exemplaires. Suite logique, on créa en 1957 un cabriolet construit, paraît-il, en seulement neuf exemplaires. Il possédait comme le coupé une boîte de vitesses présélectibles électromagnétique et plafonnait à 100 kilomètres à l'heure.

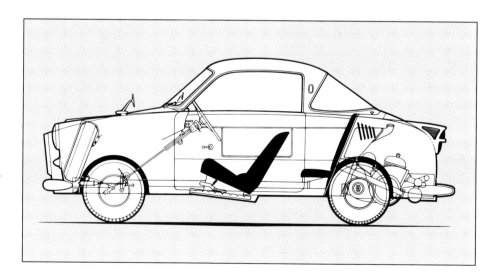

Glas Isar Coupé, Germany, Deutschland, Allemagne, 1957

If the first model of a series is a dainty coupé, you need to create more space as soon as you want to put in a more powerful engine. This means enlarging the front and putting on stronger wheels. The Glas Isar S 35 Sport Coupé of 1957 achieved a total of 85 mph (140 km/h), running at 34 HP. However, not many cars were actually produced.

Wer mit einem zierlichen Coupé beginnt, mußte beim Aufrüsten des Motors Platz schaffen, also den Bug vergrößern und kräftigere Räder bieten. Das Glas Isar S 35 Sport-Coupé von 1957 schaffte mit seinen 34 PS knapp 140 Kilometer pro Stunde. Es blieb bei wenigen Exemplaren.

La Glas Isar S 35 Sport-Coupé de 1957 était issue de la Goggo dont on avait agrandi la partie avant pour y placer un moteur plus puissant et renforcé les roues. Elle possédait 34 CV et atteignait 140 kilomètres à l'heure. Elle ne fut fabriquée qu'en quelques exemplaires.

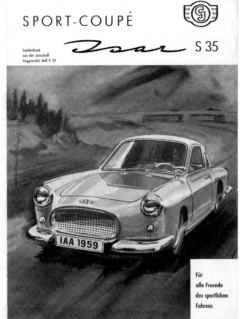

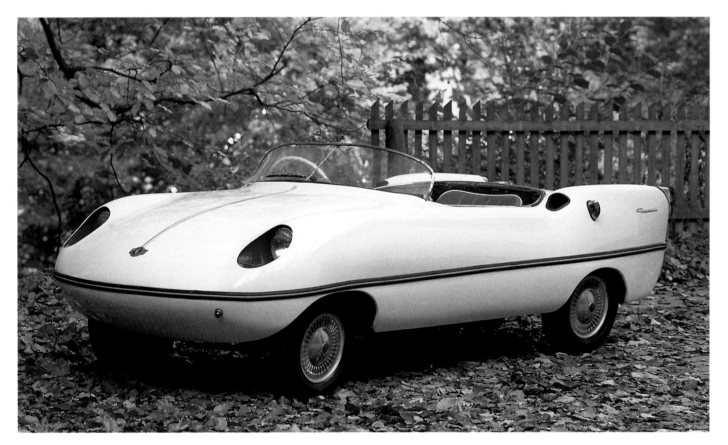

Buckle Dart (Goggo), Australia, Australien, Australie, 1959

Germans viewed the Goggo versions of others countries with some envy. Based on the Glas Isar, Michelotti tried his hand at designing a beach car that resembled the Minimoke. However, the most beautiful Goggo of all times was the Dart by Buckle, Australia (1959). Pininfarina could not have designed a better front. But having done such an exellent job with fibre glass, the company might also have designed smaller tailgates. The only indication that this a Glas is the company logo with the »G« at the front and the chromium-plated ventilation grid at the back, which can also be found on the Goggo.

Neidisch wird man auf die Goggoversionen des Auslandes. Michelotti probierte auf der Glas Isar-Basis einen Strandwagen aus, dem Minimoke nicht unähnlich. Der schönste Goggo aller Zeiten kam aber 1959 als »Dart« von der Firma Buckle aus Australien. Pininfarina hätte die Front nicht besser zeichnen können. Wer so gut in Kunststoff kleidet, hätte kleinere Heckflossen schaffen können. Der einzige Hinweis auf einen Glas ist das Firmenzeichen mit dem »G« auf dem Bug und die vom Goggo übernommenen verchromten Lüftungsgitter am Heck.

Les versions de Goggo créées à l'étranger éveillent un sentiment d'envie. Michelotti conçut sur la base de la Glas Isar une voiture de plage, ressemblant à la Minimoke. La plus belle Goggo de tous les temps vit le jour en Australie en 1959, sous le nom de Dart et fut fabriquée par la firme Buckle. La partie avant est digne de Pininfarina. Les ailes arrière auraient pu être plus petites. Le seul détail rappelant Glas est l'emblème avec un «G» sur le capot et la grille d'aération chromée de la Goggo à l'arrière.

Vespa Kipplaster, Italy, Italien, Italie, ca. 1975

There is quite a lot of metal on a motor scooter. All that is missing is a roof and a third wheel – at the back – and there is your small car. The rear axle can then be used in a variety of ways. As, for example, in this Vespa, a tipping truck that is ideally suited for a sandpit. It is a handy little car and still in use today, especially by public utilities.

Ein Motorroller hat schon einiges an Blechverkleidung. Eigentlich fehlten nur noch das Dach und ein drittes Rad – hinten – schon ist der Kleinwagen fertig. Über der Hinterachse bieten sich dann fast alle Nutzungsmöglichkeiten. Zum Beispiel der Kipper für den Sandkasten wie bei dieser Vespa. Noch heute verrichten diese nützlichen Wägelchen ihre Dienste, vorzugsweise in städtischen Betrieben.

Pour obtenir une voiture, il suffit d'équiper un scooter d'un toit et d'une seconde roue à l'arrière. La partie située au-dessus de l'essieu arrière peut subvenir à de multiples fonctions. On peut y installer par exemple une benne basculante pour le bac à sable, comme sur cette Vespa. Ces voitures sont encore en service aujourd'hui, notamment dans les entreprises urbaines.

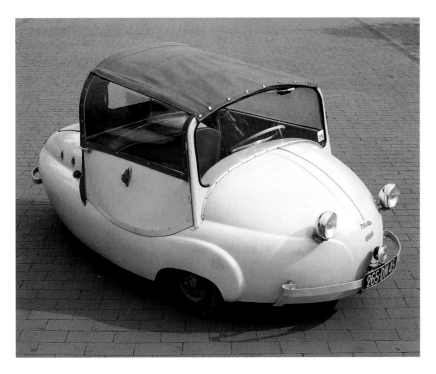

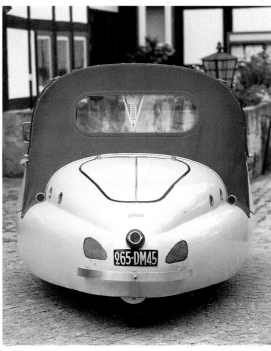

Valle Chantecler, France, Frankreich, 1956

Round, small, on three wheels, made of fibre glass and with a folding roof – these are the perfect ingredients of a simple vehicle. This car, which is reminiscent of a Meyra, a Fulda-mobile or a Brütsch, was designed by Paul Val-lée and comes from France. Called »Chante-cler« (»Nightingale«) in 1956, its little legs were far too short. Anyone who bought this 125 cc vehicle, was allowed to ride it without a driving licence in Gemany, provided he stayed within the 35 mph (60 km/h) speed limit.

Rund, klein, dreirädrig, aus Kunststoff, mit Falt-dach – ein Rezept, um möglichst einfach voranzukommen. Was hier einem Meyra, einem Fuldamobil, einem Brütsch ähnelt, kommt aus Frankreich von Paul Vallee, nannte sich 1956 »Chantecler« und hatte als »Nachtigall«, so die Übersetzung, viel zu kleine Beinchen. Wer sich für diese 125 Kubikzentimeter entschied, konnte die Nachtigall führerscheinfrei bis 60 Kilometer pro Stunde zwitschern lassen.

Petite carrosserie de plastique ronde, trois roues, toit pliant: la Chantecler avait tout ce qu'il faut pour rouler avec le moins de moyens possible. Elle ressemblait à une Meyra, une Fuldamobil ou une Brütsch. Pourtant elle était française et fut construite par Paul Vallée à partir de 1956. La Chantecler avait un moteur de 125 centimètres cube et atteignait 60 kilomètre à l'heure, pas besoin de permis pour la conduire.

Scootacar, Great Britain, England, Angleterre, 1957

The Scootacar – a British design of 1957 – was technically more sophisticated. With a body made entirely of fibre glass, it was similar to the French Nightingale. However, as its roof was not made of canvas, there was no variable headroom, and the manufacturers therefore opted for a height that was akin to the German Beetle.

Technisch anspruchsvoller zeigte sich 1957 der englische Scootacar mit Kunststoff-Vollkarosserie – im Prinzip wie die französische Nachtigall. Und weil kein Stoffverdeck nachgibt und damit keine variable Kopffreiheit gewährleistet war, hatte man gleich eine Bauhöhe gewählt, die der des deutschen Käfers nahekam.

La scootacar anglaise à carrosserie de plastique sortie en 1957, et en principe semblable à la Chantecler, était techniquement plus poussée. Les toits en tissu manquant de souplesse et ne garantissant pas une garde au toit variable, on avait choisi une hauteur de construction presque identique à celle de la Coccinelle.

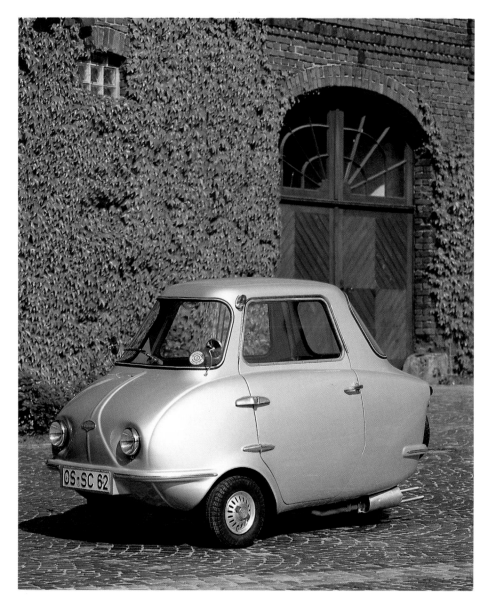

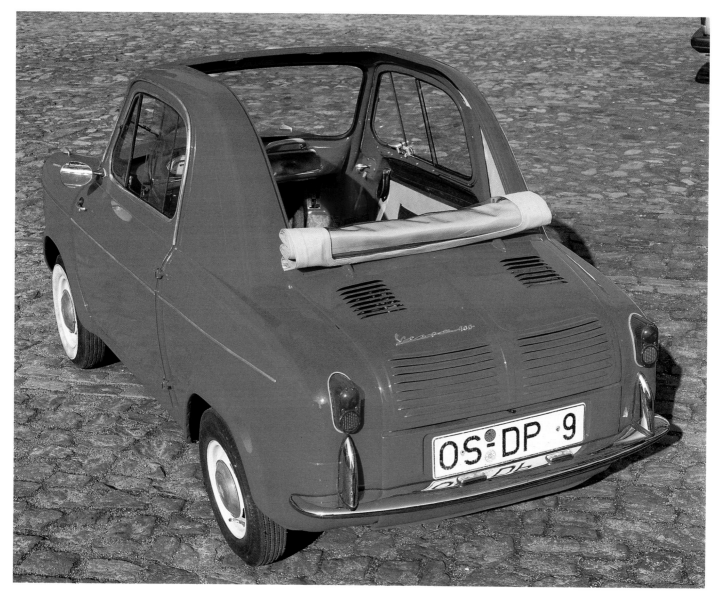

Vespa 400, Italy, Italien, Italie, 1957

One thing about Italian small cars was that they looked less feeble. The only feature that betrayed their lightness – though also their single-wheel suspension – was their relatively small wheels. If the vehicle was empty, the wheels were at an angle, like on a Goggo. This Vespa 400 of 1957 was of a similar length to the Goggo and made more of a car-like impression while at the same time offering more space inside. The folding roof was an ideal solution for this car.

Was die italienischen Kleinwagen auszeichnete: Sie sahen weniger mickrig aus. Lediglich die kleineren, beim unbeladenen Fahrzeug schräg stehenden Räder erinnerten – ähnlich wie beim Goggo – an ihr Leichtgewicht, aber auch an Einzelradaufhängung. Diese Vespa 400 von 1957, in der Länge dem Goggo vergleichbar, bot optisch mehr Auto und innen etwas mehr Platz. Das Rolldach war eine ideale Lösung für diese einer Cabriolimousine nicht unähnlichen Version.

L'atout des voitures italiennes est qu'elles n'avaient pas l'air chétives. Seules les petites roues, obliques quand la voiture était vide, rappelaient son poids plume et sa suspension indépendante. Cette Vespa 400 de 1957, bien que comparable à la Goggo au niveau de la longueur, semblait plus grande et plus spacieuse. Le toit roulant était une solution idéale pour cette voiture aux allures de berline-cabriolet.

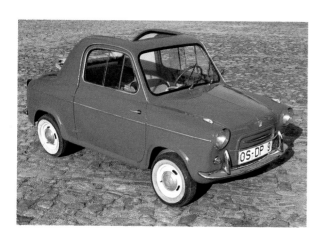

Bianchina, Italy, Italien, Italie, 1957

A little more chromium, bigger tailgates, and the basic design of a Fiat 500 – this was Autobianchi's concept for their 1957 Bianchina, a car that was equal to the Vespa 400. The production range included a coupé, a convertible, a saloon and an estate. The success of the Bianchina was reflected in its 1960 production figures, when over 60,000 vehicles left the production line.

Etwas mehr Chrom, etwas mehr Heckflosse, alles auf der Basis der Mechanik eines Fiat 500 – das war das Autobianchi-Konzept von 1957 für den Bianchina, der der Vespa 400 gleichkam. Es gab neben einem Coupé ein Cabrio, eine Limousine und einen Kombi. Wie erfolgreich der Kleine war, belegen die Produktionszahlen allein von 1960: Es waren über 60 000.

Un peu plus de chrome, des ailes plus prononcées à l'arrière, le tout sur la base de la mécanique d'une Fiat 500 – c'était le concept Autobianchi de 1957 pour la Bianchina qui égalait la Vespa 400. Au programme un coupé, un cabriolet, une berline et un break. Le chiffre de production de 1960 suffit à démontrer le succès de la petite, il s'élève à plus de 60 000.

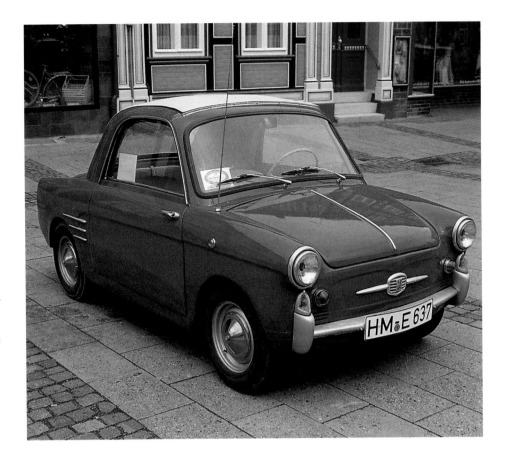

Fiat 600, Italy, Italien, Italie, 1955

129.33 x 54.92 inches (3,285 x 1,395 millimetres) of base gives you an overall space of 493.26427 sq. feet (4.582575 square metres). The Fiat 600 of 1955 provided enough space for four adults or 12.3311 sq. feet (1.1456 sq. metres) per person, including each person's share of the luggage space and the water-cooled four-cylinder engine. Millions of Italians were happy with this size, and their satisfaction was confirmed by over 300,000 cars sold in Germany, some of which had been made at the NSU-Fiat Jagst plant in Heilbronn, Germany.

3285 x 1395 Millimeter Grundfläche machen 4,582575 Quadratmeter. Weil der Fiat 600 von 1955 vier Erwachsenen Platz bot, machte das pro Nase 1,1456 Quadratmeter einschließlich dem anteiligen Raum für Gepäck und den wassergekühlten Vierzylinder. Für Millionen Italiener war diese Größe ausreichend. Über 300 000 Verkäufe in Deutschland, zum Teil aus deutscher Produktion (NSU-Fiat Jagst) in Heilbronn, bestätigten diese Ansicht.

Une surface de 3 285 x 1 395 millimètres équivaut à 4,582575 mètres carrés. Etant donné que la Fiat 600 de 1955 offrait de la place à 4 adultes, chacun avait donc 1,1456 mètres carrés à sa disposition – dont l'espace réservé aux bagages et aux quatre cylindres refroidi par eau. Ces dimensions suffisaient à des millions d'Italiens. Plus de 300 000 ventes en Allemagne, en partie de production allemande (NSU-Fiat Jagst) à Heilbronn, le confirment.

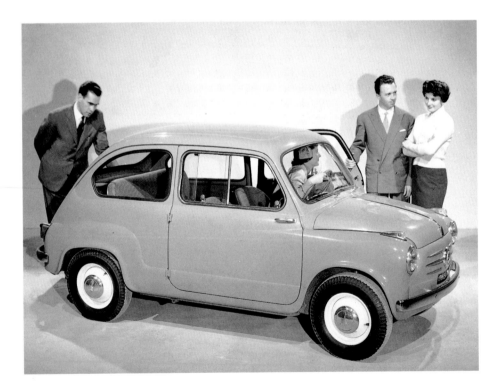

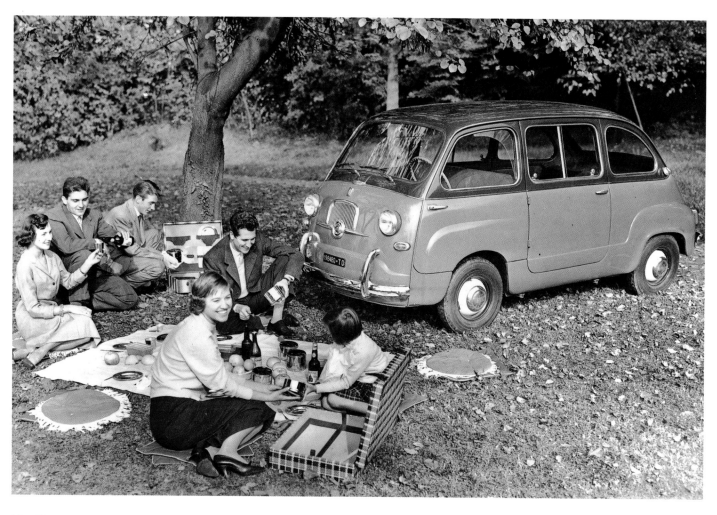

Fiat Multipla, Italy, Italien, Italie, 1956

The metal of the Fiat 600 had been subjected to a little bit of torture: stretched this way and that way, it eventually had its bonnet amputated and was called Multipla, a car that was built from 1956 to 1964. With a total length of only 139 inches (354 cm), it is remarkable that this vehicle should have accommodated three rows of seat, though it could have been more compact if it had been based not on a saloon but on the box shape of a van. This idea was later picked up by the Japanese, with a car just over 100 inches (less than 300 cm) in length.

Das Blech des Fiat 600 wurde etwas gequält: strecken, dehnen und Fronthaube amputieren, schon war die Version Multipla fertig, die von 1956 bis 1964 gebaut wurde. Drei Sitzreihen bei einer Länge von 354 Zentimetern sind beachtlich – das Ganze könnte kompakter sein, wenn als Basis keine Limousine diente, sondern das eigenständige Kistenkonzept eines Lieferwagens. Das führten später die Japaner vor – auf weniger als 300 Zentimetern.

On allongea la carrosserie de la Fiat 600, on l'étira, on amputa son capot, et la version Multipla vit le jour. Elle fut construite de 1956 à 1964. Trois rangées de sièges pour une longueur de 354 centimètres, ce n'est pas mal – le tout pourrait être plus compact, si la voiture n'était pas construite sur la base d'une berline mais sur celle d'une caisse de camionnette. C'est ce que les Japonais présentèrent plus tard, sur moins de 300 centimètres.

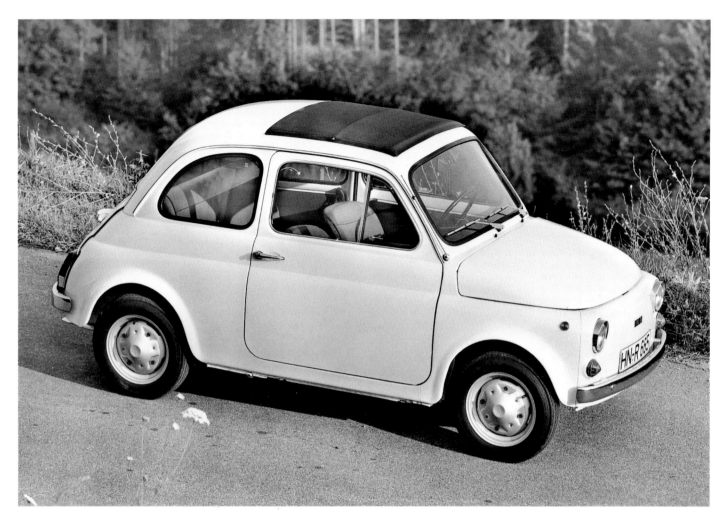

Fiat 500 A, Italy, Italien, Italie, 1957

A fast little mouse – the first Fiat 500, a milestone in the development of the automobile, and affectionately called »topolino« (»little mouse«) by the Italians. Like the German Beetle, it mobilized an entire nation at one time. The natty little vehicle had enough room for two persons, its internal space was cleverly arranged, its design was a paragon of simplicity, and its 1936 launch price was only 8,900 Lire.

Mann und Maus im Sauseschritt: Der erste Fiat 500, ein Meilenstein in der Automobilentwicklung und von den Italienern liebevoll »Topolino« – Mäuschen – genannt, mobilisierte eine ganze Nation wie einst der Käfer die Deutschen. Das schnuckelige Wägelchen bot zwei Personen Platz, verfügte über eine geschickte Raumaufteilung, war beispielhaft simpel konstruiert und kostete bei seiner Vorstellung im Jahre 1936 ganze 8 900 Lire.

La première Fiat 500, celle que les Italiens appelaient affectueusement «le souriceau», marque un jalon dans l'histoire de l'automobile, elle a mobilisé toute une nation comme l'avait fait autrefois la Coccinelle en Allemagne. La petite mignonne offrait de la place à deux personnes, l'aménagement intérieur était bien pensé, sa construction était un exemple de simplicité et elle ne coûtait lors de sa présentation en 1936 que 8900 lires.

Lloyd Arabella, Germany, Deutschland, Allemagne, 1959

The picture shows a Lloyd Arabella with a Frua body at the International Automobile Exhibition in 1959, though the 600 version was identical, apart from the front mudguards.

Das Bild zeigt zwar eine Lloyd Arabella mit Frua-Kleid auf der IAA 1959, aber die 600er-Version war bis auf die Frontstoßstangen identisch.

L'illustration présente à vrai dire une Lloyd Arabella habillée par Frua lors de la IAA 1959, mais seuls les pare-chocs avant la différaient de la version 600.

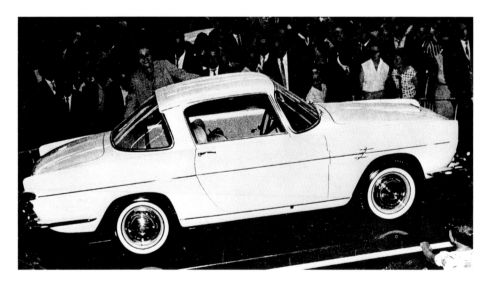

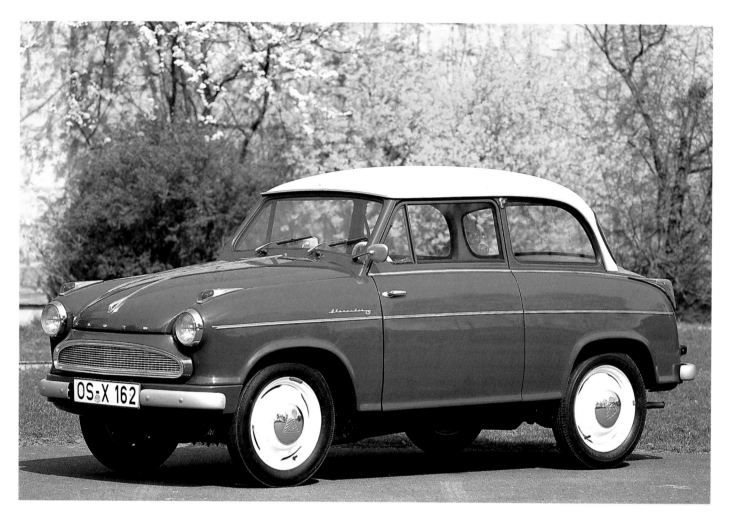

Lloyd Alexander, Germany, Deutschland, Allemagne, 1955

Even a jalopy can turn into something respectable, e.g. a car made entirely of steel, with an elegant front and wheels as big as a Beetle's. Yet the Lloyd Alexander TS was only 132 inches (335 cm) long and fast. The 600 version alone sold 176,524 times from 1955 until Borgward's bankruptcy in 1961. I know from my own experience that small-scale repair jobs – usually only advisable on DIY-type minicars – were no problem at all.

Aus einem Leukoplastbomber kann etwas Anständiges werden: zum Beispiel ein Auto ganz aus Stahl, mit elegantem Grill und Rädern so groß wie bei einem Käfer. Trotzdem war der Lloyd Alexander TS nur 335 Zentimeter lang, fuhr flott und verkaufte sich von 1955 bis zur Borgward-Pleite 1961 in allen 600er Versionen 176 524 Mal. Die Möglichkeit einfacher kleiner Schnellreparaturen, sonst nur noch bei bastelähnlichen Kleinstwagen der Zeit ratsam, hat der Autor selbst erprobt.

Même un bombardier en sparadrap peut devenir quelqu'un de bien: par exemple une voiture tout acier, à la calandre élégante et les roues aussi grandes que celles de la Coccinelle. Il n'empêche que la Lloyd Alexander TS ne mesurait que 335 centimètres de long, qu'elle était rapide, et qu'elle se vendit de 1955 jusqu'à la faillite de Borgward en 1961 176 524 fois dans toutes les versions 600. L'auteur luimême a effectué avec succès de petites réparations, ce qui n'est conseillé que pour les petites voitures du genre bricolé.

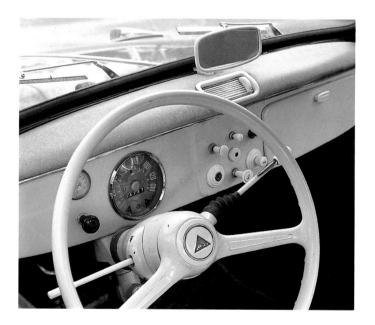

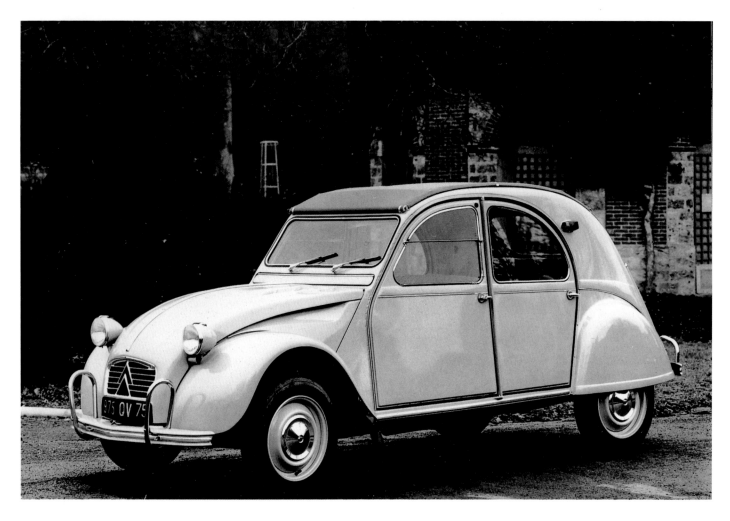

Citroën 2 CV, France, Frankreich, Version 1980

The sort of car you either loved or hated: the Citroën 2 CV did not allow you to sit on the fence. With its unassumingly nostalgic charm, the Duck was the embodiment of an entire philosophy. After 41 years of production, manufactured over five million times, one of the last distinctive cars of this century quietly breathed its last in Portuguese exile in July 1990.

Geliebt oder gehaßt: Am Citroën 2 CV schieden sich die Geister. Mit dem diskreten nostalgischen Charme verkörperte die »Ente« eine Weltanschauung. Nach 41 Produktionsjahren und über 5 Millionen verkauften Exemplaren entschlief im Juli 1990 im portugiesischen Exil sanft eines der letzten Charakterautos dieses Jahrhunderts.

Objet d'amour ou de détestation, les avis sont très partagés au sujet de la 2 CV. Avec son charme discret empreint de nostalgie elle symbolise une vision du monde. La 2 CV, la dernière voiture de ce siècle ayant du caractère, s'est endormie paisiblement en juillet 1990 dans son exil portugais. Elle avait été fabriquée pendant 41 ans en plus de cinq millions d'exemplaires.

Mini Moke, Great Britain, England, Angleterre, 1969

There are small bodies based on miniature mechanics, estate cars with wooden panels, elegant versions with radiators and tailgates, and also a more playful coupé, like this Mini Moke with a folding roof.

Neben kleinen Sonderkarossen auf Minimechanik, Kombis mit Holzwandverkleidung, Edelversionen mit Kühler und Heckflossen als auch Coupéversionen war dieser Mini Moke mit Faltdach eine Schöpfung, die Spielcharakter aufwies.

A côté de petites carrosseries spécifiques abritant une mini-mécanique, de breaks revêtus de panneaux de bois, de versions nobles avec calandre et ailes arrière et aussi de coupés, cette Mini Moke décapotable était une création à caractère ludique.

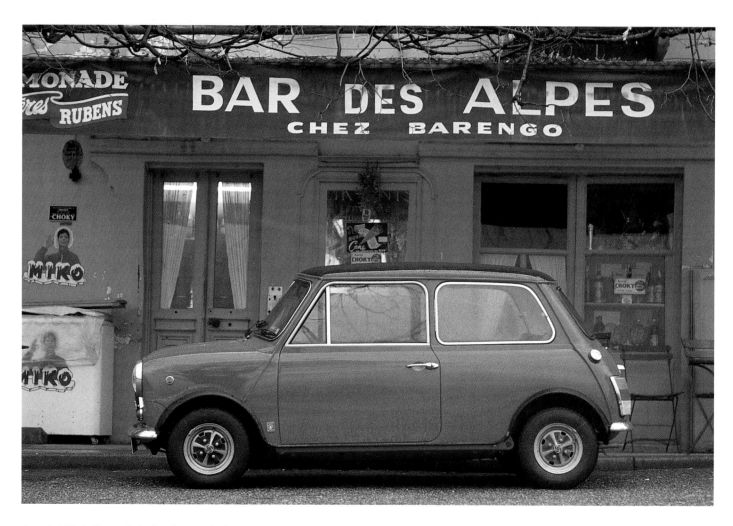

Austin Mini, Great Britain, England, Angleterre, 1959

The Austin Mini of 1959 is seen as the standard design of a 10-foot car (305-cm car) for four. Even details such as the free joints had been fashioned with great care. Nothing is superfluous or luxurious about this car. And of course the Mini is the only small car which is not only classless – like the Beetle – but also has a certain respectability about it, because nothing can appeal more to people's hearts than common sense.

Im Austin Mini von 1959 ist das Urkonzept des Autos für vier Personen bei einer Länge von 305 Zentimetern begründet. Selbst Details wie frei liegende Scharniere wurden mit Sorgfalt geformt. Nichts ist überflüssig und oppulent. Und: Der Mini ist der einzige Kleinwagen, der nicht nur klassenlos wie ein Käfer ist, sondern eher »oberklassig« im Image, weil Vernunft das Gefühl noch nie besser getroffen hat als hier.

L'Austin Mini de 1959 est la voiture étalon à quatre places pour une longueur de 305 centimètres. Même des détails comme les charnières à l'air libre ont été formés avec soin. Rien n'est superflu et opulent. En outre, non seulement il est impossible de faire entrer la Mini dans une catégorie, la Coccinelle en est un autre exemple, mais son image est celle d'une classe supérieure: raison et sentiment se rejoignent ici on ne peut mieux.

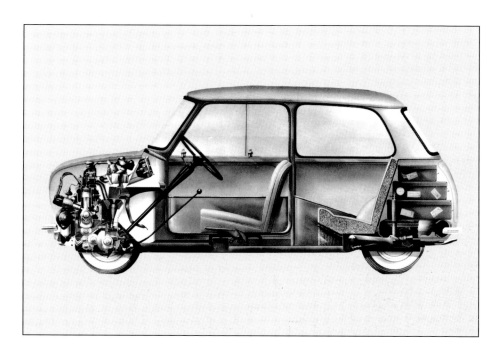

Renault R 4, France, Frankreich, 1961

Like Citroën, Renault wanted to make a spacious car with a small engine. At its 1961 première, the R 4 shone with a body and a four-cylinder engine that were much better than those of the original Duck. The engine, situated behind the front axle, had a good effect on the car's performance. It was more powerful and therefore faster, the inside space could be turned into a twin bedroom (I have tried this out myself), and to demonstrate its off-the-road performance, the car was launched in Frankfurt in a hall and on a specially prepared terrain.

Wie Citroën wollte auch Renault trotz kleinem Motor ein geräumiges Auto präsentieren. Bei der Premiere 1961 glänzte der R 4 im Vergleich zur Ente durch eine verfeinerte Blechverkleidung und einen verbesserten Vierzylindermotor. Längs hinter der Vorderachse liegend, wirkte er günstig auf das Fahrverhalten. Etwas mehr PS machten ihn flotter, und der Innenraum konnte zur Not zum Zweibettzimmer werden (autorenerprobt). In Frankfurt wurde er in der Halle und auf einem speziell aufgeschütteten Gelände vorgestellt, um die »off road«-Tauglichkeit zu demonstrieren.

Renault, à l'instar de Citroën, voulait présenter une voiture spacieuse malgré son petit moteur. Lors de sa présentation en 1961 la R 4, comparée à la 2 CV, brillait par sa carrosserie de tôle plus raffinée et un moteur de quatre cylindres amélioré. L'emplacement du moteur, en longueur derrière l'essieu avant, s'avérait favorable pour les qualités routières. Quelques CV de plus lui donnaient du nerf et son habitacle pouvait, en cas de besoin, être transformé en chambre à deux lits (l'auteur en a fait lui-même l'expérience). A Francfort, elle fut présentée dans le hall et sur un terrain spécialement aménagé, afin de démontrer ses aptitudes.

Trabant 600, Germany, Deutschland, Allemagne, 1964

Its direct predecessor was the P 70 of 1955. The Trabant P 50 (from 1957) only had minor changes to the body. The design concept was similar to that of the West German Lloyd. However, it had to hold out until April 1991, when the last Trabi finally left the production line in Zwickau (now in the new federal state of Saxony) with a four-stroke VW Polo engine. The production facilities were subsequently sold to other, poorer countries in the third and ex-communist worlds.

Sein direkter Vorläufer, der P 70, kam 1955; der Trabant P 50 (ab 1957) zeigte nur mäßige Veränderungen der Karosserie. Das Konstruktionskonzept ähnelte dem des westdeutschen Lloyd. Es mußte aber bis zum April 1991 durchhalten, als in Zwickau im nun neuen Bundesland Sachsen der letzte Trabi mit viertaktendem VW-Polo-Motor das Band verließ. Danach wurden Abnehmer für die Produktionswerkzeuge im noch armen Ausland der dritten und der sozialistischen Welt gesucht.

Son prédécesseur, la P 70, sortit en 1955; la Trabant P 50, à partir de 1957, ne montrait que peu de différences au niveau de la carrosserie. La conception était semblable à celle de la Lloyd ouest-allemande. Il fallut attendre jusqu'en avril 1991 pour qu'à Zwickau, dans le nouveau Land de Saxe, la dernière Trabi, équipée d'un moteur VW Polo à quatre temps, sorte de la chaîne. Après on chercha des acheteurs pour les outils de production dans le Tiers-Monde et les pays socialistes.

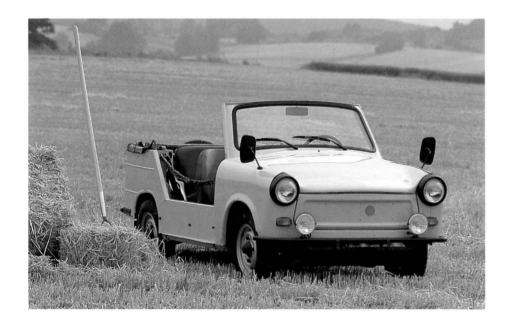

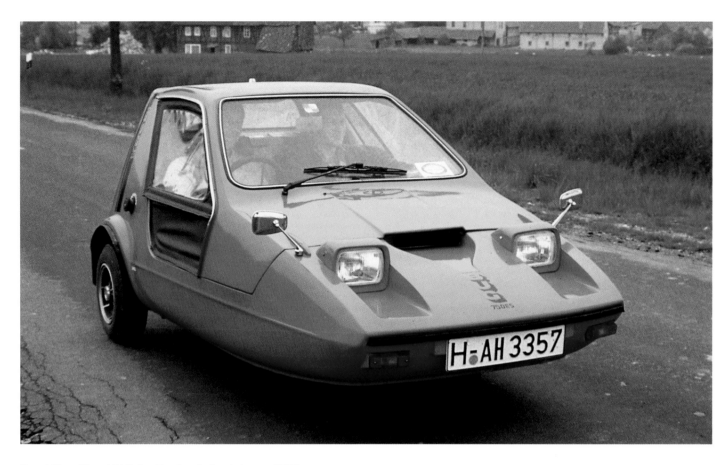

Bond Bug, Great Britain, England, Angleterre, 1970

The Bond Bug, designed by David Ogle in 1970, got rid of the idea that three-wheelers had to look like four-wheelers in the UK. Why design an awkward-looking radiator if the wedge at the front has the desired effect already? The recesses for the headlights and fresh air were somewhat rough and ready. The car is boarded like an aircraft, i.e. by folding the cabin forward. And, like the Morgan with its bare engine at the front, the Bond Bug is not too shy to show its rear axle and springy legs.

Der Bond Bug, Design David Ogle, räumte 1970 mit der Vorstellung auf, Dreiräder hätten in England wie Vierräder auszusehen. Warum einen klobigen Kühler entwerfen, wenn der Keil im Bug die gewünschte Wirkung zeigt. Etwas herb die Einschnitte für Scheinwerfer und Zuluft. Der Zustieg funktioniert wie beim Flugzeug: Die Kanzel wird nach vorne hochgeklappt. Und ähnlich einem Morgan, der seine Motorinnereien vorne freilegte, zeigte der Bond Bug freimütig seine Hinterachse nebst Federbeinen.

La Bond Bug dessinée par David Ogle a mis fin en 1970 à l'idée selon laquelle, en Angleterre, les tricycles doivent ressembler aux quadricycles. Pourquoi dessiner un radiateur massif si un capot plongeant fait le même effet? Les ouvertures pour les phares et l'aération sont un peu grossières. On y entre comme dans un avion: la porte de l'habitacle s'ouvre de bas en haut. Et tout comme la Morgan qui laissait voir devant son moteur, la Bond Bug montrait sans complexes son essieu arrière et ses jambes de force à ressorts.

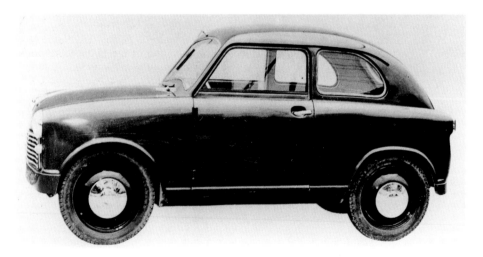

Suzuki Suzulight, Japan, Japon, 1955

If a Lloyd 400 borrows the rear portion of a Lancia Aprilia, then it is called a Suzuki Suzulight. The manufacturers had originally built textile machines, then motor bikes and eventually, in 1955, this SF Sedan. Its successor was shorter than a Mini.

Wenn ein Lloyd 400 sich das Heck vom Lancia Aprilia leiht, wird daraus der Suzuki Suzulight. Vom Textilmaschinenbau über Motorräder kam der Hersteller 1955 zu diesem Typ SF Sedan. Das Nachfolgemodell war kürzer als ein Mini.

Une Suzuki Suzulight, c'est ce qu'on obtient, lorsqu'une Lloyd 400 emprunte l'arrière de la Lancia Aprilia. Depuis la fabrication de machines textiles en passant par les motocyclettes le constructeur en arriva en 1955 à ce modèle SF Sedan. Le modèle suivant était plus court qu'une Mini.

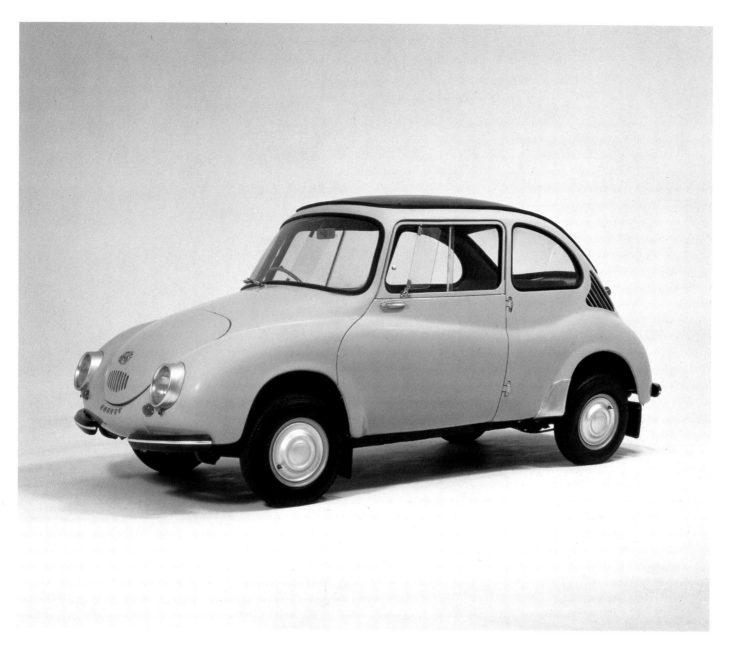

Subaru 360, Japan, Japon, 1958

Like so many cars, the Subaru 360 of 1958 had rather crooked legs. Its Beetle and Fiat 500 motifs, the characteristic face, which it owed to its headlights, and the canvas folding roof made it the most popular car of its class in Japan. Slightly elongated and with a stronger engine, it was exported – though not very successfully – to the States and Europe.

Schräge Beinchen hatte wie viele auch der Subaru 360 von 1958. Motive von Käfer und Fiat 500 mit den gesichtsprägenden Scheinwerfern, dazu ein Stoffrolldach, machten ihn zum Meistverkauften seiner Klasse in Japan. Leicht gestreckt und mit stärkerem Motor ging er – ohne großen Erfolg – in den Export in die USA und nach Europa.

La Subaru 360 de 1958 avait des jambes torses comme tant d'autres voitures. Des détails inspirés de la Coccinelle et de la Fiat 500 aux phares-yeux marquants et son toit en tissu en firent la voiture la plus vendue de sa catégorie au Japon. Légèrement étirée et plus fortement motorisée, elle fut exportée – sans grand succès – aux Etats-Unis et en Europe.

NSU Prinz III, Germany, Deutschland, Allemagne, 1958

Technically speaking, the four-wheel NSU Prinz (I-III) – which was built 94,549 times between 1958 and 162 – was a fully fledged car. The self-bearing body, the chassis (with single-wheel suspension) and the shape – especially the roof and the rear – still had some of the stuffiness of a three-wheeler.

Der Vierrad-Prinz (I-III) von NSU, gebaut von 1958 bis 1962 in 94 549 Exemplaren, war technisch ein vollwertiges Auto. Die selbsttragende Karosserie, das Fahrwerk (Einzelradaufhängung) sowie die Form – besonders in der Dachpartie und im Heck – trugen noch etwas vom Muff des Dreiradvorläufers in sich.

La Prinz (I-III) à quatre roues, construite de 1958 à 1962 en 94 549 exemplaires était techniquement parlant une voiture pleinement valable. On retrouvait dans la caisse monocoque, le châssis (suspension indépendante) et les formes – notamment celle de la toiture et de l'arrière – le caractère suranné de l'ancêtre à trois roues.

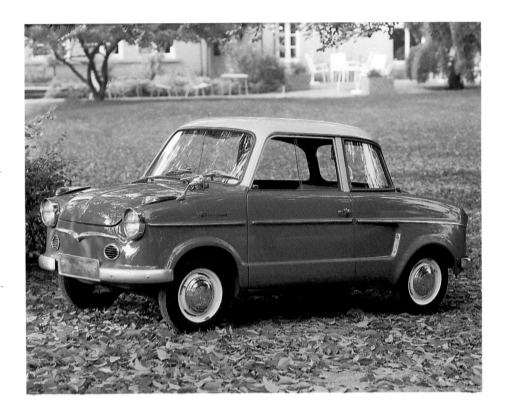

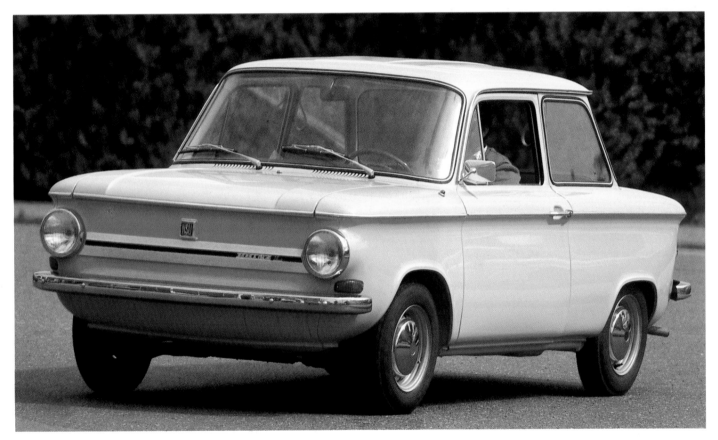

NSU Prinz IV, Germany, Deutschland, Allemagne, 1961

In 1961, nearly two years after a small styling revolution in the States, the designers of the Prinz IV decided to emulate the contours of the Chevrolet Corvair. The car was 135 inches (344 cm) long, 59 inches (149 cm) wide and 54 inches (136 cm) high. For a small car, this shape enabled designers to make the best possible use of the available space – be it for the headroom, knee space or the boot.

Knapp zwei Jahre nach einer kleinen Stylingrevolution in den USA bediente man sich beim Prinz IV 1961 des Vorbilds der Chevrolet Corvair-Linienführung. Das Formenkonzept bot die besten Voraussetzungen für die Raumausnutzung bei einem Kleinwagen, sei es in bezug auf Kopffreiheit, Kofferraum oder Knieraum bei 344 Zentimetern Länge, 149 Zentimetern Breite und 136 Zentimetern Höhe.

Près de deux ans après une petite révolution des formes aux Etats-Unis, les lignes de la Chevrolet Corvair servirent en 1961 de modèle à la Prinz IV. La forme offrait les meilleures conditions d'habitabilité chez une petite voiture, qu'il s'agisse de la garde au toit, du volume du coffre ou de l'emplacement pour les genoux, et cela par 344 centimètres de longueur, 149 centimètres de largeur et 136 centimètres de hauteur.

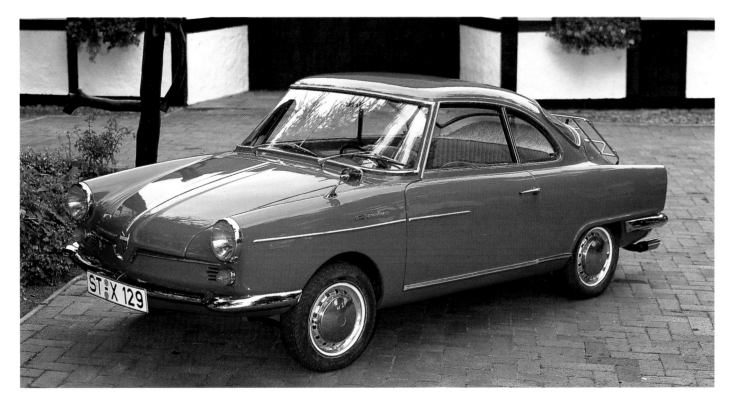

NSU Prinz III Coupé, Germany, Deutschland, Allemagne, 1958

While the saloon car was apparently influenced by American designs, the Prinz III coupé of 1958, created by Bertone was totally Italian in style. Like all designers, Bertone had left his mark, so that the front, in particular, had a touch of Alfa Romeo about it.

Auch wenn die Limousine amerikanische Einflüsse zeigte – für das Prinz III Coupé von 1958 war nur das italienische Kleid gefragt, das hier Bertone schuf. Da jeder Karossier seine Handschrift bewahrte, hatte auch der Sportprinz speziell im Frontbereich einen Hauch Alfa-Romeo.

On décèle peut-être une influence américaine dans les formes de la berline, mais pour le coupé Prinz III de 1958 on ne demandait que la carrosserie italienne, créée ici par Bertone. Comme chaque carrossier garde son style, la Sportprinz avait, particulièrement à l'avant, un petit air d'Alfa Romeo.

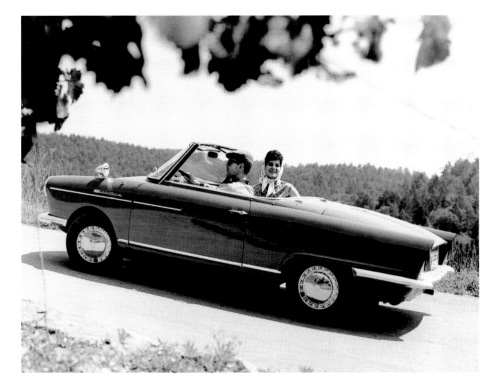

Bertone Prinz Cabriolet, Italy, Italien, Italie, 1964

Unlike the Sport Prinz, the contours of the Wankel Spider – also designed by Bertone – had a certain buoyant lightness. The new engine design involved rotary pistons without any clearly definable capacity, so that the tax class was difficult to determine. This design had found its ideal place in the Spider. There was a ventilation aperture in the bonnet, and if the sun was shining, the canvas roof could be stowed away inconspicuously.

Anders als beim Sportprinz wurde Bertones Linienführung beim Wankel-Spider 1964 duftigleicht. Das neue Motorenkonzept – Rotationskolben ohne festlegbaren Hubraum und damit zunächst steuerlich nicht belegt – war in dieser Form bestens aufgehoben. Vorn gab es eine Luftöffnung für den Kühler, und bei Sonne konnte das Stoffdach unsichtbar verstaut werden.

Chez la Wankel-Spider 1964, les lignes de Bertone se firent, autrement que chez la Sportprinz, ultralégères. Le nouveau moteur – à piston rotatif sans cylindrée décelable et donc non imposable – était bien habillé. A l'avant se trouvait une entrée d'air pour le radiateur, et par beau temps, le toit en tissu pouvait être replié complètement.

Honda N 600, Japan, Japon, 1967

Honda started to build motorbikes after the Second World War. Its growth was virtually unmatched by any other Japanese company. Honda manufactured their first cars in 1962 – roadsters with high-speed engines that could not deny their origins in the world of bicycles. The illustration shows the N 600. An inch (2½ cm) shorter than the Mini, its performance was not nearly as good, though its utilization of space was similarly efficient.

Honda begann nach dem Zweiten Weltkrieg, Motorräder zu bauen. Kaum eine andere japanische Firma wuchs so schnell. Schon 1962 tauchten die ersten Autos auf, Roadster mit hochdrehenden Motoren, die ihre Herkunft vom Zweirad nicht leugnen konnten. Noch 2,5 Zentimeter kürzer als ein Mini, hatte der N 600 bei weitem nicht dessen Fahrqualitäten, in der Effektivität der Raumnutzung kam er ihm schon näher.

Honda commença après la Seconde Guerre mondiale à construire des motocyclettes, et rares sont les sociétés japonaises qui se développèrent aussi rapidement. Les premières voitures apparurent en 1962, des roadsters aux moteurs tournant très vite et ne pouvant cacher qu'ils descendaient du deux-roues. La N 600 mesurait 2,5 centimètres de moins que la Mini dont elle était loin de posséder les qualités routières, par contre elle s'en rapprochait au niveau de l'habitabilité.

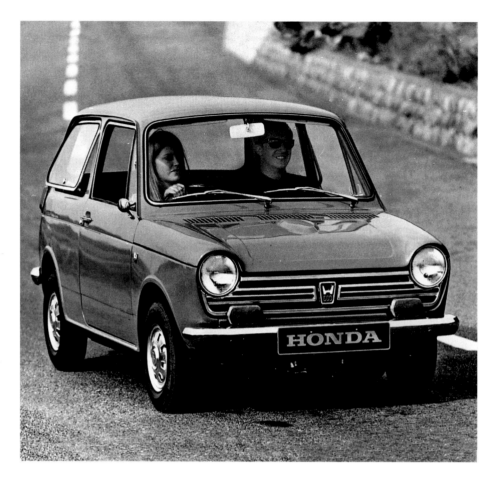

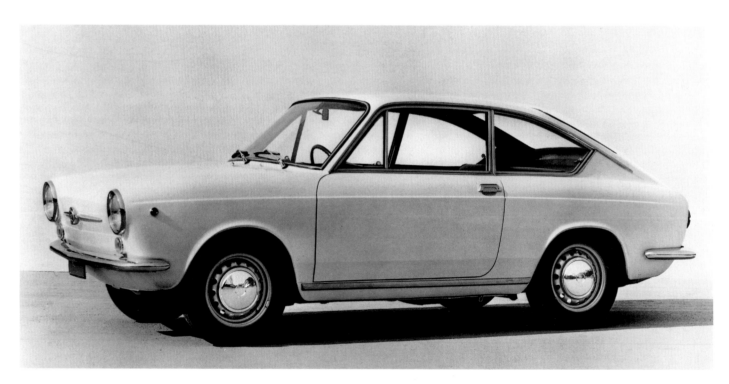

Fiat 850 Coupé, Italy, Italien, Italie, 1965

The Fiat 850 Coupé was one of the most successful coupés among small cars. The water-cooled rear engine was considered to be rather unsightly. Built from 1965 to 1974, this car was also available as a beautiful Bertone roadster.

Das Fiat 850 Coupé war eine der erfolgreichsten Coupé-Versionen auf dem Kleinwagenmarkt. Den wassergekühlten Heckmotor hatte man für optisch wenig vorteilhaft gehalten. Das von 1965 bis 1974 gebaute Auto gab es darüber hinaus auch als bildschöne Roadsterversion von Bertone.

Le coupé Fiat 850 fut un des coupés qui ont eu le plus de succès sur le marché des petites voitures. On s'était dit que le moteur à l'arrière refroidi à l'eau n'était pas très présentable. La voiture, construite de 1965 à 1974, existait également en version roadster, dans une très belle carrosserie de Bertone.

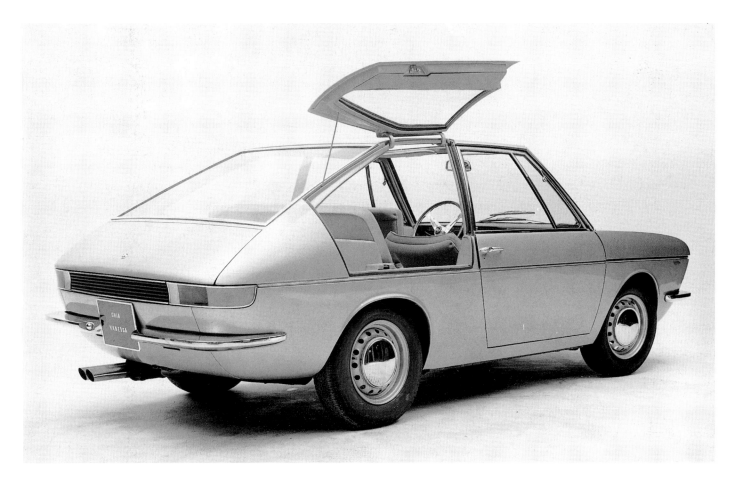

Fiat Ghia Vanessa, Italy, Italien, Italie, 1966

Based on the mechanical principle of the Fiat 850, Ghia sported a city car for elegant ladies at its Turin salon: a shopping bag could be placed quickly on the back seat through an opening in the side of the car. The purple velvet inside the car is a delight to the eye. This single item showed a clean design, as evidenced by the inconspicuous rear sun visor with air slits.

Auf der Basis der Fiat 850-Mechanik führte Ghia 1966 auf dem Turiner Salon einen Stadtwagen für die elegante Dame vor: Die Einkaufstüte wurde flott durch die Seitenklappe auf die Rücksitzbank befördert. Und das Auge erfreute sich am samtigen Violett des Innenraums. Das Einzelstück zeigt ein sauberes Design, wie z. B. die unauffällige Heckblende mit Luftschlitzen beweist.

En 1966, à l'occasion du Salon de Turin, Ghia présenta une voiture urbaine pour élégantes, basée sur la mécanique de la Fiat 850. On pouvait lancer les sacs sur le siège arrière par le volet latéral. Et le velours violet de l'habitacle réjouissait l'œil. Cette pièce unique montre un dessin net, par exemple le panneau arrière discret pourvu de fentes pour l'aération.

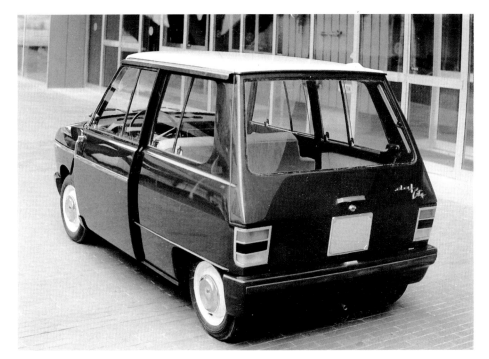

OSI Taxi, Italy, Italien, Italie, 1966

When talking about compact cars, we can also include compact taxis. In 1966 the Italian body designer Osi experimented with DAF mechanics, i.e. with infinitely variable gears, to produce a city taxi. The Fiat version turned out to be almost identical.

In die Überlegungen über Kompaktautos kann man auch Kompakttaxis einbeziehen. 1966 probierte der italienische Karossier OSI auf DAF-Mechanik, also mit stufenlosem Getriebe, ein Citytaxi aus. Fast identisch geriet die Fiat-Version.

Qui dit voitures compactes, dit taxis compacts. En 1966, le carrossier italien OSI essaya de lancer un taxi urbain sur une mécanique DAF, voiture dotée d'une transmission à réglage continu. La version Fiat était presque identique.

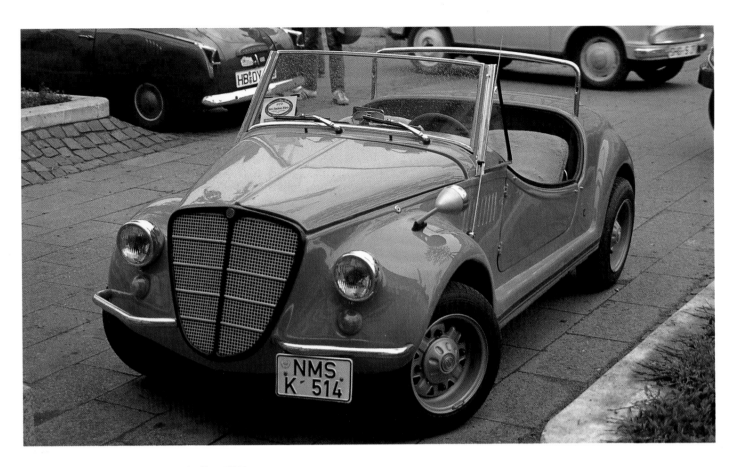

Fiat 500 Zagato, Italy, Italien, Italie, 1970

Smalls cars had become fully fledged vehicles that could cope nicely with the demands of everyday life. Eventually, therefore, their shapes were no longer governed entirely by utilitarian principles, but began to contain an element of playfulness. This is certainly true of the Fiat 500 Zagato, styled as a vintage car. The German mail order company Otto liked the idea and included the car in its 1972 catalogue. We do not know how successful they were, but it was not a failure.

Kleinwagen waren so sehr alltagstaugliche, vollwertige Autos geworden, daß man schließlich begann, ihre Formen nicht nur durch den Nutzen bestimmen zu lassen, sondern damit zu spielen. Zagato tat das mit dem Fiat 500 und dem Oldtimerlook. Das deutsche Versandhaus Otto fand das gut – und nahm's 1972 in den Katalog. Erfolg: unbekannt, also mehr als mäßig.

Les petites voitures étaient devenues des voitures à part entière. Elles remplissaient si bien leurs fonctions que l'on commença à ne plus considérer leurs formes uniquement d'un point de vue fonctionnel et à jouer avec elles. C'est ce que fit Zagato avec la Fiat 500, lui donnant un air un peu vieillot. La maison de ventes par correspondance Otto apprécia le résultat et présenta en 1972 la voiture dans son catalogue. On ne sait rien de son succès, il a donc dû rester plus que modeste.

Urbanina, Italy, Italien, Italie, 1966

A motorized washing basket on four wheels with a chair on top can hardly solve the traffic problem of the inner city, even though the designers of the Urbanina, who demonstrated the model at the 1966 Turin Salon, were convinced that the car could be parked sideways.

Ein motorisierter Wäschekorb mit vier Rädern und Stuhl kann nicht die Lösung für den Stadtverkehr sein, auch wenn die Macher des Modells Urbanina, 1966 auf dem Turiner Salon gezeigt, davon überzeugt waren: Man konnte das Auto quer einparken.

Une corbeille à linge dotée d'un moteur, de quatre roues et d'une chaise ne peut pas être la solution aux problèmes de la circulation, même si les créateurs du modèle Urbanina, présenté en 1966 au Salon de Turin, en étaient persuadés: on pouvait garer la voiture en travers.

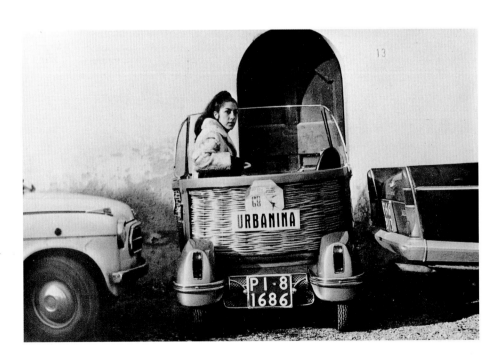

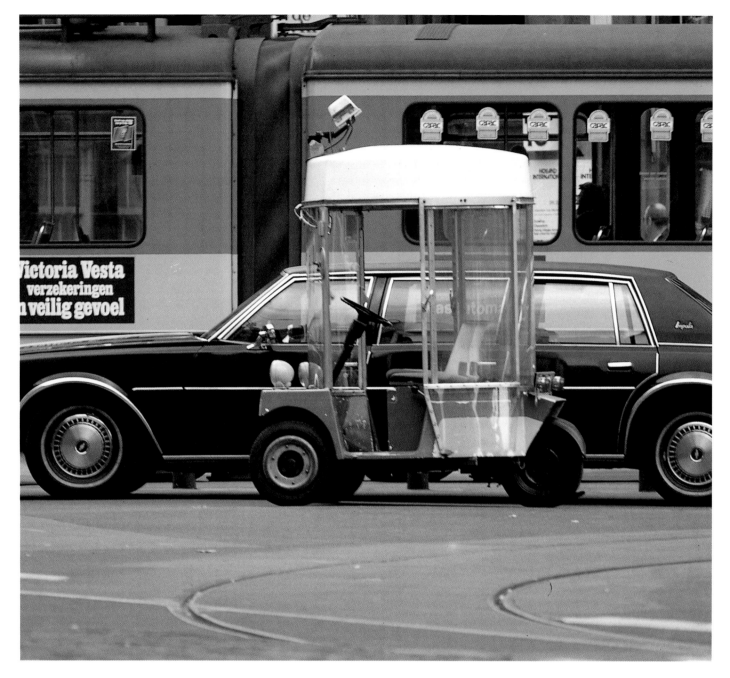

Witcar, 1980

Like the Urbanina, the Witcar – which could be found in the streets of Amsterdam in 1980 – served as a reminder that trams are a good alternative to a Chevrolet Caprice. Cars that are specially designed for the congested streets of the inner city will probably never solve the problem of overcrowded towns.

Ähnlich einem Urbanina wies dieser Witcar 1980 in den Straßen von Amsterdam darauf hin, daß es neben der Alternative eines Chevrolet Caprice noch die Straßenbahn gab. Autos, nur für die enge Innenstadt erdacht, werden das Problem überfüllter Städte wohl nie recht lösen können.

Sur cette photo prise en 1980 dans les rues d'Amsterdam, la Witcar indique qu'entre la petite voiture et la Chevrolet Caprice, on peut aussi se décider pour le tramway. Les voitures à vocation urbaine ne pourront jamais vraiment résoudre les problèmes d'encombrement.

Modern Small Cars

Moderne Kleinwagen

Petites voitures modernes

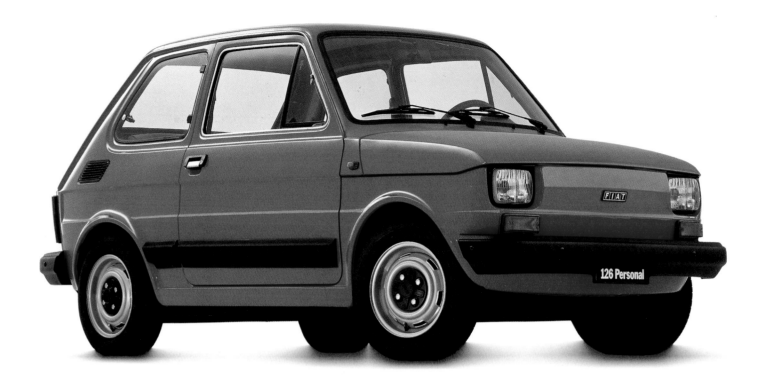

Fiat 126, Italy, Italien, Italie, 1972

The Fiat 126 has been built since 1972, and there is even a Polish licence. In fact, in Poland, it is considered to be the standard car *par excellence*. The fact that the prototype is as long as a Mini but less spacious inside shows that a rear engine is not the be-all and end-all. The Cinquecento, the successor of the 126, was therefore given a front engine, built in sideways in 1992.

Der Fiat 126 wird seit 1972 gebaut, inzwischen auch als polnische Lizenzproduktion. Dort ist er der Autostandard schlechthin. Daß das Urmodell so lang ist wie ein Mini und innen doch nicht geräumiger, beweist, daß ein Heckmotor nicht die ultima ratio darstellt. Der Cinquecento, der Nachfolger des 126er, hat denn auch 1992 einen querliegenden Frontmotor bekommen.

La Fiat 126 construite depuis 1972 est également fabriquée depuis sous licence polonaise. En Pologne, elle est tout simplement la voiture standard. Le fait que le modèle d'origine soit aussi long qu'une Mini sans être plus spacieux à l'intérieur prouve que le moteur placé à l'arrière n'est pas la solution idéale. Le Cinquecento, le successeur de la Fiat 126, lancé en 1992, est d'ailleurs équipé d'un moteur transversal à l'avant.

Autobianchi A 112, Italy, Italien, Italie, 1969

The A 112 emphasized the headlights, the front, the side contours and the rear, as this side view shows. The car was 56 inches (327 cm) long, and had its debut in 1969.

Der A 112 betonte Frontscheinwerfer, Grill und Gürtellinie auch in der Heckpartie, wie die Seitenansicht zeigt. 1969 hatte der 327 Zentimeter lange Wagen sein Debüt.

La A 112 mettait l'accent sur les phares, la calandre et la ligne médiane prolongée jusqu'à la partie arrière comme le montre l'illustration; elle mesurait 327 centimètres de long et fit son apparition en 1969.

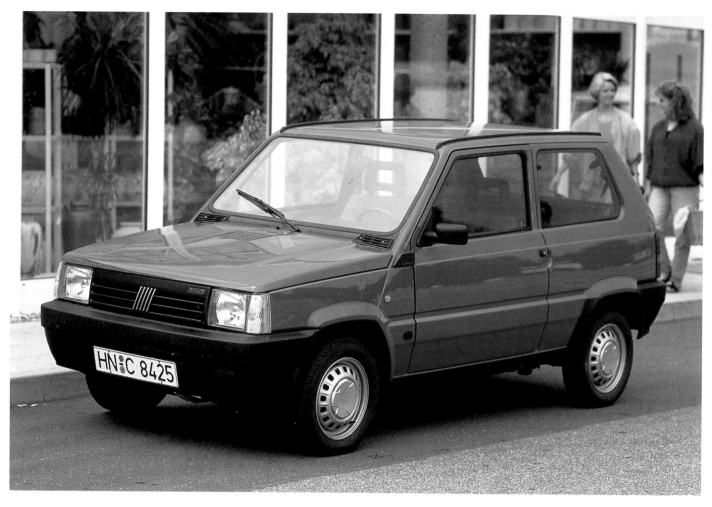

Fiat Panda, Italy, Italien, Italie, 1980

Ever since a famous film was shown through-out Germany in 1980, Germans have enjoyed referring to their cars as »boxes«, using a word that had been more a term of abuse until then. It also draws attention to the fact that motorists can quite happily choose to do without a number of features. As the succes-sor of the Fiat 127, the Panda put greater emphasis on advertising than on technology. With a height of 56 inches (142 cm), it allows passengers to sit upright.

Seit 1980 darf ein Auto ungestraft (tolle) »Ki-ste« genannt werden. Die Formulierung zielte bewußt auf das einfache Konzept in einer Welt der komfortabel gewordenen Minis. Nachdem so auf die Freiwilligkeit des Ver-zichts hingewiesen wurde, setzt der Panda als Fiat 127-Nachfolger denn auch mehr auf die Werbung als auf seine Technik. Mit 142 Zenti-metern Höhe pflegt er auch das aufrechtere Sitzen.

Depuis 1980, les voitures sont devenues des «caisses» et le terme n'est pas péjoratif puis-qu'il veut caractériser sciemment la concep-tion simple de Minis devenues confortables. Ce renoncement volontaire étant maintenant connu, la Panda, qui succède à la Fiat 127, mi-se plus sur la publicité que sur sa technique. Haute de 142 centimètres, on peut aussi s'y asseoir plus droit.

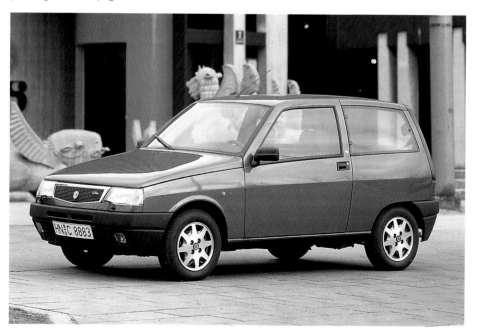

Lancia Y 10, Italy, Italien, Italie, 1992

The Y 10 of the Fiat subsidiary Lancia was similar in size to a Panda »box« and, because of its luxurious accessories, intended to be the Mercedes among the Minis.

Ähnlich groß wie eine Panda Kiste, war der Y 10 der Fiat-Tochter Lancia dank seiner Edel-ausstattung als Mercedes unter den Minis gedacht.

La Y 10 construite par Lancia, filiale de Fiat, à peu près aussi grande qu'une Panda et luxueu-sement équipée, était, ceci entraîne cela, la Mercedes d'entre les petites voitures.

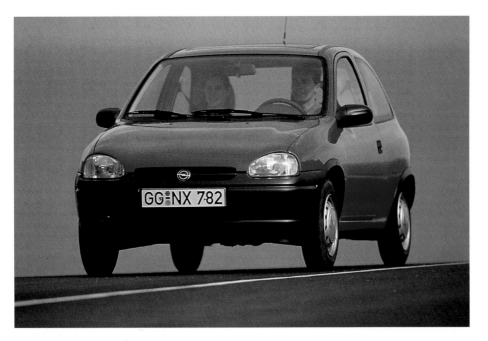

Opel Corsa, Germany, Deutschland, Allemagne, 1993

In the general struggle for market shares and with increasing expectations of comfort, small cars are turning into luxury vehicles. With its 144 inches (365 cm), the most powerful version of the Corsa (109 HP) costs nearly £12,000 ($20,000). Yet it is still a popular car.

Im Kampf um Marktanteile und bei gewachsenen Ansprüchen an den Komfort werden aus den Kleinen Luxusgefährte. 365 Corsa-Zentimeter können in der stärksten Version (109 PS) bis an die 30 000 DM-Marke getrieben werden. Trotzdem: Das Auto gefällt.

La lutte pour les parts de marché se faisant plus dure et la clientèle devenant de plus en plus exigeante au niveau du confort, les petites voitures se transforment en véhicules de luxe. 365 centimètres de Corsa peuvent, dans la version la plus performante (109 CV) atteindre les 30 000 marks. Ce qui ne l'empêche pas de plaire!.

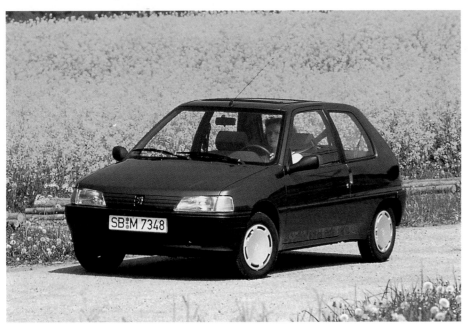

Peugeot 106, France, Frankreich, 1992

The Peugeot 106 (which had its première in 1992) is 2½ inches (6½ cm) lower than the Cinquecento and 13¼ inches (34 cm) longer. The extra length is vital to accommodate the four doors. The car is also available in a fast version with 94 HP.

Der Peugeot 106 (Premiere 1992) ist 6,5 Zentimeter niedriger als der Cinquecento und 34 Zentimeter länger. Die braucht er auch, weil seine Karosse auch mit vier Türen gebaut wird. Und: Er kann als Renner mit 94 PS gekauft werden.

La Peugeot 106 lancée en 1992 a 6,5 centimètres de moins en hauteur et 34 centimètres de plus en longueur que la Cinquecento. Elle en a besoin puisqu'elle est aussi construite en version quatre portes. Il en existe une version sportive de 94 CV.

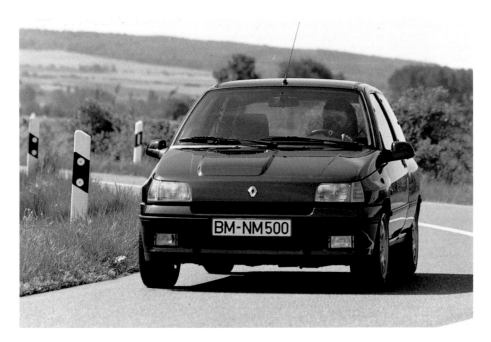

Renault Clio Williams, France, Frankreich, 1993

With its 146¼ inches (371¼ cm), the Renault Clio is about as long as the first Golf in 1974. It is an excellent little car. The 1993 version was a full upgrade, and the name of the F1 stable was taken over. With its 150 catalyzed HP, it can accelerate up to 60 mph (100 km/h) within 7.8 seconds.

Der Renault Clio, mit 371,2 Zentimetern ähnlich lang wie der erste Golf 1974, ist schon eine heiße Version. 1993 wird draufgesattelt, der Name des F1-Rennstalles übernommen. 150 katalysierte PS erreichen nach 7,8 Sekunden 100 Stundenkilometer.

La Renault Clio, dont la longueur est semblable à celle de la première Golf de 1974 (371,2 centimètres), cache bien son jeu. En 1993 elle a gagné des CV et pris le nom de l'écurie de Formule 1. Ses 150 CV équipés d'un pot catalytique atteignent en 7,8 secondes 100 kilomètres/heure.

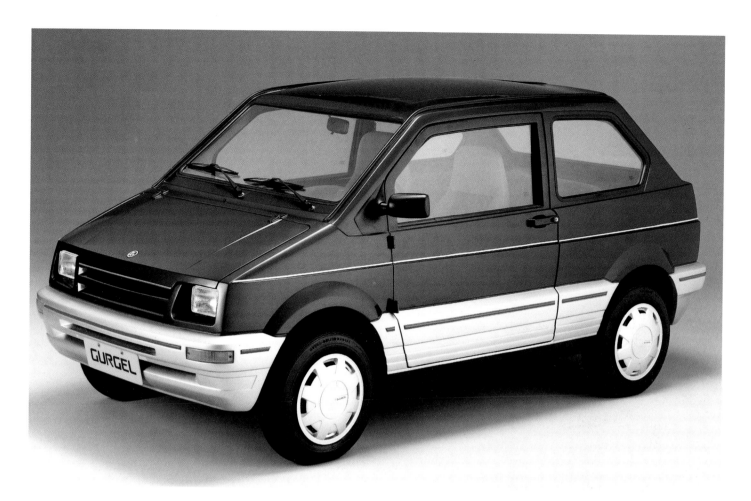

Gurgel Supermini, Brasil, Brasilien, Brésil, 1993

Brazil has its Mini, too. The Gurgel »Supermini«, here in the 1993 version, is a mere 126 inches (319) long, 59 inches (150 cm) wide and a commodious 58 inches (147 cm) high. The profiles of the window frames, wheels and front have a rustic quality about them. The off-road version, with its minivan profile, is bolder in its visual impact and more logically consistent. However, as the body is made of fibre glass, it lacks the impression of delicate craftsmanship that one might find in a metal body.

Auch Brasilien hat einen Mini. Der Gurgel »Supermini« in der Version des Modelljahres 1993 kommt mit 319 Zentimetern Höhe aus. Etwas rustikal die kräftigen Profile von Fensterrahmen, Radausschnitten und Front. Dabei ist die Geländeversion im Mini-Van-Profil mit der herben Detailsprache logischer gestaltet. Aber da die Karosserie aus Kunststoff besteht, kann nicht so fein ziseliert werden wie in Blech.

Le Brésil aussi a sa Mini. La Gurgel Supermini, modèle 1993, a 319 centimètres de long, 150 centimètres de large et 147 confortables centimètres de haut. Les profils puissants des encadrements des vitres, les échancrures des roues et le capot sont un peu rustiques. La version tout-terrain, genre Mini-Van, aux détails grossiers, est conçue plus logiquement. Mais sa carrosserie est en plastique, on peut donc la travailler moins finement qu'une carrosserie de tôle.

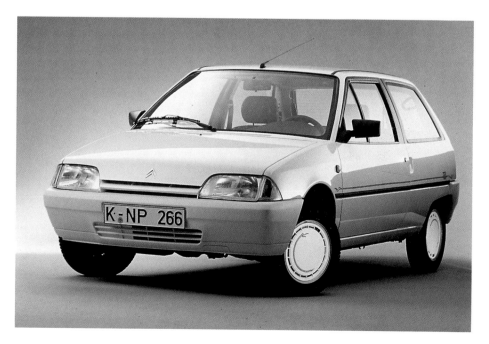

Citroen AX, France, Frankreich, 1986

With its mere 138– inches (252½ cm), this 1986 Citroën AX is just as perfectly streamlined as a large saloon. The sailor's rule that longer vessels are faster also applies to cars and their aerodynamic drag factor (or cd factor).

Dieser Citroën AX, Debüt 1986, gehört zu jener Kategorie, die mit knapper Länge (352,5 Zentimeter) windschlüpfig wie perfekt ausgelegte große Limousinen ist. Die Seglerregel »Länge läuft« gilt auch für Karosserien in puncto Luftwiderstandsbeiwert (Cw-Wert).

Cette Citroën AX, apparue en 1986, fait partie de cette catégorie de voitures qui, tout en étant petites (352,5 centimètres de longueur), ont des lignes aussi aérodynamiques que les grandes berlines parfaitement conçues. Son coefficient de traînée est très bas.

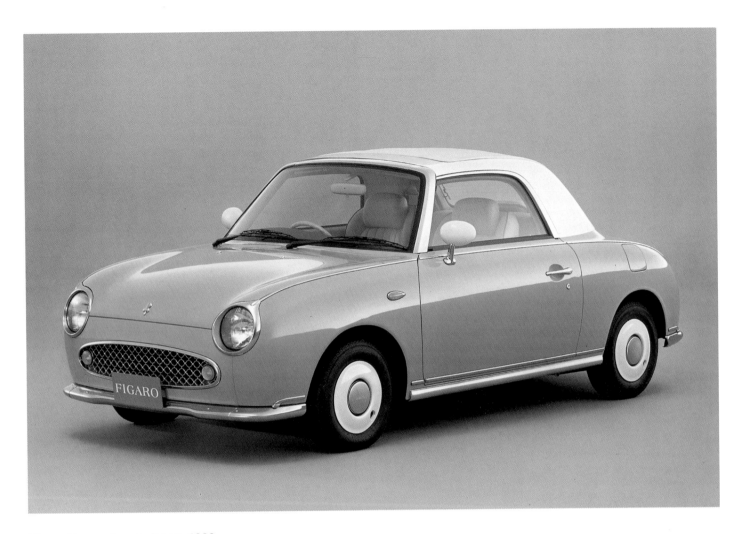

Nissan Figaro, Japan, Japon, 1990

The well-known Japanese car designer Naoki Sakai (Water Studios) was asked by Nissan to develop a new idea for the Pao and Figaro models. This is how the design of the so-called Retro cars came about.

The idea of including »Retro« elements in the styling of vehicles was to activate certain memories of the Thirties and Fifties, while combining these with elements of contemporary vocabulary of form and state-of-the-art technology.

Der bekannte japanische Konzept-Designer Naoki Sakai (Water Studios) wurde von Nissan beauftragt, eine neue Idee für die Modelle Pao und Figaro zu entwickeln; das Konzept der sogenannten »Retro-Autos« entstand.

Durch »Retro«-Elemente im Styling der Fahrzeuge wurden gezielt Erinnerungen an Modelle aus den 30er und 50er Jahren aktiviert, kombiniert mit Elementen zeitgenössischer Formensprache und modernster Technik.

Nissan chargea Naoki Sakai, le célèbre designer (Water Studios) d'élaborer une nouveau concept pour les modèles Pao et Figaro. C'est ainsi que l'idée des voitures Retro vit le jour. Les motifs de style rétro dans la carrosserie éveillent le souvenir des modèles des années 30 et 50 tout en étant combinés à des éléments formels contemporains et à la technique la plus moderne.

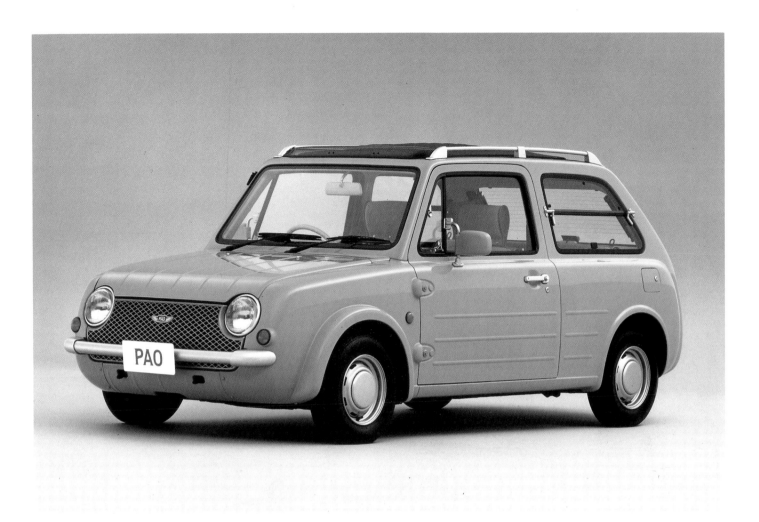

Nissan Pao, Japan, Japon, 1987

Designed in that stylistic retromix which has become so typical of Japanese cars, the Figaro, Pao and BE–1 were supported by additional marketing measures, such as the limitation of their numbers to an extremely small quantity (i.e. 28,000 items), sold in Japan only. There were special showrooms and even a special lottery for the Figaro, so that you had to win a prize before you could purchase the car.

Die Fahrzeuge Figaro, Pao und BE–1, gestaltet in der Art des inzwischen bereits typisch japanischen, stylistischen Retromix, wurden unterstützt von flankierenden Marketing-Maßnahmen wie der Limitierung auf extrem knappe Stückzahlen (28 000 Stück) und ausschließlich innerhalb Japans verkauft. Es gab spezielle Showrooms, und für das Modell Figaro wurde sogar eine spezielle Lotterie eingerichtet, bei der diejenigen Personen ausgelost wurden, die einen Wagen erwerben durften.

La Figaro, la Pao et la BE–1, conçues dans le style «retromix» devenu aujourd'hui typiquement japonais, ont également été soutenues par des mesures de marketing, par exemple la fabrication en nombre extrêmement limité (28.000) de voitures vendues uniquement au Japon. On avait prévu des halls d'exposition spécialisés et le modèle Figaro fit même l'objet d'une loterie au cours de laquelle les acheteurs furent tirés au sort.

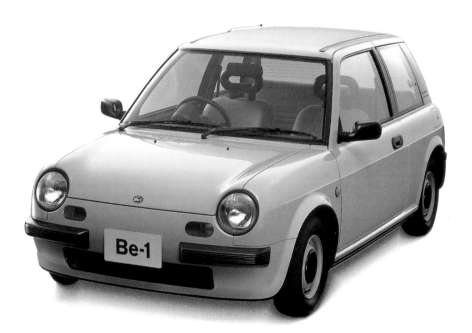

Nissan BE-1, Japan, Japon, 1987

The basic idea of the special marketing campaign for the Figaro, Pao and BE–1 was to achieve not massive sales figures but an image transfer from these special models to Nissan as a name and its ordinary models.

Grundgedanke der speziellen Vermarktung der Concept Cars Figaro, Pao und BE–1 war nicht der Massenumsatz, sondern ein Imagetransfer von diesen Spezialmodellen auf die Marke Nissan und ihre Allerweltsmodelle.

En commercialisant de manière particulière les Concept Cars Figaro, Pao et BE–1, on ne visait pas le profit mais un transfert de l'image de ces modèles spéciaux sur la marque Nissan et ses autres modèles plus ordinaires.

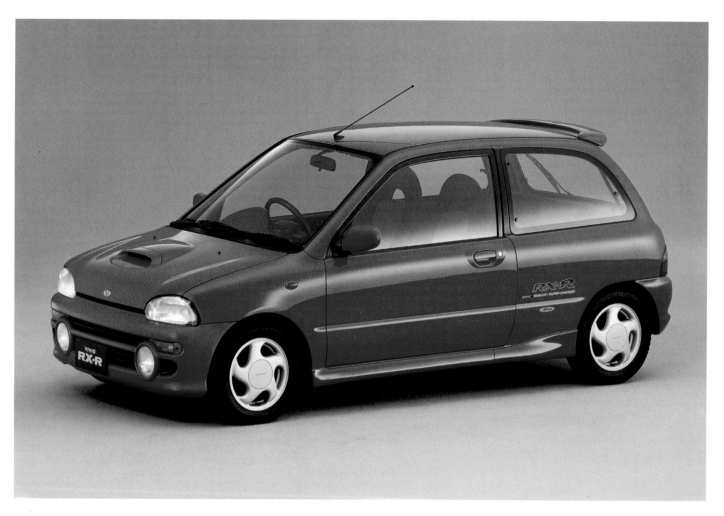

Subaru Vivio, Japan, Japon, 1992

Even the smallest cars now have relatively powerful engines, as well as a scoop, spoiler, sweller, a heavy front apron with large fog lights, aluminium wheel rims. The inevitable, but by now rather hackneyed optical tuning seems to undermine the whole mini concept. Manufacturers like Subaru are aware that what the customer wants is a car like the Vivio (1992 model) – a muscular vehicle with the telling name »Super Charger RX-R«.

Auch die Kleinsten werden mit stärkeren Motoren ausgestattet. Dazu kommen Hutze, Spoiler, Schweller und schwere Frontschürze inklusive großer Nebelleuchten. Alufelgen und das unvermeidliche, aber abgenutzte optische Tuning scheinen das Mini-Konzept zu konterkarieren. Hersteller wie Subaru wissen: Der Kunde will es so – wie den Vivio (Modell 1992), muskelstark »Super Charger RX-R« genannt.

Même les plus petites sont équipées de moteurs puissants. Déporteur, becquet, élargisseur et lourd tablier avant, plus les grands phares antibrouillard, les jantes en alliage léger et le tuning optique inévitable mais qui ne fait plus d'effet semblent contrarier la conception minimaliste. Mais des constructeurs comme Subaru savent ce que veut le client: le puissant modèle Vivio (1992), nommé Super Charger RX-R.

Suzuki Alto, Japan, Japon, 1992

The Suzuki Alto of 1992 is exactly as long as the Daihatsu Opti – down to a millimetre. It is based on an older, more angular design. While displaying a touch of Mini at the rear, it presents a more conventional view at the front (e.g. like the Citroën AX), while the rest is full of playful forms.

Auf den Millimeter so lang wie ein Daihatsu Opti, zeigt der Suzuki Alto (Modell 1992) das etwas ältere, kantigere Konzept. Ein Hauch Mini im Heckbereich, schon eher das übliche Bild an der Front (z. B. Citroën AX), mit dem Rest wird gespielt.

Au millimètre près, aussi longue que la Daihatsu Opti, la Suzuki Alto (modèle 1992) montre une conception plus ancienne, plus anguleuse. Un air de Mini à l'arrière, des lignes plutôt habituelles à l'avant (par exemple Citroën AX), on joue avec le reste.

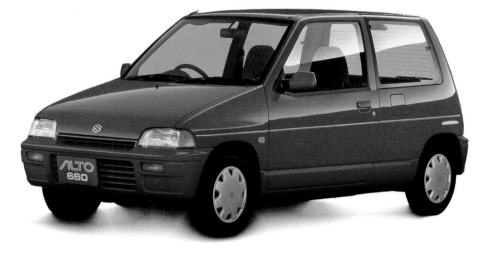

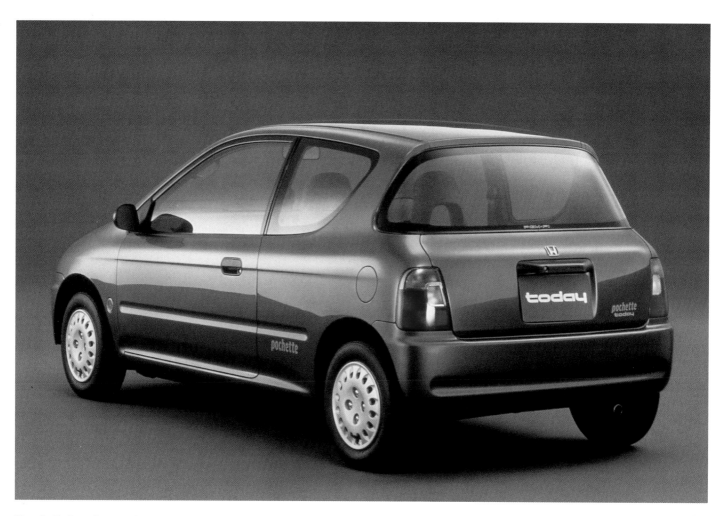

Honda Today, Japan, Japon, 1993

The first Honda Today was a one-box car without any recognizable distinction between front and back – and in fact a long time before the Twingo. This version of the Today has been around since early 1993. With its magic length of 129 inch (329½ cm) it seeks not only to fulfil the stipulations of the tax authorities about the maximum length, but also to find a compromise at the rear between a notchback, the demand for headroom and the length of the vehicle. The result: depending on the angle, the contours vary considerably – and the ancient motif of the Fifties, the wrap-around windscreen is suddenly resurrected again as a functional detail.

Der erste Honda Today war ein One-Box-Auto ohne erkennbare Bug- und Heckausprägung, und das lange vor einem Renault Twingo von 1992. Dieser Honda Today versucht seit Anfang 1993 mit der magischen Länge von 329,5 Zentimetern – siehe die anderen Japan-Minis – nicht nur Vorgaben des Fiskus in bezug auf die Länge zu erfüllen, sondern auch für das Heck einen Kompromiß zu finden zwischen Stufenheck, der Forderung nach Kopffreiheit und der Fahrzeuglänge. Ergebnis: Aus verschiedenen Perspektiven betrachtet, wandelt sich der Umriß lebhaft – und das alte Motiv der 50er Jahre, die Panoramaheckscheibe, darf plötzlich als funktionelles Detail auferstehen.

La première Honda Today avait la forme d'une caisse sans capot ni arrière marquants, et cela bien avant que n'apparaisse la Renault Twingo. Cette Honda Today tente depuis le début 1993 avec le chiffre magique de 329,5 centimètres de longueur – voir les autres Japonaises – non seulement de remplir les exigences du fisc au niveau de la longueur, mais aussi de trouver un compromis pour l'arrière entre le trois-volumes, l'exigence d'une garde au toit supérieure et la longueur du véhicule. Résultat: selon la perspective, la carrosserie semble s'animer et le motif des années 50, la lunette arrière panoramique, devient tout à coup un détail fonctionnel.

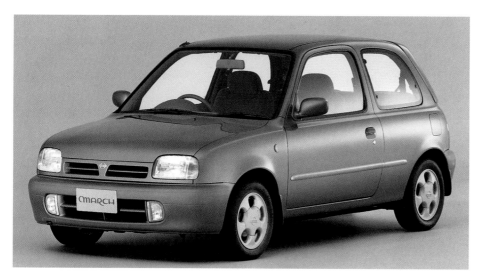

Nissan Micra, Japan, Japon, 1992

In 1992 the Nissan Micra was recreated in a new form –129– inches (370½ cm) long, 62½ inches (159 cm) wide and 56¼ inches (143 cm) high. But fast cars of this kind are really only small versions of medium-sized cars rather than minis in their own right.

1992 kam der Nissan Micra in neuer Form (Länge 370,5 Zentimeter, Breite 159 Zentimeter, Höhe 143 Zentimeter). Flotte Autos dieser Machart sind eher kleinere Ableger von Mittelklassewagen als eigenständige Minis.

En 1992, la Nissan Micra a reçu une nouvelle carrosserie (longueur 370,5 centimètres, largeur 159 centimètres, hauteur 143 centimètres). Les voitures de ce genre sont plutôt des dérivés en miniature des voitures de classe moyenne que de vraies petites voitures.

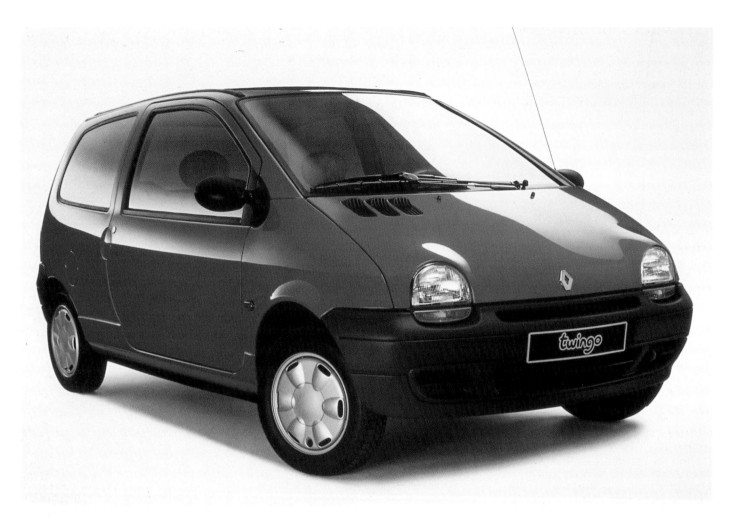

Renault Twingo, France, Frankreich, 1992

The Renault Twingo is small with its 135 inches (343 cm) in length and certainly creates a feeling of space with its front windscreen placed further forward. At the same time, however, the vision area is slightly restricted by the mullions (A-columns). The design is beautiful, but the engineers had to take a lot of stick for putting a noisy old engine inside a fresh minivan garment – even though it was sturdy and economical.

Der Renault Twingo ist mit 343 Zentimetern Länge noch klein, bietet durch die vorgerückte Frontscheibe ein Gefühl von Raum, aber ein etwas eingeschränktes Gesichtsfeld durch die Fensterpfosten (A-Säulen). Ein schönes Design, allerdings werden die Techniker beschimpft, weil dem frischen Mini-Van-Kleid ein alter, lauter Motor spendiert wurde, der jedoch robust und sparsam ist.

La Renault Twingo est encore petite avec ses 343 centimètres de longueur, mais son pare-brise plongeant procure une sensation d'espace, bien que ses montants (colonnes A) limitent la vue d'ensemble. Un design réussi, mais on n'applaudit pas les techniciens qui ont pourvu la belle carrosserie Mini-Van d'un vieux moteur bruyant, bien que robuste et économique.

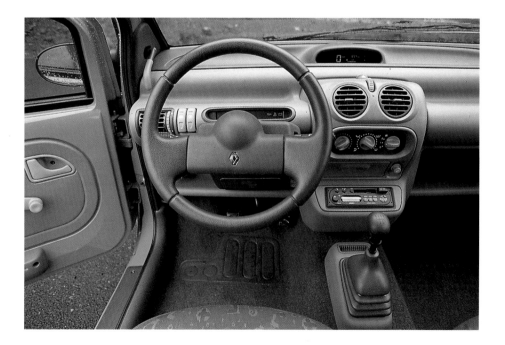

Fiat Cinquecento, Italy, Italien, Italie, 1992

127 inches (322,5 cm) long, 58½ inches (148.5 cm) wide, and 56½ inches (143,5 cm) high. Hardly ever has a small car like the 1992 Cinquecento fulfilled the needs of four so accurately. Giugiaro has helped to create a clear design and a whole culture of sitting upright.

Länge 322,5 Zentimeter, Breite 148,5 Zentimeter, Höhe 143,5 Zentimeter. Selten hat ein Kleinwagen wie der Fiat Cinquecento (1992) so akkurat die Bedürfnisse von vier Personen erfüllt. Mit Hilfe von Giugiaro ist eine klare Architektur und eine Kultur des aufrechten Sitzens entstanden.

Longueur 322,5 centimètres, largeur 148,5 centimètres, hauteur 143, 5 centimètres. Il est rare qu'une petite voiture comme la Fiat Cinquecento (1992) remplisse aussi précisément les besoins de quatre personnes. Avec l'aide de Giugiaro, on a créé un design pur et cultivé la possibilité de s'asseoir le dos droit.

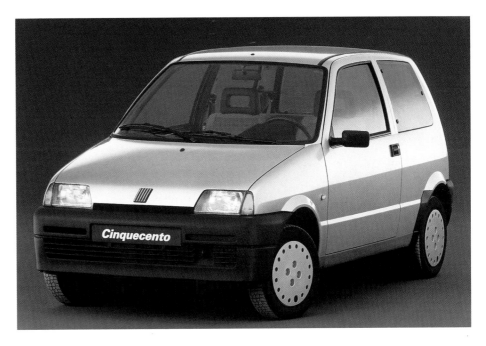

Fiat Cinquecento-Derivate, Italy, Italien, Italie

Following its 1992 première, the Fiat Cinquecento fell into the hands of body designers: the »Grigua« at the back is by Idea and has been styled as a colourful space capsule, the row in front (from left to right) shows a white pick-up with colourful splotches by Pininfarina, then the original Fiat by Maggiora with virtually no changes at all, and a variation of the Twingo in one-box design by Italdesign. The next row (from left to right) shows Boneschi's Baby Taxi, a fast mobile bicycle stand called Z Eco by Zagato in their own exotic style, and Bertone's yellow grasshopper in cross-country outfit. Finally, right at the front, a somewhat student-like design – the Fionda coupé by Coggiola.

Der Fiat Cinquecento geriet bei der Premiere 1992 in die Hände der Karossiers: Ganz hinten »Grigua« von Idea als bunte Raumkapsel, davor von links nach rechts der weiße Pick-Up mit bunten Klecksen von Pininfarina, der kaum veränderte Original-Fiat von Maggiora, eine Twingo-Variante von Italdesign im One-Box-Profil, in der Reihe davor (v. l. n. r.) Boneschi und sein »Babytaxi«, der rasende Fahrradständer »Z Eco« von Zagato in haustypischer Exotik, der gelbe Knallfrosch im Runabout-Dress von Bertone und ganz vorne eine etwas »studentische« Lösung, das Coupé »Fionda« von Coggiola.

Lors de sa présentation en 1992, la Fiat Cinquecento tomba aux mains des carrossiers: à l'arrière-plan, Grigua, capsule spatiale multicolore, devant de gauche à droite, le pick-up blanc aux taches colorées de Pininfarina, une version à peine transformée de la Fiat originelle par Maggiora, une variante monospace de la Twingo par Italdesign. Dans la rangée du devant , de gauche à droite, Boneschi et son Bébétaxi, le porte-bicyclettes frénétique Z-Eco de Zagato à l'allure exotique caractéristique de la maison, le pétard jaune déguisé en petite voiture de Bertone et au premier plan, une solution un peu «estudiantine», le coupé Fionda de Coggiola.

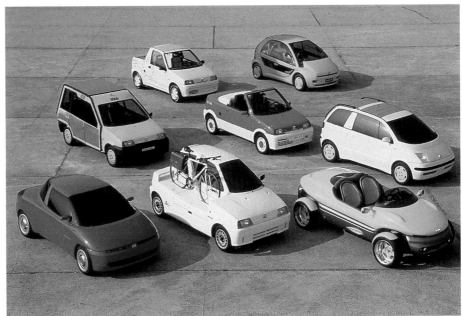

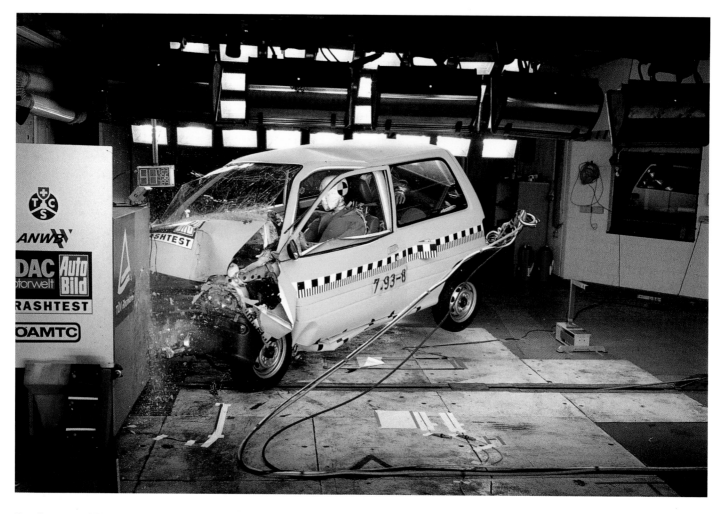

Crashtests, 1993

A large-scale crash test in 1993 left the Daihatsu Cuore (above) miles behind where safety values were concerned. The same is true of the Fiat Cinquecento (below) – just when it was about to be launched in Germany. Both cars ended up with above-average deformation of the inside. When it comes to the crunch, small cars have a hard job keeping their shape.

Ein groß angelegter Crashtest läßt 1993 den Daihatsu Cuore (oben) sicherheitstechnisch mit miesen Werten zurück, ebenso den Fiat Cinquecento (unten) – just bei seiner Markteinführung in Deutschland. Beide mit einem überdurchschnittlich verformten Innenraum. Kleine Karossen haben es schwer, formstabil zu sein, wenn es darauf ankommt.

En 1993, les résultats de simulations d'accidents indiquent un niveau de sécurité insuffisant pour la Daihatsu Cuore (en haut) et la Fiat Cinquecento (en bas), qui vient juste d'être lancée en Allemagne. L'habitacle des deux véhicules est plus déformé que la moyenne. Difficile pour une petite carrosserie de conserver sa stabilité quand il le faudrait.

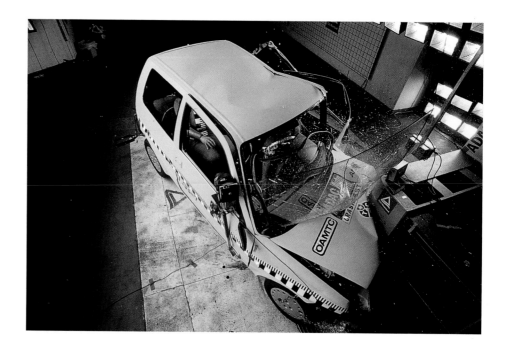

Car manufacturers get the creeps when they look at photos of yellow cars that have performed badly in crash tests. This is what happened to the Renault Twingo (middle). The Opel Corsa (top) and the Nissan Micra (below) did not mangle their dummies quite so much and achieved a good-to-medium standard. So small cars can be safe after all.

Vor diesen Bildern mit gelben, an der Wand zerschellten Autos zittern Hersteller, die schlechte Crash-Werte hinnehmen müssen. Das war in diesem Fall Renault (Mitte) mit dem Twingo, Opel mit dem Corsa (oben) und Nissans Micra (unten) hatten die Crashpuppen (Dummies) weniger strapaziert und erreichten gutes Mittelklasseniveau. Es geht doch: klein und sicher.

Les constructeurs dont les voitures sont mal notées lors des simulations d'accidents tremblent devant ces photographies de voitures jaunes écrasées sur un mur. Ici, il s'agit de la Renault Twingo (au milieu). L'Opel Corsa (en haut) et la Nissan Micra (en bas) ont mieux protégé leurs dummies et ont atteint un bon niveau de classe moyenne. On peut donc construire petit mais sûr.

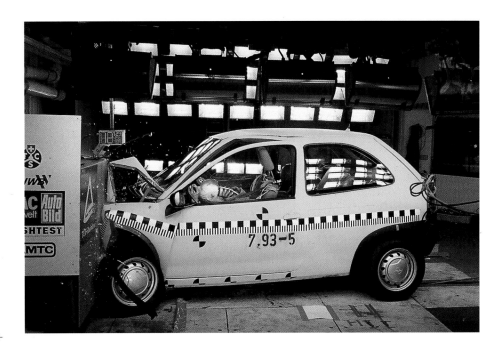

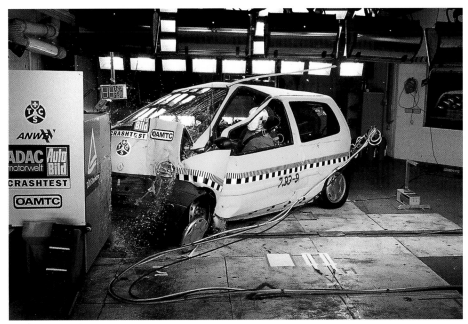

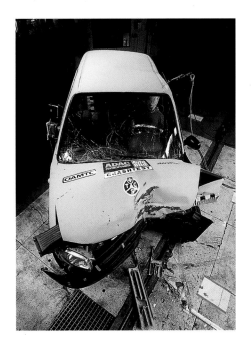

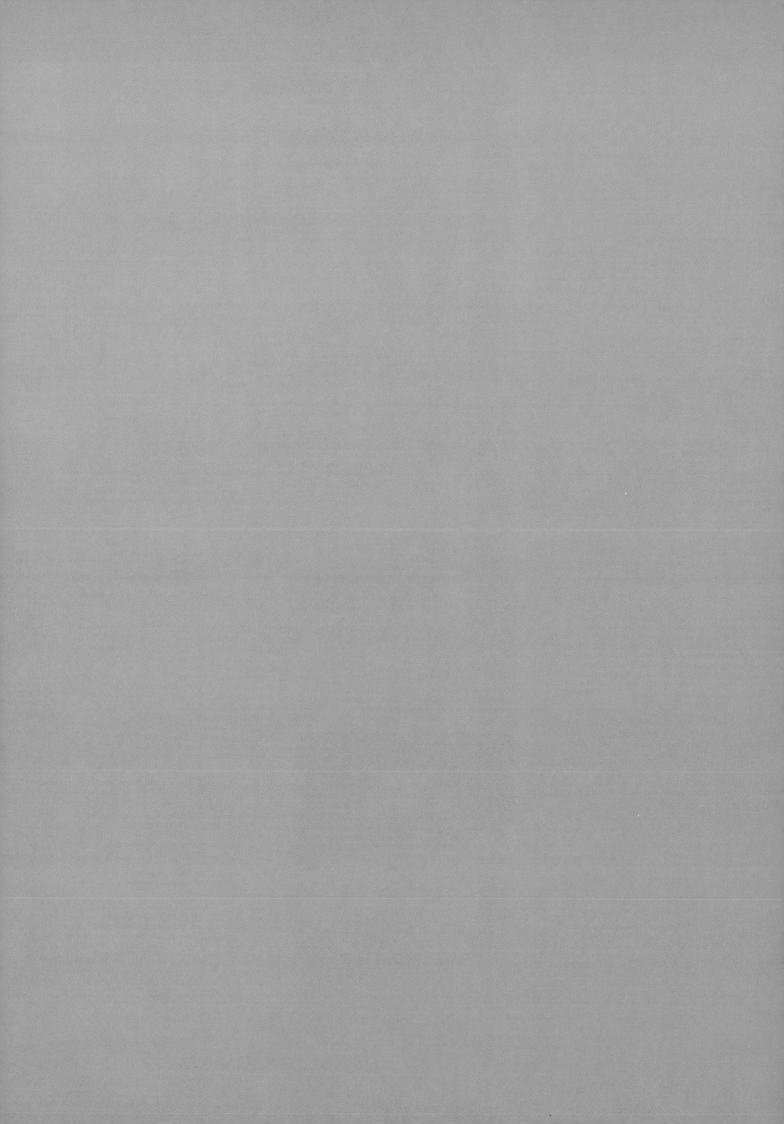

Curiosities and Innovations
Kuriositäten und Innovationen
Curiosités et innovations

Michelotti Strandwagen, Italy, Italien, Italie, 1966

Michelotti, who helped with the shape of the DAF 33 series, built this beach car as a single model in 1966. Whereas the chassis shows some potential, the canvas roof and the wicker chairs look more like pieces of garden furniture.

Michelotti, der bei dem Serienmodell DAF 33 Formfindungshilfe gab, baute diesen Strandwagen 1966 als Einzelmodell. Im Gegensatz zu dem entwicklungsfähigen Unterbau reizen das Stoffdach – wie bei einer Hollywood-Schaukel – und die korbgeflochtenen Sitze eher zum Lächeln.

Michelotti, qui a aidé à créer les formes de la Daf 33, a construit en 1966 cet exemplaire unique de voiture de plage. On aurait pu en aménager la partie inférieure , mais le toit en tissu – comme celui des balançoires hollywoodiennes – et les sièges cannés prêtent à sourire.

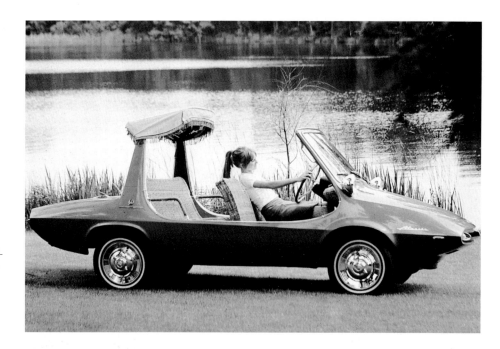

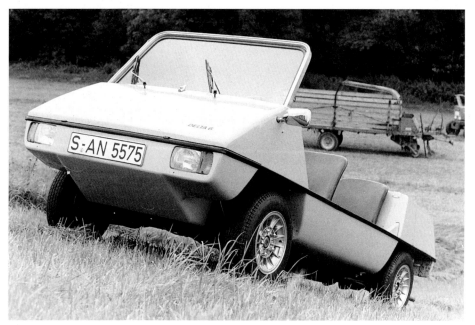

Delta 6, Germany, Deutschland, Allemagne, 1970

The Stuttgart Delta Design Team had already become famous for its Glas and NSU-based prototypes, just above the size of a Mini. Their Delta 6 of 1970 was intended as a car with a fibre-glass body for developing countries. The enclosed chassis allowed a number of different bodies to be screwed on. An elegant car with a length of 132 inches (335 cm) and a wheel base of 80¼ inches (204 mm).

Das Stuttgarter Delta-Designteam, bekannt geworden durch Prototypen auf Glas- und NSU-Basis knapp über Minigröße, wollte mit dem Delta 6 von 1970 ein Fahrzeug mit Kunststoffkarosse für Entwicklungsländer anbieten. Auf die geschlossene Bodenwanne konnten verschiedene Aufbauten geschraubt werden. Ein eleganter Wagen mit 335 Zentimetern Länge und einem Radstand von 204 Zentimetern.

L'équipe de stylistes Delta de Stuttgart, connue pour ses prototypes sur la base de Glas ou NSU à peine plus grands qu'une Mini, avait conçu en 1970 la Delta 6 dotée d'une carrosserie de plastique pour les pays en voie de développement. Sur la caisse-baquet fermée on pouvait fixer différentes constructions. Une voiture élégante de 335 centimètres de long avec un empattement de 204 centimètres.

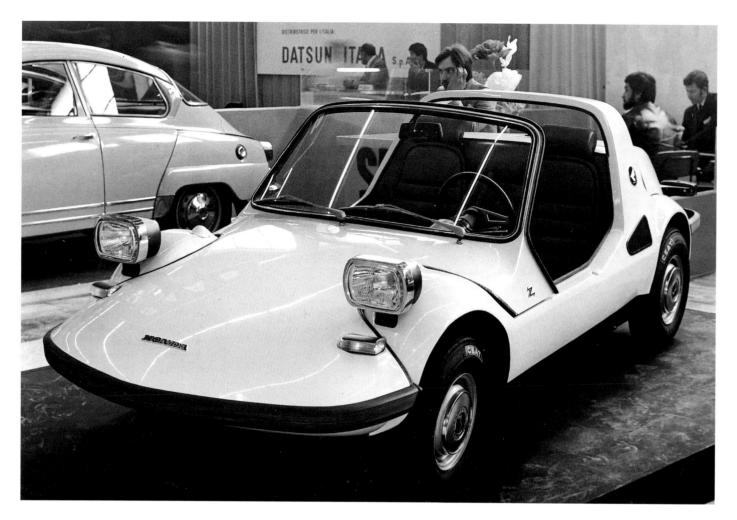

Zagato Hondina, Italy, Italien, Italie, 1970

Based on the Honda 360, the 1970 Zagato was designed as a cross-country vehicle. The deliberately ugly headlights and indicators are formal lapses in this study. However, it has been a consistent feature of Zagato for many years to disturb the smoothness of the surface, as for example the dainty front of this car.

Ein Runabout-Konzept verwirklichte 1970 Zagato auf der Basis des Honda 360. Formale »Ausrutscher« der Studie stellen die gewollt häßlichen Scheinwerfer und Blinker dar. Aber von Zagato ist man seit Jahrzehnten gewohnt, die Glattflächigkeit – wie hier den zierlichen Bug – ständig gestört zu sehen.

En 1970, Honda a réalisé une petite voiture sur la base de la Honda 360. Les phares et les clignotants volontairement vilains sont des «faux-pas» au niveau de la forme. Mais, depuis des décennies, on est habitué à voir Zagato rompre continuellement la netteté des formes, comme ici le capot gracieux.

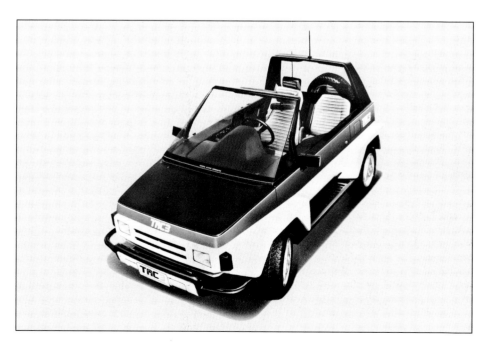

Toyota TAC 3, Japan, Japon, 1983

With their TAC 3 (Toyota Active Commuter), Toyota presented a study for a cross-country vehicle that was only 137¼ inches (350 cm) long. Note the central position of the driver – a not infrequent attempt to accommodate three passengers within less space, while at the same time giving both passengers more leg room next to the driver.

1983 zeigte Toyota mit dem »TAC 3« (Toyota Active Commuter) eine Geländewagenstudie von knapp 350 Zentimetern Länge. Auffällig ist die Mittelposition des Fahrers. Ein immer wieder gewählter Versuch, drei Passagiere auf wenig Raum unterzubringen, weil die Fondgäste die Füße neben den Fahrer strecken können.

En 1983 Toyota présenta la TAC 3 (Toyota Active Commuter), une étude de véhicule tout-terrain de moins de 350 centimètres de long. On remarque la position centrale du conducteur. Une tentative toujours renouvelée de placer trois passagers dans un espace restreint, parce que ceux qui sont assis à l'arrière peuvent allonger leurs jambes à côté du chauffeur.

VW-Bus, Germany, Deutschland, Allemagne, 1972

The DIY enthusiast who had redesigned this minibus can probably no longer claim a guarantee on it. So we will not go too much into the road-worthiness of this vehicle. Although the driver could rub his hands at having twice as much parking space, he would have a big problem passing his MOT test.

Bei VW dürfte aber dieser Bastler wohl keine Garantie auf das Gefährt geltend machen. Die Fahrstabilität bleibt getrost undiskutiert. Der Fahrer freut sich, daß plötzlich 100 Prozent mehr Parkplätze im Angebot sind – doch beim TÜV hätte er keine Chance.

Chez VW ce bricoleur ne devrait vraiment plus faire valoir de garantie sur le véhicule. La stabilité est assurée et les conducteurs sont ravis d'avoir soudain deux fois plus de possibilités de stationnement. Mais jamais le TÜV (contrôle technique) ne la laisserait passer.

R 4, France, Frankreich, 1968

If your car has a front engine and front drive, all you need to do is shorten the exhaust, fit together the front and back doors, and there is your shortest R 4 – the coupé version, as it were.

Wer Frontmotor und -antrieb vorfindet, braucht nur den Auspuff zu kürzen und vordere und hintere Tür paßgenau zusammenzuführen, schon hat er den kürzesten R 4, quasi die Coupé-Version geschaffen.

Si le moteur et la traction sont placés à l'avant du véhicule, il suffit de raccourcir le tuyau d'échappement et d'adapter les portières avant et arrière exactement l'une sur l'autre . On crée la R 4 la plus courte, la version coupé pour ainsi dire.

Dornier Delta II, Germany, Deutschland, Allemagne, 1969

In September 1969 Dornier tried their luck with a single minicar called Delta II. The trapezoid shape of the vehicle is dominated by angular tube profiles and flat plywood, normally found on boats.

Noch einmal versuchte Dornier im September 1969 mit einem einzigen Kleinstwagen Delta II sein Glück. Kantige Rohrprofile und plane Flächen (Bootssperrholz) bestimmten den trapezförmigen Würfel.

En septembre 1969, Dornier tenta une nouvelle fois sa chance avec une seule voiture, très compacte, la Delta II. Des montants anguleux et des surfaces planes (contreplaqué pour bateaux) caractérisaient la carrosserie en forme de cube trapézoïdal.

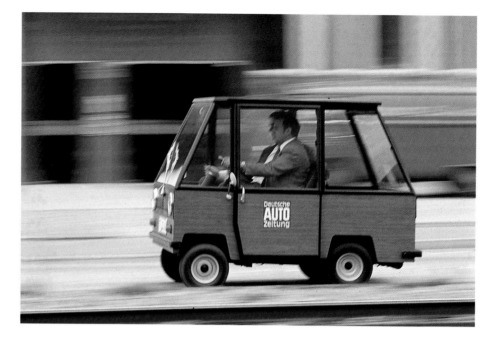

Ligier Formule, France, Frankreich, ca. 1978

Unlike Dornier, the French truck manufacturers Ligier built more than one specimen of their formule. This two-seater, which was 76½ inches (194.7 cm) long, was significantly more professional but found it difficult to gain acceptance.

Der französische LKW-Hersteller Ligier baute im Gegensatz zu Dornier mehr als ein Exemplar seines »Formule«. Wesentlich professioneller in der Form hat diese 194,7 Zentimeter lange zweisitzige Schachtel sich nur höchst mäßig etablieren können.

Contrairement à Dornier, Ligier, le constructeur de camions français, a fabriqué sa Formule en plusieurs exemplaires. Cette boîte à deux places longue de 194,7 centimètres, bien que plus professionnelle au niveau des formes, ne s'est pas spécialement bien vendue.

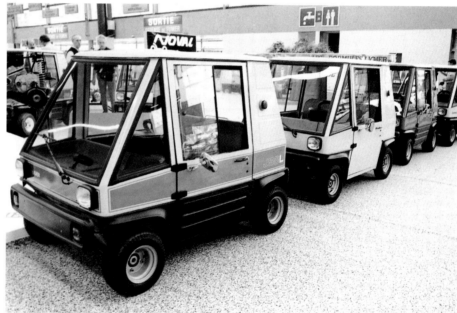

Zagato Zele 1000, Italy, Italien, Italie, 1976

The Zagato Zele 1000 was different and had far more appeal than a Comtesse. Again, it is obvious that the body was made of fibre glass, and everything – including joints and beads – were somewhat cruder.

Anders, weil viel ansprechender als eine »Comtesse«, zeigt sich der »Zele 1000« von Zagato. Auch dieser Karosserie ist der Kunststoff anzusehen, alles etwas herber in der Ausbildung, Fugen wie Sicken.

La Zele 1000 de Zagato est bien différente d'une Comtesse et bien plus séduisante. On remarque que la carrosserie est en plastique, que les formes, joints comme rainures, sont moins fines.

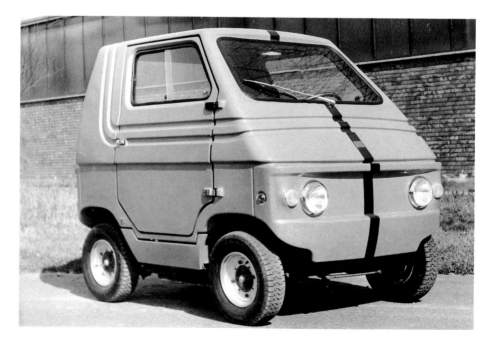

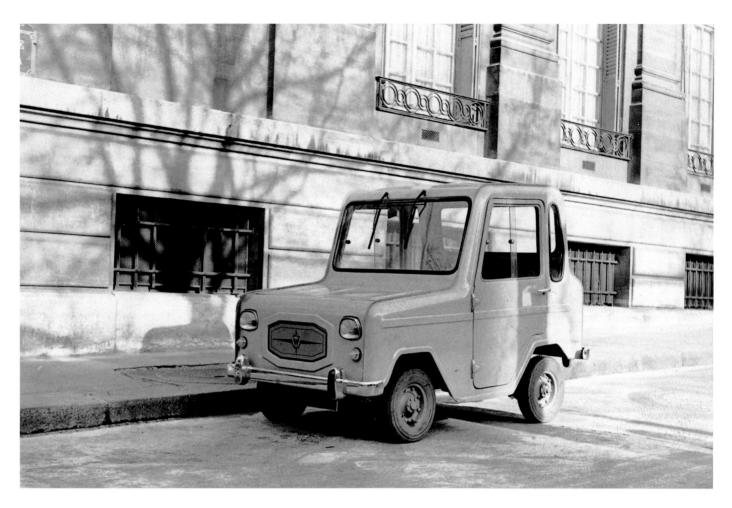

Lambretta Willam, France, Frankreich, 1969

Paris, a Sunday in early spring 1969. The little car is all on its own, so that it cannot really show its assets. It belongs to a whole host of French micro cars that were meant to appeal to the strained inhabitants of the centre of Paris. Built by the French company Lambretta, it had 123 cc, two cylinders, a two-stroke engine and two seats. In Italy it was called Lawil. Production was discontinued in the Eighties.

Paris, Vorfrühling 1969, Sonntag – so allein kann der kleine Willam gar nicht seine Vorzüge demonstrieren. Er gehörte zu einer Schar französischer Mikroautos, die streßgeplagte Bewohner der zugeparkten Pariser City ansprechen sollten. Gebaut wurde der 123 Kubikzentimeter-Zweizylinder-Zweitakt-Zweisitzer von der französischen Lambretta, in Italien nannte er sich Lawil. In den 80er Jahren wurde die Produktion eingestellt.

Paris, un dimanche de fin d'hiver en 1969 – Elle est toute seule la petite Willam (que les Italiens appellent Lawil), comment pourrait-elle montrer ce qu'elle sait faire? Elle faisait partie d'une troupe de petites voitures françaises construites à l'intention des habitants stressés de la cité encombrée. Le moteur deux-cylindres à deux temps, 123 centimètres cube sort des usines de la société française Lambretta. On cessa de la fabriquer au cours des années 80.

Ford Comuta, USA, 1967

As an electric car, 80 inches (203 cm) long, the Ford Comuta was quite well developed for the year 1967 – even though it was not exactly very beautiful. It was one of those numerous attempts to build a city car. Nevertheless, the Comuta is a true minicar.

Elektrisch, 203 Zentimeter lang, für das Jahr 1967 recht weit entwickelt, aber nicht besonders schön – so zeigte sich der Ford Comuta. Es handelt sich um einen der unzähligen Versuche, ein Stadtauto zu bauen. Vor allem aber erweist der Comuta dem Minikonzept seine Referenz.

Electrique, longue de 203 centimètres, déjà bien avancée en 1967, mais pas spécialement agréable à regarder, on peut définir ainsi la Ford Comuta. Elle n'est qu'une des tentatives sans cesse répétées de construire une voiture à vocation urbaine. On y voit surtout une réminiscence de la Mini.

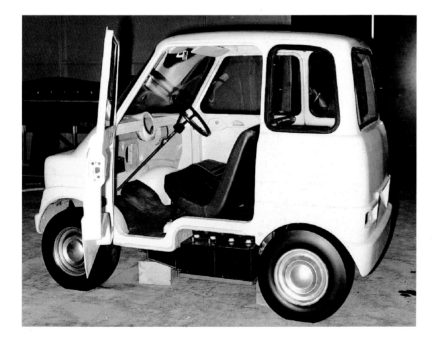

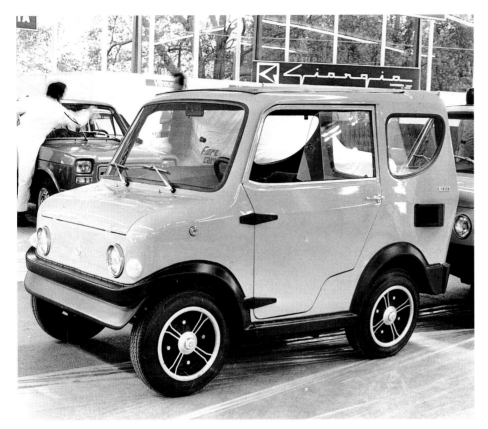

Rally, Italy, Italien, Italie

Similar to a Ford Comuta, this rally model, made by an Italian manufacturer, had great aspirations. However, apart from its pleasantly large wheels, other details displayed the typical defects of small companies. Although it was sufficiently powerful, it lacked good taste: the overall impression is far from unified, with window panes, air scoops and dreadful door frames, all purchased as add-ons from other manufacturers. A 1957 Isetta would be preferable.

Einem Ford Comuta ähnlich, soll dieses Modell »Rally« eines italienischen Herstellers auf Erfolgskurs gehen. Bis auf angenehm große Räder zeigen aber andere Details die Mängel vieler Versuche von kleinen Unternehmen. An der Kraft zum Start fehlt es nicht, wohl aber an Geschmack: Es entsteht kein einheitlicher Gesamteindruck bei zugekauften Fensterscheiben, Lufthutzen und unmöglichen Türausschnitten. Dann lieber eine Isetta von 1957.

Avec ses allures de Ford Comuta, voilà le modèle «rallye» d'un constructeur italien en quête du succès. Bien sûr, ses roues sont de bonne taille, mais d'autres détails mettent en évidence les défauts des nombreux essais des petites entreprises. On passe sur la technique, mais le manque de goût saute aux yeux: pas d'harmonie globale, ce qui n'a rien d'étonnant si on observe les vitres rapportées, les conduits aspirants et les découpes des portières impossibles. Mieux vaut s'offrir une Isetta de 1957.

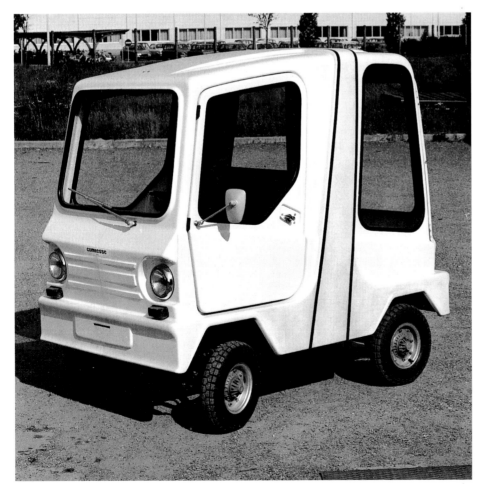

Comtesse, France, Frankreich, ca. 1984

Maybe this is the answer – the big sister of the Mini Comtesse from Anger, France. Even the little one had been as ugly as a cabbage field in November. And with this bigger model the question arises whether it is meant to be a cable car or a dustbin. It is also difficult to decide which is the front and which is the back. Fibre glass seems to be a very patient material, but should car manufacturers really take advantage of this feature?

Vielleicht ist sie's ja, die »Comtesse«, die größere Schwester der Mini Comtesse aus dem französischen Angers. Schon die kleinere war häßlich wie die Nacht. Und bei dieser fragt man sich, ob sie Berggondel oder Müllcontainer sein soll, außerdem bleibt unklar, wo vorn und wo hinten ist. Darf man Kunststoff so quälen, nur weil mit ihm fast alles machbar ist?

Voici la Comtesse, la sœur aînée de la Mini Comtesse d'Angers, en France. La petite était déjà laide à faire peur, mais en voyant celle-ci, à mi-chemin entre la nacelle et la benne à ordures, on cherche vainement le devant et le derrière. A-t-on le droit de traiter ainsi les matières plastiques sous prétexte qu'elles sont malléables à merci?

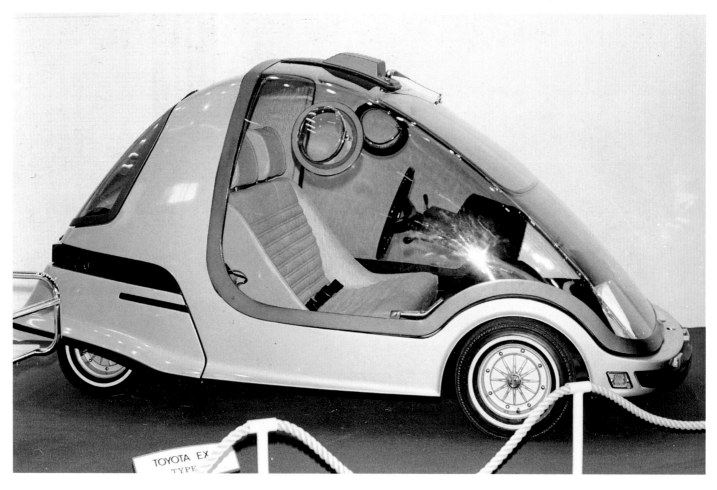

Toyota EX II, Japan, Japon, 1969

In 1969 Toyota exhibited this glass egg with an electric engine. The contours sagged a bit on the EX II. Contact with the outside world took place through bull's eyes, and the headlights were situated behind the glass cabin which enveloped the entire vehicle. It is a cross between sumptuousness and the attempt to lend a new shape to a small car – though this attempt never went beyond fashionable futurism.

1969 zeigte Toyota dieses Glasei mit Elektromotor. Die Konturen hingen etwas durch beim »EX II«. Bullaugen stellten den Kontakt zur Außenwelt her, die Scheinwerfer wurden hinter die alles umhüllende Glaskanzel gesteckt. Eine Mischung aus Üppigkeit und dem Versuch, einem Kleinwagen eine neue Gestaltung zu geben, die jedoch im Modisch-Futuristischen steckenbleibt.

C'est en 1969 que Toyota a présenté cet œuf de verre équipé d'un moteur électrique. Les contours n'étaient pas très nets. Des hublots permettaient de jeter un regard sur le monde extérieur, les phares étaient cachés sous la coque de verre. On a essayé ici de donner une nouvelle forme aux petites voitures, un air d'opulence. La EX II restera un objet à la mode, tendance futuriste.

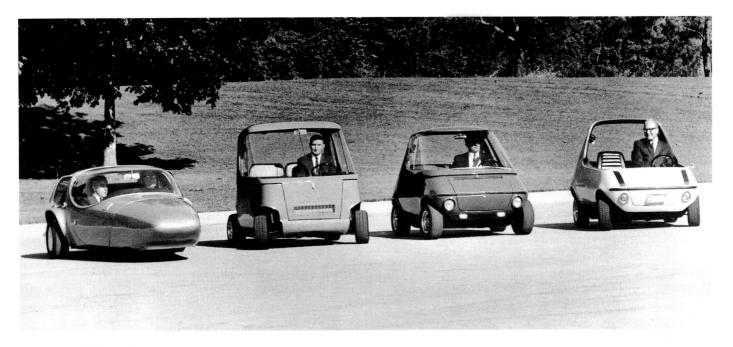

GM Minis, USA, 1972

The little car on the left is the Chevy Mini, together with its mates, i.e. variations on the same theme. As for form, each of them was far superior to the Comtesse. The pictures show that for a one-box mini the trapezium is an ideal compromise between the demands of dynamics and making the best use of the available space. This is what an Isetta could be like if its designers had decided to put a wheel on each of its four corners.

Links der kleine Chevy-Mini im Kreise weiterer Varianten, die jeder »Comtesse« in bezug auf die Form die Leviten lesen. Für One-Box-Minis ist die Trapezform ein idealer Kompromiß zwischen den Anforderungen von Raumaufteilung und Dynamik. Bildbeispiele belegen es. So könnte auch eine Isetta aussehen, wenn man sich bei ihr für vier Räder an vier Ecken entschieden hätte.

A gauche, la petite Chevy-Mini. A ses côtés d'autres variantes, toutes plus réussies que la Comtesse. Pour les voitures monospaces, la forme trapézoïdale est le compromis idéal entre les exigences de l'aménagement et la dynamique, les photos le montrent bien. L'Isetta pourrait avoir cette allure là, si on s'était décidé à lui placer quatre roues aux quatre coins de la carrosserie.

GM Elt Phantomzeichnung, USA, 1972

The hybrid drive on this minicar provides continuous power, using an IC engine that works continuously, so that there is greater control over the emission of fumes. To reduce pollution in the city centre, it can be turned off altogether, whereas if the road is clear, it can move along at high speed and on its own – without the electric engine. A concept which is being implemented widely in the Nineties.

Bei diesem Mini schafft der Hybridantrieb ständig Strom mit einem gleichmäßig arbeitenden Explosionsmotor, was bessere Emissionskontrolle zuläßt. In der Stadt kann er ganz abgeschaltet werden, um die Luft nicht noch mehr zu belasten, auf freier Strecke kann er – ohne Elektromotor – allein und schneller vorankommen. Ein Konzept, das in den 90er Jahren viel verfolgt wird.

Ici, le moteur hybride produit sans arrêt de l'électricité avec un moteur à explosion travaillant régulièrement, ce qui permet de mieux contrôler les émissions de gaz. En ville, on peut l'arrêter complètement, afin de ne pas polluer l'air, ailleurs il peut rouler plus vite sans moteur électrique. Une idée très suivie dans les années 90.

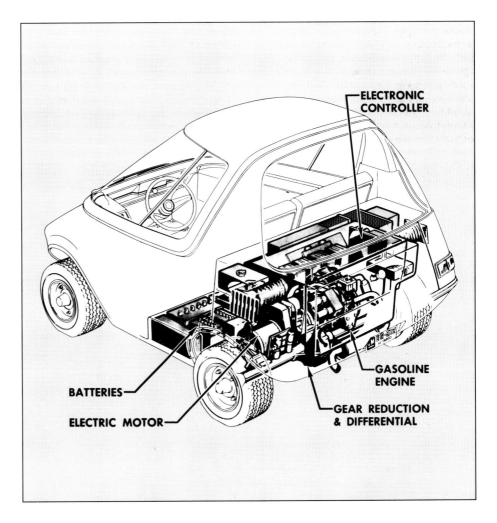

ELECTRONIC CONTROLLER

BATTERIES

ELECTRIC MOTOR

GASOLINE ENGINE

GEAR REDUCTION & DIFFERENTIAL

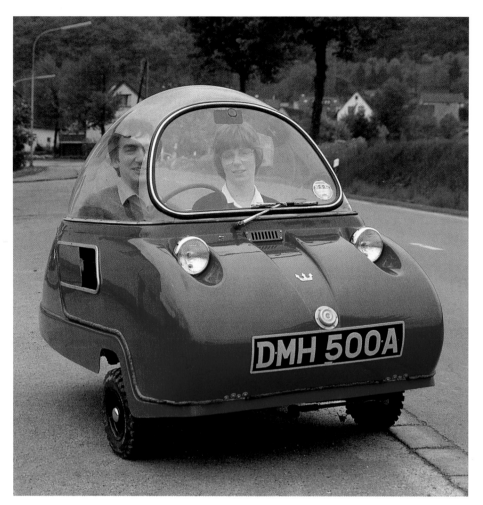

Peel Trident, Great Britain, England, Angleterre, 1964

The Peel Trident of 1964 had a heart for lovers: the plexiglass cabin was ideally suited for a clear night and moonshine romance, though when the sun was shining, it was more like an incubator because not a single window could be opened. The vehicle was simple to get into, as most of the cabin was simply lifted up. Driving it, on the other hand, was a little more adventurous: its wheels were minute, so that the slightest pothole had to be avoided at all cost.

Der Peel Trident bewies 1964 ein Herz für Pärchen: Unter freiem Himmel war die Plexikanzel bei Mondschein ideal, bei Sonne aber eher wie ein Brutkasten, denn weit und breit gab es kein Fensterchen zum Öffnen. Das Einsteigen war einfach, denn fast die ganze Kanzel hob sich. Fahren gestaltete sich schon aufregender: Bei den drei winzigen Rädern war jedes Schlagloch zu vermeiden.

En 1964, la Peel Trident était la voiture des amoureux: la coque de verre était véritablement conçue pour jouir du clair de lune. En revanche, on y rôtissait au soleil car aucune ouverture n'était prévue. Y entrer était chose facile puisque l'habitacle se soulevait presque partout. La conduite était déjà plus excitante, car les trois roues étaient si petites qu'il valait mieux éviter les nids de poule.

Suzuki CV 1, Japan, Japon, 1981

The Suzuki CV 1 of 1981 (CV stands for »community vehicle«) is 121 lbs (55 kg) heavier than the Peel Trident. It has an air-conditioned cabin, bigger wheels and a 50 cc two-stroke single-cylinder engine (the size of a standard moped). Its maximum speed is 20 mph (30 km/h). It is a one-seater and therefore unsuitable for couples.

Der Suzuki CV 1 (C=Community, V=Vehicle) von 1981 ist 55 Kilogramm schwerer als ein Peel Trident. Mit belüfteter Kanzel, mit größeren Rädern und einem 50 Kubikzentimeter-Zweitakt-Einzylindermaschinchen (die Größe unserer Standard-Mopeds) erreicht er maximal 30 Stundenkilometer. Er ist außerdem für Pärchen ungeeignet, weil Einsitzer.

La Suzuki CV 1 (C=Community, V=Vehicle) de 1981 pèse 55 kilos de plus qu'une Peel Trident. Son habitacle est aéré, ses roues sont plus grandes et son moteur monocylindrique à deux temps de 50 centimètres cube (taille standard des moteurs de mobylettes) lui fait atteindre une vitesse de 30 kilomètre à l'heure. N'offrant qu'une place, elle est sans intérêt pour les amoureux.

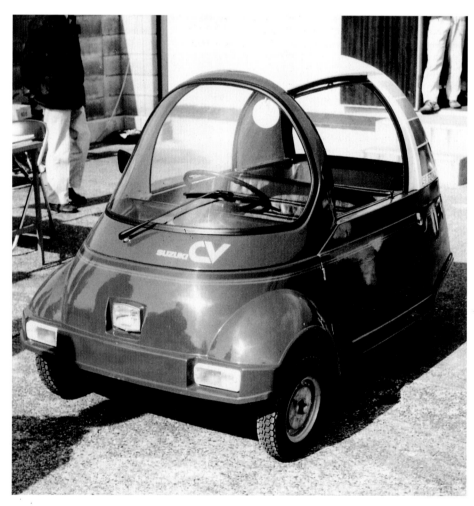

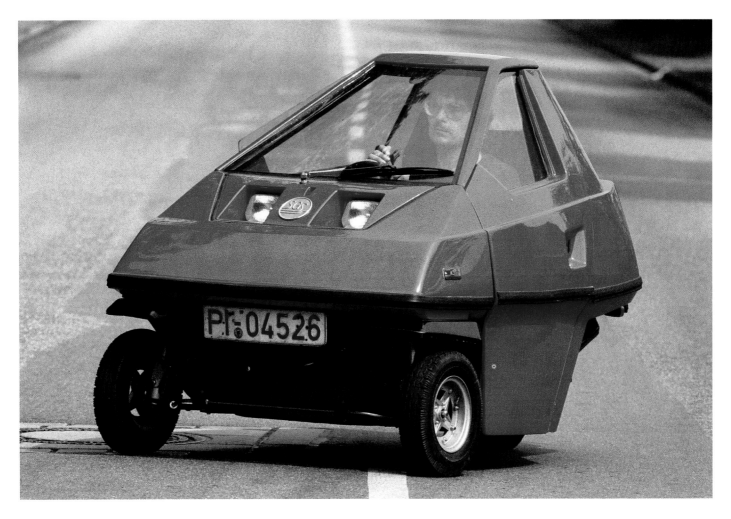

SGS Dreirad, Germany, Deutschland, Allemagne, 1983

Incredible! The Styling Garage in Hamburg – specialists in optical tuning and big cars – wanted to create a stir at the International Automobile Exhibition in 1983, and they actually succeeded with this ghastly SGS minicar. The trapezoid form of the body is further emphasized by the narrowness of the eyes. At the front, the SGS unashamedly displays a wheel suspension which has to cope with up to 35 mph (60 km/h), generated by an 80 cc one-cylinder Honda engine.

Das ist die Höhe! Da wollte die Styling-Garage aus Hamburg auf der Internationalen Automobilausstellung 1983 auffallen – und schaffte es prompt mit diesem häßlichen SGS-Kleinstauto. Zu eng stehende Äugelchen betonten die Wirkung des in Trapezformen gezwängten Aufbaus. Vorn zeigte der SGS unverblümt seine Radaufhängung, die eine Geschwindigkeit von 60 Stundenkilometern verkraften muß – erarbeitet von einem 80 Kubikzentimeter-Honda-Einzylinder.

Le comble! Un concepteur de Hambourg, spécialiste du «gonflage» optique et des grosses bagnoles, voulait se faire remarquer au Salon de l'Automobile de 1983, et il y a réussi avec cette vilaine petite SGS. Les petits yeux trop rapprochés soulignent l'effet de la construction trapézoïdale. A l'avant, la SGS montre sans complexes sa suspension conçue pour résister à la vitesse maxi de 60 kilomètres à l'heure que développe le monocylindre Honda de 80 centimètres cube.

Bambi Dreirad, Great Britain, England, Angleterre, 1983

In 1983 Alan Evans (UK) launched his 49 cc Bambi as the smallest British car. The car industry should be indebted to him for demonstrating this light-weight vehicle where the closed chassis, the tube frame and the borrowed drive mechanism are visible.

Alan Evans aus England stellte 1983 sein Bambi mit 49-Kubikzentimeter-Motor als kleinstes englisches Autochen vor. Dank sei ihm für die Demonstration des Leichtgewichts, weil man die geschlossene Kunststoffwanne, den Rohrrahmen und die ausgeliehene Antriebsmechanik sehen kann.

L'Anglais Alan Evans présenta en 1983 sa Bambi au moteur de 49 centimètres cube, la plus petite voiture du monde. Il démontre la légèreté de la Bambi en la soulevant, ce qui nous permet de voir la coque en plastique, le châssis tubulaire et le moteur, originaire d'une autre voiture.

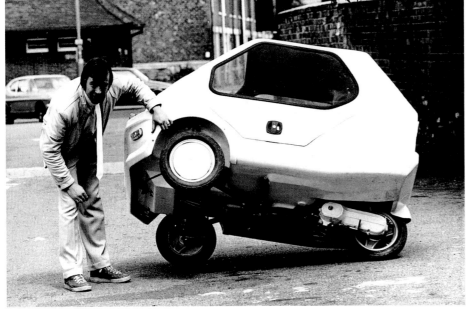

Zagato Elettrica, Italy, Italien, Italie, ca. 1976

Another Zagato. Based on the same concept, this electrically driven trapezoid box has a lot more feeling for form, though it is surpassed by the Ghia and GM designs, because any delicate styling elements (e.g. the headlight fittings and the air slits) are almost too much for such a small car. Its fate was the same: no mass production.

Ein weiterer Zagato. Auf dem gleichen Konzept basierend, zeigt die stromgetriebene Trapezschachtel schon mehr Formgefühl und wird von den Entwürfen von Ghia und GM noch übertroffen, weil feine Stylingelemente (Scheinwerfereinfassung, Luftschlitze) für ein so kleines Auto fast zuviel sind. Auch sein Schicksal: keine Serienproduktion.

Encore une Zagato. De même conception que les autres, la boîte trapézoïdale montre un peu plus de sens des formes. Elle est encore surpassée par les modèles de Ghia et de GM, parce que de fins éléments de style, tels que l'encadrement des phares et les fentes d'aération, chargent trop un si petit véhicule. Elle n'ira pas en série.

Ghia De Tomaso, Italy, Italien, Italie, 1967

Ghia is normally associated with sophisticated sports cars. However, with this little De Tomaso, they launched a city car that was beautiful for its time. Later Ghia was to become a trail-blazer for Ford. With metal that shows signs of excellent craftsmanship, the car is 78 inches (200 cm) long, has a square front profile (51 x 51 inches / 130 x 130 cm) and a 500 cc engine. The original model, the Rowan (1967), had been planned with an electric drive. Incidentally, the form of the car was designed by Giugiaro.

Ghia, später in bezug auf die Form Vordenker für Ford, hat mit diesem kleinen de Tomaso, eine Marke sonst nur für Sportwagen gehobener Art gut, einen für seine Zeit bildschönen Stadtwagen vorgestellt. Fein bearbeitetes Blech auf 2 Meter Länge und quadratischem Frontprofil (130 mal 130 Zentimeter) wird mit 500 Kubikzentimetern bewegt. Ursprünglich (1967) war das Modell Rowan mit Elektroantrieb geplant. Übrigens: Die Form hat Giugiaro gezeichnet.

Ghia, qui servira plus tard de modèle à Ford au niveau des formes, a présenté avec cette petite De Tomaso, marque de voitures de sport de haut de gamme, une petite urbaine ravissante pour l'époque. Une tôle finement travaillée sur 2 mètres de longueur et une partie avant carrée 130 sur 130 centimètres, le tout animé par un moteur de 500 centimètres cube. A l'origine (1967), il était prévu d'équiper le modèle Rowan d'un moteur électrique. Une remarque encore: Giugiaro a dessiné les formes.

Ford Ghia Berlina, Germany, Deutschland, Allemagne, 1968

Exactly like the Zündapp Janus of the Fifties, the Ford Ghia Berlina accommodates four persons sitting back to back. The 1968 prototype had a back door for the two back-seat passengers. The beautiful trapezoid motifs were the result of design studies. The short wheel base of 94 inches (137 cm) – i.e. the same as the height of the car – and the arrangement of the back seats required an almost upright steering wheel.

Nicht anders als in einem Zündapp Janus der 50er Jahre sitzen im Ford Ghia Berlina vier Personen Rücken an Rücken. Beim Prototypen von 1968 gelangten die beiden hinteren Passagiere durch die Hecktür ins Freie. Die schönen Trapezmotive wurden über viele Designstudien ermittelt, der kurze Radstand (137 Zentimeter, so viel wie die Höhe) und die hinteren Sitzplätze erforderten ein steil stehendes Lenkrad.

Les passagers de la Ford Ghia Berlina sont assis dos à dos comme dans une Zündapp Janus des années 50. Dans le prototype de 1968, les passagers arrière sortent par le hayon. Les beaux motifs trapézoïdaux furent découverts après bien des études de design. L'empattement court (137 centimètres, égal à la hauteur) et les sièges arrière exigeaient un volant presque vertical.

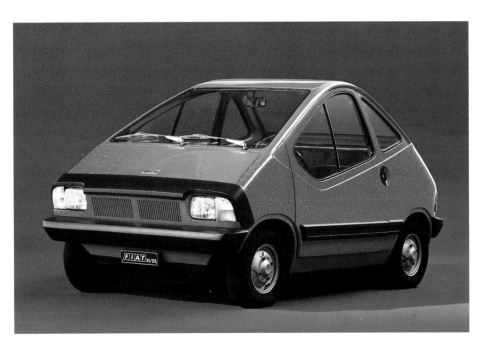

Fiat X1/23, Italy, Italien, Italie, 1973

Smaller than the Pöhlmann EL, but with a similar profile, the 1973 two-seater Fiat X1/23 tried to maintain its position – also with regard to shape – as another electric car with extremely oblique angles. With its 13½ HP electric engine, it had a maximum speed of 47 mph (75 km/h).

Kleiner als der Pöhlmann EL, aber mit ähnlichem Profil, versuchte sich 1973 der zweisitzige Fiat X1/23 als weiteres Elektromobil mit extremen Schrägen auch formal zu behaupten. Ein 13,5 PS-Elektromotor machte ihn 75 Stundenkilometer schnell.

Plus petite que la Pöhlmann EL, mais de profil semblable, la Fiat biplace X1/23 aux formes extrêmement plongeantes essaya en 1973 de se lancer sur le marché des voitures électriques. Son moteur électrique de 13,5 CV lui permettait de plafonner à 75 kilomètres à l'heure.

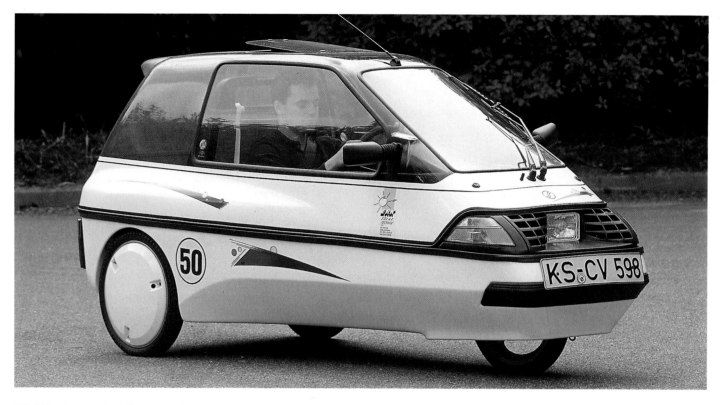

Mini EL, Denmark, Dänemark, Danemark, 1991

With their fibre-glass minicar »Hope Whisper«, Danish car manufacturers had already tried their hand – unsuccessfully – at building a mini. In the early Nineties they started to sell an MOT-approved vehicle – the Mini EL – for £4,240 ($7065). Its battery permitted a maximum speed of 25 mph (40 km/h) for a maximum journey of 44 miles (70 km).

Dänische Autokonstrukteure, die schon einmal mit der Ankündigung des Kunststoffkleinwagens »Hope Whisper« im Konzert der Minis erfolglos mitspielten, bieten Anfang der 90er Jahre für 10600 DM den TÜV-abgenommenen Mini EL an. Seine Batterie erlaubt eine Geschwindigkeit von 40 Stundenkilometern und hat eine maximale Reichweite von 70 Kilometern.

Les constructeurs danois, qui avaient autrefois annoncé la venue d'une petite voiture à la carrosserie de plastique, la Hope Whisper restée inconnue, offrirent au début des années 90 pour 10600 marks la Mini EL, qui fut acceptée par les services de contrôle technique allemands. Sa pile lui permet une vitesse de 40 kilomètres à l'heure et un rayon d'action maximum de 70 kilomètres.

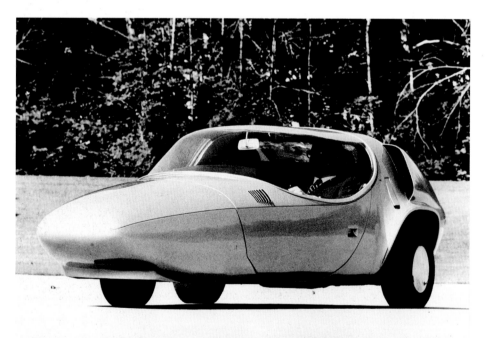

General Motors, USA, 1972

A big group of companies like General Motors is quite capable of reducing a 16½-foot car (5 metres) to half its length. This 1972 design proposal (by Shinoda) from the Chevrolet division captivates motorists with its fashionable yet neat overall shape. It is a craftsman-like further development of German Brütsch designs from the Fifties. The rear portion of the three-wheeler is reminiscent of the Corvette.

Ein Großkonzern wie General Motors ist durchaus in der Lage, ein Fünf-Meter-Auto auf die Hälfte der Länge zu reduzieren. Dieser Vorschlag aus der Chevroletabteilung (Design: Shinoda) von 1972 besticht durch eine modische, aber saubere Gesamtform; die meisterliche Weiterentwicklung deutscher Brütsch-Vorschläge aus den 50er Jahren. Das Dreirad ist mit einem Heck à la Corvette ausgestattet.

Un groupe de l'importance de General Motors est en mesure de réduire de moitié la longueur d'une voiture de cinq mètres. Cette proposition émise en 1972 par le département design de Chevrolet (Shinoda) séduit par ses formes modernes, mais claires; c'est une élaboration magistrale des travaux de Brütsch dans les années 50. Le tricycle est agrémenté d'une partie arrière à la Corvette.

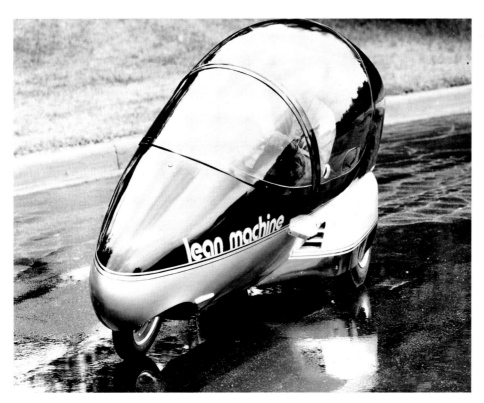

General-Motors Lean Machine, USA, 1982

It was in 1982, in Disneyland, that the Lean Machine made its first appearance – a General Motors three-wheeler with a 30 HP Honda motorbike engine. A poor solution, though: an aeroplane that goes smoothly round corners whenever desired is still rather inadequate for the challenges of overcrowded town centres. It is far more tempting to try out its performance at maximum speed.

Im Disneyland wurde die Lean Machine 1982 zuerst gezeigt. Dieses General-Motors-Dreirad mit 30 PS-Honda-Motorradmotor kann nicht die Lösung sein: Ein Flugzeug, das sich auf (Fuß-)Befehl in Kurven schön schräg legt, kann dem überbordenden Verkehr kein Paroli bieten. Eher reizt es, die Fahrqualität bei maximalem Speed auszuprobieren.

C'est à Disneyland que la Lean Machine fut montrée pour la première fois en 1982. Ce tricycle de General-Motors au moteur Honda de 30 CV ne peut pas être la solution: un avion qui plonge sur le côté dans les virages ne peut pas résoudre les problèmes de la circulation. On aurait plutôt envie de tester ses capacités à pleine vitesse.

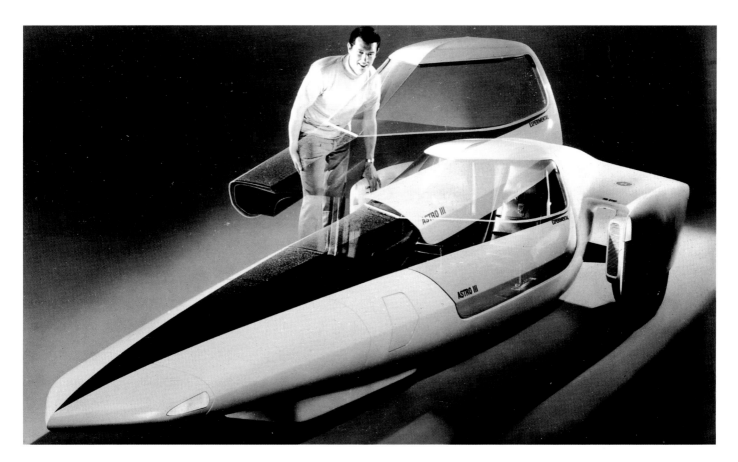

General Motors Astro III, USA, 1969

The development of General Motors' Astro III in the late Sixties was dominated by science fiction and Brave New World. Three-wheelers had never been so dynamic. In the long run, however, they had to be assigned to the small-cars section of the Dream Cars division.

Science fiction der schönen neuen Welt führte Ende der 60er Jahre Regie bei der Entwicklung des Astro III von General Motors. Dreiräder waren nie so dynamisch wie hier. Sie sind aber auf lange Sicht in der Abteilung Traumwagen, Sektion Kleinwagen anzusiedeln.

L'Astro III de General Motors élaborée à la fin des années 60 est le produit d'amateurs de science-fiction. On n'a jamais vu de tricycles plus dynamiques, mais ils resteront longtemps confinés dans le département «voitures de rêve», service des «petites voitures».

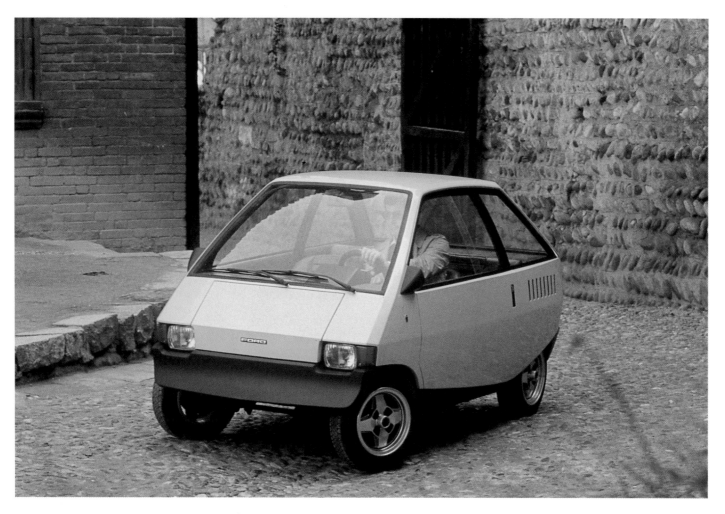

Ghia Urban, Italy, Italien, Italie, 1977

Another Ghia – at the Geneva Salon in 1977. This time with a more angular and emphatic design, allowing four passengers to sit in the usual classic position. This made the Urban 101½ inches (258 cm) long, though it was still 18½ inches (47 cm) shorter than the Mini. The seating was soft and the steering wheel at a convenient angle, due to the kink in the steering rod. With a width of 58½ inches (149 cm) there was enough room even for people with broadshoulders.

Ghia Pockar, Italy, Italien, Italie, 1980

In 1980 Ford got their Italian maestros to think hard about the junior section again. The result – called »Pockar« – was 112¼ inches (285 cm) long and comfortably accommodated four persons. With the rear seat folded, it had 24¼ cubic feet (688 litres), i.e. the space of a medium-sized car.

Ford ließ 1980 seinen italienischen Formenvirtuosen weiter über den Kleinen nachdenken. Das Ergebnis: Auf 285 Zentimetern Länge wurden vier Personen in diesem »Pockar« bequem verstaut. Aufaddiert sind das bei aufgeklappter Heckbank 688 Liter – das ist Mittelklasseniveau.

En 1980, Ford convia ses concepteurs italiens à continuer à réfléchir sur les petites voitures. Résultat: dans cette Pockar de 285 centimètres de long, quatre personnes sont à leur aise. Banquette arrière repliée, le volume intérieur s'élève à 688 décimètres cube, c'est ce qu'offrent les voitures de catégorie moyenne.

Noch einmal ein Ghia, Genfer Salon 1977. Bei etwas kantiger, architektonisch markanterer Form dürfen jetzt vier Passagiere in klassischer Anordnung sitzen. Dafür wächst der »Urban« auf 258 Zentimeter, bleibt aber immer noch 47 Zentimeter kürzer als der Mini. Er hat ein weich gepolstertes Gestühl und dank eingeknickter Lenksäule ein handlich schräg stehendes Lenkrad. Bei 149 Zentimetern Breite haben auch Breitschultrige Platz.

Encore une Ghia, au Salon de Genève de 1977. La carrosserie est plus anguleuse, plus marquante et elle abrite maintenant quatre passagers assis de manière classique. Et si l'Urban y gagne en longueur (258 centimètres), elle reste encore 47 centimètres plus courte que la Mini. Ses sièges sont bien rembourrés, et son volant agréable à manier grâce à une colonne de direction infléchie. Elle mesure 149 centimètres de large et les fortes carrures y sont à leur aise.

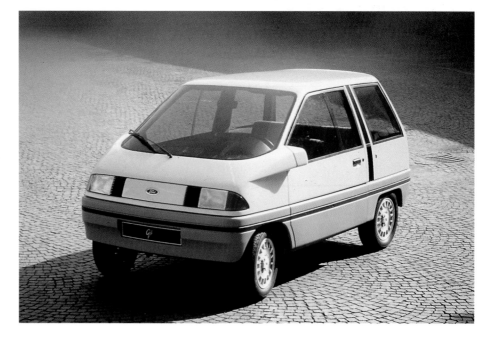

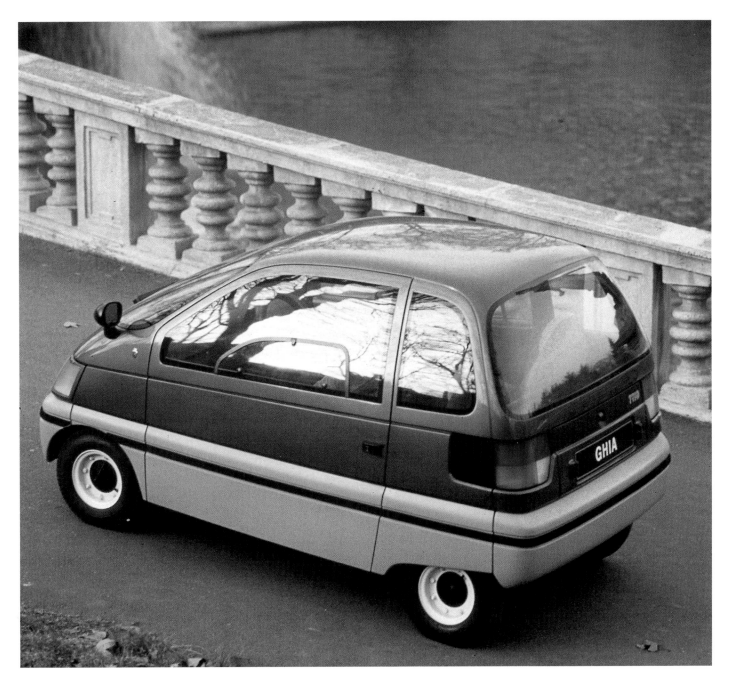

Ghia Trio, Italy, Italien, Italie, 1983

Despite its name, the 1983 Trio had four wheels – though only three seats. They were arranged in the usual order, with the driver in the middle and the two passenger's seats slightly further back. At 95 inches (241 cm), the car was shorter again. It was a successful attempt to enhance the lightness of the car with the use of aluminium and fibre glass (e.g. in the window panes). As a result, the empty car with a closed body only weighed 743 lbs (337 kg). What is more, it was also well streamlined, with a cd factor of 0.27. A two-stroke engine and 259 cc were therefore amply sufficient.

Der »Trio« aus dem Jahr 1983 hatte, dem Namen zum Trotz, vier Räder, aber nur drei Sitze in der bekannten Anordnung: Der Fahrer in der Mitte, zwei Beifahrer versetzt dahinter. Mit 241 Zentimetern war das Auto wieder kürzer. Hier versuchte man erfolgreich, durch die Verwendung von Alu und Kunststoff (z. B. bei den Scheiben) den Leichtbau zu verbessern – 337 Kilogramm Leergewicht bei einer geschlossenen Karosse sind der Beweis. Und windschlüpfig war das Ei auch: Cw-Wert 0,27. Da genügten dann 259 zweitaktende Kubikzentimeter.

La Trio de 1983 avait quatre roues comme son nom ne l'indique pas, mais trois sièges dans l'ordre classique: le conducteur au centre, deux passagers légèrement décalés en arrière. Elle était plus courte que les précédentes avec ses 241 centimètres de longueur. On a tenté ici d'utiliser de l'aluminium et des matières plastiques pour alléger le véhicule. Pari gagné: 337 kilos à vide. La Trio est également aérodynamique avec un coefficient de traînée de 0,27. Et un moteur à deux temps de 259 centimètres cube lui suffisent amplement.

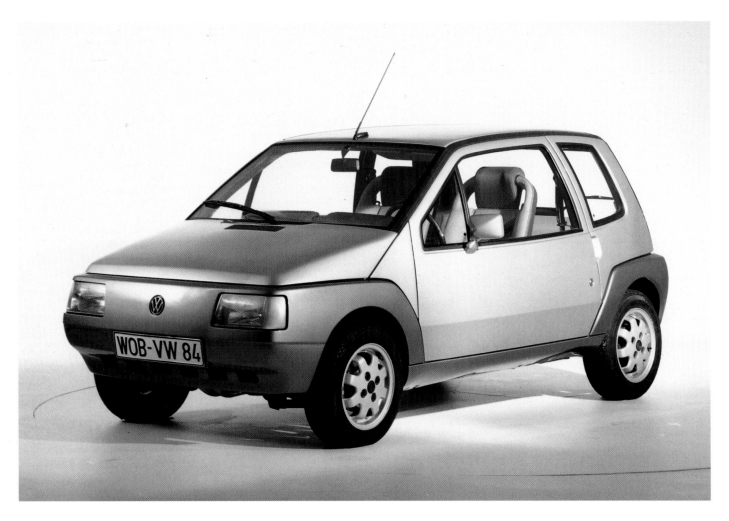

VW Student, Germany, Deutschland, Allemagne, 1984

123¼ inches (313 cm) in length, the 1984 VW Student had a refreshing quality about it. The fibre-glass surfaces at the front and rear integrated the mudguard and the bumper into a unified whole, so that the car became reminiscent of a jeep. Despite its somewhat overpowering appearance, its cd value was no more than 0.31. Even as late as 1993 VW tried to produce a mini within their Polo series, to replace the Swatch they had abandoned.

Der VW »Student« von 1984 hat bei 313 Zentimetern Länge ein frisches Erscheinungsbild. Die Kunststoffflächen an Front und Heck integrieren das Thema Kotflügel und Stoßstange zu einem neuen, an den Jeep erinnernden Motiv. Trotz der wuchtigen Erscheinung hat der Fahrtwind nur mit 0,31 als Cw-Wert zu kämpfen. Noch 1993 sucht VW nach einem Mini unter dem Polo und als Ersatz für den aufgegebenen Swatch.

La VW Student de 1984, longue de 313 centimètres, présente quelques nouveautés. Les surfaces en matière plastique à l'avant et à l'arrière intègrent les ailes et les pare-chocs dans un ensemble qui rappelle la Jeep. Elle paraît massive mais c'est trompeur, puisque son Cx ne s'élève qu'à 0,31. En 1993, VW cherche toujours une Mini qui viendrait sous la Polo dans la gamme, et qui remplacerait la Swatch dont l'idée a été abandonnée.

In its 73 HP version, the VW Student had a reasonable chance against other cars. Its rear portion reminds us of the Renault 5 of 1972/1983, and of the Volvo estate and the Fiat Uno, the Punto successor of autumn 1993. Both have their headlights in exactly the same corners of the body.

In der 73 PS-Version hatte er schon gute Chancen, der VW Student, anderen das Heck zu zeigen. Das erinnert an den Renault 5 von 1972, aber auch an den Volvo Kombi (1983) und an den Fiat Uno-Nachfolger Punto vom Herbst 1993. Beide haben detailgenau die Karosseriekanten mit Licht belegt.

Dans sa version à 73 CV, la VW Student avait des chances d'être en tête de peloton. Elle rappelle la Renault 5 de 1972, mais aussi la Break Volvo de 1983 et le successeur de la Fiat Uno, la Fiat Punto sortie en automne 1993. On retrouve dans les deux modèles exactement la même manière d'intégrer les blocs lumineux dans les montants de la carrosserie.

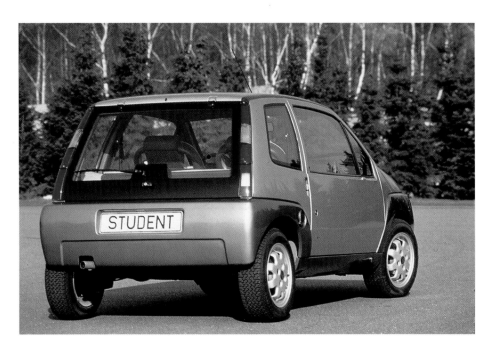

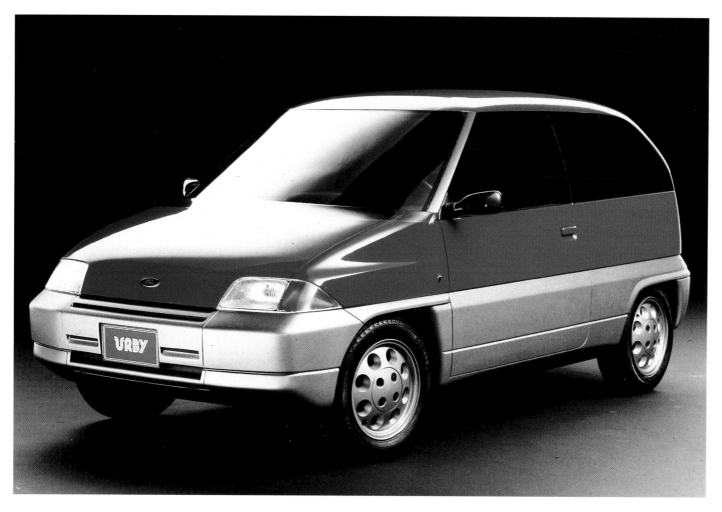

Ghia Urby, Italy, Italien, Italie, 1985

Ghia 1985. With its high body and chubby face above the front wheel recesses, the Urby reminds us of the Mazda 121. The dimensions are similar, too: 139¼ inches (354 cm) in length and 61 inches (155½ cm) in width. However, it never went beyond a study for a compact, without any clear motorization as a test object for future models.

Dieser »Urby« erinnert an den Mazda 121 mit seinem hohen Aufbau und den Pausbacken über den vorderen Radausschnitten. Mit 354 Zentimetern Länge und 155,5 Zentimetern Breite hatte der Urby auch ähnliche Abmessungen. Er blieb eine Kompaktwagenstudie ohne festgelegte Motorisierung als Testobjekt für zukünftige Modelle.

Ghia, 1985. Avec sa haute caisse et ses grosses joues au-dessus des roues avant, cette Urby nous rappelle la Mazda 121. Les dimensions de l'Urby, 354 centimètres de long et 155,5 centimètres de large étaient d'ailleurs sensiblement les mêmes. Elle est restée une étude de véhicule compact sans motorisation déterminée et sert d'optotype aux futurs modèles.

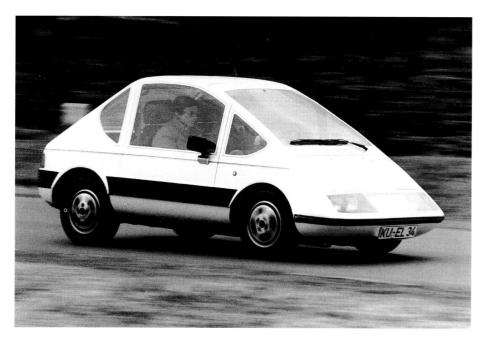

Pöhlmann EL, Germany, Deutschland, Allemagne, 1982

The Electric EL Pöhlmann was sponsored by the Rheinish-Westphalian Electricity Works. With two-plus-two seats and folding doors, it had a pleasant design. With its 70 mph (115 km/h) and a cd value of only 0.25, it was the fastest electric car of its time.

Das Elektroauto EL von Pöhlmann wurde von den Rheinisch-Westfälischen Elektrizitätswerken gesponsort. Zwei-plus-zweisitzig und mit Flügeltüren zeigte er eine ansprechende Gestaltung. Mit 115 Stundenkilometern Höchstgeschwindigkeit und einem Cw-Wert von 0,25 war er das schnellste Elektroauto seiner Zeit.

La voiture électrique EL de Pöhlmann fut sponsorisée par les usines électriques de Rhénanie-Westphalie. Elle était agréable à contempler avec ses sièges deux/deux à l'avant et à l'arrière et ses portes battantes. Avec une vitesse de pointe de 115 kilomètres à l'heure, due aussi à son Cx de 0,25, elle était la voiture électrique la plus rapide de son temps.

Opel Junior, Germany, Deutschland, Allemagne, 1983

Not many cars are truly original. Even the Opel Junior has borrowed plenty of features from other cars, though it is the combination that makes the difference. Take, for instance, the cube-shaped instruments, each of which can be added separately, retrofitted or taken out, such as the clock and the radio, which can also be found in the Peugeot Peugette (Pininfarina). The door panels double up as storage space. What is new is that the seats can be unbuttoned and rolled out to form sleeping bags. Everything is bright, fashionable and colourful, so the target group seems obvious.

Selten ist ein Auto wirklich originell. Auch der Opel-Junior hat kräftig Anleihen genommen, die Rezeptur der Mischung macht den Unterschied. So bei den würfelförmigen Instrumenten, einzeln einsetzbar oder nachrüstbar oder zum Mitnehmen wie Uhr und Radio, die man vom Peugeot Peugette (Pininfarina) kennt. So bei der Türverkleidung, die als Kofferraum fungiert. Neu: Die Sitze sind ausknöpfbar und werden ausgerollt zu Schlafsäcken. Alles farbig, poppig – die Zielgruppe ist leicht zu definieren.

Il est rare qu'une voiture soit réellement originale. L'Opel Junior s'est, elle aussi, servie un peu partout. C'est la recette du mélange qui fait la différence. Les instruments cubiques, par exemple, à utiliser séparément, à acheter plus tard en tant qu'accessoire ou à emmener avec soi, comme la montre et la radio, et que l'on a déjà vus dans la Peugeot Peugette de Pininfarina. Ou le rembourrage des portières qui sert de coffre à bagages. Une nouveauté: on peut déboutonner les sièges qui seront déroulés comme des sacs de couchage. Le tout riche en couleurs. Difficile de ne pas deviner à quel public elle s'adresse.

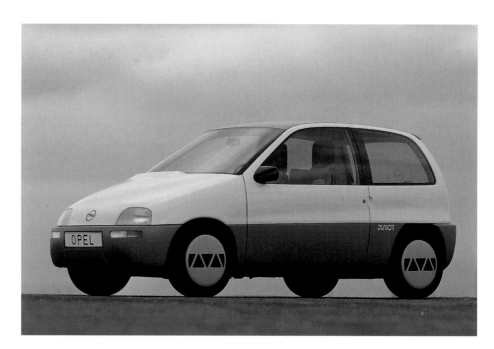

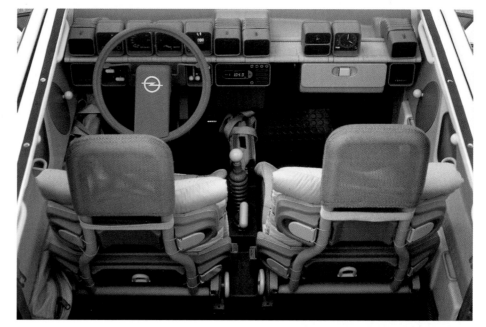

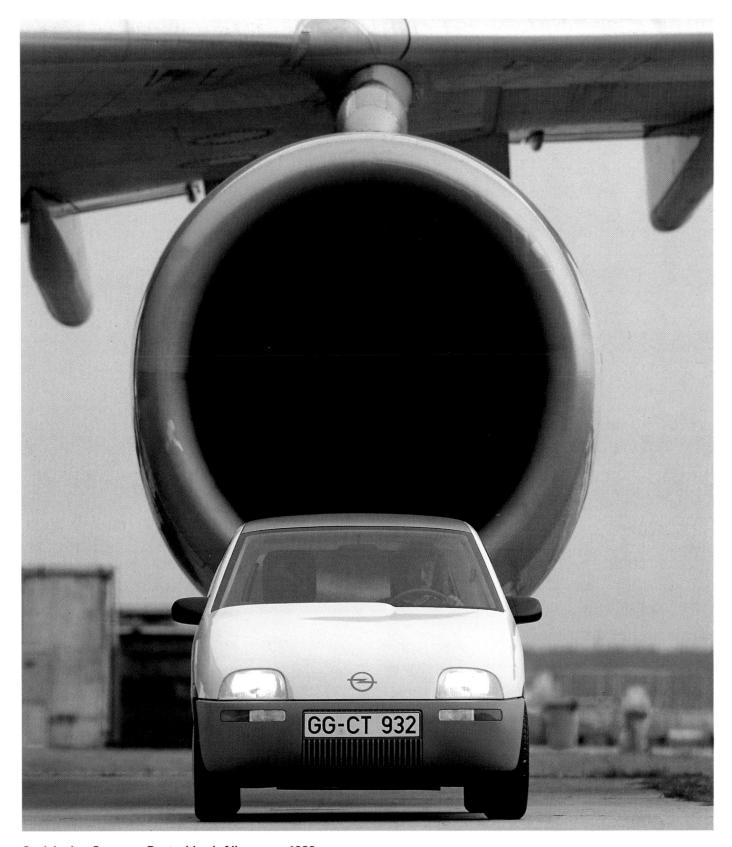

Opel Junior, Germany, Deutschland, Allemagne, 1983

The International Automobile Exhibition in Frankfurt 1983. Opel have proved – yet again – how beautiful their prototypes are. Both the Junior and the 1993 model, which it inspired, were designed by Hideo Kodama. The Junior shows that mass-produced cars require more than a clearly structured design. The only criticism we might have concerns the hub caps, but certainly not the spatial economy within the car's 212 x 97½ inches (341 x 157 cm).

IAA Frankfurt 1983. Opel bewies einmal mehr, wie schön die Prototypen seiner Autos sind. Der Junior, von dessen Ideen der Corsa profitierte (1993), stammt wie jener vom Designer Hideo Kodama. Der Junior zeigt, daß Serienautos immer mehr aufweisen müssen als eine klare Architektur. Beim Junior sind nur die Radkappen zu bemängeln, nicht die Raumökonomie auf der Grundfläche von 341 mal 157 Zentimetern.

IAA de Francfort, 1983. Une fois de plus Opel se distingue par la beauté de ses prototypes. La Junior, dont la Corsa (1993) a profité, a été créée comme cette dernière par le designer Hideo Kodama. Elle montre que les voitures de série doivent toujours montrer plus qu'une architecture nette. Si on peut critiquer les chapeaux de roues, rien à dire de l'habitabilité basée sur une surface de 341 fois 157 centimètres.

Daihatsu Marienkäfer, Japan, Japon, ca. 1990

At long last: a small car about which we know little more than the manufacture's name – Daihatsu. Probably battery-driven, probably the pride and joy of DIY enthusiasts at the company's designers' club, and probably used at a Japanese leisure park. And of course it glows after dark – at least the little lamp on the roof.

Endlich einmal ein Wägelchen, von dem nur der Hersteller bekannt ist: Daihatsu. Vermutlich batteriebetrieben, vermutlich der Bastlerstolz einer Firmenfreizeitgruppe, vermutlich ein Einzelstück, vermutlich in einem japanischen Freizeitpark eingesetzt. Und wenn es dunkel wird, dann glüht er – zumindest sein Dachlämpchen.

On ne connaît d'elle que le nom de son constructeur: Daihatsu. Pour le reste on en est réduit aux conjectures. Elle est probablement alimentée par piles, probablement le produit et la fierté d'une équipe de bricoleurs, probablement une pièce unique et elle roule probablement dans un centre de loisirs japonais. En tout cas elle brille dans l'ombre, du moins son plafonnier.

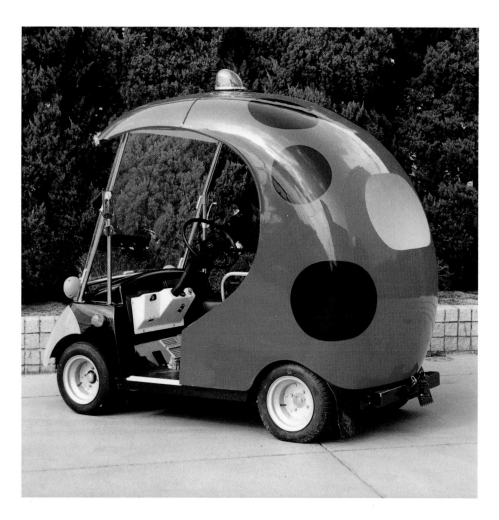

Toyota Wobbler, Japan, Japon, 1992

Here it is at last: the ultimate solution with no need for a cutting torch – and with full length. While the 1993 Renault Zoom just pulls in its hind legs, the 1992 Toyota Wobbler lifts them off the ground altogether. The little grand-piano castor at the front stops the car from falling over. It is in fact a relatively conservative design, proposed by Toyota's staff for their continuous ideas competitions.

Endlich die ultimative Lösung ohne Schneidbrenner – und trotzdem volle Fahrzeuglänge. Zieht ein Renault Zoom 1993 seine Hinterbeinchen nur an, so lüpfte der Toyota »Wobbler« 1992 die seinen ganz nach oben. Ein Umkippen verhindert das Klavierröllchen am Bug. Dieses Auto ist ein noch vergleichsweise konservativer Vorschlag im Rahmen der ständig laufenden Toyota-Ideenwettbewerbe unter der eigenen Belegschaft.

Enfin une solution qui ne passe pas par le découpage au chalumeau. La voiture conserve sa longueur. Si la Renault Zoom de 1993 replie ses gambettes arrière, la Toyota Wobbler de 1992 lève les siennes. Un rouleau de piano à l'avant empêche le tout de basculer. Comparée à d'autres, cette voiture est un projet plutôt conservateur dans le cadre des concours d'idées que Toyota organise sans relâche dans ses équipes.

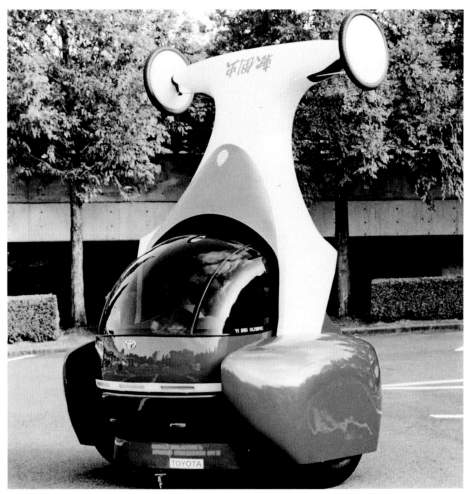

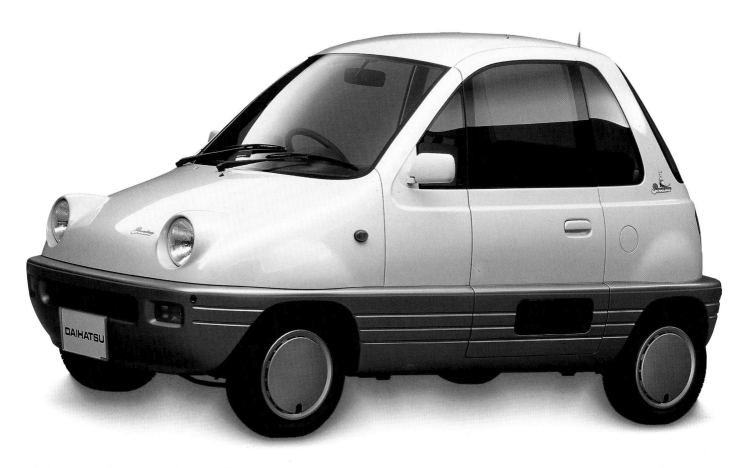

Daihatsu Sneaker, Japan, Japon, 1989

In top form, that was the 1989 Daihatsu Sneaker. Its length of only 113½ inches (288 cm) was made possible by seating the driver in the middle, with the two passengers slightly further back (cf. Toyota TAC and BMW Z 13). Like a prototype of a Sbarro in Switzerland, the Sneaker could be manoeuvred into the smallest gap, thanks to a retractable little protruding wheel. The little goggle eyes are in keeping with the general baby theme of the car. The dark spot on the side is a little window with a view of the gutter.

Fit wie ein Turnschuh zeigte sich 1989 der Daihatsu »Sneaker«. Die Länge von 288 Zentimetern war möglich, weil der Fahrer in der Mittte sitzt und zwei weitere Passagiere nach hinten versetzt unterkommen (vergleiche Toyota TAC und BMW Z 13). Wie bei einem Prototypen von Sbarro in der Schweiz konnte der Sneaker mit Hilfe eines einziehbaren querstehenden Rädchens auch in die engste Lücke manövriert werden. Die Glotzäugelchen entsprechen dem Babyschema. Der dunkle Fleck in der Flanke: ein Fensterchen für den Rinnstein!

En 1989, la Daihatsu Sneaker a la forme. Elle ne mesurait que 288 centimètres, et ceci parce que le conducteur était assis au milieu et les deux passagers décalés à l'arrière (cf. Toyota TAC et la BMW Z 13). Comme dans un prototype de Sbarro en Suisse, la Sneaker était dotée d'une petite roue transversale repliable, lui permettant d'entrer dans les créneaux les plus étroits. Ses petits yeux ronds lui font un visage de nourrisson. La tache sombre sur le côté est une fenêtre pour les bordures de trottoirs!

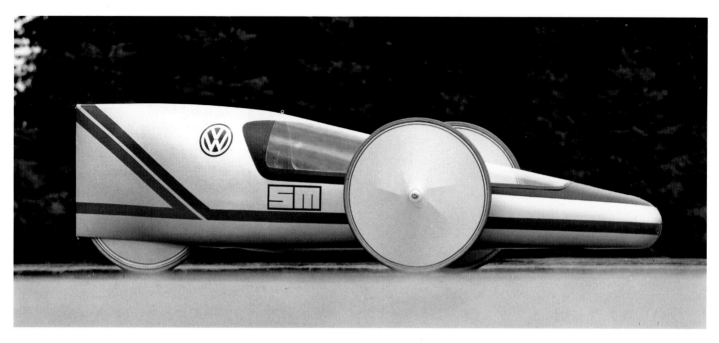

VW Sparmobil, Germany, Deutschland, Allemagne, 1983

The VW Sparmobil (Economy-mobile) needed no more than a gallon of petrol (UK) every 1,970 miles (i.e. a US gallon every 1,640 miles, or a litre every 697 km). However, although the body was well streamlined, it could hardly show its assets at an average speed of only 16 mph (25 km/h). The tyres were as thin as bicycle tyres, thus reducing the car's rolling resistance. Unfortunately, this did not augur much success for mass production: after all, who would want to take several days to get from one end of the country to the other?

1983 hat das VW-Sparmobil für 697 Kilometer einen Liter Benzin benötigt. Die strömungsgünstige Karosse kann allerdings bei einer Durchschnittsgeschwindigkeit von 25 Kilometern ihre Vorzüge kaum ausspielen, fahrraddünne Reifen senken den Rollwiderstand. Leider sind das keine erfolgversprechenden Daten für die Serienproduktion: Oder wer will mit diesem Dreirad Hamburg-München absolvieren?

En 1983, la VW Sparmobil a utilisé un litre d'essence pour parcourir 697 kilomètres. La carrosserie est aérodynamique mais elle ne peut guère montrer ses capacités avec une vitesse de pointe de 25 kilomètres à l'heure; des pneus minces abaissent la résistance au roulement. Malheureusement, ce ne sont pas des données bien alléchantes pour la production en série ou connaissez-vous quelqu'un qui ait envie de faire Hambourg-Munich avec ce tricycle?

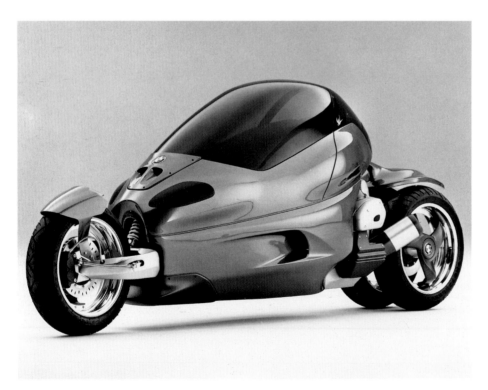

BMW C 1, Germany, Deutschland, Allemagne, 1991

This BMW study of 1991 featured a one-seater, submitted by the Vehicle Department of the Pforzheim College of Design. If a well-known company shows this kind of car, then it probably wants to cultivate an image of sportsmanship. Everything about this three-wheeler is geared towards performance and speed. It certainly wasn't inspired by any desire to produce a practical, environment-friendly car for the future.

1991 zeigte die BMW-Designstudie ein Einsitzer-Konzept, das in der Fahrzeugdesignabteilung der Pforzheimer Hochschule für Gestaltung seinen Ursprung hatte. Wenn eine bekannte Marke etwas Derartiges zeigt, will sie das sportliche Image pflegen. An diesem Dreirad ist alles auf Leistung und Geschwindigkeit ausgerichtet. Ein Beitrag zur Suche nach dem praktischen Fahrzeug der Zukunft mit ökologischem Hintergrund ist es nicht.

En 1991, l'étude de BMW présentait une monoplace, issue du service de design automobile de l'Ecole supérieure de stylisme de Pforzheim. Quand une marque connue montre ce genre de travail, c'est qu'elle veut soigner son image sportive. Ce tricycle est conçu pour les performances et la vitesse. L'étude n'est pas une contribution à la recherche de la voiture fonctionnelle de l'avenir dans un contexte écologique.

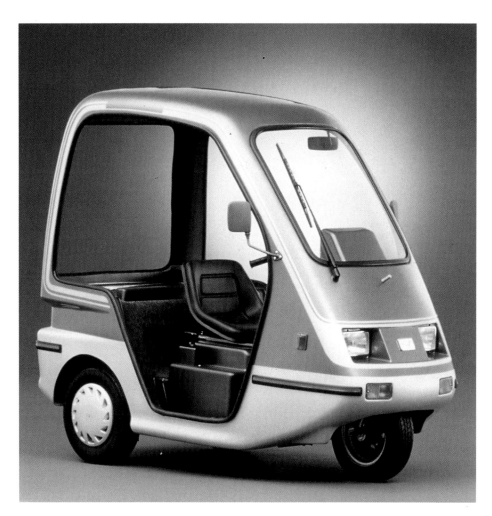

Daihatsu BL–7, Japan, Japon, 1990

The BL–7 Daihatsu study shows the absolute minimum for one person in style. – Minimum? Why bother at all, if a bicycle with a macintosh could actually achieve the same purpose, require less material and you could use your muscles at the same time?

Die Daihatsu-Studie BL–7 zeigt das gestylte Minimum an Auto für eine Person. Das Minimum? Warum überhaupt dieser Aufwand, wenn ein Fahrrad mit Regencape nicht wesentlich schlechter wäre, weniger Material brauchte und der Fahrer dabei auch noch seine Muskeln trainierte?

L'étude Daihatsu BL–7 présente la monoplace minimum. Le minimum, vraiment? Pourquoi faire simple quand on peut faire compliqué: un vélo sous un parapluie ne serait pas plus mal, il demanderait moins de matériel et, en plus, le conducteur pourrait faire du bien à ses muscles.

Honda VIP, Japan, Japon, 1989

With a 50 cc Honda engine and 86½ inches (220 cm) in length, 45¼ inches (115 cm) in height and 30– inches (78 cm) in width, this is another variation on the theme of small cars, this time by a company called VIP Corporation in Japan. Details such as the spare wheel, the seats and the steering rod are too DIY-ish. And why bother about a roof, if you can get hit by the rain from the open sides?

50 Kubikzentimeter von Honda, 220 Zentimeter lang, 115 Zentimeter hoch und 78 Zentimeter breit – ein weiterer Vorschlag, hier von einer VIP-Corporation aus Japan, zum Thema Kleinwagen. Details wie Reserverad, Sitz und Lenksäule zeigen zu sehr das Bastelstadium. Und warum ein Dach, wenn der Regen durch die offenen Seiten hereinschlagen kann?

Cylindrée de 50 centimètres cube, 220 centimètres de long, 115 centimètres de large, 78 centimètres de haut – encore une petite voiture qui nous vient cette fois de la VIP Corporation au Japon. Des détails comme la roue de secours, le siège et la colonne de direction sentent trop le bricolage. Et pourquoi l'avoir dotée d'un toit, si la pluie peut entrer par les côtés?

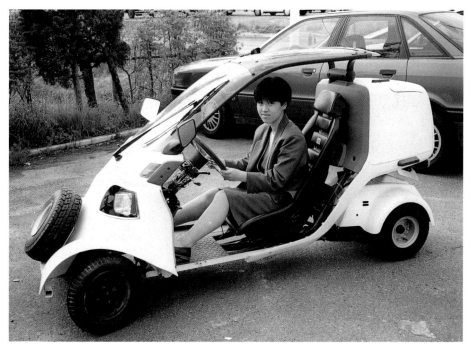

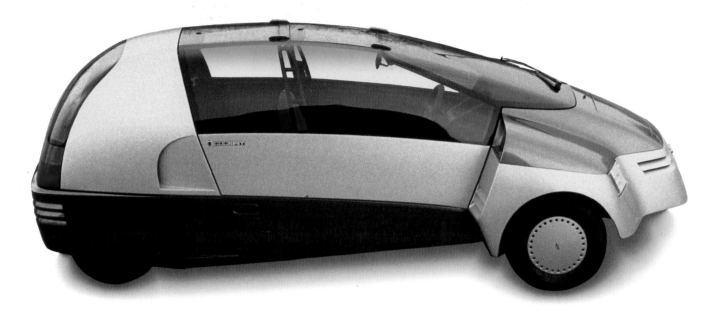

Ghia Cockpit, Italy, Italien, Italie, 1981

Like a Mini EL or GM's three-wheeler mini, the 1981 Ghia Cockpit opens at the front. This »Snow-White's Hyper Coffin« with a tandem seating arrangement is 129 inches (328 cm) long. However, it can hardly be regarded as a sensible solution, because a mini – and this is important – should offer enough space for at least three people. With its 12 HP, the Cockpit is much slower than it looks. Messerschmitt three-wheelers are more consistent here.

Das Ghia-Cockpit von 1981 läßt sich wie ein Mini EL oder das Dreiradmini von GM nach vorne öffnen. Dieser »Über- Schneewittchensarg« mit Tandem-Sitzanordnung ist mit 328 Zentimetern Länge aber nicht die Lösung, denn ein Mini, um das noch einmal zu wiederholen, muß mindestens noch zwei weitere Plätze bieten. Die 12PS machen das Cockpit nicht so schnell, wie es aussieht, Messerschmitt-Dreiräder sind da konsequenter.

La Ghia Cockpit de 1981 s'ouvre devant comme une Mini EL ou le tricycle mini de GM. Ce «super-cercueil de Blanche-Neige» où les passagers sont assis l'un derrière l'autre, mesure 328 centimètres de longueur. On ne voit pas très bien ce qu'il a d'intéressant, car une Mini, répétons-le, doit offrir au moins trois places. La Ghia-Cockpit a l'air rapide, mais ses 12 CV ne lui permettent guère d'écarts. Les tricycles de Messerschmitt se montraient plus performants.

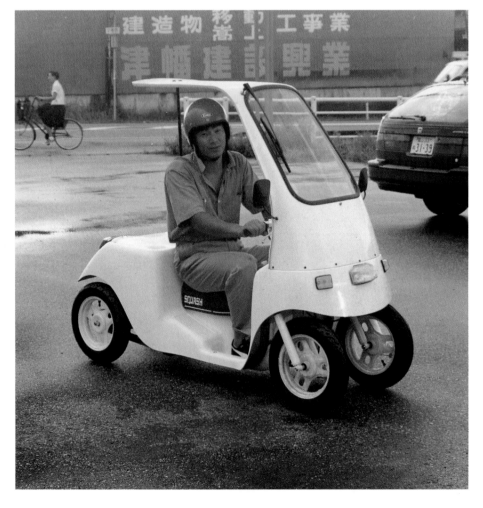

Takeoka Abbey 6, Japan, Japon, 1991

Takeoka Automobile Works in Japan are setting new standards. While others are too big (e.g. VIP), have two wheels missing (BMW C 1) or look as though they had never left the DIY shed, this car is a consistent vehicle, 69¼ inches (177 cm) long, which provides a little more stability and protection against rain by incorporating the motor scooter principle. And as this Abbey 6 only weighs 198 lbs (90 kg), you would quite happily accept a wet back.

Takeoka Automobile Works aus Japan setzt neue Maßstäbe. Sind andere zu groß (VIP), haben zwei Räder zu wenig (BMW C 1) oder kommen aus der Bastelecke nicht heraus – hier entstand ein logisches Mobil von 177 Zentimetern Länge, das durch die Einbeziehung des Motorrollerprinzips etwas Standsicherheit und Regenschutz bietet. Weil dieser Abbey 6 nur 90 Kilogramm wiegt, wird ein nasser Rücken in Kauf genommen.

La firme japonaise Takeoka Automobile Works a fixé de nouveaux jalons. D'autres modèles sont trop grands (VIP), il leur manque deux roues (BMW C 1), ou ils sont restés au stade du bricolage. Ici par contre on a créé un véhicule logique de 177 centimètres de long, et le principe du scooter qu'on y a intégré offre de la stabilité et une protection contre la pluie, encore qu'il faille s'attendre à avoir le dos mouillé. Mais le Abbey 6 ne pèse que 90 kilos, alors qu'importent les inconvénients.

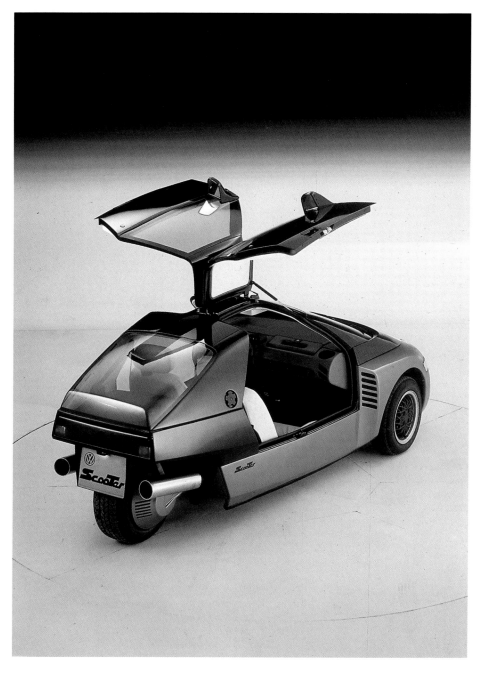

VW Scooter, Germany, Deutschland, Allemagne, 1986

If Ghia can do it, so can I, even with folding doors – says the VW Scooter (1986). Its sumptuous design gives the lie to the rear, apparently borrowed from a motorbike. Designers enjoy playing around and having fun, and so they tend to rationalize about their results. In this case the intention was to probe deeper into styling and dynamics – outside serial production. Mazda, on the other hand, does have a decent-length mass-produced car of 129 inches (329½ cm) in all: the Autozam AZ–1, a car on four wheels and with folding doors. The VW Scooter has a maximum speed of 125 mph (200 km/h). As a three-wheeler, it has its problems keeping to the straight and narrow, but the position of the driver's seat makes up for it, as it gives you a visual reference point and enables you to keep on course. Compared with the interior of other cars of the Nineties, the modesty of this car is almost refreshing, even though the colour scheme and the steering wheel leave a lot to be desired.

Was Ghia kann, kann ich auch, sogar mit Flügeltüren, sagte sich der VW Scooter 1986. Das üppige Autodesign widerspricht dem auf Motorrad getrimmten Heck. Designer spielen gern und gut und rechtfertigen ihre Lösungen oft nachträglich. Hier sollten Erkenntnisse über Styling und Fahrdynamik gewonnen werden – außerhalb der Serie. Mazda dagegen bietet 1993 serienmäßig unerschütterliche 329,5 Zentimeter Länge mit vier Rädern und Flügeltüren bei seinem Modell Autozam AZ–1 an. Der VW Scooter erreichte eine Geschwindigkeit von über 200 Stundenkilometern. Mit drei Rädern ist der Geradeauslauf nicht seine Stärke, aber ein Fahrerplatz wie bei Mittelklassewagen gibt optisch Halt und die Kraft, Kurs zu halten. Im Vergleich zu den Innenräumen anderer Autos der 90er Jahre tut hier die Schlichtheit fast wohl, obwohl Farbdesign und Lenkrad noch etwas Feinarbeit vertragen hätten.

1986: ce que Ghia peut, Volkswagen le peut, et même avec des portes battantes. Résultat: une Scooter. Il y a disharmonie entre la partie avant aux formes pleines et l'arrière inspiré de celui d'un scooter. Les designers aiment jouer et justifient souvent leurs solutions après coup. Il s'agissait ici d'étudier le style et la dynamique du mouvement – hors série. Mazda, en revanche, offre en 1993 en série son modèle Autozam AZ–1, une quatre-roues de 329,5 centimètres de long et dotée de portières-ailes articulées. La VW Scooter plafonnait à plus de 200 kilomètres à l'heure. Elle n'avait que trois roues et donc de la peine à «marcher droit», mais la place du conducteur, traitée comme dans une voiture de classe moyenne, stabilisait le tout visuellement et donnait la force nécessaire pour ne pas dévier. Comparé à celui d'autres voitures des années 90, l'habitacle nous réconforte par sa sobriété, encore qu'un petit travail de finition n'aurait pas nui aux tonalités et aux formes du volant.

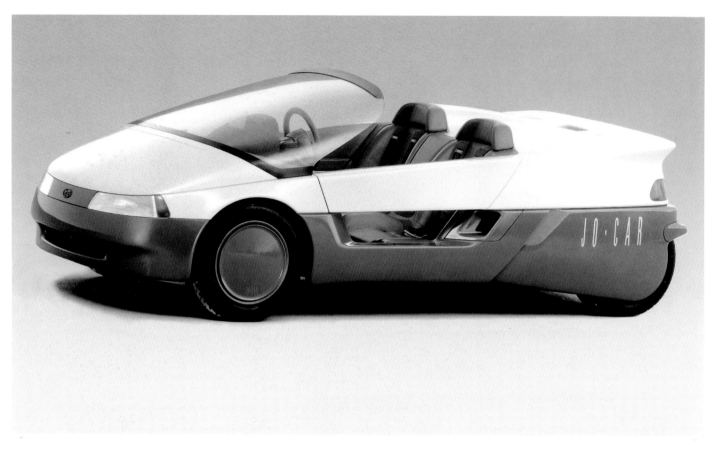

Subaru Jo Car, Japan, Japon, 1987

In 1987 Subaru designed a single item called »Jo Car« (a cross between a joke, joy and a car). It was a brightly colourful two-seater: the front and rear apron were a loud green, the hub caps and flanks red, the body yellow, and the interior red and green. What is more, the whole thing was 4 inches (100 mm) short of the sacred Japanese limit of 122¼ inches (310½ cm).

Subaru boz 1987 mit dem Einzelstück »Jo Car« (darin stecken Joker, joy und car) einen knallbunten Zweisitzer an: Front- und Heckschürze knallgrün, Radkappen und Flanken rot, der Body gelb, das Interieur rot-grün. Und alles 100 Millimeter kürzer als das in Japan sakrosankte Längenmaß von 310,5 Zentimetern.

Subaru a présenté en 1987 avec sa pièce unique Jo Car (joker, joy et car) une biplace haute en couleurs: tablier avant et arrière vert acide, côtés et enjoliveurs rouges, corps jaune, habitacle rouge et vert. Et le tout 100 millimètres plus court que les sacro-saints 310,5 centimètres japonais.

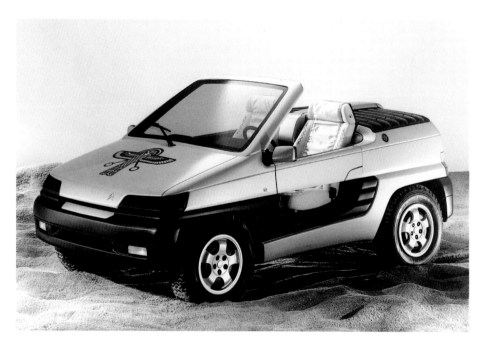

Heuliez Scarabee d'or, France, Frankreich, 1990

The French body maker Heuliez has been a successful designer for many years. This study for a cross-country mini - 126 inches (320 cm) long, 65¼ inches (166 cm) wide – is a real delight with its cuddly shape. Its 107 HP churn up a lot of dust when the car is on the dirt track. Its corrugated hood-like structure houses two small seats.

Der französische Karosseriebauer Heuliez ist seit Jahren als Designer erfolgreich. Diese Geländewagenstudie in Miniformat, Länge 320 Zentimeter, Breite 166 Zentimeter, bereitet mit ihrer knuffigen Form Freude, und 107 PS wirbeln viel Staub im Gelände auf. Unter der geriffelten Heckhaube verbergen sich zwei kleine Sitze.

Le carrossier français Heuliez a du succès depuis des années en tant que designer. Cette étude de V.T.T. miniature – longueur 320 centimètres, largeur 166 centimètres – plaît à cause de ses formes rondes, et puis 107 CV mettent de l'ambiance sur le terrain. Sous le capot arrière cannelé se cachent deux petits sièges.

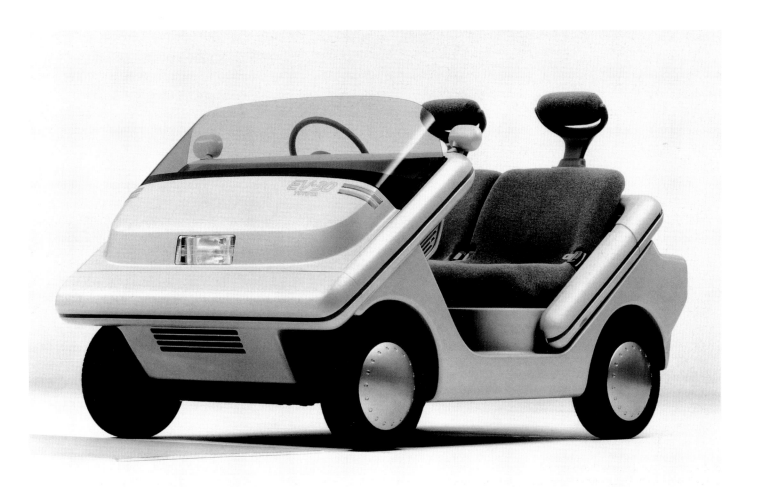

Toyota EV–30, Japan, Japon, 1987

Do you play golf? Or do you have to walk for miles at airports or trade fairs? Well, here's an electric solution to your problems – complete with a roof for the golfer. The car is 82½ inches (210 cm) long, 52 inches (132 cm) wide, and its battery capacity is sufficient for 80,000 times its length, i.e. 103 miles (165 km). In 1987, this design was more a matter of playing with forms, as battery technology had not fully developed at the time.

Spielen Sie Golf? Oder haben Sie kilometerlange Wege in Flughafenhallen oder auf Messen vor sich? Hier ist die elektrisch betriebene Lösung, für den Golfer mit passendem Dach ausgestattet. Mit 210 Zentimetern Länge und 132 Zentimetern Breite reicht die Batterieladung für das 80 000fache seiner Länge: für 165 Kilometer. 1987 stellte dieser Vorschlag eher ein Spiel mit Formen dar, denn die Batterietechnologie ist noch nicht optimal entwickelt.

Vous jouez au golf? Vous avez des kilomètres à faire à pied dans les halls d'aéroports et les salons commerciaux? Toyota a ce qu'il vous faut en version électrique, avec toit assorti pour les golfeurs. Elle mesure 210 centimètres de long et 132 centimètres de large, sa pile lui offre une autonomie de 165 kilomètres, soit 80 000 fois sa longueur. En 1987, ce projet reste une étude ludique, car les piles électriques ne sont pas encore au point.

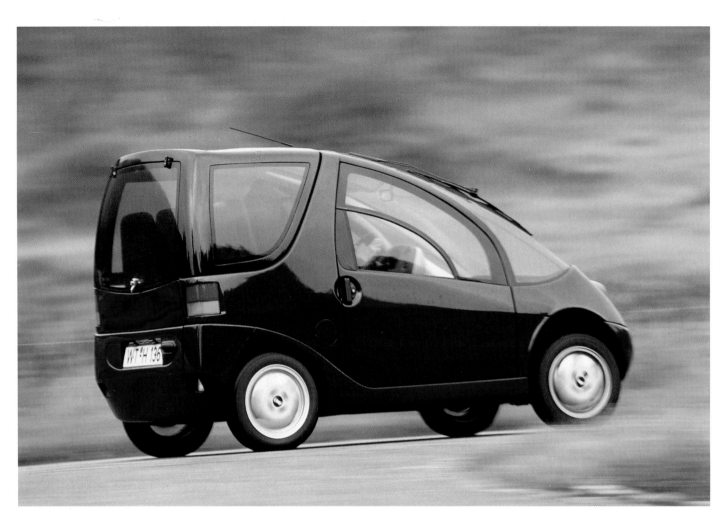

Hotzenblitz, Germany, Deutschland, Allemagne, 1992

A funny name for a car – and rightly so. This two-plus-two seater with an electric engine (1992) has a steep rear portion, with plenty of space for backseat passengers. It was sponsored by Ritter, a German chocolate manufacturer. Mass production will probably take place in the historical East German town of Suhl in Thuringia.

Wer so lustig aussieht, kann zu Recht »Hotzenblitz« genannt werden. Dieser Zwei-plus-zweisitzige Elektrowagen (1992) bietet mit seinem steilen Heck Platz für die hinteren Passagiere. Von der Schokoladenfabrik Ritter unterstützt, soll er vielleicht an einem historischen Ort gebaut werden, in Suhl in Thüringen.

Un drôle de nom pour une drôle de petite auto. Cette voiture électrique à quatre places de 1992 offre, grâce à son hayon presque vertical, assez de place aux passagers arrière. Soutenue par la chocolaterie Ritter, elle sera peut-être fabriquée dans un site historique, à Suhl en Thuringe.

Horlacher Consequento City III, Switzerland, Schweiz, Suisse, 1993

The Horlacher Consequento City III of 1993 is a rare example of a well proportioned vehicle with a minimum length. Its large wheels promise relatively good comfort. A pity that such ideas are so expensive and therefore unlikely to become very widespread.

Der Horlacher Consequento City III von 1993 ist ein selten gutes Beispiel, eine Minimalhülle in guten Proportionen zu liefern. Große Räder versprechen vergleichsweise guten Fahrkomfort. Ein Jammer, daß hohe Preise die Verbreitung solcher Lösungen immer noch erheblich erschweren.

La Horlacher Consequento City III de 1993 est un bon exemple pour montrer comment fabriquer une carrosserie minimale aux proportions excellentes. Les grandes roues promettent une suspension confortable. Dommage que leurs prix élevés rendent difficile la diffusion de tels véhicules.

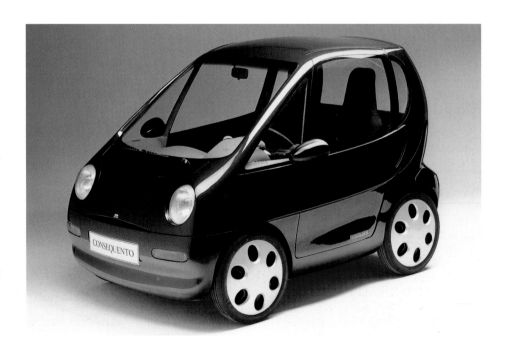

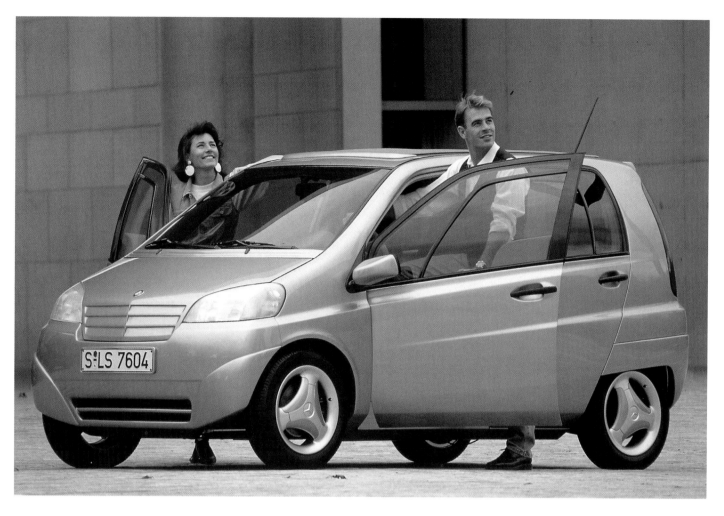

Mercedes Vision A, Germany, Deutschland, Allemagne, 1993

Mercedes demonstrated their Vision A at the International Automobile Exhibition in Frankfurt in autumn 1993. The car is 132 inches (335 cm) in length, i.e. nearly 12 inches (30 cm) longer than a Mini. Its interior is that of a medium-sized car and its safety standards are of the usual good quality, though its chubby-faced appearance still needs to be eliminated before mass production in 1997, when the car will also be a little longer (approx. 145½ inches/370 cm). Surveys have shown that the design of this car is less popular than that of the BMW Minis.

Mercedes zeigte im Herbst 1993 auf der Auto-ausstellung Frankfurt die 335 Zentimeter lange »Vision A«, 30 Zentimeter mehr als ein Mini. Mit dem Innenraum der Mittelklasse und daimlertypischer Sicherheit ein Auto, dem man aus dem Gesicht die Pausbäckigkeit nehmen muß, bis die Serie ab 1997 noch einmal in der Länge zulegt (circa 370 Zentimeter). Umfragen bescheinigen der Vision schlechtere Designnoten als den BMW-Minis.

Mercedes présente en automne 1993 au Salon international de Francfort sa Vision A, longue de 335 centimètres, 30 centimètres de plus qu'une Mini. La voiture offre l'habitabilité de la catégorie moyenne, la sécurité caractéristique de Daimler-Benz et son visage doit s'affiner jusqu'à ce que la carrosserie de la série s'allonge encore à partir de 1997 (pour atteindre environ 370 centimètres). Les sondages ont montré que la Vision A est moins bien notée que les petites BMW au niveau du design.

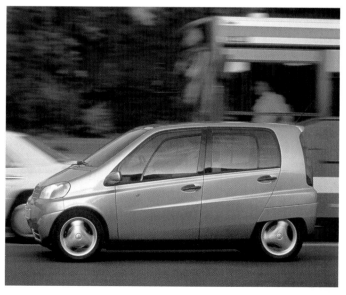

BMW E 1, Germany, Deutschland, Allemagne, 1991, 1993

In 1991 the moment had finally come: BMW had created the first purely electric car – the E1. The high separation edge, to produce a high cd value, and the rear windows seem to be in competition with each other, the fashionably styled rear lights are similarly stepped, as indeed they are in their petrol-driven siblings and, at the tailgate, they are at an oblique angle again by a couple of inches. More design, less styling, and the small volume would have a less hectic quality about it.
Below: even the smallest body, like the second-generation E1 of 1993 needs to have a number of styling motifs added to it, such as over-emphasized wheel cases at the rear and a discordant combination of windows and rear lights. The interior is more serene. In all, it is a better car than the first version which had gone up in flames on the company's premises.

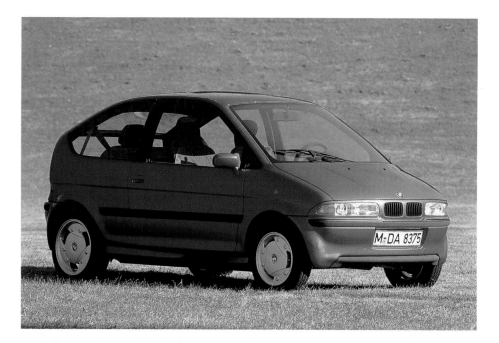

1991 war es soweit. BMW hatte mit dem »E1« das erste reine Elektroauto. Die hohe Abrißkante für einen guten Cw-Wert und die Heckfenster konkurrieren, darunter modisch modellierte Heckleuchten wie bei den Benzinbrüdern gestuft und an der Heckklappe auf wenige Zentimeter noch einmal schräg gestellt. Mehr Design, weniger Styling, und das kleine Volumen wirkte weniger hektisch.
Unten: Selbst die kleinste Karosse wie des E1 (zweite Generation) von 1993 muß noch viele Stylingmotive verarbeiten wie überbetonte Radkästen im Heck und unharmonische Kombination der Fensterpartie mit den Heckleuchten. Ruhiger geht es im Innenraum zu. Allemal besser war die erste Version des E1, die aber ist auf dem Werkgelände den Feuertod gestorben. Schade.

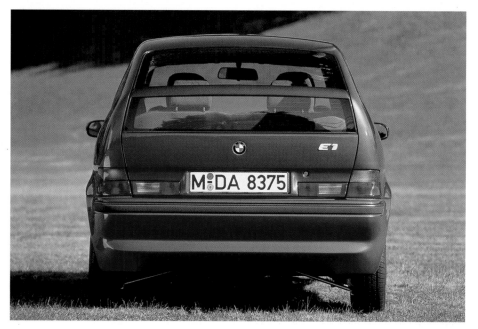

L'heure a sonné en 1991. Le E1 de BMW était la première voiture complètement électrique. L'arrière haut et court pour un bon coefficient aérodynamique rivalise avec les fenêtres arrière, en dessous des feux arrière dessinés de manière moderne sont échelonnés comme chez les voitures à essence et placés en biais encore une fois sur quelques centimètres, là où se trouve le hayon. Plus de design, moins de recherche de style, et le petit volume avait l'air moins agité.
BMW ne peut s'empêcher de doter la plus petite carrosserie, c'est le cas ici avec l'E1 (seconde génération) de 1993 de nombreux détails stylistiques, comme des carters de roue surchargés à l'arrière et une combinaison peu harmonieuse des glaces et des blocs lumineux. L'habitacle fait une impression plus paisible. La première version de l'E1 était meilleure sur tous les plans, mais elle a péri dans les flammes sur le terrain de l'usine. Dommage.

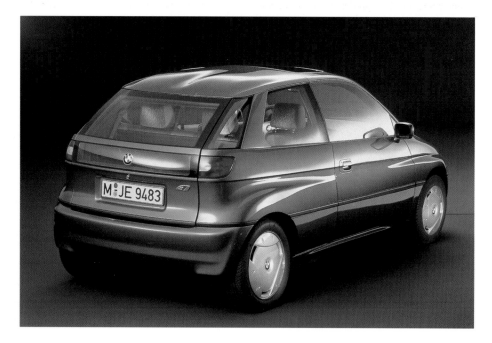

130

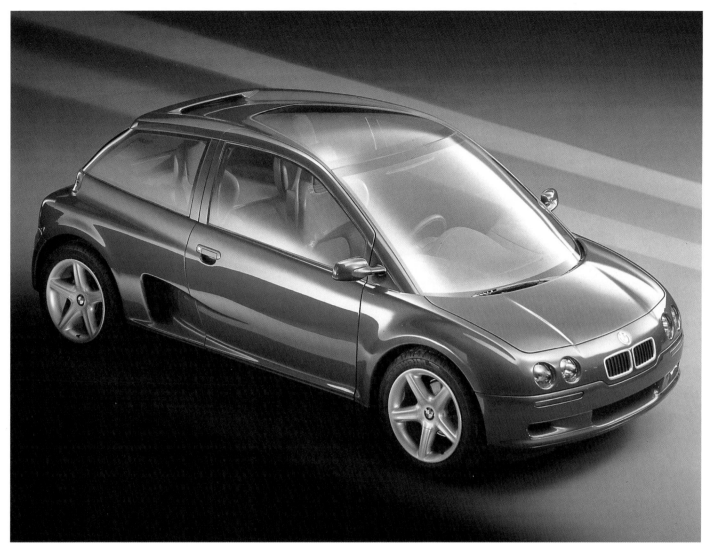

BMW Z 13, Germany, Deutschland, Allemagne, 1993

With its 135½ inches (just over 11 ft or 344 cm), the Z13 was BMW's second attempt to build a car that was less than 13 feet (4 metres) long. The mixture of a sports car chassis and an estate car, together with its design-related proportions make it rather an unbridled vehicle which actually achieves a maximum speed of 110 mph (180 km/h). A bit of a con if it is also meant to be environmentally - acceptable.

Den zweiten Anlauf von BMW, ein Auto von weniger als vier Metern Länge zu bauen, stellte der Z 13 mit 344 Zentimetern Länge dar. Die Mischung von Sportwagen-Unterbau und Kombi, gemixt mit designbestimmten Proportionen, machen ihn zur Krawallschachtel, die auch tatsächlich 180 Stundenkilometer Höchstgeschwindigkeit erreicht. Eine Mogelpackung, falls damit ökologische Gedanken transportiert werden sollten.

BMW a pris son élan une seconde fois pour fabriquer une voiture de moins de 4 mètres de long. Résultat: la Z 13 qui mesure 344 centimètres. Le mélange de châssis sport et de break, avec des proportions fixées par le design, en font une petite chahuteuse qui atteint vraiment les 180 kilomètres à l'heure. Ceux pour qui l'environnement n'est pas un vain mot doivent se méfier: l'emballage est trompeur.

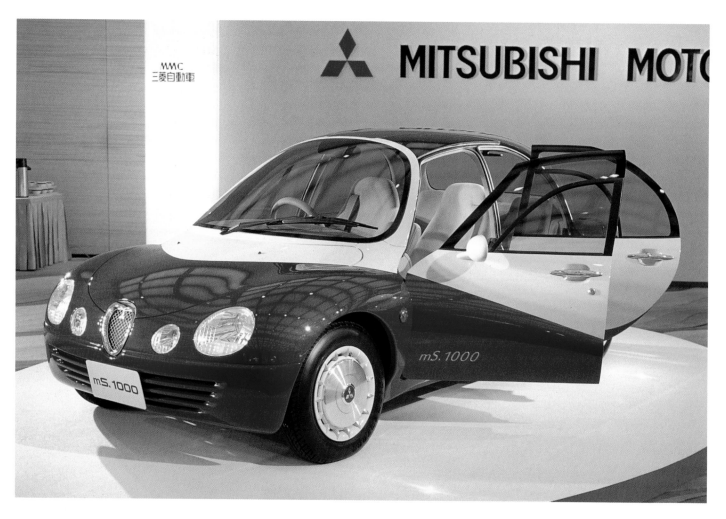

Mitsubishi MS 1000, Japan, Japon, 1991

The paint was a mixture of Bugatti and Citroën 2CV Charleston, the bonnet a mixture of Bugatti and Alfa, and everything is nicely rounded. Mitsubishi's MS 1000 of 1991 was just right for a car show. And it was not even all that small.

Die Bemalung eine Mischung aus Bugatti und Citroën 2CV Charleston, der Kühler eine Mischung aus Bugatti und Alfa, alles gerundet – das richtige Konzept für eine Autoshow, was Mitsubishi mit dem MS 1000 1991 zu bieten hatte. Und gar so klein war er auch nicht.

Un mélange peinturluré de Bugatti et de Citroën 2 CV Charleston, la calandre synthèse de Bugatti et d'Alfa, le tout arrondi – la conception idéale pour un spectacle automobile, et c'est bien ce que Mitsubishi avait à offrir avec la MS 1000 de 1991. Et puis elle n'était pas si petite que cela.

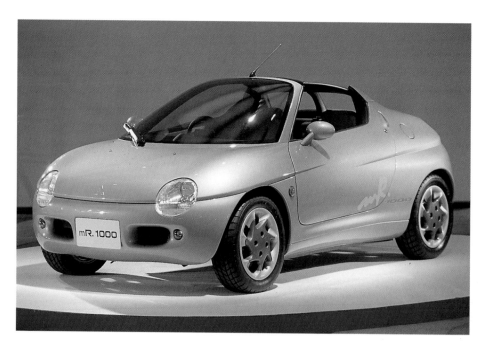

Mitsubishi MR 1000, Japan, Japon, 1991

The Mitsubishi MR 1000 has no problems passing as a small car – even in its 1991 version. As a two-seater coupé it was shorter. The rear window section with its truncated, tapered fins has been borrowed from the classical Lancia series made by Pininfarina.

Schon eher als Kleinwagen geht der Mitsubishi MR 1000 – auch von 1991 – durch. Als zweisitziges Coupé war er kürzer; er lieh sich die Heckfensterpartie mit auslaufenden Flossenansätzen von den klassischen Lancias aus Pininfarinas Hand.

La Mitsubishi MR 1000, également de 1991, se range mieux dans la catégorie des petites voitures. En tant que coupé biplace, elle était plus courte; la partie où se trouvent les glaces arrière avec des débuts d'ailerons s'élargissant, s'inspire des Lancias classiques de la main de Pininfarina.

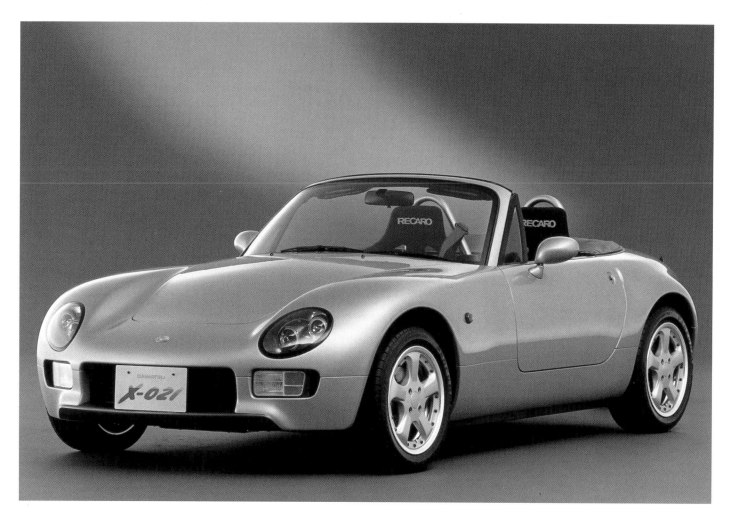

Daihatsu X-021, Japan, Japon, 1991

Daihatsu have joined the league of mini road-
sters – right down to the design. The front of
this X–021 of 1991 is similar to the Porsche
959, while the back reminds us of a Ferrari. Its
length of 141¼ inches (358½ cm) almost
puts it in the medium-sized category, and its
150 HP certainly does. Japan has the advant-
age that the smallest German convertible is
still the Golf.

Daihatsu hält bei den Miniroadstern dagegen –
bis hin zum Design. 1991 zeigte dieser X–021
am Bug Anklänge an den Porsche 959, das
Heck erinnerte an einen Ferrari. Mit seiner Län-
ge von 358,5 Zentimetern ist er auf dem Weg
zur Mittelklasse, mit 150 PS sowieso. Japans
Vorteil: Das kleinste deutsche Cabriolet ist im-
mer noch der Golf.

Daihatsu s'en tient, et ceci jusqu'au design,
aux roadsters miniatures. Ce X–021 de 1991
avait à l'avant un air de Porsche 959, l'arrière
rappelait la Ferrari. Sa longueur de 358,5 centi-
mètres la pousse dans la gamme moyenne,
avec 150 CV elle s'y trouve de toute façon.
L'avantage des Japonais: le plus petit cabriolet
allemand reste la VW Golf.

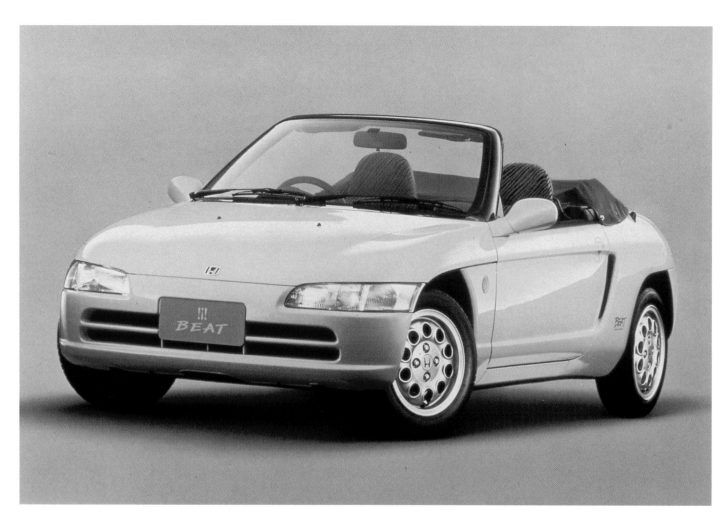

Honda Beat, Japan, Japon, 1991

The Honda Beat has a certain image value even in its own country. Despite a few design features borrowed from a Ferrari (i.e. the headlights and the lines on either side) and its loud yellow colour, it still does not cause any great furore. After nearly 20,000 cars, production was discontinued in 1992. A pity really.

Selbst in seinem Heimatland hat der Name des Honda Beat Imagewert. Mit kleinen Designzitaten eines Ferraris (Scheinwerfer, seitliche Linien im Blech) und in knallgelb machte er dennoch nicht Furore. Nach annähernd 20 000 gebauten Exemplaren wurde die Produktion 1992 eingestellt. Eigentlich schade.

Même dans son pays d'origine la Honda Beat a une image de marque. Les petits détails inspirés de Ferrari (phares, lignes latérales dans la tôle) et sa couleur jaune clinquant, ne lui ont pas apporté le succès. On en a construit 20 000 exemplaires avant de cesser la production en 1992, et c'est bien dommage.

Daihatsu Opti, Japan, Japon, 1992

Japan has the biggest range of small cars. The Daihatsu Opti is one of them. To accommodate its curves, it has to be 129 inches (329½ cm) long. The reason why the dimensions of a Mini could no longer be kept was its safety-oriented body cells. To protect a car against a crash, you do need a few more inches.

Japan bietet das größte Programm an Kleinwagen – hier der Daihatsu Opti. Für seine kurvigen Formen braucht er 329,5 Zentimeter. Daß insgesamt die Maße eines Minis nicht mehr zu erreichen sind, liegt an den sicherheitsorientierten Karosseriezellen. Zum Schutz vor einem möglichen Crash sind einige Zentimeter mehr erforderlich.

Le Japon offre la gamme la plus vaste de petites voitures – ici la Daihatsu Opti. Sa carrosserie aux formes arrondies mesure 329,5 centimètres de long, un peu plus que la Mini, son modèle. Elle est plus longue que la Mini parce que son habitacle est orienté sur la sécurité. Quelques centimètres de plus sont nécessaires pour se protéger en cas de collision.

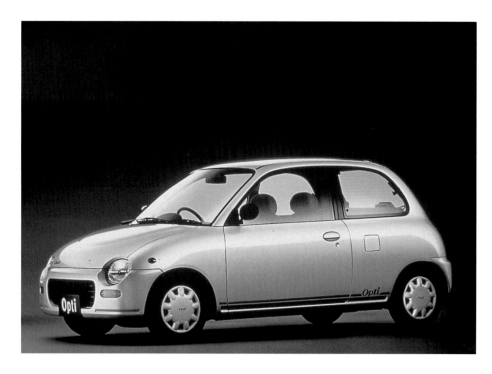

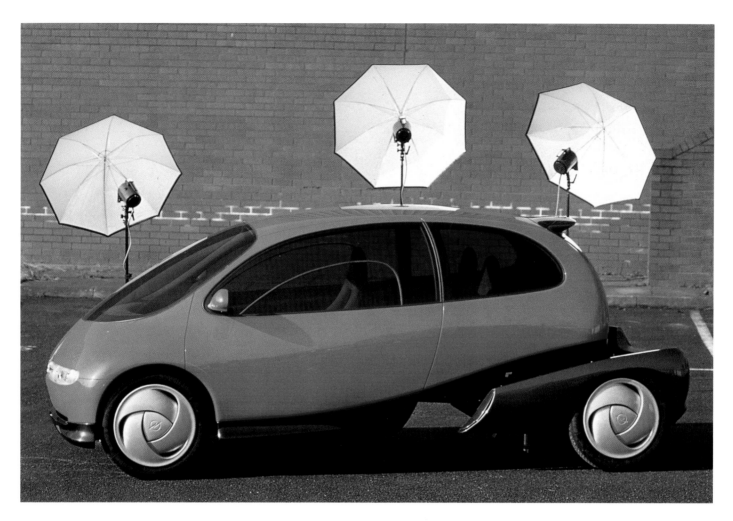

Opel Twin, Germany, Deutschland, Allemagne, 1992

In 1992 Opel developed the Twin, a car with an electric engine for use in town as well as a petrol engine for long journeys. Camouflaged unobtrusively as a rear bumper, the rear axle and the connected drive can be exchanged. The one-box design is convincing because none of its trendy curves are an end in themselves. The seating arrangement is the same as before, with a solo driver's seat and a twin seat at the rear.

1992 entwickelte Opel den Twin mit Elektromotor für die Stadt oder mit Benzinmotor für die große Fahrt. Optisch unauffällig als Heckstoßfläche getarnt, kann die Hinterachse inklusive angekoppeltem Antrieb ausgetauscht werden. Das One-Box-Design überzeugt, weil trendige Rundungen nicht zum Selbstzweck des Formalen werden. Sitzanordnung wie bekannt: Lenker solo, Pärchen hinten.

En 1992, Opel a créé deux moteurs pour sa Twin: le moteur électrique pour la ville, le moteur à essence pour les grandes distances. Il suffit de changer l'essieu arrière à propulsion intégrée, on ne le voit pas puisqu'il est camouflé sous un bouclier pare-chocs. Le design monospace est convaincant, car les rondeurs à la mode ne sont pas un objectif en soi. Le conducteur est assis à l'avant, deux passagers se partagent l'arrière.

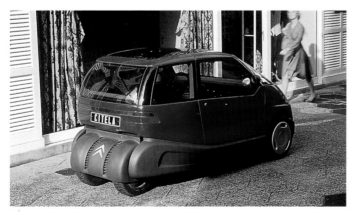

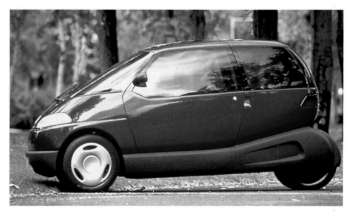

Citroën Citela, France, Frankreich, 1991

Citroën's Citela (1991) was designed as an electric vehicle for town centres. The electric engine, which gets its power from a sodium cadmium battery, is said to survive over 600,000 miles (or 1 million km) – the sort of mileage that would probably keep you going for quite a while. The base, at 116½ x 61 inches (296 x 155 cm) is nicely compact.

Citroën kam uns 1991 mit dem Citela elektrisch für die Stadt. Angeblich soll der von einer Natrium-Kadmiumbatterie gespeiste Elektromotor eine Million Kilometer Laufleistung überstehen. Wer die schaffen will, muß schon mal die Kleider wechseln können. Die Grundfläche von 296 mal 155 Zentimetern ist schön kompakt.

Citroën a présenté en 1991 la Citela électrique à vocation urbaine. Il paraît que la pile sodium-cadmium qui alimente le moteur peut résister pendant un million de kilomètres, ce qui n'est pas mal. La surface de base de 296 fois 155 centimètres donne un volume bien compact.

Fiat Downtown, Italy, Italien, Italie, 1993

The Fiat Downtown has a total length of 97½ inches (2474 mm), is 61 inches (1550 mm) high and 58½ inches (1490 mm) wide. Launched in 1993, it offers enough space for three people. The two electric engines are driven by a sodium sulphur battery – expensive but compact and with a high energy accumulation efficiency – allowing a maximum speed of 60 mph (100 km/h) if need be. This is partly due to its good cd value of 0.3.

2474 Millimeter strecken sich, 1550 erheben sich und 1490 machen sich breit. Das hat der 1993 vorgestellte Fiat Downtown mit Platzangebot für drei vorzuweisen. Eine Natrium-Schwefelbatterie, teuer, aber kompakt und mit hoher Energiespeicherdichte, treibt mit zwei Elektromotoren das Auto auf 100 Stundenkilometer, wenn es sein muß, was auch dem guten Cw-Wert von 0,30 zu verdanken ist.

Elle est longue de 247,4 centimètres, haute de 155 centimètres et large de 149 centimètres. La Fiat Downtown a donc assez de place pour trois. Une pile sodium-soufre, chère mais compacte et de haute densité énergétique, alimente deux moteurs électriques. La voiture peut atteindre les 100 kilomètres à l'heure, ce qu'elle doit aussi à son bon coefficient de traînée de 0,30.

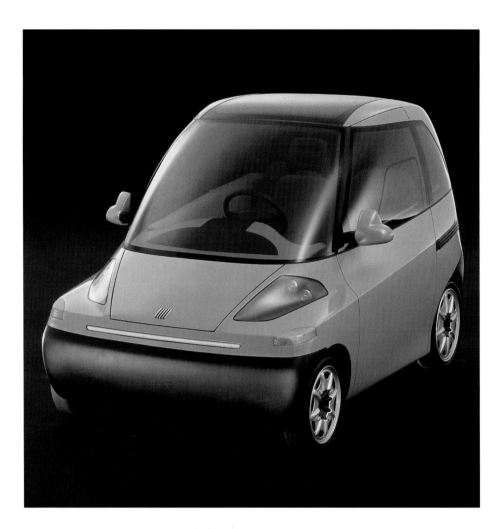

Ford Ghia Zig, Zag, Italy, Italien, Italie, 1990

With a mechanism borrowed from a Ford Fiesta, the 1990 Ghia had two designs – »Zig« (open) and »Zag« (closed). The Zag probably has better chances because it is more suitable for everyday use. The top edge of its rear also occurs in the Renault Twingo series. With its 133½ inches (339 cm), the Zag is 6 inches (15 cm) shorter than the Zig. Both have the same holes at the front and rear.

Vom Ford Fiesta abgeleitete Mechanik gab die Basis der Ghia-Entwürfe »Zig« (offen) und »Zag« (geschlossen) 1990 her. Größere Chancen müßte der »Zag« haben, weil alltagstauglicher. Sein oberer Heckabschluß findet beim Renault Twingo Serieneinsatz. Mit 339 Zentimetern ist der »Zag« 15 Zentimeter kürzer als der »Zig«; beiden gemeinsam sind die Blechlöcher an Front und Bug.

La mécanique de la Ford Fiesta sert de base à la Ford Ghia Zig (ouverte) et Zag (fermée) de 1990. La Zag semble plus prometteuse, parce que plus adaptée à la vie quotidienne. On retrouve le haut de sa partie arrière en série dans la Renault Twingo. La Zag a 15 centimètres de moins que la Zig; elles ont en commun les trouées dans la tôle à l'avant de la voiture.

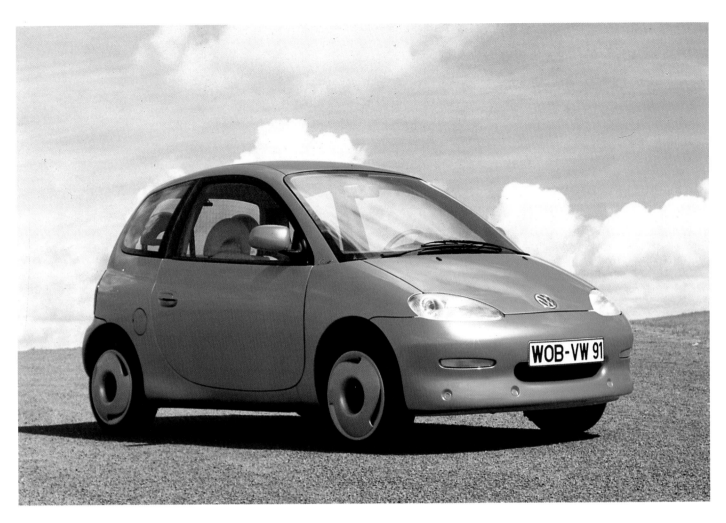

VW Chico, Germany, Deutschland, Allemagne, 1991

The VW Chico of 1991 proves that its design has finally reached the same fashionable level as other cars throughout the world. Only the VW logo still reminds us that it is a native German car. With its 124 inches (315 cm) in length, it is just over a foot (31 cm) shorter than the BMW E1. For mass production, the Chico will be stretched by a further 8 inches (20 cm). The car is another attempt to implement a hybrid drive, i.e. a combination of electric and IC engine.

Der VW Chico von 1991 beweist, im Design international modisch gleichgezogen zu haben, nichts außer dem VW-Zeichen erinnert an bodenständiges Design aus Niedersachsen. Mit 315 Zentimetern Länge unterbietet der Chico den BMW E1 um 31 Zentimeter, hat aber auf den Fondsitzen knapperen Raum. Für die geplante Serienproduktion will sich der Chico um 20 Zentimeter strecken. Er versucht sich mit dem Hybridantrieb, der Koppelung von Elektro- und Explosionsmotor.

La VW Chico de 1991 prouve qu'elle a joué le jeu du design international moderne. A part l'emblème VW, plus rien ne rappelle ce à quoi les usines de Wolfsburg nous ont habitués. La Chico mesure 315 centimètres de long, donc 31 centimètres de moins que la BMW E1, mais elle est moins spacieuse que celle-ci à l'arrière. On prévoit de la construire en série en l'allongeant de 20 centimètres. Il y a des tentatives de moteur hybride, d'accouplement de moteur électrique et de moteur à explosion.

The use of bulging curves is a great asset for safety, i.e. to soften the impact on people's bodies. However, they follow very closely the current fashion of soft undulating lines. Yet the steering wheel was not subjected to such reshaping and has retained the relatively classical form.

Die Diktion von schwellenden Rundungen hat Vorteile für die Sicherheitsaspekte (Körperaufprall), gerät aber voll in den Trend weicher Designwelle. Das Lenkrad wurde nicht dem Formwillen unterworfen, sondern gibt sich vergleichsweise klassisch.

Les formes rondes, avantageuses au niveau de la sécurité en cas de collision, sont également en plein accord avec la vague du design doux. Le volant n'a pas été soumis à une volonté de recherche esthétique, il est même relativement classique.

ACCE BMW, Switzerland, Schweiz, Suisse, 1991

One of the best opportunities for studying automobile design in Europe is offered by the Art Centre College of Europe on the Lake of Geneva. This breeding ground for talented designers is occasionally sponsored through design jobs, and sometimes the topics are geared specially towards a particular name. A BMW was developed here in 1991 and did just as well as BMW's own Z13, on which it was modelled.

Eine der besten Möglichkeiten, Autodesign in Europa zu studieren, bietet das Art Center College Europe am Genfer See. Die Talentschmiede wird gelegentlich durch Designaufträge gesponsort, oder die Themen zielen speziell auf eine Marke. Hier sollte 1991 ein BMW entwickelt werden – er schneidet im Vergleich mit dem Münchener Vorbild Z 13 nicht schlechter ab.

Le Art Center College situé sur les rives du Lac Léman offre une des meilleures possibilités d'étude du design automobile en Europe. Ce berceau de talents est sponsorisé à l'occasion avec des commandes de design, ou bien les thèmes ciblent une marque particulière. La BMW que l'on a conçue ici en 1991 ne fait pas moins bonne figure que la Z 13 munichoise qui lui a servi de modèle.

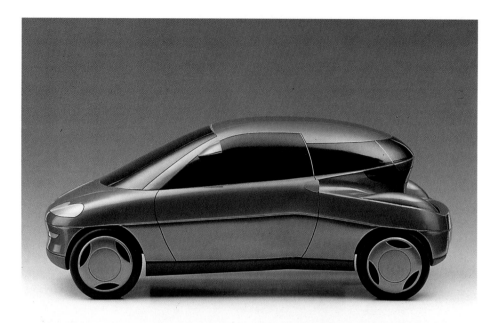

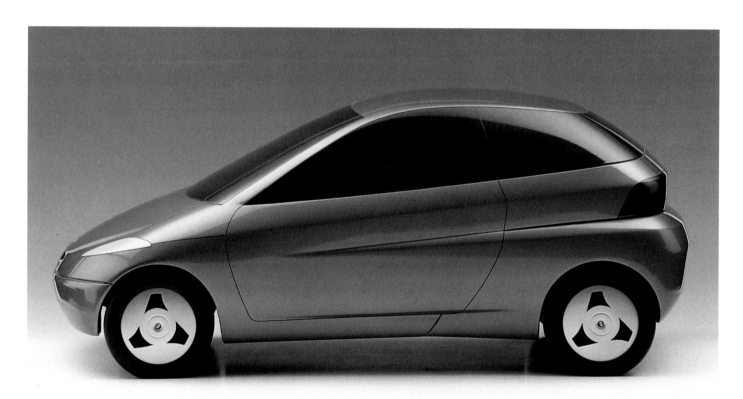

ACCE BMW, Switzerland, Schweiz, Suisse, 1991

Here the student project from the Art Centre is in fact superior to the Z13. Both cars were to be representative of BMW as a name. But this 1991 draft, which has the same rear, is more harmonious while keeping the same dynamic effect.

Hier darf sogar das Schulbeispiel vom Art Center besser gefallen als der Z 13, denn beide sollen die Marke BMW repräsentieren. Und dieser Schülerentwurf (1991) ist bei identischem Heckmotiv harmonischer, ohne an Dynamik einzubüßen.

La ACCE issue de l'école Art Center a le droit de plaire davantage que la Z 13, car les deux études représentent la marque BMW. Cette étude scolaire de 1991, qui présente une partie arrière identique à celle de la Z 13, est plus harmonieuse, et ceci sans perdre de son effet dynamique.

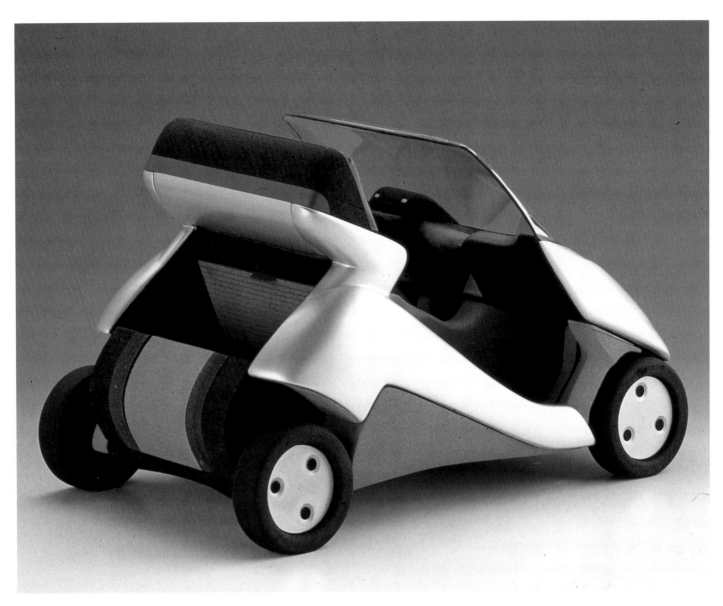

ACCE Mazda, Switzerland, Schweiz, Suisse, 1991

The colour scheme almost predetermines the use of this Mazda Study from the Art Centre: it is intended as a golf cart. Studies of this kind confirm our impression that the small car of the future will continue to be measured against the standard of the 1959 Mini, the Japanese minis of the Nineties and the Fiat Cinquecento – until, that is, the numerous variations of micro cars, partly with an environmental touch, have gained acceptance. And this does not seem to have happened in the early Nineties.

Die Farbstellung gibt die Nutzung fast schon vor bei dieser Art Center-Mazda-Studie: Einsatz als Cart auf dem Golfplatz. Die gezeigten Entwürfe der Designschulen lassen vermuten: Noch ist ein Mini von 1959, noch sind die japanischen Minis der 90er Jahre und noch ist ein Fiat Cinquecento der Maßstab, an dem sich zukünftige Kleinautos messen lassen müssen, solange sich Micros – teilweise mit Ökotouch – in ihren unzähligen Varianten nicht durchgesetzt haben. Und das ist Anfang der 90er Jahre immer noch zweifelhaft.

Sa couleur nous donne presque déjà une indication sur l'utilisation de cette étude Mazda de l'Art Center: un kart sur le terrain de golf. Les études des écoles de design présentées ici nous laissent deviner que les petites voitures de l'avenir ne doivent se laisser mesurer ni à la Mini de 1959, ni aux minis japonaises des années 90, ni à la Fiat Cinquecento, tant qu'elles – parfois avec une pensée écologique – ne se seront pas imposées dans leurs innombrables variantes. Et on doute encore que ce soit le cas au début des années 90.

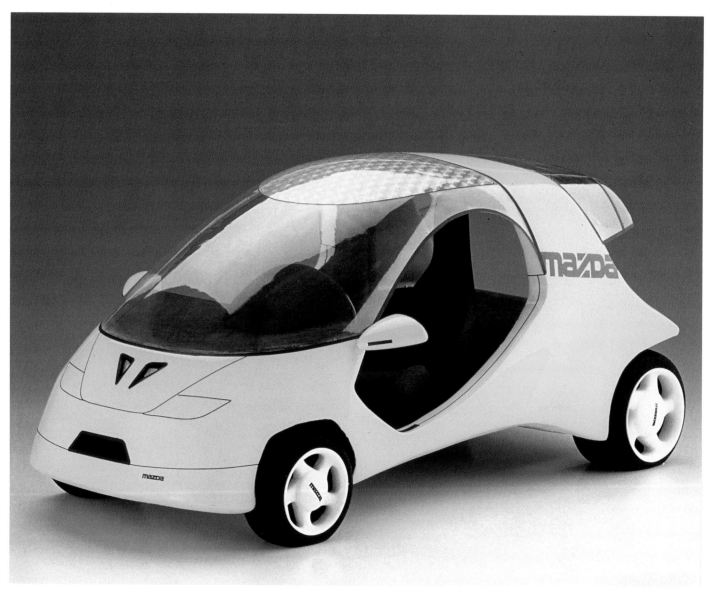

ACCE Mazda, Switzerland, Schweiz, Suisse, 1991

In 1991 the students at the Art Centre were given free reign to think about a Mazda. The result was a yolk-coloured egg, open at the side. All the designs were of a playful kind with shapes that were governed by the designer's imagination rather than functional considerations. This is of course possible as long as no mass production is intended – which is not intended as an argument in favour of dull cars.

1991 durfte beim Art Center frei über einen Mazda nachgedacht werden. Es entstand ein seitlich offenes Ei in Dottergelb. Alle gestaltenden Ansätze waren spielerisch, Form folgte nicht mehr der Funktion, sondern der Phantasie. Das ist möglich, solange solche Entwürfe nicht in Serie gebaut werden sollen – was kein Plädoyer für Langeweile sein soll.

En 1991, les designers de l'Art Center réalisèrent une étude libre pour Mazda. Résultat: un œuf, couleur jaune poussin, ouvert sur le côté. Tous les détails formels ont été traités de manière ludique, la fantaisie avait le pas sur la fonction. C'est possible, tant que de telles études ne sont pas destinées à la fabrication en série, ce qui ne signifie pas que nos voitures doivent être ennuyeuses.

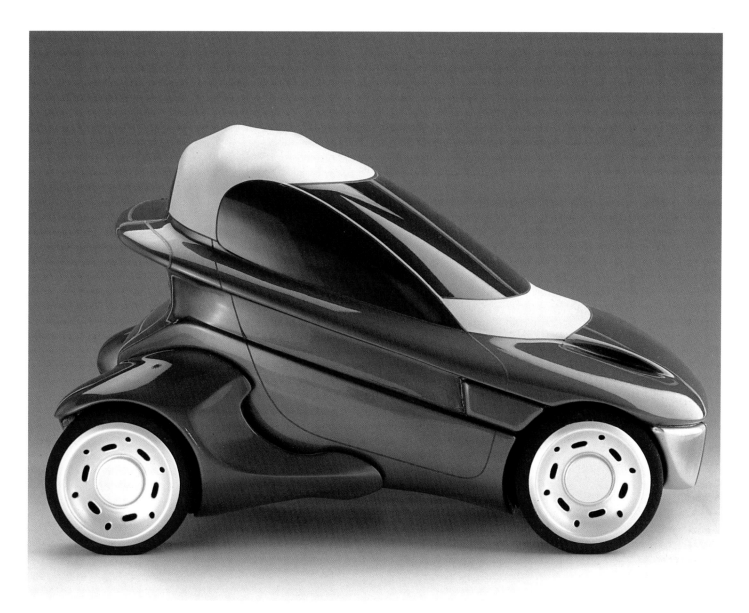

ACCE Mazda, Switzerland, Schweiz, Suisse, 1991

This Art Centre study for a Mazda is an exaggeration of the VW Chico motif. There is no longer a wedge on the rear axle, which should increase performance and speed. It is important that some cars should just be sheer fun, but they do not solve problems. Neither can they replace existing ideas. All they can do is extend them as expressions of an affluent society.

Diese Art Center-Studie für Mazda überzeichnet das VW Chico-Motiv. Der Keil löst sich von der Hinterachse, als müßte die Leistung für hohes Tempo sorgen. Spaßautos können und dürfen sein, aber sie lösen keine Probleme, ersetzen nicht bestehende Konzepte, sondern erweitern sie als Ausdruck einer Überflußgesellschaft.

Cette étude d'Art Center pour Mazda reprend en les exagérant les formes de la VW Chico. L'arrière en pointe se libère de l'essieu comme si la voiture était très rapide. Qu'il existe des véhicules fantaisistes est une bonne chose, mais ils ne résolvent pas les problèmes, et ne remplacent pas les conceptions existantes, au contraire ils les élargissent en tant qu'expression d'une société d'abondance.

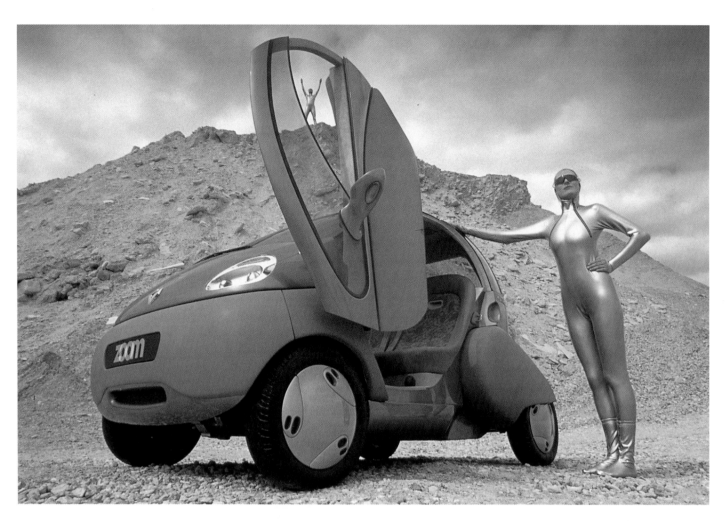

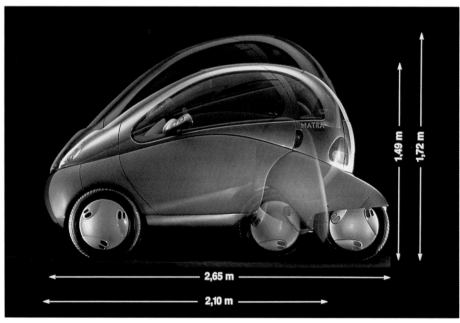

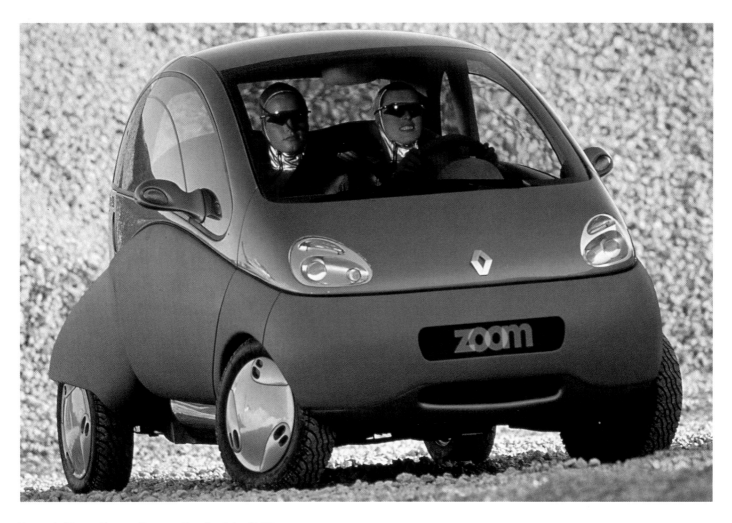

Renault Matra Zoom, France, Frankreich, 1992

The Renault subsidiary Matra developed an egg on retractable stilts. As a result, the length of the car could be reduced from 104¼ to 90½ inches (265 to 230 cm). And as the turning circle of the Zoom electric car of 1992 is only 21 ft 8 inches (6.6 metres), the quest for a car park in the centre of Paris is no longer a problem. But do we really need so much technology to gain 14 inches (35 cm) of stability on the road or, to look at it differently, to fit into even smaller parking spaces? A small Leo, designed by the Target Design Team in 1989, is 98½ inches (104 cm) long, has a similar amount of space inside and is a lot more practical.
If Renault had designed their Zoom without its shaky legs and confined it to a total length of 90 inches (230 cm), then the mass-produced result could have been a couple of thousand pounds (or several thousand dollars) cheaper. According to a survey by the German motoring magazine *Auto Motor und Sport* in 1992, 54% of all respondents did not want to spend more than £10,000 ($16,000) on an electric car. Electric cars can probably only become widespread if the state forces people to use them: take, for instance, California with its zero emission law.

Die Renault-Tochter Matra entwickelte ein Ei auf einziehbaren Stelzen. Die Wagenlänge konnte so von 265 auf 230 Zentimeter schrumpfen. Und weil der Wendekreis des Elektroautos »Zoom« von 1992 nur 6,6 Meter beträgt, ist die Parkplatzsuche in der City von Paris kein Problem mehr. Aber ist soviel technischer Aufwand nötig, um mit 35 Zentimetern mehr etwas Fahrstabilität zu bekommen oder umgekehrt eine noch kleinere Parklücke? Ein »Leo«-Kleinwagen mit ähnlich großem Innenraum zeigte bei 250 Zentimetern vom Target-Designteam 1989 viel mehr Praxisnähe.
Hätte man beim Renault Zoom auf die Wackelbeine verzichtet und sich auf eine Länge von 230 Zentimetern beschränkt, so hätte ein möglicher Serienbau das Auto um einige Tausender billiger gemacht. Nach einer Umfrage der Autozeitung »auto motor und sport« wollten 54 Prozent der Befragten nicht mehr als 25000 DM für ein Elektroauto ausgeben. Zum Elektroauto führt wohl nur staatlicher Zwang: Beispiel Kalifornien mit der Zero-Emission-Forderung.

Matra, filiale de Renault, a conçu un oeuf sur échasses escamotables. La longueur de la carrosserie a ainsi pu tomber de 265 à 230 centimètres. Dotée d'un très faible diamètre de braquage (6,6 mètres), la Zoom de 1992 peut se nicher dans les plus petits recoins. Mais un tel déploiement technique était-il nécessaire pour obtenir une stabilité routière un peu plus élevée avec 35 centimètres de plus, ou inversement pour se garer dans des espaces plus petits? La petite Leo de l'équipe de design Target, qui mesurait 250 centimètres de long et était dotée d'un habitacle de dimensions semblables, affichait plus de sens pratique.
Si Renault avait renoncé à ces jambes flageolantes et s'était limitée à une longueur de 230 centimètres, les coûts d'une possible fabrication en série auraient été réduits de quelques milliers de marks. Un sondage du magazine «auto motor und sport» de 1992, nous apprend que 54 pour cent des personnes interrogées ne veulent pas dépenser plus de 25000 marks pour une voiture électrique. Il semble qu'on ne se décide que contraint et forcé pour la voiture électrique: exemple, la Californie qui exige des émissions de gaz d'échappement voisines de zéro.

Company Profiles

Firmenportraits

Les compagnies

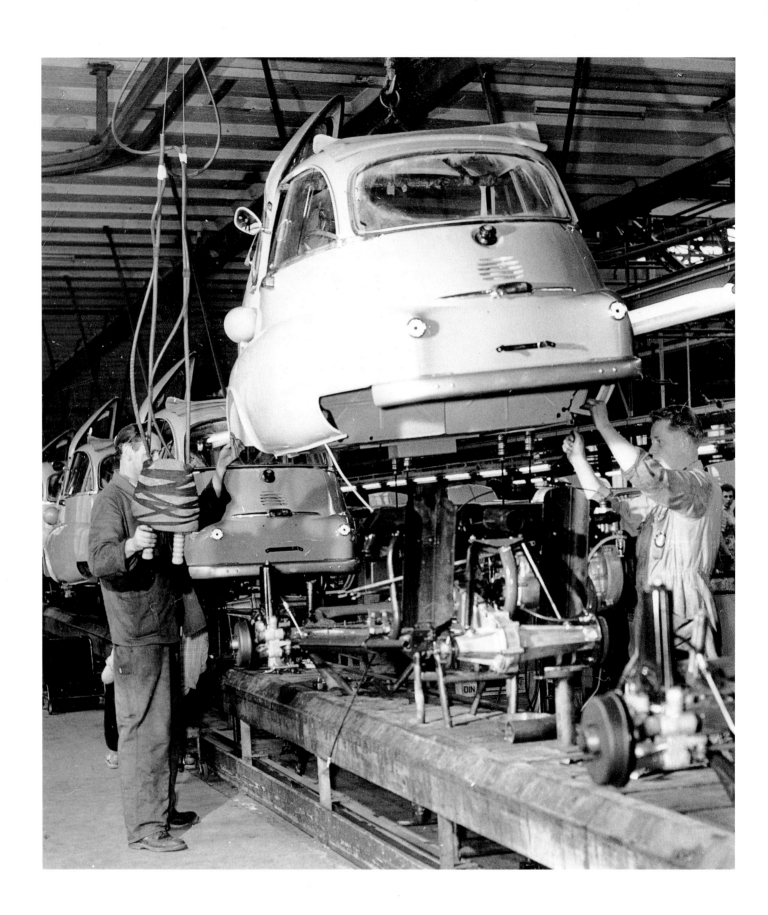

Company Profiles Firmenporträts Les compagnies

The companies and names mentioned here are only a selection from hundreds of manufacturers. Small cars are at an advantage, because their size makes them an ideal experimenting ground for a whole host of car makers. We have therefore only included the most important examples from all continents. Importance was not simply seen as a matter of high production figures but also one of innovative ideas.

Die aufgeführten Firmen oder Marken sind eine Auswahl einer in die Hunderte gehenden Zahl von Herstellern. Gerade der Vorzug klein zu sein, machte Kleinwagen zu einem Übungsfeld für kaum noch übersehbare Anbieter. Es wurden daher nur die wichtigsten Beispiele aus allen Kontinenten aufgeführt. Wichtigkeit orientiert sich dabei nicht immer nur an hoher Produktionszahl, sondern auch an innovativen Ideen.

Les petites voitures, de par leur taille, sont un champ d'action privilégié pour les constructeurs et nous avons choisi parmi une centaine de noms ceux que nous présentons ici. Les exemples que nous avons sélectionnés dans le monde entier ne le sont pas toujours en fonction de l'importance de la production, mais du caractère innovatif des véhicules proposés.

Autobianchi

Italy

autobianchi

Originally called Bianchi and founded in 1899, this company made vehicles for 56 years – big cars, tanks (during the war) and, from 1939, trucks with Mercedes engines. Bianchi was based in Milan. In 1955 it merged with Pirelli and Fiat to build the more streamlined Autobianchis, based on the mechanical specifications of Fiat. This included the Fiat–500-based Bianchina, a car that was rich in chromium and nearly ten feet (3 metres) long. In 1958 it was given a stronger engine and became available as a saloon, coupé, convertible and estate. In the same year Bianchi sold its shares to its partners, Fiat and Pirelli. In 1960 just over 30,000 of the little Italian cars were built. The convertible continued to be manufactured until 1970, the saloon and estate until 1969. Today the name lives on in the Lancia Y 10, a name that has dominated Autobianchi since 1975. The Y 10 is one of the most elegant – though not cheapest – series of small cars.

Erst nannte sich die Firma Bianchi: Gegründet 1899 in Mailand baute sie 56 Jahre lang große Autos, im Krieg Panzer, ab 1939 Lastwagen mit Mercedes-Motoren. 1955 schlossen sich Pirelli, Fiat und Bianchi zusammen, um die auf mechanischer Fiatbasis feinstreifigeren »Autobianchis« zu bauen. Auf der Fiat 500- Basis kam ein chromstarkes Drei-Meter-Auto »Bianchina« auf den Markt, 1958 mit stärkeren Motoren und insgesamt in den Varianten Limousine, Coupé, Cabrio und Kombi. 1958 gab Bianchi sein Aktienpaket an die Partner Fiat und Pirelli ab. 1960 wurden gut 30 000 der kleinen Italiener gebaut. Der Kombi blieb bis 1970, Limousine und Cabrio blieben bis 1969 in Produktion. Heute lebt der Name im Lancia Y 10 weiter, schließlich führt diese Marke seit 1975 Regie bei Autobianchi – und der Y 10 ist eines der nobelsten, wenn auch nicht gerade der preisgünstigsten Kleinwagenkonzepte.

Bianchi, c'était son nom à l'origine, était sise à Milan. Dès 1899 et pendant cinquante-six ans on y a construit de grosses voitures, pendant la guerre des chars d'assaut, à partir de 1939 des camions avec des moteurs Mercedes. En 1955, Pirelli, Fiat et Bianchi se regroupent pour construire les «Autobianchis». Une «Bianchina» de trois mètres de longueur, aux chromes étincelants, fut fabriquée sur la base de la mécanique de la Fiat 500, en 1958 on la dota de moteurs plus puissants. Elle était disponible en version berline, coupé, cabriolet et break. En 1958, Bianchi vendit son paquet d'actions à ses partenaires Fiat et Pirelli. En 1960, plus de 30 000 petites Italiennes quittèrent les chaînes. La berline et le cabriolet furent fabriqués jusqu'en 1969, le break jusqu'en 1970. Aujourd'hui la Lancia Y 10 a repris le flambeau, puisque la marque dirige Autobianchi depuis. 1975 la Y 10 est une des petites voitures les plus luxueuses et les plus chères.

Austin

Great Britain

In 1905 Herbert Austin, an ex-Wolseley man, set up his own car factory in Long-bridge, near Birmingham. He acquired a good reputation for his large-volume cars, but he did not become famous until 1922, with the Austin Seven. This car, which had long gone beyond the stage of a cycle car, was of such good quality that he was soon giving out licences: in France it was called Rosengart, in Germany Dixi (BMW from 1928), and in the USA Bantam. In 1951, when Austin and Morris merged to form BMC (British Motor Corporation), the new company also launched a new small car – the A 30 (originally called »Seven«, to demonstrate continuity). It had a self-bearing body and an 803 cc engine. Like many other Austin-Morris models, its later versions were designed by Pininfarina. Austin's biggest success, though, was the 1959 Mini, designed by Sir Alec Issigonis. Until then, no other car had been so consistent in its shape and functions, with a total length of 10 feet (305 cm) – which is probably why it is still built today. The history of the name was less troublefree. In 1968, with the restructuring of the British car industry, Austin became part of the British Leyland group, and in 1988 it was privatized and found a niche with British Aerospace.

1905 gründete der Ex-Wolseley-Mann Herbert Austin seine eigene Autofabrik in Longbridge bei Birmingham. Seinen Ruf hatte er sich mit großvolumigen Autos geschaffen, berühmt aber wurde er mit dem Austin Seven 1922. Dieses Auto, längst nicht mehr ein »Cyclecar«, war qualitativ so gut, daß er bald Lizenzen vergeben konnte: In Frankreich hieß das Auto Rosengart, in Deutschland Dixi (ab 1928 BMW), in USA Bantam. 1951 wurde im Jahr des Zusammenschlusses mit Morris zur BMC (British Motor Corporation) ein neuer Kleinwagen vorgestellt: der A 30 (ursprünglich in Anlehnung an den Vorgänger »Seven« genannt) mit selbsttragender Karosserie und 803 Kubikzentimeter-Motor. Wie viele andere Austin-Morris-Modelle wurde auch er in späteren Versionen von Pininfarina entworfen. Den größten Erfolg aber hatte Austin mit dem Mini von 1959, entworfen und konstruiert von Sir Alec Issigonis. Bisher wies kein anderes Auto so konsequent Form und Funktion auf 305 Zentimetern Gesamtlänge auf – darum wird er wohl heute noch gebaut. Problematischer verlief die Markengeschichte. Ab 1968, nach Umgruppierungen in der englischen Autoindustrie, gehörte Austin zum British Leyland Konzern, seit 1988 ist Austin privatisiert und untergeschlüpft bei der British Aerospace.

En 1905, Herbert Austin, qui a travaillé chez Wolseley, crée sa propre usine de voitures à Longbridge près de Birmingham. Les grosses voitures avaient fait sa réputation, mais c'est l'Austin Seven de 1922 qui l'a rendu célèbre. Elle n'avait vraiment plus rien d'un «cyclecar», et était si bien faite qu'il put bientôt concéder des licences: en France, la voiture s'appelait Rosengart, en Allemagne Dixi (BMW à partir de 1928), aux Etats-Unis Bantam. En 1951, l'année de la fusion avec Morris pour former la BMC (British Motor Corporation), on présenta une nouvelle petite voiture, la A 30 (appelée à l'origine la Seven à cause de son prédécesseur). Elle était dotée d'une caisse monocoque et d'un moteur de 803 centimètres cube. Comme beaucoup d'autres modèles d'Austin-Morris, ses versions ultérieures furent dessinées par Pininfarina. Mais c'est avec la Mini dessinée et construite par Sir Alec Issigonis en 1959 qu'Austin a eu le plus de succès. Jusqu'alors aucune voiture n'avait été conçue dans ses formes et ses fonctions avec autant d'esprit de suite, et ce, sur 305 centimètres de longueur – c'est la raison pour laquelle elle est encore fabriquée aujourd'hui. L'histoire de la marque est plus problématique. A partir de 1968, différents regroupements eurent lieu dans l'industrie automobile anglaise et Austin entra dans le groupe British Leyland. La marque a été privatisée en 1988 et a trouvé refuge chez British Aerospace.

BMW

Germany

BMW started off airborne. In 1916 two companies – Otto Flugmotoren Fabrik and Rapp Motorenwerke – set up Bayerische Flugzeugwerke (Bavarian Aircraft Manufacturers). The entire design work became the responsibility of the BMW subsidiary. The company logo – a stylized propeller – was never abolished. In 1928 BMW bought Eisenach Vehicle Manufacturers who had been building the Dixi since 1903. The Austin Seven licence of 1929 helped the company through lean times. The six cylinders of their series-three cars provided them with a suitable image after victories at car races, and the Dixi gave them their daily bread, followed by an extremely small successor after the Second World War: the Isetta, again a licence product, though this time from ISO in Milan. It started to bring in money from 1955 onwards (with over 160,000 cars in eight years). Then there were the BMW 600 of 1957, an enlarged version of the Isetta, and the BMW 700 of 1959 (saloon and coupé, later with a wider wheel base). Designed by Michelotti, they did bring in money. These cars were built for six years and sold 180,000 times, thus paving the way for the world of bigger cars. BMW continued to make motorbikes – though after the demise of the Isetta, no longer with one-cylinder engines, but with opposed cylinders and recently also with straight-type engines. The company's unbalanced method of handling models led to a financial crisis in 1958/59 which nearly culminated in a take-over by Mercedes. However, by 1991 (the year of the E 1) and 1993 (Z 13 and the second-generation E 1) BMW had become quite a wealthy company and had even slightly overtaken Mercedes in the production of new small cars that reflected a new self-image – sporty rather than utilitarian, with more styling than design.

Zunächst ging BMW in die Luft. 1916 gründen die Otto-Flugmotoren-Fabrik und die Rapp Motorenwerke die Bayerische Flugzeugwerke AG; für alle Konstruktionsarbeiten ist die Tochter BMW zuständig. Das Firmenlogo – ein stilisierter Propeller – geriet nicht in Vergessenheit. 1928 kaufte BMW die Fahrzeugfabrik Eisenach, die seit 1903 den Dixi baute. Der Lizenzbau des Austin Seven ab 1929 half über magere Zeiten, die 6-Zylinder der 3er-Serien sorgten fürs Image mit Rennsiegen, der Dixi fürs Brot, wie nach dem Zweiten Weltkrieg ein ganz Kleiner: die Isetta, wieder eine Lizenz, diesmal von ISO aus Mailand. Sie verdiente seit 1955 in München Geld (in acht Baujahren mehr als 160 000 Exemplare). Die gestreckte Isetta, der BMW 600 (1957) und der BMW 700 (Limousine und Coupé später mit längeren Radständen) seit 1959 (Design Michelotti) waren Geldbringer (sechs Baujahre und gut 180 000 Exemplare) für den Weg in die Welt großer Autos. Motorräder blieben weiter in Produktion, seit dem Tod der Isetta aber nicht mehr mit Einzylindermotoren, sondern nur boxend oder seit kürzerem auch in Reihe arbeitend. Durch unausgeglichene Modellpolitik gerät das Unternehmen 1958/59 in eine Finanzkrise, die beinahe zur Übernahme durch Daimler-Benz führt. 1991 (E 1) und 1993 (Z 13 und E 1 zweite Generation) bescherte BMW, inzwischen wohlhabend und in der PKW-Produktion Mercedes leicht überholend, neue Kleinwagen im Stil des neuen Selbstverständnisses: eher sportlich als praktisch, eher Styling als Design.

BMW a fait ses débuts dans le ciel. En 1916, l'usine de moteurs d'avions Otto et l'usine de moteurs Rapp fondent la Bayerische Flugzeugwerke AG; la filiale BMW est responsable de tous les travaux de construction. L'emblème de la société – une hélice stylisée – n'en fut pas oubliée. En 1928, BMW acheta l'usine automobile Eisenach qui fabriquait la Dixi depuis 1903. La construction sous licence de l'Austin Seven à partir de 1929 lui permit de se maintenir à flot, les 6-cylindres de la série 300, vainqueurs dans de nombreuses courses, veillèrent à l'image de marque. La Dixi, elle, veillait sur les finances comme le fit l'Isetta, une toute petite et encore une licence, cette fois d'ISO, Milan, après la Seconde Guerre mondiale. Elle fit rentrer l'argent à partir de 1955 à Munich (plus de 160 000 exemplaires en huit ans). L'Isetta allongée, la BMW 600 (1957) et la BMW 700 (berline et coupé, dont l'empattement fut étiré plus tard) à partir de 1959 (design Michelotti) financèrent (six années de fabrication et plus de 180 000 exemplaires) l'entrée dans le monde des grandes voitures. On continua à fabriquer des motocyclettes, non plus à un cylindre depuis la disparition de l'Isetta mais à cylindres à plat et opposés ou, plus récemment, en ligne. Un déséquilibre dans le choix des modèles déboucha sur une crise financière en 1958/59, ce qui faillit entraîner l'absorption par Daimler-Benz. Avec la E 1 de 1991, puis la Z 13 et la seconde génération de E 1 en 1993, la firme BMW, devenue riche entre-temps et dont la production dépasse légèrement celle de Mercedes, dispose de nouvelles petites voitures au goût du jour: l'accent y est porté sur l'aspect sportif plus que sur l'aspect pratique, sur le styling plus que sur le design.

Bond and Reliant

Great Britain

No, not James , but Lawrence Bond – from Lingridge, Lancashire. He had started off by designing aeroplanes. In 1947, he decided to keep his feet on the ground and think about road tax: so far as the Inland Revenue was concerned, three-wheelers were motorbikes, and so Bond designed a motorbike with a front wheel and a front engine that would go round bends along with the rest of the vehicle. The first prototype was made in 1948, and mass production started in 1949. As a special gimmick, the 90-degree turning radius of the wheels allowed the little vehicle to turn as if placed on a disc. In 1955 the company manufactured 100 three-wheelers per week. The idea was working. The size and demands on the design grew and began to be oriented towards real cars. In 1963 Bond branched out and mass-produced mini sports cars based on the Triumph Herald. In 1969 Reliant merged with Bond, having built cars since 1935, when it was founded by T.L. Williams. Most Reliants were three-wheelers, though claiming to be fully-fledged cars from the very beginning. As a result, Reliant had become the biggest UK manufacturers of three-wheelers. With the 1962 Sabre and the 1965 Scimitar, the company finally produced four-wheelers again after a long break. Although the Bond plant in Preston was eventually shut down, there was another Bond car under Reliant management – the Bond Bug of 1970, a completely wedge-shaped car with a fibre-glass skin, almost the sort of vehicle James B. would have loved. However, when the Bug was discontinued in 1975, this was also the end of Bond as a name. The name Reliant still survives today, with the three-wheelers Robin and Rialto, a Metrocab taxi (produced by Hooper since 1991) and the Scimitar Sabre.

Beim Namen Bond denken viele nur als James, unserer heißt Lawrence, kommt aus Lingridge, Lancashire und konstruierte erst Flugzeuge. 1947 blieb er auf dem Boden, besann sich der Steuergesetze – Dreiradautos waren steuerlich Motorräder –, konstruierte ergo eines mit Frontrad und Frontmotor, der in Kurven mitdrehte. 1948 erster Prototyp, 1949 Serienstart. Gag der Beweglichkeit: Der Radeinschlag von 90 Grad ließ das Wägelchen »auf dem Teller« drehen. 1955 war man bei 100 Dreirädern pro Woche, das Konzept funktionierte. Größe und Designanspruch wuchsen, orientiert an echten Autos. 1963 machte Bond einen Ausflug zu Kleinstseriensportwagen auf Triumph Herald-Basis. 1969 kaufte sich Reliant ein, die selbst seit 1935 Autos bauten (Gründer T.L. Williams), vorzugsweise dreirädrig und von Beginn an mit dem Anspruch, ein vollwertiges Auto zu sein. Ergebnis: größter Dreiradhersteller in England. 1962 (Sabre) und 1965 (Scimitar) kamen nach längerer Zeit wieder vierrädrige Modelle. Trotz Schließung des Bond-Werkes in Preston kam unter Reliant-Regie ein Bond: der Bond Bug von 1970, ein absoluter Keil mit Kunststoffhaut, fast schon etwas für James B. Mit Produktionsende des Bugs 1975 verschwand auch der Name Bond. Die Dreiräder Robin und Rialto, ein Taxi Metrocab, seit 1991 bei Hooper in Produktion, und das Modell Scimitar Sabre tragen den Namen Reliant in die Gegenwart.

Beaucoup de gens ne connaissent que James, le nôtre s'appelle Lawrence Bond, est originaire de Lingridge, Lancashire, et a débuté dans les avions. En 1947, il resta sur terre, réfléchit à la législation fiscale – les voitures à trois roues étaient considérées comme des motocyclettes – et en construisit une à roue avant unique et moteur à l'avant, qui tournait aussi dans les virages. Premier prototype en 1948, début de la fabrication en série en 1949. Un gag: la petite voiture tournait sur place à cause de son braquage de roues de 90 degrés. En 1955, on construisait cent tricycles par semaine, ce qui montre que l'idée était bonne. La taille des voitures et la recherche au niveau du design s'accrurent, s'orientant sur les «vraies» voitures. En 1963, Bond se lança dans les voitures de sport en toute petite série sur la base de la Triumph Herald. En 1969, Reliant acheta des parts. Reliant fabriquait des voitures depuis 1935 (fondateur T.L. Williams), de préférence à trois roues et se voulant complètes. La maison devint le plus grand constructeur de voitures à trois roues d'Angleterre. En 1962 (Sabre) et en 1965 (Scimitar) apparurent à nouveau après un long silence des modèles quadricycles. Malgré la fermeture des usines Bond à Preston, une Bond vit le jour sous la régie de Reliant: la Bond-Bug de 1970, un bolide à la carrosserie de plastique, digne de James B. Lorsque la Bug cessa d'être fabriquée en 1975, le nom de Bond disparut lui aussi. Les tricycles Robin et Rialto, un taxi Metrocab, fabriqué depuis 1991 chez Hooper, et le modèle Scimitar Sabre perpétuent le nom de Reliant.

EGON BRÜTSCH

Egon Brütsch's father was a manufacturer of ladies' stockings. Egon himself was extremely ambitious at first. A long time before producing small cars, he had built his own racing car with a Maserati engine and was very much involved in car racing. In 1958 he went off cars altogether. Until then he had built a large number of small cars, though many had never gone beyond the prototype stage, as Brütsch did not have enough money for mass production. In March 1953 he put a 400 cc car with Porsche appeal on the road, though no more than two items were ever produced. The Brütsch Spatz (»sparrow«) of 1954, on the other hand, was more economical, with a 191 cc engine, a fibre-glass body and three wheels – beautiful! Built under licence, it was given four wheels and turned out less attractive. Next the Spatz was turned into the Spatz 200 by Friedrich in Traunreut. A hard-top version with folding doors never made it into car showrooms at all – because the doors were under patent. In 1956 Brütsch merged with his partner, Victoria, in Nuremberg, forming the Bayerische Auto Gesellschaft (BAG). By the time production was discontinued, in 1958, about 1,500 Spatz cars had been built. In 1955 Brütsch made a car called Zwerg (»dwarf«), though only five times. This was followed by the Brütsch Mopetta, a tiny little 50 cc three-wheeler, which almost reached mass-production with the help of Georg von Opel. However, only 14 Mopettas were built. Another Brütsch project that was never massproduced was the ambitious V–2 convertible of 1957.

Ursprünglich war der Ehrgeiz groß von Egon Brütsch. Lange vor seinen Kleinwägelchen baute sich der Sohn eines Damenstrumpffabrikanten einen Maseratimotor in die eigene Rennwagenkarosse und frönte dem Motorsport. 1958 hatte er mit Autos nichts mehr im Sinn. Dazwischen lagen viele Kleinwagen, viele blieben Prototypen mangels Geld für den Serienbau. Im März 1953 bringt Brütsch 400 Kubikzentimeter unter einem Blechkleid mit Porsche-Appeal auf die Straße, es bleibt bei zwei Exemplaren. Mit dem Brütsch Spatz 1954 wird wieder mehr gespart: 191 Kubikzentimeter unter Kunststoffschale und mit drei Rädern – bildschön. Als Lizenz wird er vierrädrig und weniger schön. Aus dem Spatz wird der Spatz 200 von Friedrich in Traunreut. Eine vorgestellte Hardtopversion mit Flügeltüren bleibt unverkauft – die Türen waren patentrechtlich geschützt. 1956 wird der Partner Victoria aus Nürnberg in die Firma genommen, es entsteht die BAG (Bayerische Auto Gesellschaft), bis Produktionsende 1958 wurden rund 1 500 Spatz gebaut. 1955 kommt der Brütsch Zwerg, ganze 5 Exemplare entstehen. 1956 hat das Brütsch Mopetta, ein Winzling von 50 Kubikzentimeter und dreirädrig, mit Hilfe des Frankfurters Georg von Opel beinahe Serienreife bekommen. Nur 14 wurden gebaut. Nicht in Serie ging ein weiterer Brütsch-Vorschlag: das ambitionierte V–2 Cabrio von 1957.

Au départ Egon Brütsch avait de grosses ambitions. Bien avant de se lancer dans les petites voitures, ce fils d'un fabricant de bas installa un moteur Maserati dans sa voiture de course et s'adonna aux joies du circuit. En 1958, les voitures ne l'intéressaient plus. Mais avant d'en arriver là, il avait élaboré une multitude de petites voitures, la plupart étant restées à l'état de prototypes par manque d'argent. En mars 1953, il habille un moteur de 400 centimètres cube d'une carrosserie à la Porsche, il y en aura deux exemplaires. En 1954, avec la Brütsch Spatz, on recommence à faire des économies: 191 centimètres cube sous une coque de plastique – à croquer. Sous licence, la Brütsch acquiert quatre roues, un préjudice à sa beauté. La Spatz devient la Spatz 200 de Friedrich à Traunreut. Une version hard-top à portières en ailes reste invendue – les portières étaient protégées par un brevet. En 1956, le partenaire Victoria de Nuremberg entre dans la firme, et la BAG (Bayerische Auto Gesellschaft) est créée. On construira environ 1 500 Spatz jusqu'en 1958, date à laquelle la production cesse. En 1955, la Brütsch Zwerg voit le jour, elle sera fabriquée en cinq exemplaires. En 1956, la Brütsch Mopetta, une miniature à trois roues et au moteur de 50 centimètres cube, est presque fabriquée en série grâce à l'aide de Georg von Opel de Francfort. On en construira quatorze. Une autre proposition de Brütsch, l'ambitieux cabriolet V–2 de 1957, ne sera pas non plus fabriquée en série.

Champion

Germany

The Champion was modelled on the cycle car. Designed in 1946 and built from 1949 onwards, the roadster version was characterized by the lean post-war years and had wheels with spokes. A cogwheel company in Friedrichshafen sold the exploitation rights of this tiny vehicle to the former BMW engineer Hermann Holbein. With its generously curved mudguard, the successor (prototype CH 1 of 1949) was rather similar to the Triumph TR 2. The Champion 400 of 1950 proved that even with identical doors on the left and right and the same bonnet, it was possible to make a beautiful coupé. Production started in Paderborn in 1951. However, the car consisted entirely of complete components, delivered ready for assembly (with about 200 suppliers under contract), so that it rather priced itself out of the market, and customers rebelled. In autumn 1952, production was discontinued. Until then 2,042 cars with 400 cc engines had been delivered. After the sale of the company to the Champion dealer Hennhöfer, production was moved to Ludwigshafen. The falling prices of the competition put an end to the innovative car, so that even a saloon prototype could not save it any longer. The company was bought by two brothers, Otto and Wilhelm Maisch, who turned the Champion into the Maico 400, a model that was later succeeded by the Maico 500. However, it only survived from 1955 to October 1957, and the number of cars that were built totalled a mere 8,000. The final blow came with bankruptcy in early 1958.

Ein Cyclecar war das Vorbild: Speichenräder und zeitgemäße Nachkriegsdürre machten den Champion (Konzept 1946, Bau ab 1949) in seiner Roadsterversion aus. Die Zahnradfabrik Friedrichshafen verkaufte an den Rennfahrer und ehemaligen BMW-Ingenieur Hermann Holbein die Verwertungsrechte des Winzlings. Schon der Nachfolger (Prototyp 1949 CH 1) hatte mit großzügig geschwungenen Kotflügeln und Scheibenrädern eine nicht unähnliche Verwandschaft zum Triumph TR 2. 1950 zeigte der Champion 400, daß mit identischen Türen links und rechts und identischen Hauben dennoch ein schönes Coupé entstehen kann. Die Produktion begann im Frühjahr 1951 in Paderborn. Da jedoch nur einbaufertig angelieferte Einzelteile montiert wurden – über zweihundert Zulieferer standen unter Vertrag! –, trieb dies den Preis in unverantwortliche Höhen. Die Kundschaft rebellierte; im Herbst 1952 wurde die Produktion stillgelegt. 2042 Typen mit 400 Kubikzentimeter-Motor waren bis dahin ausgeliefert. Nach Verkauf der Firma an den Championhändler Hennhöfer wurde die Produktion nach Ludwigshafen verlegt. Die sinkenden Preise der Konkurrenz machten dem innovativen Auto ein Ende, auch ein Limousinenprototyp konnte nichts mehr retten. Die Gebrüder Otto und Wilhelm Maisch kauften die Firma, als Maico 400, später als 500 weiterentwickelt, überlebte der Champion aber nur von 1955 bis Oktober 1957 mit knapp 8 000 gebauten Modellen. Das endgültige Aus: Konkurs Anfang 1958.

Elle s'est inspirée d'un cyclecar: des roues à rayons et un équipement spartiate en ces temps d'après-guerre caractérisent la Champion (idée 1946, construction à partir de 1949) dans sa version roadster. L'usine de roues dentées Friedrichshafen en vendit les droits d'exploitation à Hermann Holbein, pilote de course et ex-ingénieur de BMW. Le modèle suivant (prototype 1949 CH 1), avec ses ailes généreusement arquées et ses roues à centre plein avait déjà un air de parenté avec la Triumph TR 2. En 1950, la Champion 400 montra qu'il était possible de créer un beau coupé avec des portes identiques à droite et à gauche et des capots identiques. La production démarra au printemps 1951 à Paderborn. Mais comme on ne montait que les pièces détachées prêtes à être ajustées – elles étaient fournies par plus de 200 sous-traitants! – le prix atteint des hauteurs vertigineuses. La clientèle s'insurgea; en automne 1952, on stoppa la production. 2 042 modèles équipés d'un moteur de 400 centimètres cube avaient été livrés. La firme fut vendue au concessionnaire Champion Hennöfer et la production transférée à Ludwigshafen. Les prix en baisse de la concurrence causèrent la fin de cette voiture innovative et même un prototype de berline ne put la sauver. Les frères Otto et Wilhelm Maisch achetèrent la firme. La Champion, devenue Maico 400 puis plus tard 500, ne survécut que de 1955 à octobre 1957 avec près de 8 000 modèles construits. La maison fit faillite au début de l'année 1958.

Citroën

France

The company logo: interlocking gear-wheels. The sort of thing which the owner of the company, André Citroën, started to build in 1900, although he did not start making cars until 1919. His compact 5 CV Trèfle served as a model for Opel's 1924 Tree Frog. Not only did Citroën build a number of unusual cars – the 7 CV, 11 CV as well as (later) the 15 CV »gangster car«, the ID and DS (pronounced »déesse« – goddess), and the Duck. They also differed from other companies in a number of ways, i.e. with their social benefits, their pioneer work in customer service, their advertisement of an Eiffel Tower with lights on, and expeditions through Central Asia in track-laying vehicles. All this was expensive: the revolutionary idea of the 7/11 CV (1934) with front drive and a self-bearing body eventually ruined André Citroën, so that he lost the company altogether and died in 1935. at the age of 57. In 1933, and with state backing, Michelin became the majority shareholder. Later, Citroën became part of the Peugeot group in 1974. The »biggest« small car in the world, the Duck, was first designed in 1936. By 1939, 250 had been built, and it was finally released for mass manufacturing in 1949. Production was continued until July 1990, the last licencee being a Portuguese manufacturer. During those years, the model had undergone a considerable process of progressive sophistication, with a large number of special versions, such as the Charleston, with special paint, as well as one-off vehicles produced for the advertising industry, e.g. a two-seater coupé with a real steel roof instead of a roll of canvas between the passengers and the sky. For a small car, the Duck was unique – an expression of individualism, not just student lifestyle.

Das Firmenzeichen der Marke: die Pfeilverzahnung von Zahnrädern. Der Firmengründer André Citroën baute so etwas seit 1900, ab 1919 aber komplette Autos. Sein kompakter Typ 5 CV »Trèfle« wurde das Vorbild für Opels Laubfrosch von 1924. Citroën baute nicht nur ausgefallene Autos (7 CV, 11 CV, später noch 15 CV »Gangsterwagen«, ID und DS – gesprochen »déesse« gleich »Göttin«, Ente), sondern war sonst auch anders als die anderen (Sozialleistungen, Kundendienst-Pionierleistungen, Werbung mit lichtgeschmücktem Eiffelturm, Expeditionen durch Zentralasien mit Kettenfahrzeugen). Das ging ins Geld: Das revolutionäre Konzept des 7/11 CV (1934) mit Frontantrieb und selbsttragender Karosserie brachte André Citroën das Ende: Finanziell ruiniert verlor er das Werk und starb 1935 mit siebenundfünfzig Jahren. Ab 1933 auf Drängen des Staates war Michelin Mehrheitsaktionär, seit 1974 gehört Citroën zur Peugeot-Gruppe. Der »größte« Kleinwagen, die Ente, wurde 1936 zum ersten Mal vorgedacht, bis 1939 in 250 Prototypen gebaut und ab 1949 in die Serie entlassen. Erst im Juli 1990 wurde die Produktion beim damaligen portugiesischen Lizenznehmer eingestellt. Dazwischen lagen eine lange Modellreifung und viele Spezialversionen, etwa der »Charleston« mit Speziallackierung oder auch für die Werbung gefertigte Einzelexemplare wie zweisitzige Coupés mit echtem Stahldach anstelle der Stoffrolle zwischen Kopf und Himmel. Die Ente als das Extrem eines Kleinwagens wurde Ausdruck eines individuellen Lebensgefühls – nicht nur des studentischen.

La maison dont l'emblème est un double chevron. André Citroën, le fondateur, fabriquait des roues dentées en 1900 avant de se lancer dans la construction de voitures en 1919. Sa 5 CV compacte servit de modèle à la Laubfrosch de Opel sortie des chaînes en 1924. Citroën ne construisait pas seulement des voitures hors du commun (7 CV, 11 CV, plus tard la 15 CV «Traction», la «Deuch» et l'ID et la DS aux noms prometteurs) ses méthodes sortaient, elles aussi, de l'ordinaire (prestations sociales, premiers services après-vente, publicité lumineuse sur la Tour Eiffel, expéditions à travers l'Asie centrale en autochenilles). Tout cela coûtait très cher: le concept révolutionnaire de la 7/11 CV (1934) à traction avant et caisse monocoque causa la perte d'André Citroën. Ruiné, il perdit les usines et mourut en 1935 à 57 ans. A partir de 1933 et poussé par l'Etat, Michelin devint actionnaire majoritaire, depuis 1974 Citroën fait partie du Groupe Peugeot. La «plus grande» des petites voitures, la 2 CV fut «pensée» en 1936, on en construisit 250 prototypes jusqu'en 1939 et la fabrication en série démarra en 1949. La production n'en fut stoppée qu'en juillet 1990 dans les usines sous licence au Portugal. Entre ces deux dates le modèle avait eu le temps de mûrir et on vit de nombreuses versions spéciales, la Charleston aux couleurs caractéristiques par exemple, ou les pièces uniques fabriquées pour la publicité tels les coupés à deux places au toit d'acier au lieu d'un toit roulant en toile. La «Deuch», petite voiture exceptionnelle, devint l'expression d'un mode de vie – et pas seulement celui des étudiants.

Crosley

USA

Building and selling small cars in the US is about as lucrative as selling ice-cream lollies on the North Pole. An unsuccessful attempt was made by Powell Crosley as early as 1907, before he finally made his fortune with radios and refrigerators. Eventually, in 1939, another car was produced by his Indiana factory – with a fat nose, a dwarf-like appearance, a meagre 12 HP, but quite a bargain for an introductory price of only $ 300. It sold 5,000 times. The 1946 successor model was rather more powerful and more expensive, with 26 HP and a $ 905 price tag. When production was moved to Cincinnati, Crosley also produced a larger variety of bodies. The best sales year was 1948, when 29,084 orders were recorded – though only a year later, sales went down to a quarter. On July 3rd 1952 production was discontinued. Even Crosley's participation in the Le Mans race – supposedly a sales promotion activity – could not save the car. All that was left in the end was its sturdy engine which continued to be made for naval boats. The history of technology is often more complex than we think.

Kleinwagen in USA zu bauen und zu verkaufen ist ungefähr so erfolgversprechend wie ein Stand mit Stangeneis am Nordpol. Bereits 1907 wagte der Unternehmer Powell Crosley zunächst erfolglos eine Autoproduktion, bevor er dann erfolgreich mit Radios und Kühlschränken sein Geld verdiente. 1939 kam endlich wieder ein Auto aus der Fabrik in Indiana: dicknasig, zwergig, 12 PS schwach, aber gut genug für 5 000 Käufer bei 300 Dollar Einstandspreis. Der Nachfolger von 1946 wollte für 26 PS schon 905 Dollar. Die nach Cincinnati verlagerte Produktion brachte variantenreiche Karossen, das beste Verkaufsjahr (1948) hatte 29 084 Orders zu vermelden, schon das nächste Jahr sah nur noch ein Viertel davon. Am 3. Juli 1952 war Produktionsstop. Selbst die als Verkaufsförderung gedachte Teilnahme am Le Mans-Rennen rettete nichts mehr. Übrig blieb der standfeste Motor: Als Antrieb für Boote der Navy wurde er weiter produziert. Technikgeschichte ist oft verwegener als vermutet.

Fabriquer et vendre des petites voitures aux Etats-Unis est aussi prometteur que vendre des esquimaux au Pôle Nord. Dès 1907, Powell Crosley, chef d'entreprise, tenta sans succès au départ de produire des voitures, avant de gagner sa vie avec des radios et des réfrigérateurs. En 1939, on revit enfin sortir une voiture de l'usine d'Indiana: une naine au gros nez, dotée d'un petit moteur de 12 CV, mais qui trouva quand même 5 000 acheteurs prêts à débourser 300 dollars. Le modèle qui la suivit en 1946 ne réclamait pas moins de 905 dollars pour ses 26 CV. Les usines de production transférées à Cincinatti élaborèrent des carrosseries variées. On enregistra 29 084 commandes en 1948, la meilleure année de ventes, l'année suivante n'en voit déjà plus que le quart. La production fut stoppée le 3 juillet 1952. Même la participation aux Vingt Quatre Heures du Mans, conçue comme opération promotionnelle, ne put sauver la marque. Il ne resta que le solide moteur que l'on continua à fabriquer pour les bateaux de la Navy. L'histoire de la technique est souvent plus compliquée qu'il n'y paraît.

Datsun

Japan

DAT were the initials of the three sponsors of the founder of the company, Masujiro Hashimoto – Den, Aoyama and Takeuchi. Also, the Japanese word »dat« means »speed«. The original name of the company was Kwaishinsha Motor Car Works. After their first attempts to build cars, they decided to join forces with their partners, Jitsuyo Jidosha Seizo, and made trucks instead. After a long gap, their first car was built again in 1930, called Datson – son of DAT. To do homage to the sun in the Japanese flag, it was soon renamed Datsun. The 750 cc car looked very much like an Austin Seven. Although the design was typical of the Thirties, production was continued in 1947, though this time with 722 cc. The 1948 Deluxe Sedan (saloon) model, which was pontoon-shaped, tried in vain to keep up with the times, and the jeep-faced 1951 successor never did any better. In 1952, a one-litre sports car was launched on the market, followed by other models of different sizes. Datsun also built the Austin A 40 and A 50 under licence. Group restructuring meant that Datsun and Nissan suddenly found themselves alongside each other on the market, with very few differences between their models. In Japan's booming car industry Datsun soon became No. 2, after Toyota. The company became famous in 1969, with the 240 Z (designed by Count Goertz), a coupé that was also highly successful outside Japan. In 1983, Datsun tried to collaborate with Alfa Romeo. The result, a Datsun Cherry with an Alfa kidney and mechanics, was a flop. Proper small cars had never been the strength of this company. The smallest one, the Micra, was similar to the first Golf.

DAT waren die Anfangsbuchstaben der drei Geldgeber des Firmengründers Masujiro Hashimoto 1912: Den, Aoyama und Takeuchi. Außerdem bedeutet »dat« auf japanisch so viel wie »Geschwindigkeit«. Nach ersten Versuchen mit PKWs baute ihre Firma Kwaishinsha Motor Car Works mit dem Partner Jitsuyo Jidosha Seizo wegen hoher Nachfrage nur LKWs. Erst 1930 taucht wieder ein PKW auf, er nennt sich der »Sohn des DAT« – Datson. Eingedenk der japanischen Sonne in der Nationalflagge wird er bald zum Datsun umgetauft. Der 750 Kubikzentimeter starke Wagen ähnelte dem Austin Seven. 1947 wurde die Produktion mit einem im Design aus den 30er Jahren stammenden Auto mit 722 Kubikzentimetern weitergeführt. Das 48er Modell Deluxe Sedan versuchte vergeblich, mit einer Pontonform Anschluß zu halten, der 51er Nachfolger mit Jeepgesicht machte es nicht besser. 1952 kam ein 1 Liter-Sportwagen neu auf den Markt, weitere Modelle verschiedener Größe folgten, auch die Austin A 40 und A 50 wurden in Lizenz gebaut. Konzernumbauten brachten beide Markennamen Datsun und Nissan parallel auf den Markt mit nur wenig Unterschieden bei den Modellen. Im boomenden Autogeschäft Japans wurde der Konzern Nr. 2 hinter Toyota. Bekannt wurde die Marke 1969 mit einem exportstarken Coupé 240 Z (Design Graf Goertz). 1983 versuchte man sich in einer Kooperation mit Alfa Romeo. Das Ergebnis: Ein Datsun Cherry mit Alfa-Niere und - Mechanik war ein Flop. Echte Kleinwagen sind nie die Stärke dieser Marke gewesen. Der kleinste, der Micra, hat fast Ur-Golf-Format.

D, A, T étaient les initiales des trois hommes qui avaient financé la firme fondée par Masujiro Hashimoto en 1912: Den, Aoyama et Takeuchi. En outre «dat» signifie «vitesse» en japonais. Après des premiers essais avec des voitures de tourisme, la maison Kwaishinsha Motor Car Works avec son partenaire Jitsuyo Jidosha Seizo ne fabriqua plus que des camions très demandés à l'époque. Il fallut attendre 1930 pour que réapparaisse un véhicule de tourisme: le «fils de DAT», Datson, qui deviendra Datsun, à cause du Soleil levant du pavillon japonais. La voiture, dont la cylindrée faisait 750 centimètres cube, ressemblait à l'Austin Seven. En 1947, on construisit une voiture au design des années 30 et un moteur de 722 centimètres cube. Le modèle Deluxe Sedan de 1948 tenta en vain de s'accrocher à la forme en ponton, le modèle de 1951, au capot de jeep, n'y réussit pas mieux. En 1952, une voiture de sport au moteur d'un litre fut lancée sur le marché, suivie d'autres modèles de tailles différentes; on construisait également les Austin A 40 et A 50 sous licence. Des remaniements au sein du consortium amenèrent les deux marques Datsun et Nissan en même temps sur le marché, leurs modèles se distinguaient peu les uns des autres. Dans le marché automobile japonais en expansion, Datsun devint le second groupe après Toyota. C'est en 1969 qu'on commença à connaître la marque avec le Coupé 240 Z (design Graf Goertz) orienté sur l'exportation. En 1983, il y eut des tentatives de coopération avec Alfa Romeo, mais la Datsun Cherry équipée d'une mécanique Alfa fut un flop. Les vraies petites voitures n'ont jamais été le point fort de Datsun. La plus petite, la Micra, a la taille de la première Golf.

Fend
Germany

During the lean years after the war Fritz Fend sought his luck in the motoring industry with pedal-driven three-wheelers. In April 1947, he managed to obtain Allied permission for a »Technical Manufacturing Company«. Shortly before the introduction of the new Deutschmark, in 1948, Fend made his first Flitzer (»fast little car«), which had a touch of aircraft design about it. It was still pedal-driven and intended for disabled people. Its first engine had 38 cc and was also used as an auxiliary engine for bicycles. When its capacity grew to 100 cc, the one-seater Flitzer soon became more popular – and faster. Old contacts with Messerschmitt were revived, and Fend began to develop a two-seater for this company in Regensburg. Mass production started in March 1953, the car cost DM 2,100, and 20,000 KR 175s were sold within two years – despite the heat under the plexiglass cabin and a roaring engine right behind the seats. The 1955 successor model – the KR 200 – was even more successful, though Messerschmitt's profit position was not. The company was more interested in building aircraft, and in 1956 it decided to sell its unprofitable car production to Fend who set up Fahrzeug- und Maschinenbau GmbH Regensburg (Vehicle and Machine Engineering Regensburg Limited), or FMR for short. A great stir was caused in 1958, when Fend launched his four-wheeled Tiger (Tg 500). However, Fend had to pay a price for his interest in real cars, and his cabin scooters were soon ousted by drink machines. A rather disastrous prototype of a »real« car in 1962 did not help either, so that the production of his »Snow White Coffins« had to be stopped in 1964.

Fritz Fend suchte in den Mangeljahren nach dem Zweiten Weltkrieg mit pedalgetriebenen Dreirädern sein mobiles Glück. Im April '47 gründet Fend mit alliierter Erlaubnis einen »Technischen Fertigungsbetrieb«. Kurz vor Einführung der D-Mark bringt Fend 1948 seinen ersten »Flitzer«, mit einem Hauch Flugzeug in der immer noch pedalgetriebenen Karosse; es war für den Einsatz als Versehrtenfahrzeug gedacht. Der erste Motor für den Flitzer hatte 38 Kubikzentimeter und war Hilfsmotor für Fahrräder. Wachsender Hubraum (100 Kubikzentimeter) machte den einsitzigen Flitzer beliebter – und schneller. Alte Kontakte zu Messerschmitt lebten auf. Fend entwickelte für das Regensburger Werk von Messerschmitt den Zweisitzer. Ab der Serie – Start März 1953, Preis 2 100 DM – wurden in zwei Jahren 20 000 »KR 175« verkauft – trotz Hitze unter der Plexikanzel und Motorgetöse direkt hinter den Sitzen. Der Nachfolger 1955 »KR 200« war noch erfolgreicher. Nicht so die Rendite. Messerschmitt – wieder mehr am Flugzeugbau interessiert – verkaufte 1956 an Fend die nicht mehr gewinnbringende Produktion. Es ensteht die »Fahrzeug- und Maschinenbau GmbH Regensburg«, kurz FMR. Noch einmal großes Aufsehen, als der vierrädrige »Tiger (Tg 500)« 1958 erscheint. Das Interesse an echten Autos hieß für Fend Produktionsumstellung: Getränkeautomaten verdrängten Kabinenroller. Ein formal verunglückter Prototyp eines »echten« Autos von 1962 konnte Fend nicht helfen. 1964 endete der Bau der »Schneewittchensärge«.

Fritz Fend tenta sa chance dans les années de pénurie qui suivirent la Seconde Guerre mondiale en construisant des tricycles à pédales. En avril 1947, il créa, avec l'autorisation des Alliés, une «usine de fabrication technique». En 1948, peu de temps avant l'apparition du mark, Fend lança sa première Flitzer, belle comme un avion et manœuvrée par pédales, destinée aux conducteurs invalides. Le premier moteur de la Flitzer avait 38 centimètres cube, c'était un moteur auxiliaire pour bicyclettes. Avec l'augmentation de sa cylindrée (100 centimètres cube) la voiture devint plus rapide et plus intéressante. Il y eu une reprise de contact avec Messerschmitt. Fend mit au point le modèle biplace pour les usines Messerschmitt à Ratisbonne. On commença à fabriquer la voiture en série en mars 1953 et à la vendre au prix de 2 100 marks. 20 000 KR 175 furent vendues en deux ans, malgré la chaleur étouffante qui régnait sous la coque de plexiglas et le bruit assourdissant du moteur placé directement derrière les sièges. Le modèle KR 200 qui suivit en 1955 connût encore plus de succès. Le rendement financier, en revanche, n'était guère satisfaisant. Messerschmitt, retrouvant son intérêt pour l'aéronautique, vendit en 1956 à Fend la production qui ne rapportait plus de bénéfices. La FMR (Construction de véhicules et de machines S.A.R.L. Ratisbonne) vit le jour. La Tiger à quatre roues (Tg 500) sortie en 1958 fit encore sensation. L'heure des vraies voitures était venue et Fend changea son fusil d'épaule: les distributeurs de boisson automatiques évincèrent les scooters carénés. Un prototype de «vraie» voiture aux formes peu engageantes, apparu en 1962, ne sauva pas la situation. Le dernier «cercueil de verre» fut fabriqué en 1964.

Fiat

Italy

Fiat are probably the biggest car manufacturers with the largest number of small cars. However, cars have never been their only line of business – though this is how they started off in 1899, when they built a car with a flat-twin engine and 679 cc. The Fabbrica Italiana Automobili Torino made a name for themselves with bigger cars and at races, before the Fiat 500 – the well-known Topolino – was massproduced on a large scale and finally put Italy on the road. Fiat cleverly avoided selling this car as a small car. Instead, they had scaled down the dimensions of the big Fiat, while at the same time giving it 15-inch wheels – like the Beetle in later years. The company's German subsidiary in Weinsberg even made an elegant roadster version. In 1948 Fiat launched a redesigned version of the 500, as a saloon, saloon convertible and estate with wooden panels. The body was totally redesigned in 1949, and by 1955, 376,000 cars of this type had been built. The successor, the Fiat 600, had a water-cooled four-cylinder rear engine. Mass production started in 1955, and the car sold 2 million times. In 1957 the Fiat 500 model was even more successful. Both provided the basis for innumerable body variations produced by North Italian metal cutters. The same was true of the 1992 Cinquecento, the best design of a small car alongside the Mini.

Fiat dürfte der größte PKW-Hersteller mit den meisten Kleinwagen sein. Dabei waren und sind Autos nicht das einzige Geschäft – dies war der Fall beim Start des Automobilbaues 1899 mit einem 2 Zylinder-Boxermotor und 679 Kubikzentimetern. Die Fabbrica Italiana Automobili Torino machte sich auf Rennstrecken und mit größeren Autos einen Namen, bevor der Fiat 500, bekannt geworden als »Topolino«, in Großserie die Italiener mobil machte. Dieses Auto vermied es geschickt, als Kleinwagen daherzukommen, weil er die Linie der großen Fiats maßstabsgerecht verkleinert übernahm und trotzdem 15 Zoll-Räder – wie später der Käfer – hatte. Die deutschen Werke Weinsberg hatten sogar eine elegante Roadsterversion zu bieten. 1948 kam eine formal überarbeitete Version des 500, als Limousine, Cabriolimousine und als Kombi mit Holzverkleidung. Schon 1949 wurde die Karosse komplett überarbeitet, bis 1955 wurden 376000 dieses Typs gebaut.
Der Nachfolger Fiat 600 mit wassergekühltem Vierzylinderheckmotor schaffte sogar über 2 Millionen seit 1955, und der Fiat 500 ab 1957 hatte noch höhere Auflagen. Beide waren Basis für unzählige Karosserievarianten der Blechschneider Norditaliens. Genauso wie der seit 1992 verkaufte Cinquecento, das beste Kleinwagenkonzept neben dem Mini.

Fiat est probablement le plus grand constructeur de petites voitures. Il n'était et n'est d'ailleurs pas axé uniquement sur les voitures. La première vit le jour en 1899, son moteur avait deux cylindres à plat opposés et une cylindrée de 679 centimètres cube. La Fabbrica Italiana Automobili Torino se fit un nom sur les circuits de course avec de grosses voitures, avant que la Fiat 500 Topolino, ne mobilise les Italiens. Cette voiture évitait adroitement de faire son entrée en tant que petite voiture, elle avait repris les lignes des grandes Fiat à une échelle plus petite et était équipée de roues de 15 pouces, comme plus tard la Coccinelle. Les usines allemandes Weinsberg en offraient même une élégante version roadster. La 500 fut retravaillée au niveau des formes et, en 1948, apparurent une berline, une berline-cabriolet et un break revêtu de bois. La carrosserie fut complètement remaniée dès 1949 et 376000 voitures de ce type sortirent des chaînes jusqu'en 1955.
Elle fut remplacée par la Fiat 600 équipée d'un moteur à quatre cylindres placé à l'arrière et refroidi à l'eau, qui fut même vendue à plus de 2 millions d'exemplaires à partir de 1955. La Fiat 500 de 1957, elle se vendit mieux encore. Les deux modèles furent la base d'une multitude de carrosseries Fiat. Exactement comme la Cinquecento, sur le marché depuis 1992, et qui représente le meilleur concept de petite voiture à côté de la Mini.

Fuldamobil

Germany

Elektromaschinenbau GmbH (Electrical Engineering Limited) in Fulda made their first money with emergency power units and other electrical components, as well as acting as a Bosch representative. And yet between 1950 and 1969 nearly 3,000 Fuldamobiles were produced, thanks to the owner of the company, Karl Schmitt. Helped by the ingenious designer Norbert Stevenson, the first Fuldamobile was built at a caravan factory and launched in 1950. It was a three-wheeler with a wooden frame, and the first model was still steel-plated and held together with nails. Neither a feeble Zündapp engine nor a tree-saw engine gave it enough power. It did not really gain strength until it had a Fichtel & Sachs engine. After a rather mediocre initial success and the introduction of a pleasantly curved aluminium body, production was moved to the company's partner – Nordwestdeutsche Fahrzeugbau GmbH (North West German Vehicle Engineering Limited) in Wilhelmshaven. However, this was only for a short period and soon followed by bankruptcy. From 1955 onwards any improved versions came from Fulda itself – soon also with a fourth wheel and a track arrangement that was similar to the Isetta. Production was made easier through the use of fibre-glass bodies, though the Fuldamobile no longer sold very well. Others, such as Lloyd and Fiat, were offering small cars that felt more like real cars. Karl Schmitt managed to sell licences to other countries, so that his car appeared as the Nobel 200 in the UK, the Bambino in Holland, the Attica in Greece, the King in Scandinavia and the Bambi in South America. However, when four-stroke Heinkel engines were no longer available, production of this last small German car was finally discontinued in 1969.

Notstromaggregate und andere Elektrobauteile nebst einer Boschvertretung brachten das Geld bei der Elektromaschinenbau GmbH in Fulda. Dabei waren zwischen 1950 und 1969 knapp 3 000 Fuldamobile entstanden, was Karl Schmitt, dem Firmeneigner, zu verdanken war. Mit ingeniöser Hilfe des Konstrukteurs Norbert Stevenson wurde das erste Fuldamobil – dreirädrig mit Holzrahmen und beim ersten Modell noch mit genageltem Stahlblech – gebaut von einer Wohnwagenfabrik und 1950 vorgestellt. Weder der schlappe Zündapp-Motor noch ein Baumsägenmotor lieferten ausreichende Fahrleistungen, die erst ein Fichtel & Sachs-Motor brachte. Nach mäßigen Anfangserfolgen und Einführung einer Alukarosse mit gefälligen Rundungen wurde die Produktion zum Partner Nordwestdeutsche Fahrzeugbau GmbH nach Wilhelmshaven verlegt, jedoch nur kurz – dann folgte der Konkurs. Schon 1955 kamen nur aus Fulda weitere verbesserte Versionen, bald auch mit einem vierten Rad – in der Spuranordnung ähnlich der Isetta. Eine Kunststoffkarosse machte die Herstellung der immer schwieriger zu verkaufenden Mobile einfacher, andere Kleinwagen wie Lloyd und Fiat boten einfach mehr »Auto«. Karl Schmitt schaffte es noch, Lizenzen ins Ausland zu verkaufen (nach England als Modell »Nobel 200«, Holland als »Bambino«, Griechenland als »Attika«, Skandinavien als »King« und Südamerika als »Bambi«). Als schließlich keine viertaktenden Heinkelmotoren mehr zu haben waren, wurde auch das Fuldamobil als eine der letzten deutschen Kleinwagenproduktionen 1969 eingestellt.

L'usine de construction de machines électriques S.A.R.L. de Fulda fabriquait des groupes électrogènes de secours et autres éléments électriques, tout en représentant à côté de cela la maison Bosch. Entre 1950 et 1969, près de 3 000 Fuldamobils sortirent également des usines, et ceci grâce à Karl Schmitt, le propriétaire de la firme. La première Fuldamobil, un tricycle à châssis de bois et panneaux de tôle cloués, fut mise au point avec les idées ingénieuses du constructeur Norbert Stevenson, construite par une usine de caravanes et présentée en 1950. Ni le faible moteur Zündapp ni un moteur de scie électrique ne fournissaient des performances suffisantes, il fallut attendre un moteur Fichtel & Sachs. Après un succès modéré au départ et l'introduction d'une carrosserie en aluminium aux agréables rondeurs, la production fut transférée chez le partenaire de Wilhelmshaven, Construction de véhicules de l'Allemagne du Nord et de l'Ouest S.A.R.L., mais la faillite ne se fit pas attendre. Déjà en 1955, d'autres versions améliorées ne venaient que de Fulda, elles furent bientôt dotées d'une quatrième roue – leur voie était semblable à celle de l'Isetta. Une carrosserie de plastique facilita la fabrication des véhicules toujours plus difficiles à écouler, vu que d'autres petites voitures, comme la Lloyd et la Fiat, étaient plus intéressantes. Karl Schmitt réussit encore à vendre des licences à l'étranger (en Angleterre sous le nom de Nobel 200, en Hollande la Bambino, en Grèce l'Attika, en Scandinavie la King et en Amérique latine la Bambi). Il devint finalement impossible d'obtenir des moteurs Heinkel à quatre temps et la production de la Fuldamobil, une des dernières petites voitures allemandes, fut stoppée en 1969.

Glas

Germany

The story of the car manufacturer Hans Glas started with agricultural machinery and – in 1951 – with a motor scooter. This was followed by the Goggomobile in 1955 which, as a prototype, still had a front that opened sideways – like the Isetta. The most beautiful Goggo of all times, however, was produced under licence by Buckle in Australia. Only three years later Glas was able to follow up this tiny two-stroke car with well designed large four-stroke vehicles (the Isar 600 and 700) and an entire series of Goggos (a coupé, convertible and transporter). With its wrap-around windscreen the 600 was a miniature version of an American »battleship« car. Neither the 600 nor the angular 1204 and 1304 models achieved a breakthrough, even though they were heavily involved in the motoring sport. The Goggomobile survived until 1969, i.e. 2 years after BMW had taken over. Obviously, small cars no longer fitted in, and the new Glas Coupé 1300 was soon adapted to the firm's design, while Glas's medium-size car (designed by Frua) was dumped altogether, because their former competitors had given preference to their own, identical idea, with their new 1500. And the very big Glas with its V8 engine suited neither a Glas nor a BMW profile: it had become too big for the Glas and had turned into a burdensome liability for BMW. This means that it was in fact a manufacturer of small cars who had succeeded in making genuine vintage cars in Germany.

Die Lebensgeschichte des Autobauers Hans Glas begann mit Landmaschinen und 1951 mit einem Motorroller. 1955 folgte das Goggomobil, als Prototyp noch mit seitlich schwenkender Fronttür in der Seitenansicht wie bei der Isetta. Der schönste Goggo aller Zeiten aber kam als Lizenzproduktion aus Australien von der Firma Buckle. Schon drei Jahre später konnte Glas dem zweitaktenden Autowinzling formschöne und größere Viertakter (Isar 600 und 700) dazustellen, nach einer variantenreichen Goggoreihe (Coupé, Cabrio und Transporter). Mit Panoramafrontscheibe war der 600 die Miniausgabe amerikanischer Straßenkreuzer. Die kantigen 1204- und 1304-Modelle schafften wie die 600 keinen Durchbruch, auch wenn sie im Motorsport heftig mitmischen konnten. Das Goggomobil überlebte noch bis 1969, als BMW bereits seit zwei Jahren Herr im Hause war. Da paßt natürlich kein Kleinwagen mehr ins Bild, ein Glas Coupé 1300 wurde schnell mit einer Niere geschmückt und der Mittelklassewagen von Glas (Design Frua) gar ganz gekippt, weil die Münchener Konkurrenz mit identischem Konzept bei dem neuen 1500 den Vortritt hatte. Und der ganz große Glas mit V8-Motor paßte weder in ein Glas- noch in ein BMW-Profil – dem einen über den Kopf gewachsen, dem anderen eine nicht bezahlbare Altlast. So hat ausgerechnet der Erfolg eines Kleinwagenbauers noch Autos in Deutschland hervorgebracht, die wahre Raritäten sind.

Le constructeur automobile Hans Glas débuta dans la vie avec des machines agricoles et un scooter caréné en 1951. La Goggomobil suivit en 1955, son prototype avait encore une porte frontale fixée sur les côtés comme l'Isetta. La plus belle Goggo de tous les temps est pourtant celle que construisit sous licence la firme australienne Buckle. Trois ans plus tard, Glas pouvait déjà ajouter à cette mini-voiture à deux temps de belles automobiles, plus grandes, dotées de moteurs à quatre temps (Isar 600 et 700), après une série Goggo très variée (coupé, cabriolet, transporter). Avec son pare-brise panoramique la 600 était une reproduction en miniature des belles américaines. Les modèles 1204 et 1304 aux lignes anguleuses, tout comme les 600, ne surent pas percer, même s'ils étaient très engagés dans le sport automobile. La Goggomobil survécut jusqu'en 1969, alors que BMW dirigeait la maison depuis deux ans. Une petite voiture ne correspondait pas à l'image de marque, on garnit vite un coupé Glas 1300 de l'emblème BMW et la voiture de catégorie moyenne de Glas (design Frua) fut même abandonnée, car la concurrence munichoise présentait un concept identique avec sa nouvelle 1500, et il fallait s'effacer devant elle. Quant à la grande Glas au moteur V8, elle n'avait ni le profil de Glas ni celui de BMW, trop grande pour l'un, trop chère et de conception trop ancienne pour l'autre. C'est donc précisément un constructeur de petites voitures qui a produit en Allemagne des autos devenues de véritables pièces rares.

Heinkel

Germany

Like Messerschmitt, Heinkel was another aircraft engineer who was interested in putting Germany on the road after the war. The Heinkel works had been bombed out almost completely, but there were still remnants in Zuffenhausen, near Stuttgart, the home of the Porsche. The engine factory had not been destroyed at all, though the owner was only allowed access to it by the Allies in 1950. However, during the first post-war years the company was already building Veritas racing-car engines, as well as engines for Vidal (for their Tempo van) and Saab. In 1953 Heinkel produced their first scooter – called Tourist – with a four-stroke engine. In 1956, after a slump in the sale of scooters, Heinkel launched their three-wheeler cabins – just in time. By 1959, nearly 12,000 cabin cars from the Speyer plant had been sold. Heinkel even succeeded in selling a licence to Ireland. The design of the cabin showed clearly that a skilled aircraft engineer had been at work: thanks to the metal, which bore part of the load, it weighed 220 lbs (100 kg) less than its major competitor, the Isetta – and it had more space inside. The original design of the cabin had twin rear wheels, but, to allow a more favourable MOT classification as a motorbike, it was exported to the UK with a solo rear wheel. A clever trick, which was also used by the manufacturers of the Bond and Reliant three-wheeler minis. An Argentinian licence resulted in nearly 2,000 vehicles being built there. Finally, in 1966, when the Heinkel Cabin was called the Trojan 200, production was discontinued.

Neben Messerschmitt war Heinkel ein weiterer Flugzeugbauer mit Nachkriegsinteresse am mobilen Fortkommen der Nation. Reste der zerbombten Heinkel-Werke gab es nur in Stuttgart-Zuffenhausen, der Heimat von Porsche. Dort blieb ein Motorenwerk erhalten, zu dem erst 1950 dem Eigner Zutritt durch Zustimmung der Alliierten erlaubt wurde. In den ersten Nachkriegsjahren wurden allerdings schon Rennmotoren für die Marke Veritas gebaut, aber auch für Vidal (»Tempo«-Lieferwagen) und für Saab entstanden Motoren. 1953 kam der erste Heinkel-Roller »Tourist« zum Verkauf – mit Viertaktantrieb. Ab 1956, nach abgesackten Rollerverkäufen, wurde rechtzeitig die dreirädrige Heinkel-Kabine angeboten. Bis 1959 kamen knapp 12000 Wägelchen aus dem Werk Speyer auf die Straßen. Eine Lizenz konnte sogar nach Irland verkauft werden. Flugzeugbauergeschick zeigte die Konstruktion der Kabine: Sie wog dank mittragender Blechteile 100 kg weniger als die große Konkurrenz Isetta – und bot mehr Innenraum. Die eigentlich mit hinterem Zwillingsrad gelieferte Kabine wurde, wegen der günstigeren steuerlichen Einstufung als Motorrad, mit Soloheckrad nach England geliefert. Ein Kniff wie bei den Konstruktionen von Bond- und Reliant-Dreiradminis. Auch eine nach Argentinien verkaufte Lizenz brachte es dort auf an die 2 000 gebauten Fahrzeuge. Erst 1966 fand mit dem Modell »Trojan 200« die Heinkel-Kabine einen endgültigen Produktionsstop.

Heinkel, comme Messerschmitt, était un avionneur qui commença après la guerre à s'intéresser à l'automobile. Les usines Heinkel avaient été bombardées, des vestiges ne subsistaient qu'à Stuttgart-Zuffenhausen, là où se trouvent les usines Porsche. Une usine de moteurs existait encore, mais le propriétaire n'y eut accès qu'en 1950 avec l'autorisation des Alliés. Dans les premières années après la guerre on y construisit déjà des moteurs de voitures de course pour la marque Veritas, mais on fabriqua aussi des moteurs pour Vidal (camionnettes Tempo) et Saab. En 1953 apparut le premier scooter Tourist de Heinkel, équipé d'un moteur à quatre temps. A partir de 1956, les ventes de scooters se firent plus rares, mais la Kabine à trois roues de Heinkel fut lancée à temps. Environ 12 000 petites voitures sortirent des usines de Speyer jusqu'en 1959. On put même vendre une licence en Irlande. La construction de la Kabine montrait l'adresse de l'avionneur: grâce à ses éléments de tôle portants, elle pesait 100 kilos de moins que sa grande concurrente l'Isetta, et son habitacle était plus spacieux. La Kabine, normalement dotée de roues jumelles à l'arrière, fut livrée en Angleterre avec une roue arrière unique, car une motocyclette était fiscalement plus avantageuse: une «ficelle», utilisée aussi pour les mini-voitures à trois roues de Bond et de Reliant. Une licence vendue en Argentine amena elle aussi la fabrication de près de 2 000 voitures. C'est en 1966 que la Kabine de Heinkel devenue la Trojan 200 cessa vraiment d'être produite.

Honda

Japan

It is a well-known fact that Soichiro Honda built so many motorbikes after 1949 that he became number one in the world. However, in 1962, his company also began to make cars, starting with a small van and a small sports car, the Honda S 600. This car and the excellent mini Honda N 360 were the first Hondas in Germany. The N 360 was also the first Honda in Japan to be available with a sports car body. The range was soon extended to include racing cars such as the NSX of 1989 – a car that was good enough to compete with Ferrari – as well as the successful compact Civic. A number of even smaller models, such as the Jazz, its successor Today (from 1985) and the convertible Beat (a fun car launched in 1991) show the quality of Honda's design when it comes to small cars. Unfortunately, the Beat and Today never became available in Europe. This makes it all the more significant that Honda rose from an exporter to an international manufacturer. In the US, the most widely sold compact is the Acura, in the UK Honda collaborate very intensively with the Rover group, and in Germany they even have their own design division.

Eigentlich baute Soichiro Honda seit 1949 ja so viele Motorräder, daß er Nummer eins in der Welt wurde. Aber seit 1962 wurden auch Autos in Serie produziert, zuerst Lieferwägelchen und Sportautos der kleinen Klassen (Honda S 600). Dieses Modell und der Miniadept Honda N 360 – er war 1962 als erster Honda auch gleich in einer Sportkarosse in Japan erhältlich – wurden die ersten Autos dieser Marke in Deutschland und Europa. Neben der Modellausweitung bis hin zu Boliden wie dem NSX (1989) mit dem Zeug zur Ferrarikonkurrenz wurde besonders das Kompaktmodell Civic sehr erfolgreich. Noch kleinere Modelle wie der Jazz und der Nachfolger Today (seit 1985) und das Spaßcabrio Beat (Debüt 1991) belegen konstruktive Qualität und Designleistung Hondas in der Kleinwagenklasse. Leider werden Beat und Today in Europa nicht angeboten. Um so mehr ist die Marke Honda Beispiel dafür, wie man vom Exporteur zum internationalen Hersteller werden kann. In USA ist die Kompaktmarke Acura das meistgekaufte Modell, in England kooperierte Honda stark mit der Rover-Gruppe, in Deutschland wird sogar eine eigene Designabteilung geführt.

A vrai dire, Soichiro Honda fabriquait depuis 1949 tant de motocyclettes qu'il en devint le leader mondial. A partir de 1962, des voitures commencèrent à sortir des chaînes de fabrication, tout d'abord des voitures de livreurs et des voitures de sport de catégorie inférieure (Honda S 600). Ce modèle et la petite Honda N 360 – en 1962 elle était, en tant que première Honda, livrable également dans une carrosserie sportive au Japon – devinrent les premières voitures de la marque en Europe. A côté de l'élargissement du programme qui comprenait également des bolides comme la NSX (1989) qui aurait pu concurrencer la Ferrari, le modèle compact Civic eut beaucoup de succès. Des modèles encore plus petits comme la Jazz et son successeur la Today (depuis 1985) ainsi que le cabriolet ludique Beat (présenté en 1991) prouvent les qualités de construction et de design de Honda dans la catégorie des petites voitures. Malheureusement, la Beat et la Today ne sont pas sur le marché européen. La marque Honda n'en est que plus l'exemple de ce qu'un exportateur peut faire pour devenir un constructeur international. Aux Etats-Unis, la voiture compacte Acura est le modèle le plus acheté. Honda coopère de manière approfondie avec le groupe Rover en Angleterre, et en Allemagne le constructeur a même son propre service de design.

Kleinschnittger

Germany

Kleinschnittger continued to make spare parts until 1967, though their credit limit had already been stretched too far ten years earlier. As with so many post-war initiatives in vehicles, it went bust. By the time the company closed down, its 60 staff in Arnsberg, Westphalia, were only building a small number of cars. Yet the model had been very hopeful, with its 250 cc engine, closed body and fastback. The Kleinschnittger F 125 had brought in a fair amount of money, though. Between 1949 and August 1957, 2,980 cars were built which even the upgraded F 150–2 of 1953 (built once!) was unable to oust. All this had started with an engineer called Paul Kleinschnittger in a place where names like Heinkel and Messerschmitt had never penetrated at all. Using aircraft wrecks and scrap metal from old vehicles, Kleinschnittger built his first small cars in Ladelund, Holstein. In 1949 he set up his own manufacturing facilities in the Sauerland region. The special feature of these tiny cars was that they had an aluminium body, something that was not rediscovered by the automobile industry until the Nineties and is only reaching mass production again with the Audi flagship of 1994.

Ersatzteile gab es von Kleinschnittger noch bis 1967. Aber schon zehn Jahre vorher machte der Kreditrahmen nicht mehr mit. Wie bei vielen Nachkriegsinitiativen für fahrbare Untersätze hieß es: Konkurs. Bis zum letzten Produktionsjahr wurden vom Hoffnungsträger mit 250 Kubikzentimeter-Motor von der 60 Mann starken Belegschaft in Arnsberg/Westfalen nur wenige Exemplare gebaut: Varianten einer geschlossenen Karosserie mit Schrägheck. Geld verdient wurde allerdings vorher mit dem Kleinschnittger F 125. Von 1949 bis August 1957 wurden 2 980 Exemplare gebaut, die auch von einer verbesserten Variante F 150–2 von 1953, nur einmal gebaut, nicht verdrängt werden konnten. Und angefangen hatte es mit dem Ingenieur Paul Kleinschnittger dort, wo Namen wie Heinkel und Messerschmitt aufhörten. Kleinschnittger baute sich in Holstein im Ort Ladelund aus Flugzeugwracks und Fahrzeugresten seine ersten Kleinstwagen, um dann 1949 die Kleinschnittgerwerke im Sauerland zu gründen. Was diese Winzlinge auszeichnete: Sie hatten eine Aluminiumkarosserie, etwas, was erst Mitte der 90er Jahre wieder im Automobilbau entdeckt wird und mit dem Audi-Flaggschiff ab 1994 in die Serie zurückkehrt.

En 1967, on trouvait encore des pièces détachées pour les Kleinschnittger. Mais le cadre financier s'était écroulé déjà dix ans plus tôt. La maison avait fait faillite, comme beaucoup d'autres initiatives d'après-guerre dans le domaine de l'automobile. Jusqu'à la dernière année de production, les 60 employés de l'usine de Arnsberg en Westphalie ne fabriquèrent que peu d'exemplaires de la Kleinschnittger au moteur de 250 centimètres cube: des variantes d'une carrosserie fermée à l'arrière profilé. C'est le modèle précédent, le Kleinschnittger F 125 qui avait rapporté de l'argent. De 1949 au mois d'août 1957, on en construisit 2 980 exemplaires, qui ne purent même pas être évincés par la version améliorée F 150–2 de 1953, fabriquée une seule fois. L'ingénieur Paul Kleinschnittger reprit le flambeau de Heinkel et Messerschmitt. A Ladelund, dans le Holstein, il construisit ses premières petites voitures à partir de débris et de restes d'avion. En 1949, il fonda les usines Kleinschnittger dans le Sauerland. Ces petites voitures se distinguaient par leur carrosserie d'aluminium, matériau que l'on ne redécouvrira dans la construction automobile qu'au milieu des années 90, et que l'on retrouve dans la construction en série à partir de 1994 chez le fleuron de Audi.

Lloyd

Germany

Consul F. W. Borgward was a typical entrepreneur – the kind that easily survived all the upheaval of the war. Successful, headstrong, imaginative and ending up in legendary bankruptcy in 1961. By then he had built virtually anything that might have four wheels and run on roads. His company made both cars and trucks, and in addition to the names Borgward and Goliath, Lloyds had the largest variety of post-war models. Starting with the LP 300 of 1950 – a year after the company was set up – Lloyds soon became established very quickly. The LP 300, which was known as the »Leukoplastbomber« (sticking plaster bomber), came with a plywood body covered with imitation leather. The wheels were large, the car itself sufficiently fast, and it had enough room for four persons. It was therefore much better than some rather too intimate cars, like the Isetta or Heinkel Cabin. From 1951 onwards it was also available as a convertible, coupé, estate and minivan. In 1954 the lower part was supplied in metal, in 1955 the whole body followed suit, and by 1958 the Lloyd had reached a proud 600 cc and 25 HP. With another leap forward in 1959, complete with tailgate and the mellow name Arabella, Lloyds tried to keep up with the Joneses in the car industry. However, like other ambitious projects of the Borgward parent company, it incurred a large amount of debt. After its bankruptcy in 1961, the Bremen plant was taken over by Siemens, among others. Until 1986 an interest group with minimum staff continued to reproduce large numbers of spare parts, also for other obsolete models, such as the Hansa and the Goggomobile.

Konsul Carl F. W. Borgward war der Urtyp des Unternehmers, der alle Kriegswirren überstand. Erfolgreich, eigensinnig, einfallsstark, eine legendenumwobene Pleite 1961 hinlegend. Bis dahin hatte er fast alles mit Rädern gebaut, was auf Straßen rollen konnte. Neben LKWs und PKWs, neben den Marken Borgward und Goliath hatten die Lloyds die typenreichste Ansammlung nach dem Zweiten Weltkrieg zu bieten. Angefangen mit dem 1950 gezeigten LP 300 (Markengründung 1949), dem »Leukoplastbomber« mit Sperrholzkarosse und Kunstlederbezug, konnten sich die Lloyds schnell etablieren. Große Räder, ausreichend flott, mit Platz für vier Personen, das war allemal ein besseres Angebot als die nur wenig billigeren »Knutschkugeln« vom Schlage Isetta oder Heinkel-Kabine. Schnell gab es ab 1951 Varianten als Kombi, Coupé, Cabrio und Kleinlieferwagen. Ab 1954 unten, ab 1955 ganz aus Blech, erstarkte der Lloyd bis zu 600 Kubikzentimeter und 25 PS (1958). Mit einem Sprung weiter nach oben, mit Heckflossen und dem wohlklingenden Namen »Arabella« wollte Lloyd ab 1959 den Anschluß an den automobilen Wohlstand suchen. Dieser Lloyd machte vor allem Schulden wie andere teure Ambitionen der Muttermarke Borgward. Nach der Pleite 1961 gingen die Bremer Werke u. a. an Siemens. Bis 1986 wurde von einer Interessengemeinschaft mit Minibelegschaft einiges an Ersatzteilen nachproduziert – auch für andere inzwischen untergegangene Marken wie Hansa oder Goggomobil.

Le Consul Carl F. W. Borgward était le type même du chef d'entreprise ayant survécu à tous les malheurs de la guerre. Il avait du succès, de l'obstination et des idées, plus une faillite auréolée de légende en 1961. Jusque-là il avait à peu près tout construit de ce qui peut se déplacer sur roues. A côté de camions et de voitures de tourisme, à côté des marques Borgward et Goliath, Lloyd offrait la gamme de voitures la plus diverse après la Seconde Guerre mondiale. Commençant avec la LP 300 présentée en 1950 (création de la marque en 1949), le «bombardier en sparadrap» à la carrosserie de contreplaqué recouverte de cuir synthétique, les Lloyds purent s'établir rapidement. De grandes roues, une vitesse suffisante, de la place pour quatre passagers, c'était quand même mieux que ce qu'offraient ces boules propices aux ébats des amoureux du genre Isetta ou Kabine de Heinkel. A partir de 1951, les versions break, coupé, cabriolet et camionnette firent leur apparition à un rythme rapide. A partir de 1954, le bas était en tôle, à partir de 1955 tout était en tôle, la Lloyd se fit plus puissante jusqu'à atteindre 600 centimètres cube et 25 CV (1958). A partir de 1959, en faisant un bond vers le haut avec l'Arabella au joli nom dotée d'ailerons, Lloyd voulut profiter de l'opulence qui régnait dans l'automobile. Cette Lloyd généra surtout des dettes comme d'autres ambitions onéreuses de la maison-mère Borgward. Après la faillite de 1961, les usines de Brême furent rachetées, entre autres par Siemens. Jusqu'en 1986, un groupement d'intérêts au personnel restreint reproduisit quelques pièces détachées, et ceci également pour d'autres marques disparues entre-temps comme Hansa ou Goggomobil.

Mazda

Japan

Having started as a cork factory, the first roadworthy products of the Toyo Kogyo group, Hiroshima, in 1931 were motorbikes and three-wheeler vans. The first prototype of a car was developed in 1940, though it took another 20 years before mass production could start. Along with the entire Japanese car industry, the development of Mazda then took off at a truly breath-taking speed. The first model in 1960 was the R–360 (the number indicates the capacity), a coupé which survived until 1970. In 1962, it was followed by the slightly larger Carol (available with 360 and 600 cc), a car that was similar to the Ford Anglia and had a negatively positioned rear window. It was nearly 10 feet (3 metres) in length and had four doors. In 1964 the series was complemented by a convertible. One of the reasons why Mazda became known in Germany was because it took over the Wankel licence in 1961 and is still faithfully using and enhancing this particular combustion engine technology today. Mazda collaborates extensively with Ford, is still making a Carol for the home market (128 inches / 325 cm long), and has shown with its AZ–1 since 1992 that a coupé with folding doors does not have to be called »SL«, that it does not have to come from Stuttgart and that it can still be beautiful, despite its 130 inches (329½ cm) in length. As with other Japanese vehicles, small cars were Mazda's springboard into a higher class.

Erst Motorräder und dann dreirädrige Lieferwägelchen waren ab 1931 die ersten Mazda-Erzeugnisse für die Straße des Toyo Kogyo Konzerns aus Hiroshima, hervorgegangen aus einer Kork-Fabrik. Ein erster PKW-Prototyp wurde 1940 entwickelt, aber es brauchte noch einmal 20 Jahre, bis eine Serienproduktion anlief. Dann aber überstürzte sich, parallel mit der gesamten japanischen Autoproduktion, die Entwicklung der Marke. 1960 kam der R–360 (Zahl steht für Hubraum), ein Coupé, das bis 1970 überlebte. 1962 zeigte der etwas größere »Carol« mit wahlweise 360 oder 600 Kubikzentimeter, Ähnlichkeiten zum Ford Anglia mit negativ stehender Heckscheibe. Die Baulänge von 3 Metern offerierte auch vier Türen. 1964 wurde die Baureihe von einem Kombi ergänzt. Bei uns wurde Mazda auch deswegen bekannt, weil die Firma 1961 die Wankel-Lizenz übernommen hatte und noch bis in diese Tage treu das Konzept dieser Verbrennungsmotortechnik verwendet und verbessert. Mazda kooperiert stark mit Ford, bietet immer noch einen »Carol« für den heimischen Markt (Länge 325 Zentimeter) und zeigt seit 1992 mit dem AZ–1, daß ein Coupé mit Flügeltüren nicht »SL« heißen und aus Stuttgart kommen muß und trotzdem mit 329,5 Zentimetern Länge bildschön aussehen kann. Wie bei den anderen Japanern waren Kleinwagen das Sprungbrett für Mazda in die große Klasse.

Le groupe Toyo Kogyo de Hiroshima, à l'origine une usine de liège, commença par fabriquer des motocyclettes puis, à partir de 1931, des camionnettes de livreurs à trois roues. Un premier prototype de voiture de tourisme fut élaboré en 1940, mais la fabrication en série se fit attendre vingt ans. Et puis les événements se précipitèrent, la marque se développa comme toute la production automobile japonaise. En 1960 apparut la R–360 (le chiffre indique la cylindrée), un coupé qui fut construit jusqu'en 1970. En 1962, la Carol, un peu plus grande, livrable au choix avec un moteur de 360 ou 600 centimètres cube, offrait une certaine ressemblance avec la Ford Anglia avec sa lunette arrière inclinée vers l'intérieur. Elle mesurait 3 mètres de longueur et avait aussi 4 portes. En 1964, la gamme fut enrichie d'un break. Mazda se fit connaître en Europe parce que la firme avait acheté la licence Wankel et qu'elle utilise et améliore fidèlement aujourd'hui encore cette technique de moteur à piston rotatif. Mazda coopère étroitement avec Ford, offre toujours une Carol pour le marché intérieur (longueur 325 centimètres), et montre depuis 1992 avec la AZ–1 qu'un coupé à portières en ailes ne doit pas s'appeler SL et venir de Stuttgart, et qu'il peut être superbe en ne mesurant que 329,5 centimètres de long. Ce qui est vrai pour les autres marques japonaises, l'est également pour Mazda: la construction de petites voitures lui a servi de tremplin pour arriver jusqu'aux grandes.

Messerschmitt

Germany

If it had not been for Fritz Fend, Messerschmitt's history as a manufacturer of road vehicles would probably be totally unimportant. Interestingly, apart from the 1953–1956 Cabin Scooter, Messerschmitt had already produced items other than aeroplanes, i.e. sewing machines and prefabs. Even though it had never gone beyond the trial stage, there had even been a study for a car – a vehicle with a five-cylinder radial engine, i.e. a cylinder arrangement that could normally only be found in aeroplanes. Apparently, only one prototype was ever built. And as Messerschmitt had sold production to Fend again, the name had to be altered. The models now went under the name of FMR, i.e. Fahrzeug- und Maschinenbau GmbH Regensburg (Vehicle and Machine Engineering Regensburg Limited), with a number to indicate the capacity. However, Messerschmitt had two strokes of bad luck; they were not allowed to use their company logo (with a circle) or the name »Tiger« for the four-wheel version. The logo was vetoed by Mercedes on the grounds that it was too similar to their star, and the Tiger incurred the wrath of a Krupp-owned truck company called LKW Südwerke, whose truck bore the same name. When Messerschmitt tried to use three rings for its FMR, this irritated DKW with its four rings. Eventually, the Cabin Scooter ended up with three diamonds at the front, a logo which it kept until the end of production in 1964.

Messerschmitts Firmengeschichte als Hersteller von Straßenfahrzeugen wäre ohne die des Fritz Fend wohl kaum der Rede wert. Insofern bleibt bei der Vita des Flugzeugbauers zu ergänzen, daß er neben dem Bau des Kabinenrollers (von 1953–1956) schon vorher flugzeugfremde Produktionsideen hatte und sich im Bau von Nähmaschinen und Fertighäusern versuchte. Im Versuchsstadium blieb auch eine PKW-Studie, die mit einem fünfzylindrigen Sternmotor angetrieben wurde, eine sonst nur bei Flugzeugen verwendete Zylinderanordnung. Davon soll nur ein Prototyp gebaut worden sein. Und weil Messerschmitt die Fertigung wieder an Fend verkauft hatte, mußte der Name des Flugzeugbauers aufgegeben werden. Als »FMR« (Fahrzeug- und Maschinenbau Regensburg) wurden die Modelle weiter bezeichnet, mit einer Ziffer als Hinweis auf den Hubraum. Zweifaches Pech dabei: Sowohl das Firmenzeichen im Kreis als auch der Name »Tiger« für die vierrädrige Version durften nicht weiterverwendet werden. Einmal kam Einspruch von Mercedes, das Kreiszeichen sei dem Stern zu ähnlich, und beim Tiger hatten die LKW-Südwerke (Krupp) Vorbehalte, weil ein eigenes LKW-Modell so hieß. Der Ausweg, es mit drei Ringen bei FMR zu versuchen, nervte wiederum DKW mit seinen vier Ringen. So kam der Kabinenroller zu seinen drei Rhomben am Bug – bis zum Produktionsende 1964.

L'histoire de Messerschmitt en tant que constructeur de voitures ne vaudrait pas la peine d'être racontée, s'il n'y avait pas eu Fritz Fend. Nous parachevons donc le parcours de celui-ci en disant qu'à côté de la construction du scooter caréné (de 1953 à 1956), il avait déjà eu auparavant des idées de production étrangères à l'aéronautique et qu'il avait tenté sa chance dans les machines à coudre et les maisons préfabriquées. Une étude de voiture, à moteur en étoile de cinq cylindres, un système utilisé sinon uniquement dans les avions, resta aussi au stade de l'essai. On n'en construisit qu'un prototype. Et Messerschmitt ayant revendu les usines à Fend, le nom du constructeur d'avions dut disparaître. Par la suite, les modèles furent nommés FMR (Construction de véhicules et de machines de Ratisbonne), le tout accompagné d'un chiffre indiquant la cylindrée. Double malchance: aussi bien l'emblème de la marque entouré d'un cercle que le nom de «Tiger» pour la version quadricycle durent être abandonnés. En effet, Mercedes avait protesté contre l'emblème cerclé qui ressemblait trop à son étoile, quant au «Tiger», les Usines de camions du sud (Krupp) avaient formulé des réserves, parce qu'un de leurs camions portait le même nom. On eut alors l'idée d'utiliser trois anneaux pour définir FMR, mais cette fois cela irrita DKW qui en avait quatre. C'est ainsi que le scooter caréné se retrouva avec trois losanges sur le capot, jusqu'à sa disparition en 1964.

Meyra

Germany

The first half of Wilhelm Meyer's surname was also that of his company, which still makes wheelchairs and vehicles for the disabled at the Vlotho facility on the river Weser. Straight after the war it seemed sensible to build small cars, using canvas and one-cylinder engines. The first one, called Type 48 with a 200 cc engine, still rather resembled the front of a motorbike with a side car. When the flow of material began to improve, the company also produced rickshaws for export to Asia, though its main product line was still vehicles for the disabled. The Meyra 55 of 1952 had a smooth body, not unlike the Goliath Pioneer. About 300 of them sold within two years. The development towards a real small car never went beyond the prototype stage. Neither their first three-wheeler (with a solo rear wheel) nor their four-wheeler of 1953 were particularly beautiful compared with their competitors. The same was true of the Meyra 200 of 1953 (a four-seater three-wheeler which was only built until 1955, just under 50 times) and the 200–2 (480 vehicles with fibre-glass bodies, built from May 1955 to July 1956). Both cars were no more than ugly, elongated Isettas. Although a large number of orders seemed to indicate that the 200–2 was a good car for the future, it ran at a loss. This was due to the expensive manual work that had to be done, especially on the fibre-glass cover. And yet, the 200–2 was by no means cheap: its retail price of DM 3,450 was a lot of money at the time. Commercial considerations therefore forced the company to discontinue the production of small cars in 1956.

Die erste Namenshälfte des Wilhelm Meyer machte auch die seines Firmennamens aus. Produziert wurden und werden noch bis in diese Jahre Versehrtenfahrzeuge und Rollstühle im Werk Vlotho an der Weser. Es lag direkt nach dem Krieg nahe, mit etwas Segeltuch und Einzylindermotor Kleinstwagen zu bauen. Der erste – Typ 48 mit Ilo – 200 Kubikzentimeter-Motor – ähnelte aber noch eher einem Motorradvorderteil mit angehängtem Beiwagen. Nebenher wurden dank besserer Materialzuteilung – Versehrtenfahrzeuge hatten Vorrang in der Belieferung – selbst Rikschas gebaut, die nach Asien geliefert wurden. 1952 hatte das Modell Meyra 55 eine an den Goliath Pionier erinnernde glatte Karosse. In zwei Jahren kamen ca. 300 Exemplare auf die Straße. Der Weg zu einem richtigen Kleinauto blieb im Prototypenstadium stecken. Der erst dreirädrig (Soloheckrad), dann vierrädrig konzipierte Wagen war 1953 im Vergleich zur Konkurrenz auch keine Schönheit. Das galt auch für den viersitzigen, aber dreirädrigen Meyra 200 von 1953 (bis 1955 knapp 50 gebaute Exemplare) und dem 200–2 (von Mai 1955 bis Juli 1956 480 Fahrzeuge mit Kunststoffkarosserie), beide im Konzept eine häßlich gestreckte Isetta. Obgleich viele Bestellungen für den 200–2 für die Zukunft hoffen ließen, beim Nachrechnen der teuren Handarbeit auch im Bereich der Kunststoffhaut kam immer nur ein Minus heraus, selbst bei dem für damalige Verhältnisse hohen Preis von 3 450 DM. Kaufmännische Konsequenz: Ab 1956 wurden keine Kleinwagen mehr gebaut.

La première moitié du nom de Wilhelm Meyer formait aussi celle du nom de sa maison qui produisait, et produit encore, des véhicules pour handicapés et des fauteuils roulants dans l'usine de Vlotho sur la Weser. Juste après la guerre, il semblait logique de construire de toutes petites voitures avec un peu de toile de voiture et des moteurs d'un cylindre. La première – le modèle 48 équipé d'un moteur de 200 centimètres cube – avait plutôt l'air de la partie avant d'une motocyclette avec side-car. Parallèlement, le matériel étant mieux réparti – les véhicules pour handicapés devaient être livrés en priorité – on construisait même des pousse-pousse destinés aux pays asiatiques. En 1952, la carrosserie aux lignes nettes du modèle Meyra 55 ressemblait à celle de la Goliath Pionier. On en construisit 300 en deux ans. Mais la vraie petite voiture resta un prototype. La voiture de 1953, dotée d'abord de trois roues (roue arrière unique), puis plus tard de quatre roues n'était pas bien jolie comparée à ses concurrentes. Il en fut de même pour la Meyra 200 à quatre sièges et trois roues de 1953 (une cinquantaine d'exemplaires fabriqués jusqu'en 1955) et la 200–2 (480 véhicules à carrosserie de plastique de mai 1955 à juillet 1956), qui ressemblaient à une Isetta vilainement tirée en longueur. Bien que de nombreuses commandes pour la 200–2 aient permis de gros espoirs, la fabrication à la main et le revêtement synthétique étaient si chers que l'on vendait à perte, même au prix, élevé pour l'époque, de 3 450 marks. Conséquence commerciale: à partir de 1956, on ne construisit plus de petites voitures.

Mitsubishi

Japan

»Mitsu bishi« means »three diamonds«, and this is also the logo of this large conglomerate, founded in 1870. Following the restructuring of the group in 1970, Mitsubishi Heavy Industries (1946–70) was renamed Mitsubishi Motors Corporation. It is a company that even owns banks and whose annual turnover is considerably higher than that of the German company Daimler-Benz, one of the business associates with whom Mitsubishi co-operates. The first small series of cars was made in 1917 by the Mitsubishi Dockyard Works, a company that forms part of this group. Until the Second World War Mitsubishi mainly concentrated on utility vehicles. The first post-war car was launched in 1959. Until then Mitsubishi had tried to get into the car industry with motor scooters, three-wheel trucks and heavy utility vehicles. Their first car in 1960 was 124 inches (314 cm) long, had a 493 cc engine, 21 HP in its rear engine and a design that seemed like a cross between a Goggo and a Trabant. The successor model of 1962 was less powerful, a little more elegant and also available as a convertible and a mini pickup truck. The saloon version was called Minica, a name that has survived on the Japanese market until today. It was only 6 inches (15 cm) longer. This was a relatively moderate development compared with German small cars which had very daringly lost their identity in the medium-sized category. Such a fate was shared by the Mitsubishi Colt, a car that started with a 25 HP rear engine and an extremely compact body. Today, the Colt is 13 feet (nearly 4 metres) long, and the most popular version in Germany has 140 HP.

»Mitsu bishi« heißt »drei Diamanten« – und das zeigt das Signet des riesigen Mischkonzerns, der bereits 1870 gegründet wurde. Der Unternehmensbereich »Mitsubishi Heavy Industries« (1946–70) – nach einer Reorganisation 1970 »Mitsubishi Motors Corporation« –, der auch Banken sein eigen nennt, läßt die Umsätze des deutschen Kooperationspartners Daimler-Benz um ein Mehrfaches hinter sich. Schon 1917 kam eine erste kleine PKW-Serie in den zum Konzern gehörenden Mitsubishi Dockyard Works zustande. Bis zum Zweiten Weltkrieg wurden hauptsächlich Nutzfahrzeuge gebaut. Der erste Nachkriegs-PKW wurde 1959 vorgestellt. In den Jahren vorher wurde mit dem Bau von Motorrollern, Lastendreirädern und schweren Nutzfahrzeugen der Einstieg in den Automobilbau geübt. Das erste Auto (1960) war 314 Zentimeter lang, hatte einen Motor mit 493 Kubikzentimetern mit 21 PS im Heck und ein Design in der Mischung von Goggo und Trabi. Das Nachfolgemodell 1962 war schwächer, etwas eleganter und kam auch als Kombi und Minipickup. Als Limousine hieß er »Minica«, ein Name, der sich bis heute auf dem heimischen Markt in Japan gehalten hat und bei dem Modell gerade mal 15 Zentimeter mehr an Länge brachte. Eine moderate Entwicklung im Vergleich zu deutschen Kleinwagen, die sich übermütig in der Mittelklassenmasse verrannt haben. Dieses Schicksal teilt sich dafür das Mitsubishi-Modell »Colt« mit den deutschen. Es begann 1963 mit 25 PS im Heck in einer noch sehr kompakten Karosse. Heute bringt dieser »Colt« bei knapp 4 Metern in der heißesten in Deutschland erhältlichen Version 140 PS.

«Mitsu bishi» signifie «trois diamants», et c'est ce que montre l'emblème du groupe mixte géant fondé en 1870. Le secteur d'entreprise «Mitsubishi Heavy Industries» (1946–70), – devenu après une réorganisation «Mitsubishi Motors Corporation» – qui possède même des banques, a des chiffres d'affaires bien supérieurs à ceux de son partenaire allemand Daimler-Benz. En 1917 déjà, les Mitsubishi Dockyards Works appartenant au groupe lancèrent une première série de petites voitures de tourisme. Jusqu'à la Seconde Guerre mondiale, on construisit surtout des véhicules utilitaires. La première voiture de tourisme de l'après-guerre fut présentée en 1959. Auparavant, on s'était exercé en construisant des scooters, des tricycles pour livreurs et de lourds véhicules utilitaires. La première voiture (1960) avait 314 centimètres de long, un moteur de 493 centimètres cube et 21 CV à l'arrière, elle ressemblait à un mélange de Goggo et de Trabant. Le modèle qui suivit en 1962 était moins performant, un peu plus élégant et existait également en tant que break et pickup miniature. La berline s'appelait Minica, un nom qui existe toujours sur le marché intérieur japonais et mesurait 15 centimètres de plus que la première voiture. Une évolution modérée si on la compare à celle des petites voitures allemandes qui ont couru la tête la première dans la classe moyenne et s'y sont fourvoyées. Le modèle Colt, en revanche, partage le sort des voitures allemandes. La Colt vit le jour en 1963 avec 25 CV à l'arrière d'une carrosserie fort compacte. Aujourd'hui, elle mesure près de 4 mètres et possède dans sa version la plus puissante sur le marché allemand un moteur de 140 CV.

Mochet

France

The founder of this company, Charles Mochet, had an idea for a small car as early as 1924, when it was known as a *cycle car* or *vélocar* in France. This little car continued to be built until 1930, but was revived almost unchanged with a two-stroke engine in 1951. One look at it reveals the money-saving concept behind this revival of a 1920s' design. The greatest luxury was the engine, because 25 years earlier it had still been a pedal car. The post-war model came without back wheel suspension, in the hope that the frame and the narrow tyres would be sufficiently elastic to absorb any big jolts. Its 1953 successor – the CM Grand Luxe – had a more contemporary design, as it was almost pontoon-shaped, and the 1954 model – the CM 125 Y – had the dimensions of a real car. Spokes had been replaced by steel rims, and it even had doors with sash windows. This was a real luxury for a Mochet, as was the choice of four colours which were added later. In 1953 Mochet tried to make a 750 cc sports car, a convertible which never went beyond the prototype stage. It had become obvious that such vehicles could not keep up with people's affluence and demand for mobility. Production was therefore discontinued in 1958.

Der Firmengründer Charles Mochet hatte schon 1924 ein Kleinwagenkonzept, damals bekannt als »Cyclecar« bzw. »Velocar«, man war ja in Frankreich. Dieses Autochen wurde bis 1930 gebaut, das fast unverändert 1951 mit Zweitaktmotor wieder auflebte. Schon der Anblick machte das Sparkonzept mit dem Rückgriff auf die 20er Jahre deutlich, der größte Luxus war der Motor, denn 25 Jahre vorher mußte man noch in die Pedale treten. Bei dem Nachkriegsmodell wurde auf eine Hinterradfederung verzichtet, in der Hoffnung, der Rahmen und die schmalen Reifen würden elastisch genug sein, grobe Stöße abzufangen. Der Nachfolger CM Grand Luxe von 1953 wurde in der Karosse etwas zeitgemäßer, weil die Pontonform in Ansätzen verwirklicht wurde. Und richtige Autoproportionen bot das 1954 vorgestellte Modell CM 125 Y. Da wichen Speichen den Stahlfelgen, da gab es sogar Türen mit Schiebefenstern, für einen Mochet echter Luxus, ebenso wie später wahlweise vier Farben. Der 1953 gestartete Versuch mit einem 750 Kubikzentimeter-Sportcabrio blieb im Prototypenstadium stecken. Es war abzusehen, derartige Mobile konnten mit dem Wohlstand und den Wünschen an den mobilen Untersatz nicht mithalten. Das Produktions-Aus kam 1958.

En 1924, Charles Mochet, le fondateur de la maison, avait déjà une idée de petite voiture, connue à l'époque sous le nom de Vélocar. Cette voiturette fut construite jusqu'en 1930 et reparut presque inchangée en 1951 avec un moteur à deux temps. Impossible de ne pas remarquer en la voyant sa conception économique remontant aux années 20, son plus grand luxe était son moteur: 25 ans plus tôt, il fallait en effet manœuvrer les pédales. Après la guerre, on renonça à la suspension des roues arrière, en espérant que le châssis et les minces pneus seraient assez élastiques pour intercepter les chocs les plus rudes. La carrosserie du modèle suivant, la CM Grand Luxe de 1953, était déjà plus en accord avec son temps, et on y retrouvait des accents de la forme en ponton. Le modèle CM 125 Y présenté en 1954 avait, lui, les vraies proportions d'une voiture. Les rayons firent place à des jantes d'acier, les portières s'offrirent des vitres coulissantes – un véritable luxe pour une Mochet – puis plus tard quatre couleurs au choix. On tenta bien en 1953 de lancer un cabriolet de sport de 750 centimètres cube, mais il resta au stade du prototype. Ce qui est logique, car de tels véhicules ne correspondaient plus aux désirs de la clientèle et à la prospérité ambiante. La production fut stoppée en 1958.

NSU

Germany

While Opel had started with sewing machines and bicycles, NSU earned their first cash with knitting machines and bicyles. The first car was built in 1905. It was a licence for a Belgian car called Pipe. A small NSU-branded vehicle of 1906 and – later – a number of six-cylinder cars were stopped again in 1929, when NSU began to concentrate more on motorbikes. Having slightly overestimated their strength with the purchase of a body factory in 1926, NSU later took Fiat on board. In 1932 they started to assemble Italian Fiats in Neckarsulm. After the war, the Fiat production continued in Heilbronn. Indigenous NSU cars were not made again until 1957, at a time when the company had made a name for itself as the biggest motor bike manufacturers in the world (»Max«). The Prinz was a compact car at first, with no more than two cylinders. Its capacity and size varied considerably, going right up to the bottom end of the medium-size range. Bertone's design of a sports car – a 1959 coupé – caused quite a stir. No other German car manufacturers could have produced such an elegant design. The same was true of the Spider. The second part of its name – Wankel – acted as a reminder that, in 1964, this car was the first in the world with a planetory piston engine. The design of the Ro 80 (1967–1977) by Claus Luthe had a touch of futurism about it and was far ahead of its time – despite its frequent engine problems. In 1969 NSU merged with Auto Union (DKW) and was later bought up by VW. NSU's own medium-sized car reached the market as the VW K 70. Today, NSU only survives in the name of NSU GmbH (NSU Limited), a company that looks after the past history of this brand.

Opel fing mit Nähmaschinen und Fahrrädern an, NSU mit Strickmaschinen und Fahrrädern, bevor 1905 erste Autos gebaut wurden, als Lizenz der belgischen Marke Pipe. Ein seit 1906 selbstentwickelter kleiner Wagen und später auch Sechszylinder wurden nur bis 1929 gebaut, dann konzentrierte man sich mehr auf Motorräder. Nachdem man sich beim Kauf eines Karosseriewerkes 1926 leicht übernommen hatte, nahm NSU später Fiat mit in das Geschäft. Seit 1932 wurden in Neckarsulm italienische Fiats montiert. Nach dem Krieg ging diese Produktion in Heilbronn weiter. Autos made by NSU gab es erst wieder 1957, zu einer Zeit, da sich die Marke als größter Motorradhersteller der Welt rühmen konnte (»Max«). Der zunächst kompakte Prinz mit zwei Zylindern mutierte hubraum- und größenmäßig bis zur unteren Mittelklasse. Aufsehen erregte das Bertone-Design des Sportprinz in der Coupéversion 1959, eine Kleinwagenkonzeption, wie sie eleganter kein deutsches Werk bieten konnte. Das gilt auch für die Spider-Version. Der Zusatz »Wankel« erinnert daran: Dieses Auto war 1964 der Welt erster Wagen mit Kreiskolbenmotor. Das Design des Modells Ro 80 (1967–1977) von Claus Luthe war futuristisch und der Wagen seiner Zeit weit voraus – trotz der häufigen Motorprobleme. 1969 fusionierte NSU mit der Auto Union (DKW), die dann bei VW unterkam. Eine eigene Mittelklasseentwicklung von NSU kam bereits als VW K 70 auf den Markt. Heute lebt der Name NSU nur noch in einer GmbH weiter, die sich um Vergangenes der Marke kümmert.

Opel a débuté avec des machines à coudre et des bicyclettes, NSU avec des machines à tricoter et des bicyclettes, avant de commencer à fabriquer des automobiles en 1905, sous licence de Pipe, une marque belge. Une petite voiture conçue par la maison et plus tard également des six-cylindres ne furent construits que jusqu'en 1929, ensuite on se concentra sur les motocyclettes. En 1926, NSU dépassa un peu ses moyens pour acheter une usine de carrosseries, et elle prit plus tard Fiat pour partenaire. A partir de 1932, on fabriqua des Fiat italiennes à Neckarsulm. Après la guerre, on continua à les fabriquer à Heilsbronn. NSU ne recommença à construire des voitures qu'en 1957, à une époque où la marque pouvait se flatter d'être le plus grand constructeur de motocyclettes du monde (Max). La Prinz, tout d'abord compacte et dotée de deux cylindres, s'agrandit au niveau du moteur et de la carrosserie jusqu'à entrer dans la classe moyenne. Le design Bertone de la Prinz Sport en version coupé de 1959, la plus élégante petite voiture sortie d'usines allemandes, fut beaucoup remarqué. Ceci vaut également pour la version Spider. On se souvient du nom de Wankel sur les carrosseries: en 1964, la NSU fut la première voiture dotée d'un moteur à piston rotatif. Le modèle Ro 80, dessiné par Claus Luthe (1967–1977), présentait un design futuriste et était bien en avance sur les voitures de son temps, malgré les nombreux problèmes causés par le moteur. En 1969, NSU fusionna avec Auto Union (DKW), qui trouva ensuite refuge chez Volkswagen. NSU élabora ensuite une voiture de classe moyenne, la VW K 70. Aujourd'hui, NSU n'est plus qu'une société à responsabilité limitée, qui veille sur le passé de la marque.

Renault

France

The year of the first Renault by Louis Renault was 1898. It was the year when Louis had taken over the company from his deceased brother Fernand. Two years later he managed to sell a proud total of 179 cars. His work in the motoring industry remained in the family: the strong engines, which were used successfully in car races, were designed by his brother-in-law Georges Boutons, and Louis and his brother Marcel took part in the races where they won several victories. In 1907 Renault was the market leader in his own country. Tough competition between Renault, Peugeot and Citroën meant capacities of up to 8 litres (1– UK gallons, 2 US gallons). A real mini, however, was not designed until 1938, and the prototype had to wait until 1942. During the war, in January 1945, Renault was nationalized. An updated version was launched in 1946, which took until 1947 before it found its way to the customer as the 4 CV. By the time production was discontinued in 1961, it had sold 1,150,000 times and undergone continuous improvement. The Renault R 4, a direct successor of the »slice of cream cake« (the 4 CV), followed the Duck concept – with simple mechanisms and extremely comfortable (1961 until the late Eighties). In 1972, the R 5 made its appearance. Its perfect design may well have made it the best-selling French car of all times. It is certainly an aim which its successors, the Clio (1990) and Twingo (1992), though similar in size, have yet to achieve.

1898 kam der erste Renault unter der Regie von Louis Renault in dessen erstem Amtsjahr heraus. Er hatte die Firma vom verstorbenen Bruder Fernand übernommen. Schon zwei Jahre später konnten immerhin 179 Renaults verkauft werden. Familiär blieb die Zuarbeit auf dem Motorsektor, Schwager Georges Boutons konstruierte starke und in Renneinsätzen erfolgreiche Motoren, Louis und sein Bruder Marcel Renault fuhren Rennen und errangen Klassensiege. 1907 war Renault Marktführer im eigenen Land. Die harten Konkurrenzkämpfe zwischen Renault, Peugeot und Citroën brachten Hubräume bis knapp 8 Liter unter die Haube. Ein richtiges Komplettauto im Kleinmaßstab wurde aber erst ab 1938 konstruiert und war 1942 als Prototyp fertig. Noch während des Kriegs, im Januar 1945, wurde Renault verstaatlicht. Der Prototyp wurde 1946 überarbeitet vorgestellt, brauchte aber noch bis 1947, um den Weg als 4 CV zu den Kunden zu finden. Bis zum Produktionsende 1961 brachte er es auf mehr als 1 150 000 Exemplare, ständig verbessert. Der Renault R 4, ein indirekter Nachfolger des »Cremeschnittchens« 4 CV, war ähnlich dem Enten-Konzept gebaut worden: einfache Mechanik und viel Komfort (1961 bis Ende der 80er Jahre). 1972 kam der R 5 auf den Markt. Hatte das perfekte Design ihn zum bestverkauften französischen Wagen aller Zeiten gemacht? Das müssen die Nachfolger Clio (seit 1990) und Twingo (seit 1992) als ähnlich große Modelle erst mal schaffen.

La première Renault sortit en 1898, moins d'un an après que Louis Renault ait pris la direction de la maison après la mort de son frère Fernand. Deux ans plus tard, on en avait déjà vendu 179 exemplaires. Le travail aux moteurs restait dans la famille: le beau-frère Georges Boutons construisait des moteurs puissants remportant des succès sur les circuits sportifs, Louis et son frère Marcel pilotaient les voitures de course et fêtaient des victoires. En 1907, Renault était le numéro 1 des constructeurs français. La compétition acharnée entre Renault, Peugeot et Citroën vit naître des cylindrées atteignant les huit litres. Une vraie voiture en petit format ne fut construite qu'en 1938, son prototype était prêt en 1942. C'est en janvier 1945, pendant la guerre, que Renault fut nationalisée. Le prototype fut amélioré et présenté en 1946, mais il fallut attendre 1947 avant que le public puisse voir la 4 CV. Objet d'améliorations constantes, la 4 CV fut produite jusqu'en 1961 en 1 150.000 exemplaires. La R 4, qui lui succéda indirectement en 1961 et disparut à la fin des années 80, fut conçue selon la même philosophie que la 2 CV de Citroën: une mécanique simple et un grand confort (de 1961 à la fin des années 80). En 1972, on assiste au lancement de la R 5, qui sera la voiture française la plus vendue de tous les temps. Peut-être à cause de son design. Ses successeurs, la Clio (sortie en 1990) et la Twingo (en 1992), de taille semblable, vont devoir prouver qu'elles en sont capables.

Spatz

Germany

The Sparrow was built as the Victoria 200 by the Bayerische Autowerke GmbH (Bavarian Motor Company Limited), a company founded in 1956 by H. Friedrich (of Alzmetall) and the Victoria Works in Nuremberg. The engine had 200 cc and four manual gears. In the end, it even had electromagnetic ratchet gears that could be changed at the flick of a button. The shells, assembly facilities and material of the Victoria 130 were taken over by Burgfalke, a former glass-cutting company in Burglengenfeld near Regensburg. True to their name, Burgfalke wanted to turn the little sparrow into a soaring falcon. In the past, they had already learnt the art of production with the manufacturing of gliders. However, technological improvements in other small cars meant that the competition was stronger and only very few falcons were hatched. Although the development of the Sparrow had been helped greatly by the well-known Tatra engineer Hans Ledwinka, it did not save the car from frequent death by fire. The interior of the fibre-glass case had a coarse surface which gradually absorbed drops of petrol/oil mixture. This meant that the hot exhaust – situated diagonally in the engine area behind the back seat – or some electric spark or the electromagnetic gears eventually ignited the whole car at some stage. The father of the Sparrow, Egon Brütsch, was even served a court order, testifying that his design was unsafe. A disappointing result, considering that advertisers had proudly proclaimed a car »designed with care and built with love«. If we were to count all the Sparrows that were ever bought, they would add up to no more than 1,600.

Gebaut wurde der Spatz als »Victoria 200« von der Bayerischen Autowerke GmbH, die 1956 von H. Friedrich (Alzmetall) und den Victoriawerken (Nürnberg) gegründet wurde. Verwendet wurde ein 200 Kubikzentimeter-Motor mit manuellem Vierganggetriebe; am Ende hatte er sogar ein elektromagnetisches Ratschengetriebe, die Gänge wurden per Knopfdruck gewechselt. Die Firma Burgfalke in Burglengenfeld bei Regensburg übernahm von Victoria 130 Rohkarossen, Montageeinrichtungen und Material und wollte in einer ehemaligen Glasschleiferei aus dem Spatz einen erfolgreichen Burgfalken machen. Produzieren hatte man schon im Segelflugzeugbau geübt. Doch bessere Technik der konkurrierenden Kleinautos ließ nur wenige Burgfalken entstehen. Daß der Spatz vorher konstruktive Hilfe für seine Entwicklung vom bekannten Tatra-Ingenieur Hans Ledwinka erhielt, hatte ihn nicht davor bewahrt, häufig als Lagerfeuer zu enden: Die auf der Innenseite grobfaserige Kunststoffwanne saugte sich im Motorbereich nach und nach voll Tropfbenzin und Ölgemisch; entweder der heiße Auspuff, der hinter der Sitzlehne quer durch den Motorraum verlief, oder irgendein Funke der Elektrik oder der elektromagnetischen Schaltung ließen das Ganze dann irgendwann hochgehen. Dem Vater des Spatz, Egon Brütsch, wurde sogar gerichtlich die Verkehrsuntauglichkeit seiner Konstruktion bescheinigt. Dabei hatte die Werbung treu behauptet: »Mit Sorgfalt erdacht – mit Liebe gebaut«. Wenn alle Spatzen von den Dächern ihrer jeweiligen Inhaber pfeifen würden, dann käme ein Konzert von knapp 1 600 Stimmen zusammen.

La Spatz fut fabriquée sous le nom de Victoria 200 par les Usines automobiles bavaroises S.A.R.L., fondées en 1956 par H. Friedrich (Alzmetall) et les usines Victoria (Nuremberg). On utilisa un moteur de 200 centimètres cube avec boîte manuelle de quatre vitesses; à la fin elle possédait même une boîte de vitesses électromagnétique à cliquet, il suffisait d'appuyer sur un bouton pour passer les vitesses. La firme Burgfalke, sise à Burglengenfeld près de Ratisbonne, prit en charge 130 carrosseries brutes de Victoria, des installations de montage et du matériel. Dans une ancienne fabrique de polissage du verre elle voulait transformer le «moineau» en «faucon» (Falke). On s'était exercé à la production en construisant des planeurs. Mais la technique de la concurrence était meilleure et peu de Burgfalkes sortirent des usines. Bien que le célèbre ingénieur de Tatra, Hans Ledwinka, ait participé à la construction de la Spatz, cela ne l'avait pas empêchée de finir souvent en feu de joie. Elle avait une caisse en baignoire synthétique dont les fibres grossières à l'intérieur jouaient le rôle d'un buvard dans la région du moteur et absorbaient petit à petit les gouttes d'essence et le mélange huileux. Jusqu'à ce qu'un beau jour, le tuyau d'échappement chaud qui passait de derrière les sièges à travers le moteur, une quelconque étincelle électrique ou la boîte électromagnétique y mette le feu. Un tribunal certifia même à Egon Brütsch que ses voitures étaient inaptes à la conduite sur route. Pourtant la publicité assurait:«Conçue avec soin, construite avec amour». Le «moineau» de Brütsch fut fabriqué près de 1 600 fois, ce qui fait quand même un joli concert.

Trabant

Germany

If the Beetle was an important symbol of German post-war diligence, the Trabant was probably even more: a symbol of stamina they would finally go through the German Wall – without being stopped by border guards. This duroplast car with a steel frame was made at the Mosel plant in Zwickau. Its predecessor, the Type P 70, first left the production line in 1955, manufactured by a pre-war DKW plant. In 1957, a coupé was added – for a market where people were pleased enough when they got any cars at all, after ten years on a waiting list. The next car, the P 50 of 1957 was the actual Trabant – almost 16 inches (40 cm) shorter than the P 70. An estate followed in 1960. Called Trabant 601, it was far more attractive, although its fibre-glass body – which was made of cotton and groundwood pulp, soaked in artificial resin – attracted a good deal of scorn. And as VW were eventually to take over the Zwickau plant, it was no coincidence that the last Trabis were built with Polo engines, thus eliminating the smell of lubricated petrol. Although the Trabi did not survive the breakdown of the German Wall in 1989, it does live on in East German jokes – or as a means of inverted one-upmanship among Westerners who enjoy attracting attention with metallic engine noises and broad tyres. The production facilities were sold to poorer countries abroad. By now the Trabi has become rather a rare feature on German roads, even in the East.

Der Käfer war ein Symbol deutschen Fleißes nach dem Krieg, der Trabi dürfte fast noch mehr sein: Symbol fürs Durchhalten, so lange, bis die Mauer durchfahren werden kann – in freier Entscheidung. Dieses Kunststoffauto (Duroplast) mit dem stählernen Rückgrat wurde in Zwickau im Werk Mosel gebaut. 1955 kam mit dem Typ P 70 der Trabantvorgänger aus dem Werk, das einst vor dem Krieg DKWs montierte. 1957 wurde ein Coupé nachgeschoben – für einen Markt, der schon froh war, nach 10 Jahren das bestellte Auto zu erhalten. 1957 war mit dem Nachfolger P 50 der eigentliche Trabant geboren, immerhin knapp 40 Zentimeter kürzer als der P 70. Ab 1960 folgte eine Kombiversion. Als Trabant 601 wurde er mit gestraffter »Rennpappen«-Hülle (das war das Schimpfwort für die Kunststoffkarosse aus Baumwolle und Holzschliff, getränkt in Kunstharz) wesentlich ansehnlicher. Und weil inzwischen VW in Zwickau ansässig wurde, war es kein Zufall, daß letzte Exemplare mit dem Polo-Motor bestückt wurden, was die Zweitaktfahne verschwinden ließ, aber nicht für das Überleben nach der »Wende« 1989 sorgen konnte. So lebt der Trabi in Witzen weiter – oder als schriller Gag bei jenen Wessis, die mit ihm auffallen wollen, besonders wenn Metallic-Lack oder Breitreifen für Verfremdung sorgen. Die Produktionsanlagen wurden ins arme Ausland verkauft. Heute ist der Trabi bereits selten geworden, sogar auf den Straßen der neuen Bundesländer.

Si la Coccinelle fut le symbole du labeur acharné des Allemands après la guerre, la Trabant devrait être plus encore, un symbole de la ténacité: ne pas céder, jusqu'à ce qu'on puisse passer a l'Quest, quand on le veut. La voiture en duroplast au squelette d'acier était construite à Zwickau dans les usines Mosel qui fabriquaient des DKW avant la guerre. En 1955 le modèle P 70, prédécesseur de la Trabi, fit son apparition. Un coupé suivit en 1957, et cela sur un marché où les gens pouvaient déjà s'estimer heureux d'obtenir une voiture commandée dix ans auparavant. En 1957, la P 50 sort des chaînes: la Trabant est née, elle mesure 40 centimètres de moins que la P 70. La version break, Trabant 601, sort en 1960. Sa carrosserie plus compacte en «carton de course», (la dérision était de mise: la carrosserie était constituée de coton et de pâte de râperie mécanique, le tout trempé dans de la résine synthétique) était plus agréable à contempler. Et ce n'est pas un hasard si, Volkswagen s'étant entre-temps installé à Zwickau, les derniers exemplaires de la Trabi furent dotés d'un moteur de Polo. Les émissions gazeuses en furent peut-être améliorées, mais cela ne suffit pas à la sauver après la réunification en 1989. La Trabi a survécu dans les plaisanteries ou les gags de mauvais goût de «ceux de l'Ouest» qui veulent se faire remarquer, notamment en affublant les voitures de peinture métallique ou de pneus extra-larges. Les chaînes de production ont été vendues dans les pays pauvres. Aujourd'hui la Trabi se fait rare sur les routes des nouveaux länder allemands.

Vespa

Italy

Unless you are Italian, you probably associate the name Vespa with a classic chubby-faced motor scooter. Only very few people are aware that Vespa three-wheelers have been rendering good service as council-operated waste-disposal vehicles. Yet Vespa in Genoa had started to build a small convertible saloon as early as 1952 – on four wheels. The prototype, which was the size of a Goggo, was launched in 1956. It had a self-bearing body, a two-stroke engine, 400 cc and 14 HP. And as the history of the automobile is sometimes a matter of sheer survival, it is hardly surprising that Vespa were concerned about the Fiat 500, a new competitor on the small-car market, and therefore decided to move production to the French scooter plant Fourchambault, south of Paris. The première of the Vespa 400 took place at the Paris Salon in 1957. Built over 12,000 times, the Vespa was in fact very successful during its first year of production and even exported vehicles to Germany – though, like the little Autobianchis, they only played a minor role among small cars. It simply did not stand a chance against its German competitors in this category. The same was true for its entire European operations. Other car manufacturers were offering more successful and stronger minis, so that Vespa never actually made it. Production of the Vespa 400 was therefore discontinued in 1961, though its scooters and three-wheelers have continued until the present day.

Der Nicht-Italiener verbindet mit dem Namen Vespa den klassischen dickbackigen Motorroller. Nur wenige kennen zudem die fleißigen Dreiräder städtischer Reinigungsbetriebe. Dabei hatte sich das Werk in Genua schon 1952 an den Bau einer kleinen Cabriolimousine gemacht – mit vier Rädern. Goggogroß kam der Prototyp 1956 auf die Straße, mit selbsttragender Karosserie, zweitaktenden 400 Kubikzentimetern und 14 PS. Und weil automobile Geschichte manchmal schlichtes Überleben nachzeichnet, nimmt es nicht Wunder, daß Vespa aus Sorge um die bei Fiat entstandene Konkurrenz des neuen Kleinwagens Fiat 500 die Produktion ins französische Vespa-Rollerwerk Fourchambault südlich von Paris verlegte. Der Pariser Salon 1957 war dann die Premiere für den Vespa 400. Mit über 12 000 gebauten Exemplaren im ersten Produktionsjahr war der Vespa recht erfolgreich, Exporte gingen auch nach Deutschland. Hier spielten sie aber wie die kleinen Autobianchi nur eine untergeordnete Rolle bei den Kleinwagen: Die deutsche Konkurrenz im Angebot der kleinen Klassen war zu groß. Das gilt schließlich für das gesamte Angebot in Europa. Andere Marken hatten erfolgreichere und stärkere Minis zu bieten, für Vespa keine Zukunft. Das Produktionsende von 1961 galt aber nur dem Vespa 400, bis heute gibt es noch Roller und Dreiräder.

Pour les étrangers, la Vespa, c'est le scooter classique joufflu. Ils sont rares à connaître aussi les tricycles toujours en action des entreprises de nettoyage publiques. Pourtant l'usine avait déjà commencé en 1952 à Gênes à construire une petite berline-cabriolet à quatre roues. Le prototype sortit en 1956, il avait la taille de la Goggo, une caisse monocoque, un moteur à deux temps de 400 centimètres cube et 14 CV. Nul ne s'étonnera d'apprendre – on la comprend très bien – que la firme Vespa, craignant pour son existence après la création chez Fiat de la nouvelle Fiat 500, ait transféré sa production dans l'usine de scooter Vespa de Fourchambault au sud de Paris. La Vespa 400 fut alors présentée au Salon de Paris de 1957. 12 000 Vespas furent fabriquées la première année. La voiture avait beaucoup de succès, elle fut même exportée en Allemagne. Mais comme l'Autobianchi, elle n'eut dans ce pays qu'un rôle secondaire, car la concurrence allemande dans la gamme des petites voitures était trop importante. Ce qui est vrai pour l'Allemagne l' est également pour l'Europe. D'autres marques offraient des petites voitures plus puissantes et se vendant mieux, la Vespa n'avait pas d'avenir. On cessa de produire la Vespa 400 en 1961, mais on fabrique toujours des scooters et des tricycles.

Zaporozhets

CIS, Ukraine

Zaporozhye on the river Dnepr in the Ukraine, 60 miles (100 km) north of the Crimea, is the location of a tractor factory called Kommunar, where small cars have been made since 1959. The car is called Zaporozhets and already had an air-cooled V4 rear engine in its 1960 series. It was based on a prototype called Nami–13, designed by Y. Dolmatovski. Nami is the name of a Moscow car factory that functioned as a trailblazer and intellectual centre of Soviet production. Their prototypes were numbered consecutively. Alongside this type, there was also the Belka (»squirrel«) as a parallel development. It had the same self-bearing body as the ZAZ, and there was a certain spindle-shanked awkwardness about it – a typical feature of many Soviet cars, as this was the only way of coping with the state of the roads, both inside and outside the towns. The successor model, the ZAZ–068 A of 1966, had a stronger engine and was even exported to other countries. In Austria it was sold under the name Eliette. Other trade names were Star and Cossack. In 1962 it began to resemble the German NSU Prinz 1000 – apart from the rear engine air scoops on the sides and its spindly appearance. The Zaporozhets was assembled in Belgium for a while, where it was given a 950 cc Renault engine. After the launch of new models in 1963, the old ones continued to be sold under the name ZAZ–965 A. As ZAZ–968 M, it is still being sold with virtually no modifications in 1993. The 1993 product range is further complemented by a ZAZ Tavriya with a 1-litre engine in the Golf class and a very well designed ZAZ (Vac 1111) with two cylinders and 644 cc in the mini class.

Die Stadt Zaporozhye am Dnjepr in der Ukraine, 100 Kilometer nördlich der Krim, ist Sitz der Traktorenfabrik Kommunar und seit 1959 auch Heimat kleiner Autos. Der Kleinwagen hieß Zaporozhets und hatte bereits in der Serie von 1960 einen luftgekühlten V 4-Heckmotor. Basis war ein Prototyp des Konstrukteurs J. Dolmatovski mit der Bezeichnung Nami 13. Nami ist eine Moskauer Autofabrik, die für UdSSR- Produktionen als Vordenker und Schaltzentrale fungierte. Ihre Prototypen wurden fortlaufend numeriert. Eine Parallelentwicklung zu diesem Typ war der Belka (Eichhörnchen). Die selbsttragende Karosserie des ZAZ wirkte stelzbeinig, typisches Detail vieler russischer Autos, denn nur so ließen sich Straßenverhältnisse auch außerhalb der Städte bewältigen. Das Nachfolgemodell ZAZ–968 A ab 1966 konnte mit verstärktem Antrieb sogar exportiert werden. In Österreich wurde es unter dem Namen Eliette vertrieben. Weitere Verkaufsnamen waren Star und Kosak. Seit 1962 sah er dem deutschen NSU Prinz 1000 sehr ähnlich – bis auf seitliche Lufthutzen für den Heckmotor und die hohen Beine. Der Zaporozhets wurde zeitweilig in Belgien montiert, hier mit einem 950 Kubikzentimeter-Renaultmotor. Seit Einführung neuerer Modelle 1963 als Zaporozhets wurden die alten unter der Bezeichnung ZAZ–965 A vertrieben. Als ZAZ–968 M wird er fast unverändert noch 1993 angeboten. Ein ZAZ Tawrija mit 1 Liter-Motor in der Golfklasse und ein wirklich gelungener ZAZ (Vac 1111) mit 2 Zylindern und 644 Kubikzentimetern in der Miniklasse ergänzen das Werksprogramm 1993.

Une ville nommée Zaporojie sur le Dniepr en Ukraine, cent kilomètres au nord de la Crimée, est le siège de l'usine de tracteurs Kommunar et, depuis 1959, on y construit également des petites voitures. Le véhicule en question, la Zaporojets, possédait déjà en 1960 un moteur en V de 4 cylindres placé à l'arrière et refroidi à l'air. Elle était basée sur un prototype du constructeur J. Dolmatovski, la Nami–13. Nami est une usine automobile de Moscou, qui travaillait comme concepteur et centre de communication pour les productions de l'U.R.S.S. Ses prototypes étaient numérotés de manière continue. La caisse monocoque de la ZAZ semblait perchée sur des échasses, ce que de nombreuses voitures russes ont en commun, car c'est la seule manière de pouvoir maîtriser les conditions du terrain à l'extérieur des villes. Le modèle suivant, la ZAZ–968 A, produite à partir de 1966, put déjà être exportée, son moteur était plus puissant. Elle fut diffusée en Autriche sous le nom d'Eliette et aussi vendue sous d'autres noms, tels que Star et Cosaque. A partir de 1962 elle se mit à ressembler fortement à la NSU Prinz 1000 – mis à part les bouches d'aération pour le moteur placé à l'arrière et les «grandes jambes». La Zaporojets fut même montée un moment en Belgique avec un moteur Renault de 950 centimètres cube. Après l'apparition de nouveaux modèles Zaporojets en 1963, les anciens furent vendus sous le nom de ZAZ–965 A. On peut encore les acheter en 1993, presque inchangés, sous le nom de ZAZ–968 M. Une ZAZ Tawrija d'un litre dans la catégorie de la Golf et une ZAT vraiment réussie (Vac 1111) au moteur de deux cylindres et 644 centimètres cube dans la classe des petites voitures arrondissent la gamme du constructeur en 1993.

Zündapp

Germany

Who would have guessed that Ferdinand Porsche designed not only at the Beetle, but in 1931 he also showed his talent at the Zündapp plant in Nuremberg. This precursor of the Beetle had a five-cylinder radial rear engine, though it was never mass-produced. To save money for the production of a widely popular car, the motorbike manufacturer and sole proprietor of Zündapp, Fritz Neumeyer started by making ammunition. After the First World War, he was also very successful with motorbikes. In 1925 he would have liked to produce the British Rover under a licence agreement, but had to give up the idea because of financial constraints. Two years later he succeeded in making a combination of a motorbike (at the front) and a platform (at the back). The next stage was a fast little van on four wheels, with a 400 cc engine. Many years later, in 1956, helped by Pininfarina, he tried to build a coupé with a Coventry Climax engine. This was followed by a rather too ambitious project – the Delta model by Dornier in the form of the Janus in 1957. Zündapp only produced 6,900 cars of this type, just enough to become known, but too little to survive in a country with rising expectations. The back-to-back seating arrangement of the Janus never really gained any widespread acceptance. In 1958 production was discontinued. The Munich plant continued to make motor scooters, mopeds and motor boat engines for another 25 years, until its production facilities were finally sold to China in 1984.

Wer hätte das gedacht: Ferdinand Porsche hat nicht nur den Käfer konstruiert. Bereits 1931 zeigte er sein Talent für das Zündapp-Werk in Nürnberg. Als Vorläufer zum Käfer hatte dieses Auto einen Fünfzylinder-Sternmotor im Heck, ging aber nie in Serie. Geld für Absichten, ein Volksauto anzubieten, verdiente sich Fritz Neumeyer, Motorradfabrikant und Alleininhaber der Zündapp-Werke, zunächst mit Munitionstechnik. Auch der Bau von Motorrädern brachte nach dem Ersten Weltkrieg viel Erfolg. Eine Lizenzproduktion des englischen Rover konnte 1925 nicht verwirklicht werden mangels finanzieller Mittel. Zwei Jahre später reichte es für eine Kombination aus Motorrad vorne und Pritsche hinten. Vier Räder schaffte danach ein Schnellieferwägelchen mit 400 Kubikzentimeter-Motor. Viel später, 1956, versuchte man mit Pininfarinas Hilfe, ein Coupé mit Coventry-Climax-Motor zu bauen. Offensichtlich eine Nummer zu groß, denn danach wurde das von Dornier entwickelte Modell Delta als Janus 1957 aufgelegt. Gerade 6 900 Exemplare wurden gebaut, genug, um bekannt zu werden, zu wenig zum Überleben im Land mit steigenden Ansprüchen. Die Rücken-an-Rücken-Sitzanordnung des Janus setzte sich nicht durch. 1958 wurde die Produktion eingestellt. Noch 25 Jahre länger baute man im Münchener Werk Motorroller, Mopeds und Bootsmotoren, bis 1984 die Produktionsanlagen nach China verkauft wurden.

Le saviez-vous? Ferdinand Porsche n'a pas seulement construit la Coccinelle. En 1931 déjà, il exerçait ses talents à Nuremberg dans les usines Zündapp. Le prédécesseur de la Coccinelle avait un moteur en étoile de cinq cylindres placé à l'arrière, mais il ne fut jamais fabriqué en série. Avant de construire une voiture populaire, Fritz Neumeyer, fabricant de motocyclettes et propriétaire exclusif des usines Zündapp, dut d'abord gagner de l'argent en produisant des munitions. Il eut aussi beaucoup de succès avec ses motocyclettes après la Première Guerre mondiale. Une production sous licence de la maison anglaise Rover ne put être réalisée, faute d'argent, en 1925. Deux années plus tard, on en avait assez pour construire un véhicule combiné, motocyclette à l'avant et remorque à l'arrière. Ensuite, il y eut une voiturette de livraison à quatre roues dotée d'un moteur de 400 centimètres cube. Beaucoup plus tard, en 1956, on tenta, avec l'aide de Pininfarina, de créer un coupé équipé d'un moteur Coventry-Climax. Ensuite, et manifestement une pointure de trop, le modèle Delta élaboré par Dornier fut fabriqué en 1957 sous le nom de Janus. On en construisit 6 900 exemplaires, ce qui suffit pour être connu, mais pas pour survivre dans ce pays aux exigences de plus en plus grandes. Le dos-à-dos proposé par la Janus, ne put s'imposer et la production fut stoppée en 1958. On fabriqua encore pendant 25 ans des scooters, des mobylettes et des moteurs de bateaux dans les usines de Munich jusqu'en 1984, date à laquelle les installations de production furent vendues à la Chine.

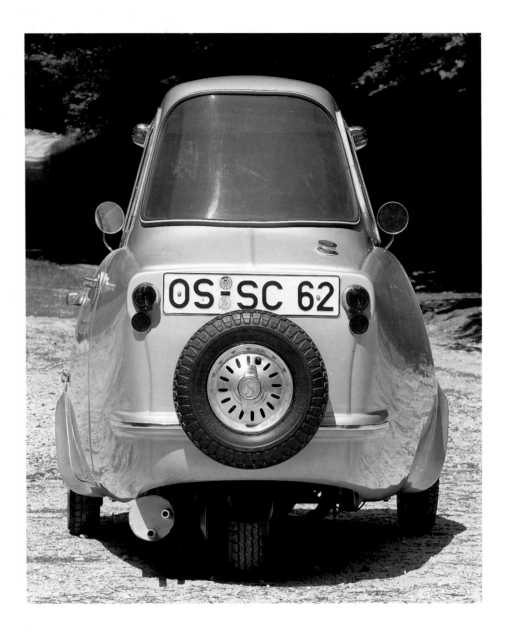

Photographic Credits

Art Center College of Design, La Tour-de-Peilz, Switzerland: 138, 139, 140, 141, Back Cover
Bernd Ahrens/AutoBild, Hamburg: 96, 97
Austin Rover Deutschland GmbH: 20, 73
Autozeitung, Köln: Front Cover, 21, 22, 25, 27, 41, 42, 49, 51 (Wilkin Spitta, Zeitlarn), 52 (ibd.), 53 (ibd.), 54, 59, 62, 68, 69, 73, 76, 78, 79, 82, 83, 86, 93, 101 (D.P.P.I., Paris), 103, 105, 106, 108, 109, 110, 112, 117, 126, 131, 132, 133, 135, 136, Back Cover
BMW AG, München: Front Cover, 8, 10, 12 (Hans Glas), 13, 42 (Historisches Archiv), 57, 58, 63, 130, 131, Back Cover
Rolf Bürgel, Köln: 65
Citroën Deutschland AG, Köln: 46, 72, 89, 135
Daihatsu Deutschland GmbH, Tönisvorst: 36, 120, 121, 123, 133, 134, Back Cover
Fiat Automobil AG, Heilbronn: 19, 70, 95, 104, 111, 114, 115, 117, 124, 136

Ford Werke AG, Köln: 104, 111, 114, 115, 117, 124, 136
Dieter Günther, Hamburg: 49, 61, 69
Gurgel Motors, Brazil: 89
Ernst Hedler, Selb: Front Cover, 59
Honda Deutschland, Offenbach: 29, 134
Horlacher, Möhlin: 128
Lancia, Turin: 87
Reinhard Lintelmann, Espelkamp: 1, 7, 11, 15, 16, 17, 23, 43, 44, 45, 48, 53, 55, 56, 57, 60, 62, 64, 65, 66, 67, 71, 75, 78, 79, 176
Hans-Ulrich von Mende, Frankfurt am Main: 63, 81, 82, 88, 100, 101, 102, 104, 107, 112, 113, 120, 122, 126
Mercedes-Benz AG, Stuttgart: 129
National Motor Museum, Beaulieu: 46, 68, 74, 80
Nissan Motor Deutschland GmbH, Neuss: 28, 30, 33, 90, 91, 93

Opel AG, Rüsselheim: 40, 88, 118, 119
Peugeot Talbot Deutschland GmbH, Saarbrücken: 88
Bern Rauh/AutoBild, Hamburg: 37
Deutsche Renault AG, Brühl: 47, 94, 102, 142, 143, Back Cover
Subaru Fuji Heavy Industries Ltd., Tokyo: 77, 92
Bildarchiv Süddeutscher Verlag, München: 146
Suzuki Motor Corporation, Hamamatsu: 76, 92
Takeoka, Tokyo: 124
Toyota Deutschland, Köln: 127
VIP Corporation, Tokyo: 123
Volkswagen AG, Wolfsburg: 35, 116, 125, 137
WTM Thomas Möller, Ludwigsburg: 128